# Poland

The Publisher
makes acknowledgements
to the Management and Employees of the State Archives
for their effort which contributed
to this publication.

# POLAND

## in Old Photographs

BOSZ

## Photographs

All the photographs included in the album come from the collections of the State Archives.
The photographic material for the album was provided by the Archives of Mechanized Documentation.

## Introduction

Janusz Tazbir, Daria Nałęcz

## Texts

Tomasz Jurasz

## Graphic Layout

Władysław Pluta

## Translation

Magdalena Iwińska

## Photograph Selection Concept

Iza Wojciechowska

## Editor

Joanna Kułakowska-Lis

## Cooperation and Consultancy

Violetta Urbaniak

## DTP

Piotr Hrehorowicz, Małgorzata Punzet, Inter Line SC

## Print

Sun Fung Offset Binding Co., Ltd, Printed in China

© Copyright by Wydawnictwo BOSZ
Illustration © Copyright by Naczelna Dyrekcja Archiwów Państwowych

First Edition Olszanica 2005

ISBN 83-89747-17-0

Wydawnictwo Bosz
38-622 Olszanica 311
Office:
ul. Parkowa 5 38-600 Lesko
tel. +48 13 469 90 00, 469 90 10
tel./fax +48 13 469 61 88
email: biuro@bosz.com.pl
www.bosz.com.pl

# Contents

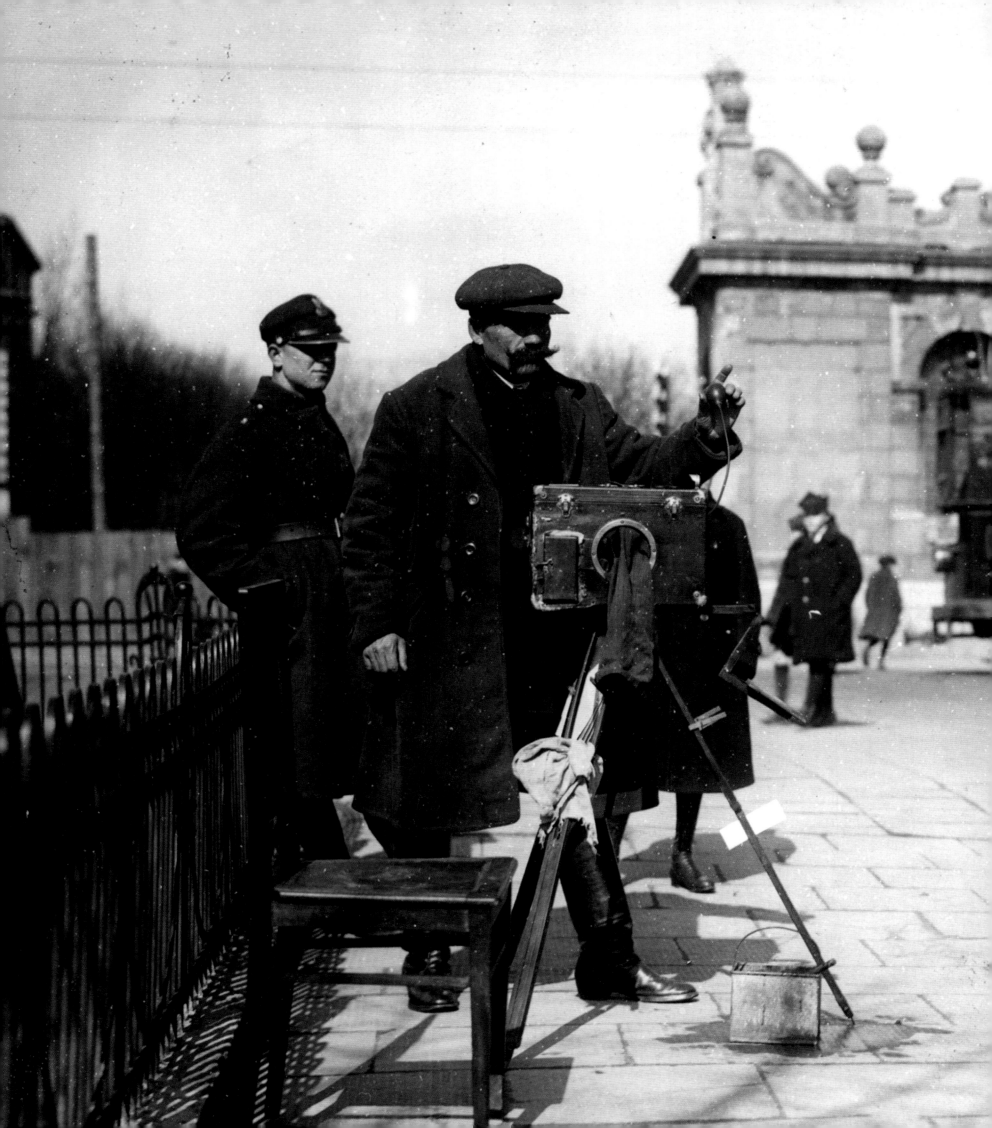

# Introduction

Photography, at first in the form of daguerreotype, started to accompany our history from the second half of the 19th century, that is the period when Poland had lived more than eight hundred years of independence and also for one hundred years deprived of her national freedom. And just like the first books tried to copy old manuscripts and the first train carriages imitated a stage-coach, photography, specially the portrait one, for a long time was a continuation of painting. Portraits actually soon lost their importance, since human figures were better and more accurately shown in a picture taken by a camera, which was being quickly improved, than by the painter's brush. Yet, even still in the first half of the 20th century people are arranged for photographs similarly as in paintings. Both group and individual photographs usually show people with a "Sunday" face and in a "Sunday" dress. Photographs were more willing to show the big and powerful of this world and their homes than an ordinary man, and his work place or home. Despite Communist Poland's effort to rub out the land owners' culture, a number of photographs of castles and palaces, as well as smaller and bigger manors

have been preserved; yet, the farm hands' living quarters are known only from descriptions in literature.

Both Polish culture and academic activity of the 19th century continued to consistently regard all the three partitions as one whole, held together by the common history and the same aspiration to regain independence. The tradition of the state of the nobility acquired national character, which was also consolidated by historical novels showing such a concept of Poland's history. This is precisely the approach represented by the authors of this album which, territorially speaking, in the east goes beyond not only the frontiers imposed on Poland in 1945, but even also those that had been delineated by the Peace of Riga of 1921.

An important factor that helped us survive the partition periods were the traditions of Polish culture, both those from the 16th century and those which created Sarmatism, being a unique symbiosis of the influences of the material culture from the Orient with the freedom ideology of the Polish nobility. During the partition period the term "Sarmatian" stopped being applied only to the gentry and was conceived more as a synonym of all Poles. Being a Pole meant, in turn,

participation in all the subsequent insurgencies, and "in the meantime", working on the cultural and economic development of the country.

Another important reason can be seen in an open character of Polish culture and henceforth derived positive attitude to all the arriving outsiders, who, in turn, quite easily let themselves be tempted by the charms of Polish life. This, naturally, was also possible due to the long tradition, reaching the 14th century, of the co-existence of various nationalities, denominations, and cultural and customary systems.

The third reason for Polish culture to be attractive has been found (and on this we should agree with the opinions of the historians of literature) in the fascinating romantic visions of national independence and armed struggles for freedom carried out by individuals and the whole nation. Those slogans popular at the time penetrated even the circles in which German was the language spoken at home. It has been justly pointed out that Austrian censorship, when putting a ban on the works of great German writers of the Romanticism, encouraged young people, not only Polish, to passionately read the works

by Mickiewicz, Słowacki, or Krasiński, smuggled into Galicia. In the Kingdom of Poland this literature affected strongly the young enthusiasts of German or Czech origin, who just like their Polish peers, belonged to conspiracy structures or insurgence authorities.

An important consolidating role was also played by the Catholic Church, specially on those territories where the defence of Polish identity was related to the defence of Catholicism, thus in the Russian and Prussian partitions.

The Poles were led to independence both by their culture, which integrated them strongly, and by the armed struggle in insurgencies; this is what the Legions commanded by Józef Piłsudski referred to. In a way, the partitioning powers themselves had unconsciously, and against their true intentions, paved the way for it. It was precisely in reaction to their oppression that national consciousness was consolidated and the Polish desire to rebuild their own state was strengthened. Independence would not have been possible, however, had it not been for World War I and the defeat of all the three powers in it. Yet, this very war also brought about a severe economic destruction of the

territories which later formed the rebuilt state. Soon, the devastation caused by the war actions in 1914–1918 was increased by the effect of the war Poland fought against the Bolshevik Russia; Polish fresh independence was defended against that threat in 1920.

In the result of all the above, the level of industrial production on the Polish territories reached the level equal to that from before World War I only in 1935. Judging the achievements in the brief period of 18 years (counting between the concluding of the Peace of Riga until the outbreak of the next war) a lot was accomplished, specially in the sphere of economic, civilizational, and legal integration of the three former partitions. Time did not allow this process to be completed. Until the tragic September of 1939 there remained this division into two categories of Poland: "A" Poland and "B" Poland, the latter meaning eastern territories which continued to be underdeveloped. They were incorporated into the Soviet Union in 1939 to be never regained, although we heroically struggled on the side of the victorious coalition.

In the interwar period Poland managed to build in an amazing way the new efficient port on the Baltic,

Gdynia, which allowed our sailing on the Baltic regardless of the whim of the Free City of Gdańsk, not favourable to the Poles. We developed transportation networks and a railway system, and the Polish trains were famed for being the most punctual in Europe. All this was accompanied by the modernization of industry carried out on a large scale.

Quite a lot was done in the effort to overcome illiteracy. The so-called mass culture popularised by press, whose circulation was systematically increasing, and radio had an impact on the growing circles of society. Art and literature could boast of many accomplishments. Towns were enlarged and had new representative buildings raised; they were to reflect the aspirations of the reborn Republic of Poland. Let us not forget that all this was accompanied by significant difficulties of political and economic nature. It is true, though, that in 1924 inflation was stopped by the introduction of a new currency, namely the zloty, but already five years later Poland suffered the effects of the world economic crisis. It implied unemployment and the decrease in real wages, as well as a painful impoverishment of the villagers. Farmers and workers carried out

mass strikes violently suppressed by the police.

Unemployment was to diminish partially thanks to the construction of the Central Industrial Area, which began in 1937 was meant to be the base for our war industry. Plans for the year 1941 assumed the end of the modernization of the army, and the years to follow would allow the state to focus on transportation and agriculture.

However, attempts to introduce a parliamentary system in the Republic of Poland were not fully successful. The fact that the Parliament partially compromised itself, allowed Piłsudski supported by vast groups of society and the army to take over power in 1926. Poland did not turn into a totalitarian state of the Soviet, German, or Italian type, for there still continued to exist opposition political parties having their representatives in the Parliament, as well as independent press. On the whole, it can be said that the development of the Second Republic of Poland resembled the processes happening in Western Europe at the time.

But what is most important, in the period of that Second Republic it was possible to educate a new generation of the Poles, strongly attached to the independence which had been won at a price of so many victims, and ready to sacrifice their blood and life in Poland's defence; this was possible, among others, thanks to the schooling, for which the best proof is the fact that in the communes where the Polish Military Organization headed by Piłsudski had been established in 1914–1918 and which had had merely several hundred members, during World War II the clandestine forces of the Home Army and Peasants' Battalions commanded several thousand soldiers. One must not forget this when summing up our second, actually very brief, period of independence. It was interrupted by the September defeat and after that half a century had to pass for a truly independent and sovereign Republic of Poland to be reborn.

Many of the issues brought up in this introduction have, for obvious reasons, remained beyond the photographer's lens. Besides, many pictures have also been destroyed. Photographs have shared in the fate of houses, manors, culture treasures. History was not at all any kinder to them. Ksawery Pruszyński writes that when in London among the emigrants he had to constantly explain to the English that his family adobe was first burnt down by the Cossacks during the Kościuszko Insurgence, then the house was demolished by the Russian artillery in 1915, and finally a town house in Warsaw, where he had moved with the remains of the saved paintings and furniture, burnt down in September 1939.

So, please, dear Reader, consider the few words of this introduction as a commentary to the illustrated part of this book. It is quite clear that out of major historic events only several have been included in the book. Fortunately, in the Third Republic of Poland so many different perspectives on our history have been published, showing it as a whole, but also focusing on particular epochs that each Pole wishing to know more about his or her nation has a lot to pick from to consult. It is not our intention for this album to replace a text book on our history or a guide to Polish monuments and landscapes. We will be, in turn, happy if this book encourages its Readers to make a journey in time and carry out some excursions across the country that since May 1, 2004 has been part of the large community of free European nations.

Janusz Tazbir

**Prof. Janusz Tazbir**, historian, specializing in Old Polish history, authored more than 30 books and 1000 scholarly papers, member of the Polish Academy of Sciences, Warsaw Academic Society, PEN Club, Chairman of the Central Commission of Academic Titles and Grades.

# Poland
## in Old Photographs

Poland immortalized in the photographs shown in the present album is first of all the Second Republic of Poland, a state reborn in November 1918 after 123 years of being deprived of freedom and violently erased from the map of Europe by the Nazi and Soviet invaders in September 1939. Today we often refer to that independence experience, thinking that it can provide us with some examples how to function in sovereignty and democracy. In this respect the experience of the Communist Polish People's Republic is much less useful, since it was the period when even under a slightly loosened authoritarian corset, all the major decisions were taken beyond the Poles, namely in the capital of the Soviet empire.

However, when modelling on the legacy and experience of the Second Republic of Poland, one should bear in mind the fact that despite many similarities, mainly within culture and political system, that state differed from today's Poland in many respects.

Its territory totalling 388.6 thousand square km placed that country, similarly as today's Poland, among larger European states (the sixth place). It was, nevertheless, a country stretched towards the east by some hundred kilometres; its major towns were not only Warsaw, Kraków, and Poznań, but also Vilnius and Lviv.

The inter-war Poland was a country with geographically differentiated regions. In the north it had a very modest access to the Baltic: only 140 km of coast line, of which 68 made the Puck Bay. Vistula's estuary was outside the boundaries, which quite efficiently blocked our contact with the sea. The change was only brought about by the construction of the port in Gdynia and joining it with Silesia by means of a very modern trunk-line. In the south the natural frontier was made by the Carpathians. In the south-east there loomed the wooded tops of the Bieszczady and Gorgany Mountains, as well as mountain pastures of the Chornohora Ridge with the peaks of Mount Hoverla and Pop Ivan. This is where the frontiers of Poland, Czechoslovakia, and Romania met. Beyond the elevations of the Carpathians the territory significantly lowered. In the western part there stretched the Valley of the Vistula and Sandomierz Plane. In the east, the valleys of the Dniester and Stryjsko-Stanisławowska. Soil was fertile here and the population dense. A region apart could be found in the Silesian-Great Poland Upland. It enchanted with the variety of geological forms, hiding underground true wealth of natural resources. On the surfaces the picturesque elevations of Kraków-Częstochowa Jurassic Rocks delighted visitors. The beauty of this region could be possibly rivalled by the ancient landscape of the Świętokrzyskie Mountains. The eastern part of the region was made of the Black Sea table-land, with the Lublin Heights, Roztocze, Volhynia and Podolia, picturesque with their winding ravines and monuments of the past devastated by numerous wars. What dominated central Poland were the planes, that is why it was called the Region of Great Valleys. In the west there stretched Great Poland, known for a high agrarian culture and the centres of ancient Polish statehood: Gniezno and Poznań. Near from there, fertile humus of Kujawy was found, with ancient Kruszwica on Lake Gopło. Further on the area had a monotonous landscape, but it was also very poor. Flat and sandy Mazovia neighboured on the wooded Podlasie and marshy Polesie traversed by lazily flowing rivers: the Prypeć, Styran, Horynia, and Słucz.

Out of the stretch of the Great Lakes only a modest fragment was Polish: the Brodnica Lake District.

More lakes were to be found in the Suwałki province and in Vilnius with Narocz (80.5 sq km) dominating the area as the second largest water reservoir of the Polish Republic.

The state revived in 1918 consisted of, to use Stefan Żeromski's phrase, "three unequal halves". The former Russian partition had covered 260,000 sq km, Austrian — 80,000 sq km, and the Prussian — 48,600 sq km. The fact that they had functioned within different states for over a hundred years caused significant differences among those areas. They each had different political habits, legal and economic structures, different arrangement of social forces. Different were also customs, everyday habits, life styles. And the greatest discrepancies were found in their economies. The Poznańskie province used to be a food granary. In Upper Silesia and Dąbrowskie Basin what dominated was heavy industry. In the former Congress Kingdom there dominated metal and textile industries, being challenged seriously by the loss of an absorbing Russian market, lost forever after the victory of the Bolsheviks. Attempts to industrialize Galicia, where by the end of the 19th century oil was being extracted, were not very

successful. It remained the poorest region of Poland with an income three times smaller than on the territories of the Prussian partition.

According to the first census carried out in 1921, Poland was inhabited by over 27 million citizens. Up to 75 percent of those lived in the country, and 65 percent made their living by cultivating land. Such an agrarian structure of a country was anachronic in the then Europe and Poland was far behind economically developed countries in which the percentage of farmers ranged between 20 and 40, not to mention Britain which was most advanced in this respect (5 percent).

Such stratification was the most evident index showing the outdated character of economic and social relations, which made Poland rank among the less developed countries in Europe and the world, though it was ahead of all the colonies and the poorest European countries. And though the percentage of the population who made their living by farming gradually decreased, no essential changes in this respect occurred during the 1920s and 1930s.

The 1921 census also proved a large number of middle-class, who made up to 11 percent of Poland's population.

The number of intelligentsia was assessed at 5 percent, the middle class and land owners constituting 2 percent of the population.

The peasants usually worked on dwarfed and little plots (34 percent of farms were smaller than 2 hectares) Up to 45 percent of all farming land belonged to less than 19 thousand land owners, who owned more than 100 hectares. So, the agrarian reform was one of the major concerns of the state. It also had to boost the civilization of the countryside which, specially on the vast territories in the east still maintained self-sufficient economy. This, however, required enormous financial inputs and development of the educational system, since the peasant population (which did not apply to Great Poland) had an overwhelming majority of the illiterate (70 percent on the eastern territories and 50 percent in Galicia).

In the country, which struggled most with poverty, there prevailed traditional culture. Family was a fundamental element there and it exerted a significant range of functions. It was within the family that economic, social, intellectual, and moral life was organized. There prevailed many-generation families, with a domineering

father and a serving function of the woman. The life style in the country was strongly determined by the rhythm of field work, which, in turn, determined close bonds with nature.

Significant disproportions in particular regions were clearly visible, for example, in the material standard of living. In the western provinces what dominated were brick buildings, most frequently with several rooms. In the east, and partially in the south, there prevailed wooden buildings with thatched roofs, most generally with a single room. Here, you could also come across chimneyless cabins in which only a thin partition wall separated people from their breeding animals.

The Church was the main moral authority among those circles and the customs were mainly based on religion. This rule applied to all the countryside, regardless of its national diversification, which reflected the diversification of the whole of society.

The above-mentioned census showed that the Republic of Poland was inhabited by 18.6 million Poles, 4.6 million Ukrainians, 2 million Jews, 1.5 Byelorussians, less than 1 million Germans. This national mosaic was completed with a less numerous concentration of the Czechs, Lithua-

nians, Slovaks, Armenians, Tartars. Each of those groups cultivated their own customs, enjoyed entertainment to the sound of different music, dressed differently. Some of them went into the trouble of having their own periodicals, press, and even theatre. In central and western provinces the Poles amounted up to 86–92 percent of the population. In the eastern ones this figure was merely 37 percent. Apart from the Jewish population dispersed throughout the country, and particularly numerous in towns and little towns of the former Russian and Austrian partitions, the remaining national minorities inhabited quite uniform territories of the borderland, which additionally consolidated the centrifugal tendencies.

The national differentiation most commonly coincided with religious divisions. A Pole was predominantly a Catholic, a Ukrainian was a Greek Catholic or an Orthodox, a German was a Protestant. In 1938, 65 percent of the Republic of Poland confessed Roman Catholic religion. The Episcopate had 46 cardinals, archbishops, and bishops, and the number of diocese clergy amounted to almost 10,000 people, whereas the convents had 23,000 people. With time, the earlier

dominating traditionalism of the Polish clergy gave way to the new forms of priesthood that combined the religious doctrine with more social commitment. This was the kind of effort in which the following convents excelled, namely the Piarists, nuns of the order of the Holy Family of Nazareth, and the Franciscans, who headed by Father Maksymilian Kolbe organized an important centre in Niepokalanów. But despite the fact that the Catholic religion being most numerously represented, enjoyed some constitutional privileges, the Second Republic of Poland was, generally speaking, a country of tolerance, in which millions of Orthodox believers, Jews, and Protestants, could freely profess their faith.

The strongest differentiations went along political lines, which applied to all the nationalities. However, for the functioning of the state what mattered most was the political tissue of the Polish community. Simply because the minorities, despite the fact that they were represented in the Parliament, did not participate in running the country.

The major political camps which had the strongest influence, namely the national-democratic one, peasant, socialist, and conservative, had formed even before Poland regained inde-

pendence and they survived during the whole period of twenty years, though they thoroughly reformed their programmes and activities. Each of those political groups had its own vision of an independent state based on a set of values and tradition. A new group that came on stage as a politically independent force could be seen in Piłsudski's followers: initially socialists, participants of the 1905 revolution, later riflemen and legionaries, and POs during World War I, in May 1926 they took over power in Poland.

Poland was reborn as a fully democratic state, which was ultimately confirmed by the constitution adopted in March 1921. With time and influenced by the information on subsequent scandals, society gradually resented the "Seymocracy". The myth of Poland being wealthy and just, omnipresent when the country was not free, was being undermined. The statehood was regained, yet the evil that until recently had been attributed to the partitioning powers, was still there. The disappointment was visible in literary texts, which had always been sensitive to social moods. The protagonist of Zofia Nałkowska's *Teresa Hennert's Love Affair* complained in the following way: "We have already got

independence. We have got the borders. We have got everything that is elsewhere, what we envied the others so much. There is also corruption, our local, seeking private interests, favouritism, the rule of the populace, big scandals, big wealth, business, and business first of all". The most dramatic protest came from Stefan Żeromski, the greatest moral authority of the then Poland. "The providence has given the homeland into your hands", he wrote disgusted in *Before the Spring*:. "And what have you, governors, done with this longing of the dying? Poland desperately needs a grand idea! Be it an agrarian reform, a new industry, whatever, any grand deed that people could breathe in like the air, because here the air is very close". No one would admit the fact that the hard situation was caused by the World War I destruction, a terrible legacy of the partitions, and also international swings in economy. All the criticism was addressed to the politicians who were running the country, first of all, the Seym deputies. Such an atmosphere made people think that the country needed a shock therapy. And they perceived the saviour in Piłsudski, who was by many Poles regarded to be the father of Polish independence. He made himself

worthy of such a title with the consistency of his actions in the years of the war, by being the Chief of State in the years 1918–1922, and also in 1920 by stopping the Bolshevik invasion which constituted a threat not only to Poland, but also to the whole of Europe. Under such circumstances in May 1926 there was an armed coup d'etat and the Marshal took over power. Only with time and new experience was it possible to find out that the authoritarian system coped even worse with the Polish problems than democracy had done before.

Today, the Second Republic of Poland merits respect for the great achievements, civilizational accomplishments, economic progress, blossoming of culture, setting great educational models. For almost fifty years they were for many the symbol of freedom and independence, more a dream than a subject of historical investigation. And it is today, under the circumstances of regained sovereignty that we can better understand the problems and dilemmas inevitably present in the country which has gained independence and is trying to function in sovereignty.

Daria Nałęcz

**Assoc. Prof. Daria Nałęcz,** historian, specializing in the most recent history of Poland, authored scholarly and knowledge-popularizing monographs, as well as source materials. Since 1996 the Director of State Archives in Poland.

# On the Album

It is generally thought that photography was the invention of the 19ᵗʰ century. Yet, the truth is slightly different. The very beginning of photography, the prototype of a camera, was a *camera obscura*, a dark box invented possibly around 900 by the Arabs. Some scholars claim that it had been discovered even earlier. The instrument first served as a tool for astronomic observation. Later, already starting in the 16ᵗʰ century, it was used by painters. Merely a lense was needed in the front side, later with changeable focal length, to invent a camera.

The question at that point was how to register the image. In 1838 Louis Jacques Daguerre and Joseph Niecephore Niépce accomplished this task. And so a daguerreotype was made. It is an image exposed directly onto a copper polished surface of silver first exposed to iodine vapour; later, when exposed to light, it features a reaction occuring in mercury vapour. In Poland the first daguerreotype was created in 1839 and was executed by Maksymilian Strasz, an engineer from Kielce. Such was the beginning, and later things just moved on fast and effectively. Photography conquered the world and today it would be hard to imagine our life without it. It is omnipresent. It has developed from primitive cameras to digital photography.

The album that we are offering to our Readers features Polish photographs, executed first of all in Poland. With very few exceptions only, like the daguerreotype of Fryderyk Chopin, for example, taken in France. They testify to our history, people living here, events, landscapes, architecture. They bring back to life sights and events which are already in the past, which inspire reflection and stir up memories.

All the photographs date from before 1939, so they show Poland within its pre-war frontiers: from Great Poland, Pomerania, and Silesia, up to the Vilnius Land, Polesie, Volhynia, and Podolia.

From the material perspective, a photo is a piece of paper covered with light-sensitive emulsions. This, however, sounds a bit clumsy. Old photograph is, after all, an opportunity provided for us to return to the past times, it is the past, both private in a family album, and the grandiloquent one speaking of the state and society. The collection of photographs included in the present book is merely a selection, a fragment of the memory of the past years. But let us only look how much truth and how many memories can be found in the selection of all and each of the photographs. We thus encourage everyone who reaches for this album to look throug those pages with emotion and respect. These will certainly help us discover both the past and the contemporary times.

Poland. Topographic, transportation, and administration map, under ed. E. Romer. Published by the E. Romer Cartographic Institute. 1:600 000. Lwów-Warszawa 1929.

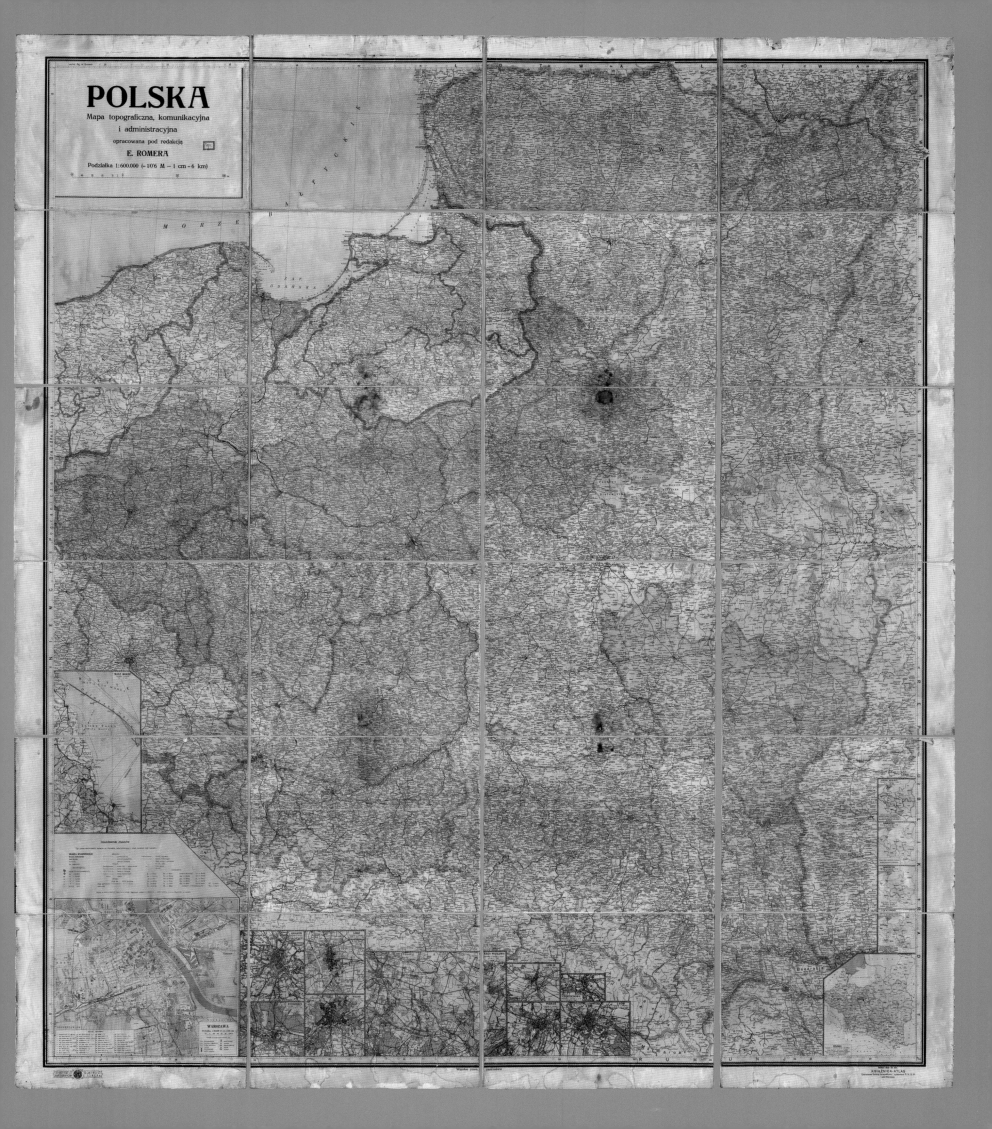

# POLSKA

Mapa topograficzna, komunikacyjna
i administracyjna
opracowana pod redakcją
**E. ROMERA**

Podziałka 1:600.000 (~10'6 M — 1 cm = 6 km)

# Landscape

Is there one describable landscape of our country, a kind of its synthesis, an image that sums up this concept? I doubt it, because each of us, consciously or not, bears in the heart or memory his or her own recollection of the shape of this piece of land, specifically Europe, that is associated with homeland. There may be many of those recollected images: the landscape of the childhood homeland, the landscape being the scenery of major events in our lives. We could go on searching like this for much longer, but is there any sensible purpose for it? Let us then set aside all the useless divagations and may our loved landscapes stay inside us forever. They always soothe memories and remind one of the old days.

However, it is our inherent feature to wish, or even feel the urge for recording the loved sights. In the previous centuries they appeared first in paintings, initially as merely the filling of the background, later as autonomous subjects, composed and interpreted by the artists. However, it was only the spontaneously developing photography, black-and-white at first, and later colour, which allowed to immortalize those sights in a more truly way, since copies of the reality were made on paper, allowing to stop the time. For we must not be tempted to give in to the illusion; it is enough to take a closer look at old photographs, to compare them with the present conditions in order to realize how everything has been changing. How our activity has been continuously introducing new elements into what seems to be an eternal landscape.

The landscape of our country, the landscape immortalized in old photographs, takes us back into the old times, it takes us some decades back, but despite this time shift, it is nevertheless so close to our hearts, and so dear. From the murmuring waves of the Baltic, across Pomerania, the planes of Great Poland, and Mazovia, the busy Kielce Region, Polesie marshes, mountainous character of the southern and eastern territories of former Poland from before 1939, since the selection of photographs included in the present album precisely covers the areas once confined within the boundaries of the Polish state.

Naturally, both the sea and the peaks of the Tatras remain unmoved. But there are no more sandy lanes, cobbled roads. They have been replaced by asphalt roads. So few of wooden squatted peasants' huts, now enclosed in open-air museums, have survived amidst our landscape. What a change have we witnessed in our towns, surrounded by blocks of flats, with skyscrapers in the centre. The country, seemingly the same, has nevertheless transformed. When undertaking this return trip to the past let us reflect and recollect a little bit. And the truth is that nothing can make one realize the transition of time better than old photographs, reproducing by means of technology and artist photographer's eye what has been left in the past forever. For some elderly Readers, who remember the past epochs, they will mean a return to their memories; to the younger ones, who will have the opportunity to observe some no longer existing details and places destroyed or erased by the modern times, these photographs will provide the opportunity to discover Proust's "lost time".

1. Morsztyn near Stryj. A sandy road with ruts of carriages runs near the lake, in the avenue of linden trees. Electricity wires leading to a nearby town testify that the photograph was shot already in the 20th century.

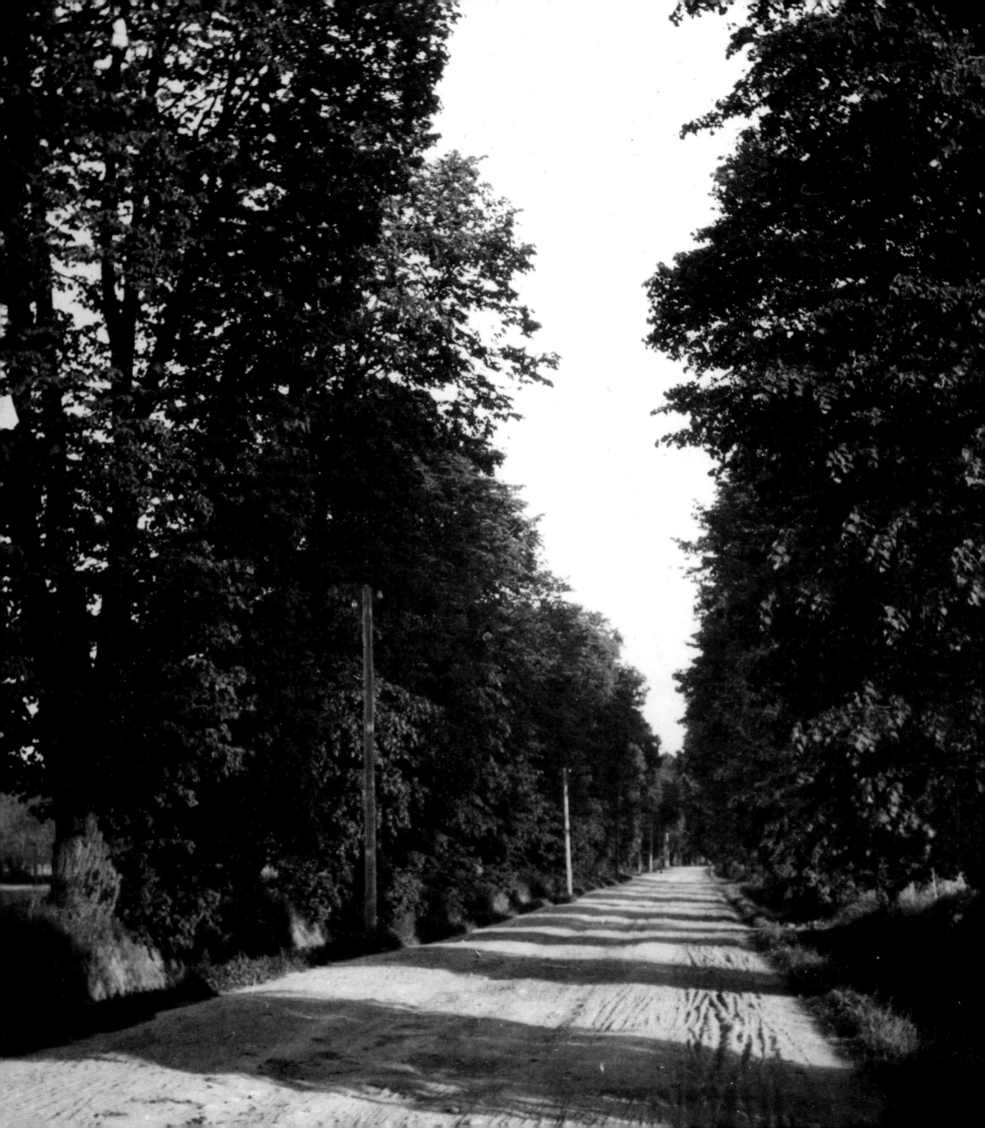

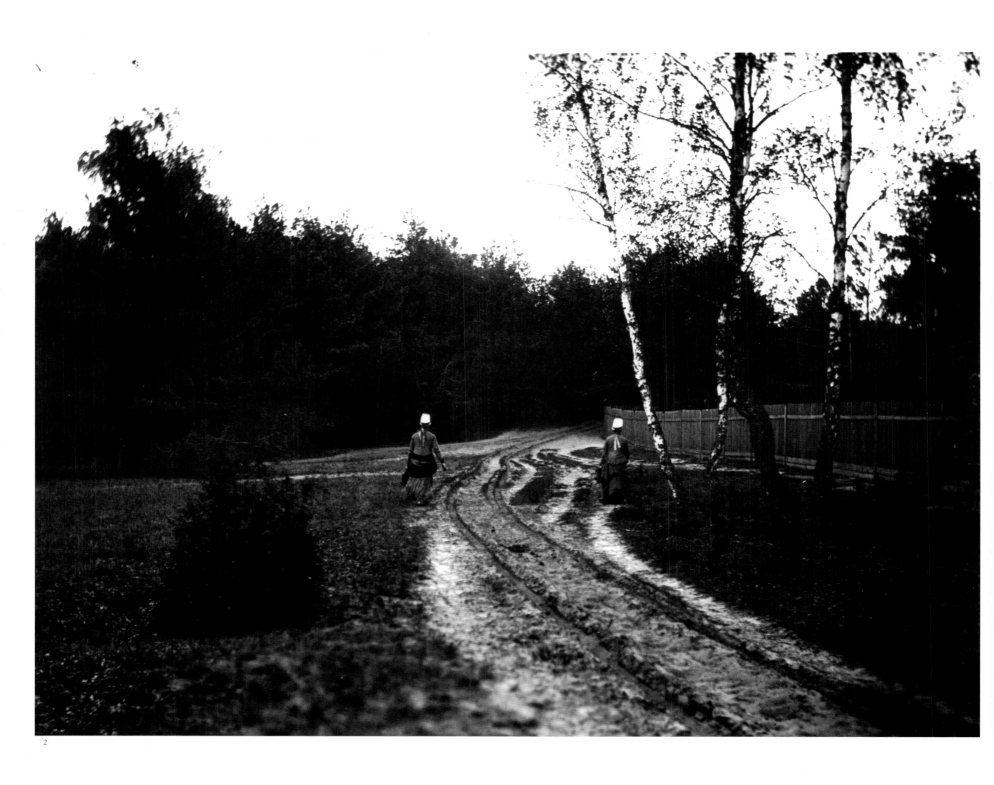

2

2. Polish roads… At the time they still used to be muddy, like the one along which two women
are heading towards the forest. Old photographs provoke questions like: Who were they? Where
were they really going? But all we can do is just to imagine things. Photo Z. Marcinkowski

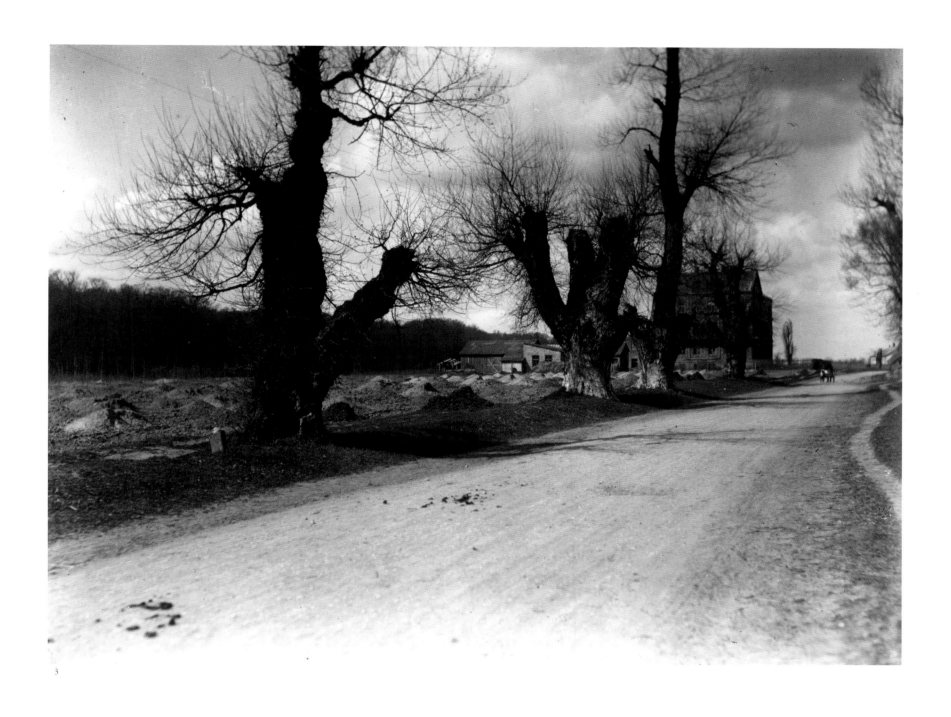

3. Such was a beaten tract that joined little towns and villages, served horse carriages, and even single cars that were rare at the time. Along the hard shoulder there were still old trees, occasionally of some incredible shapes. Photo Z. Marcinkowski

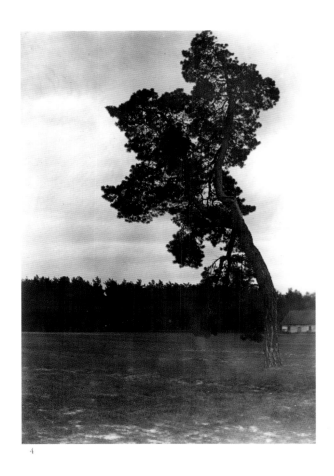

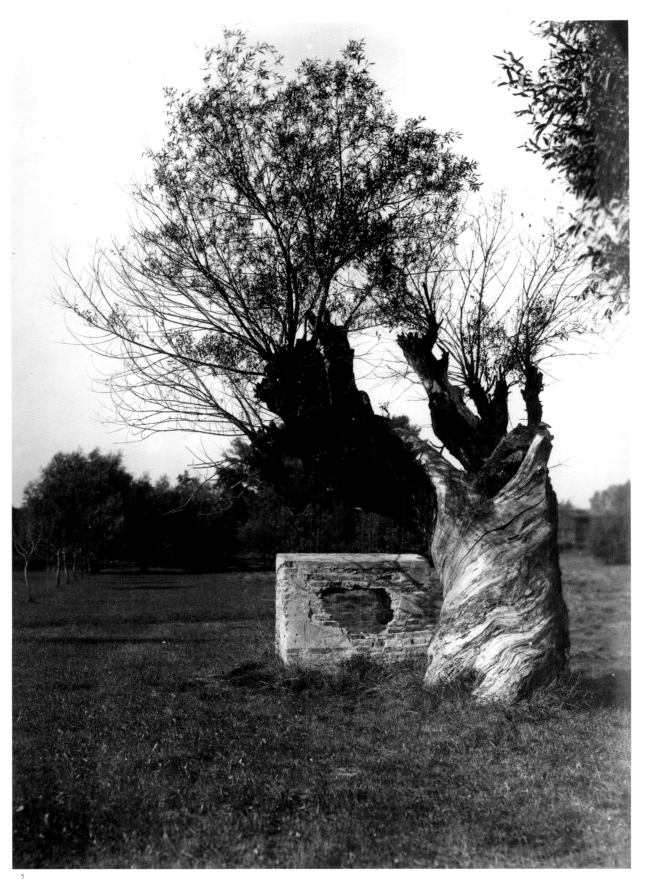

4. Lonely trees against a dark forest form almost a painterly composition. Photo Z. Marcinkowski

5. How much dramatism there is in the massive trunk of an old willow tree, twisted as if by an inhuman force. Photo Z. Marcinkowski

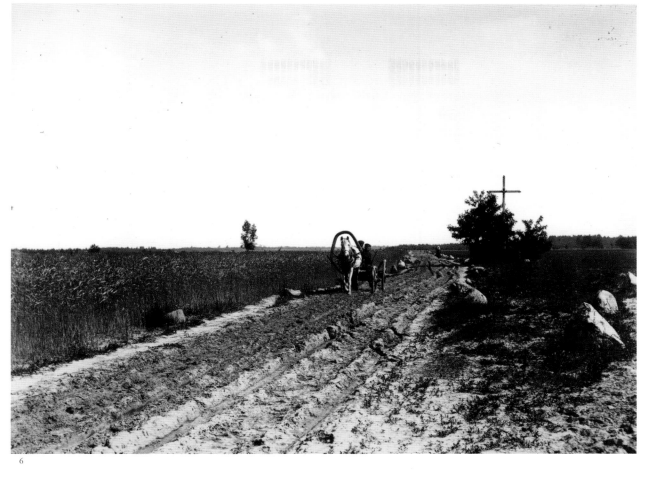

6

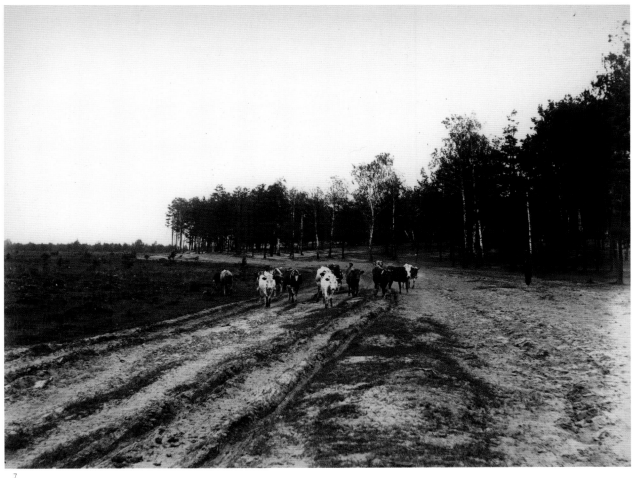

7

6. An image as if from centuries ago. A horse is drawing a cart along a damaged road. On the side, among the bushes, there is a cross. A kind of idyllic landscape that we will not see today.

Photo Z. Marcinkowski

7. Along a sandy lane, and there were many of those in the inter-war Poland, a herd of cows is heading for the enclosure from pasture. Photo Z. Marcinkowski

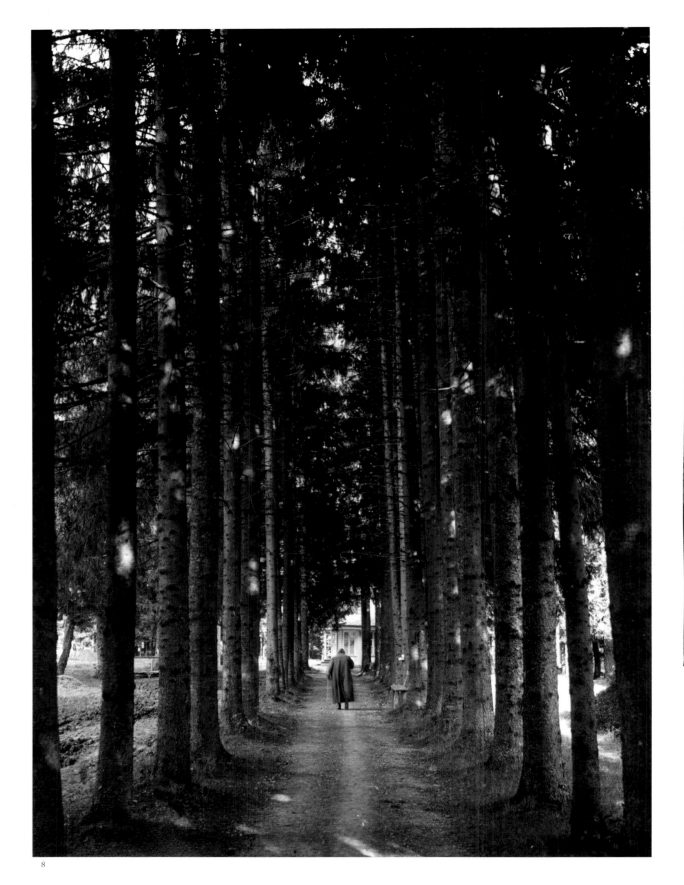

8

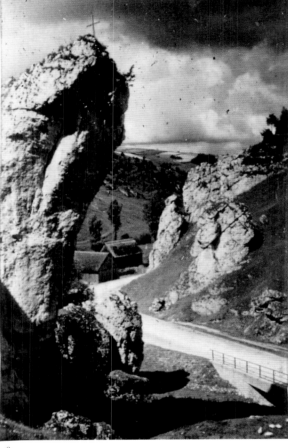

9

8. Old photographs, like this one taken in Morsztyn near Stryj in 1926, have retained the charm of the old years. Actually, does this fragment of the world still exist? A narrow, sandy walking avenue, aligned with high trees, leads us to some buildings. And this lonely figure is walking as if in the search of the lost time.

9. These photographs from the area around Ojców were shot in the mid-1930s. But even today they can inspire to some attractive trips — actually things have not changed very much there. Only the number of parking lots has increased to keep more and more modern cars of today's tourists.

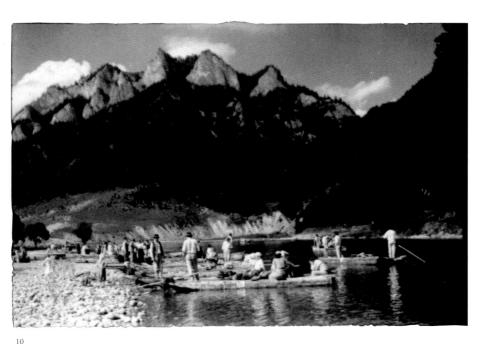

10

11

10. The panorama of the Dunajec river, the Trzy Korony peak domineering over the river, rafts, raftsmen getting ready to transport yet another group of tourists, have not actually changed for decades. This is what it all looked like in 1934, this is what it had looked like before and continues to look today. Is it not beautiful that in our country there have been preserved such places keeping a strong perfume of water, lit up with the sun, leaning against a majesty of a marvellous mountain?

11. A modest chapel in Limanowa in Podhale. Perhaps it is around here that the locals gathered to pray during Mass services.

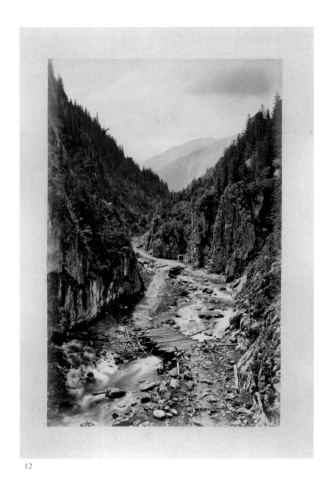

12

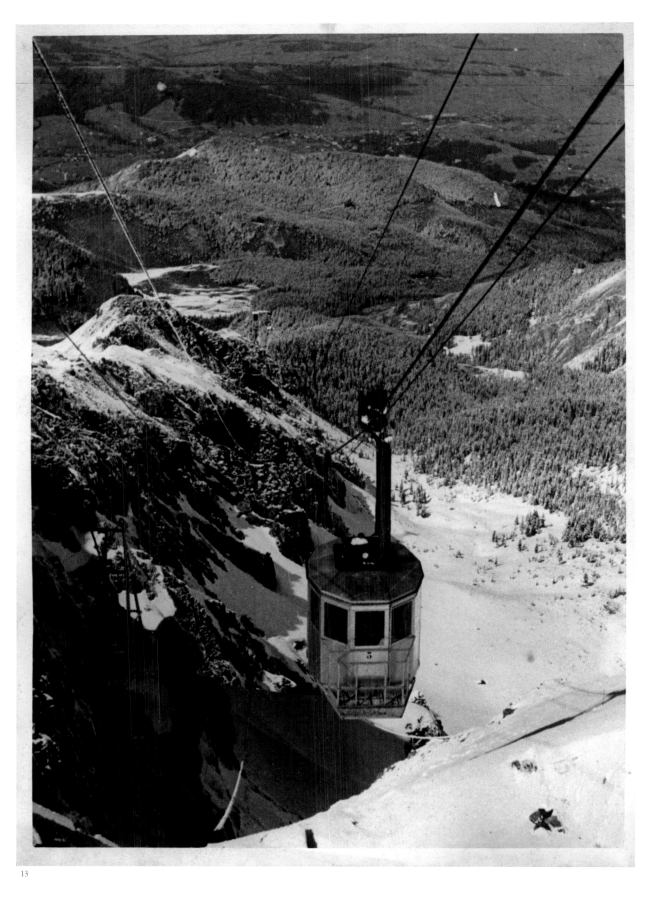

13

12. By Pisana in the Kościeliska Valley the Dunajec river is merely a rapid stream full of foaming water. It is only further on that it will turn into a true river, it will grow bigger and broader, but will not lose any of its charm.

13. Cable cart from Kuźnice near Zakopane to Kasprowy Wierch has been carrying tourists and skiers for almost seventy years now, as it was inaugurated in 1936. The difference in the stations' altitude is 936 metres.

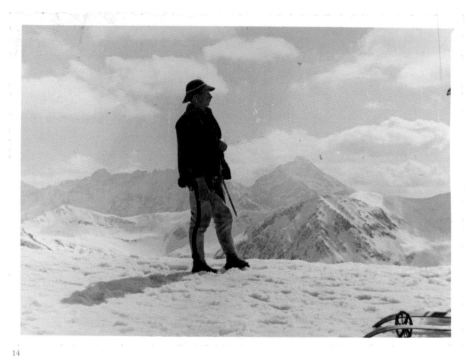

14

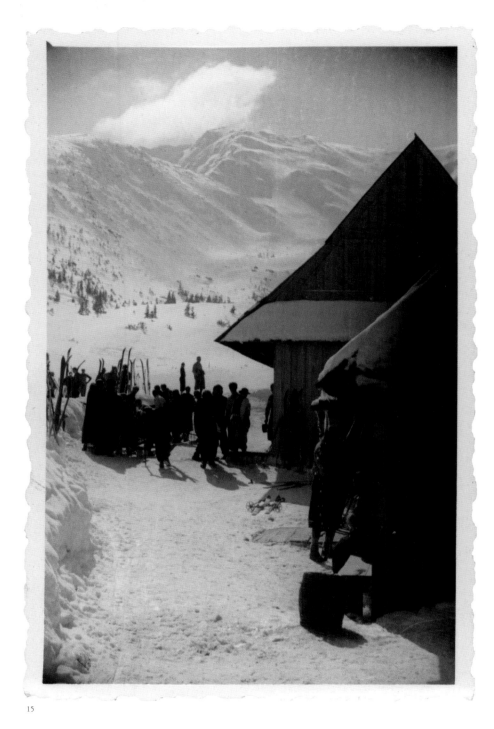

15

14. This young mountaineer in traditional trousers, a fur waistcoat, and with an alpenstick looks like an inherent piece of the Tatras.

15. A true winter, like in the Tatras. Next to a mountaineer's hut with a steep shingled roof there is a group of skiers, town tourists: plainsmen getting ready for an excursion or runs down.

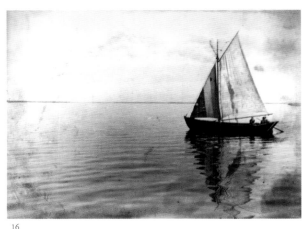

16

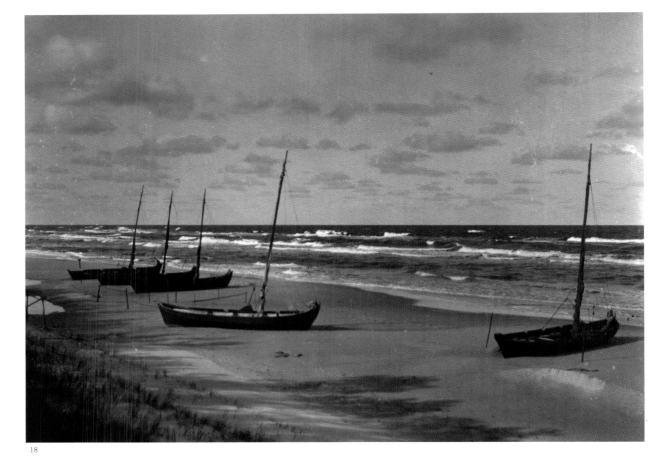

18

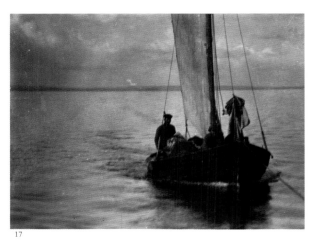

17

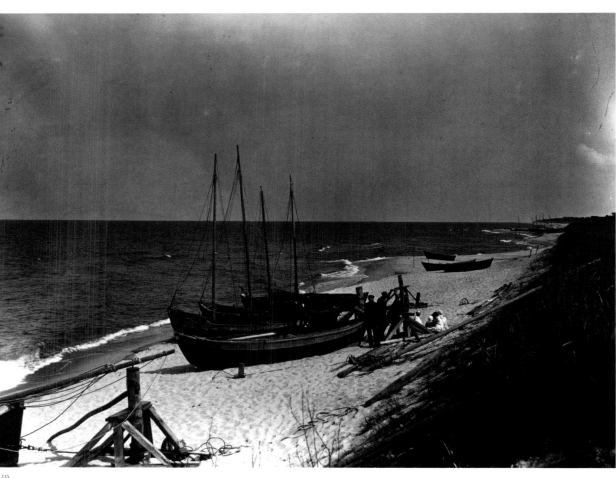

19

16, 17. A fishing boat is returning to port across smooth sea, hardly wrinkled by the breeze. Photo Z. Marcinkowski

18, 19. A narrow beach and delicate waves beating against the sand. The boats pulled out on the beach, resemble corpses of huge fish; there are windlasses helping to pull them out, fishermen are busy nearby. This is an every day life at the sea-side. Photo Z. Marcinkowski

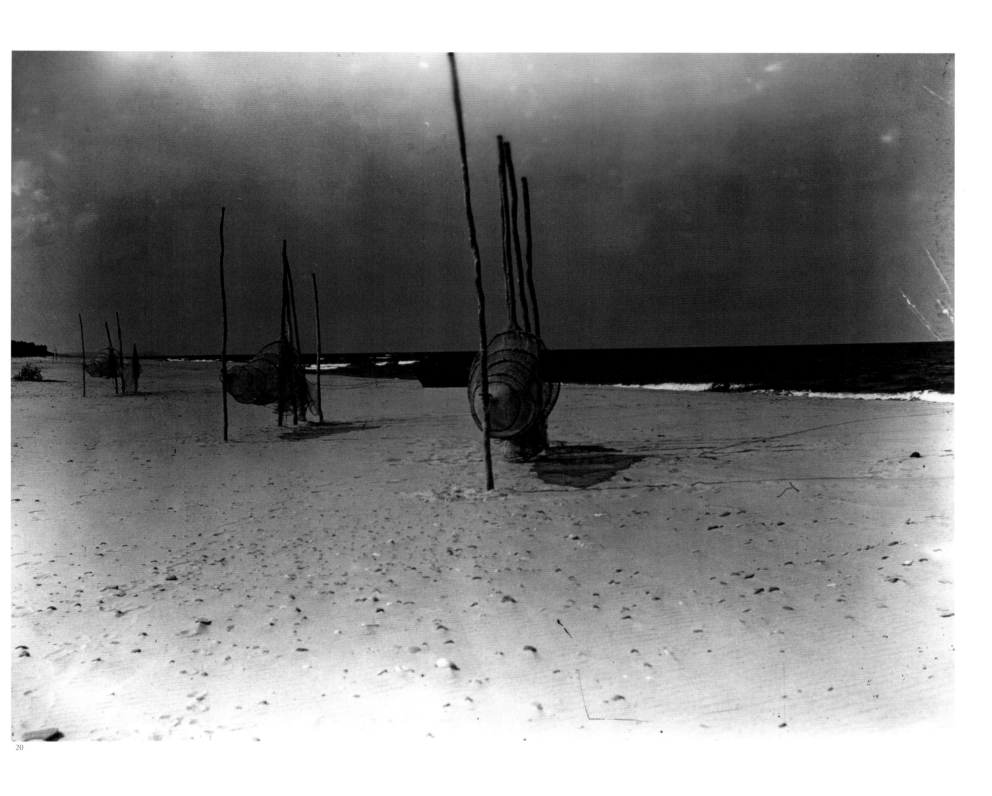

20

20. Fishermen's nets are drying on the empty sandy beach. Photo Z. Marcinkowski

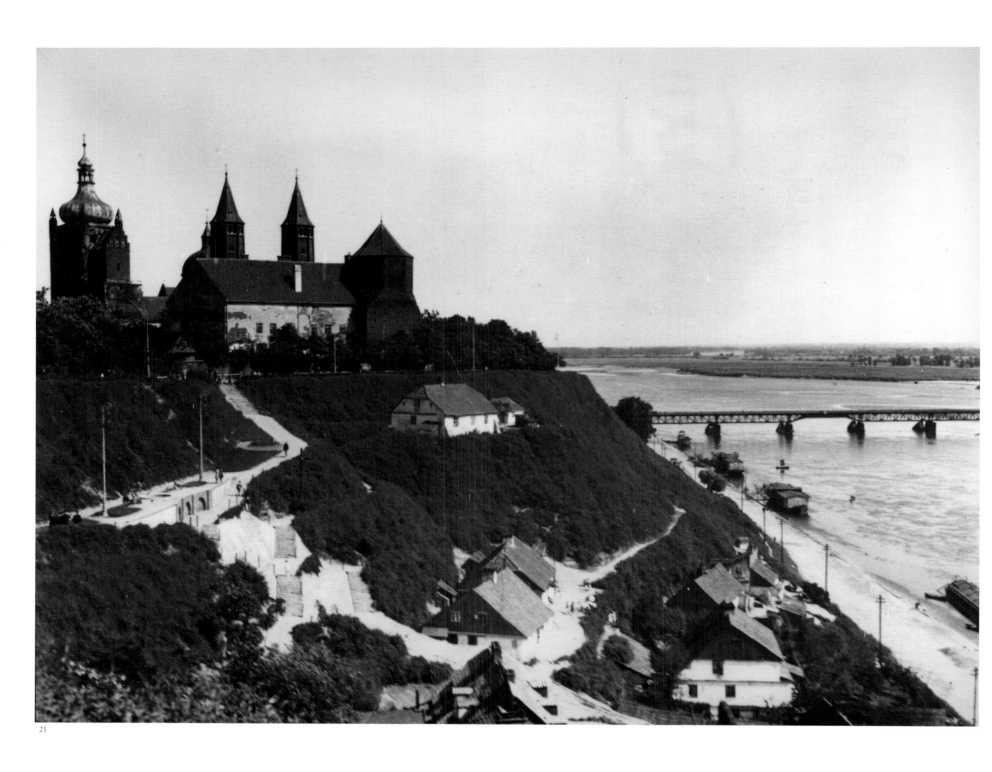

21.

21. Płock, an old capital of Mazovia, full of monumental buildings, enchanting streets, all proudly placed on the Vistula escarpment. The promontory protruding towards the river features the Cathedral, Romanesque in its walls, significantly altered at the beginning of the 20th century.

Photo Z. Marcinkowski

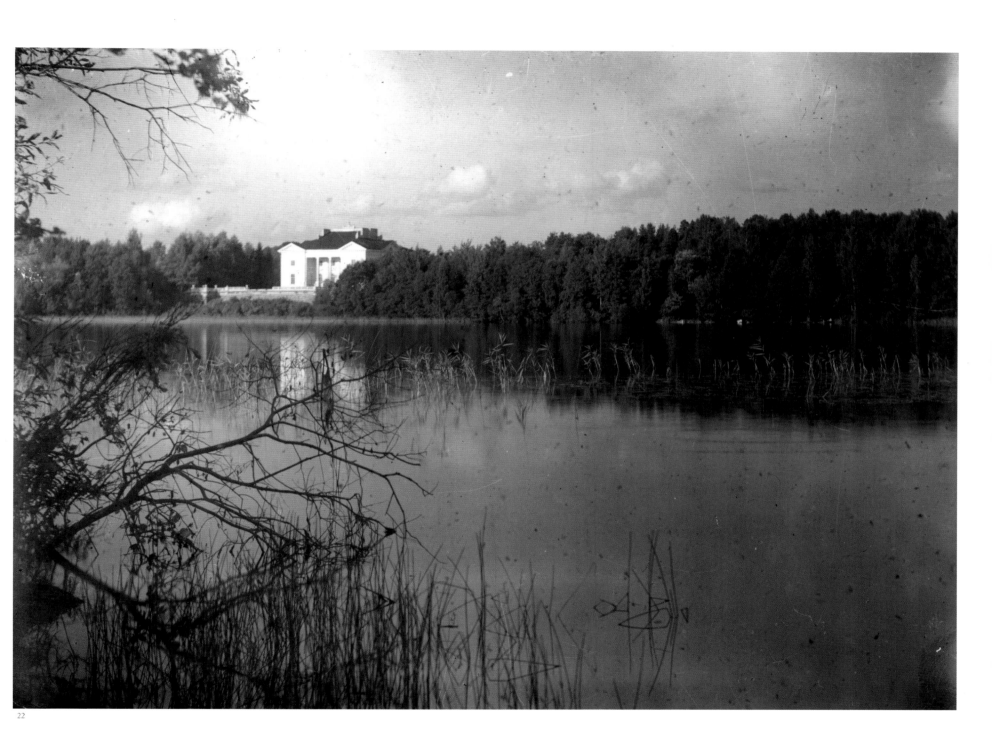

22

22. The old Tyszkiewicz Palace at Zatrocze near Vilnius, perfectly fitted in the surrounding
landscape. The building was erected by Count Józef Tyszkiewicz in 1896–1904. Neo-Classicist in
its form, with a colonnade and breaks, it was raised on Lake Galve making its perfect shape reflect
in the calm water. Surrounded by the green of the wood and riverside rushes, it constitutes such
a lyrical whole that its sight will be recalled by everyone who gets to the Vilnius Land.

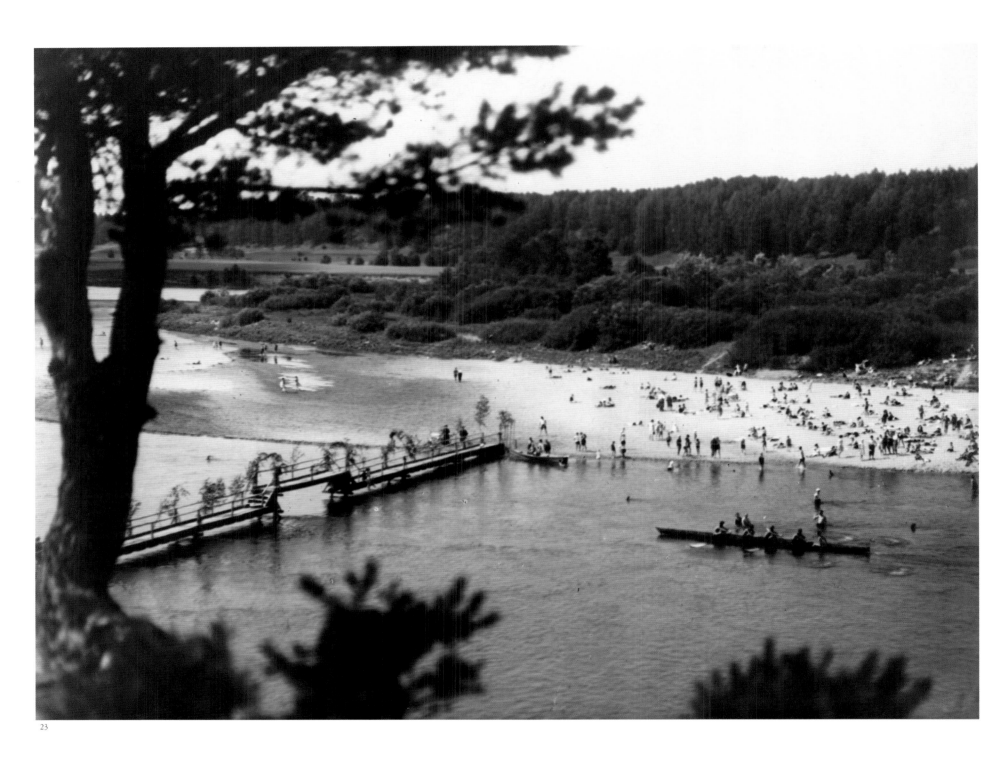

23

23. Druskienniki on the Neman once used to be a renown spa attracting holiday makers. This is where Marshal Józef Piłsudski enjoyed coming. He had his favourite bench on the river. The calm of the lazily flowing water, a sandy beach, but first of all clear water and air, made up an excellent enclave of peace that we welcome today, too. Swimming in the Neman was great fun. Poles continue to enjoy visiting this, today foreign, spa. Photo I. Baranowski

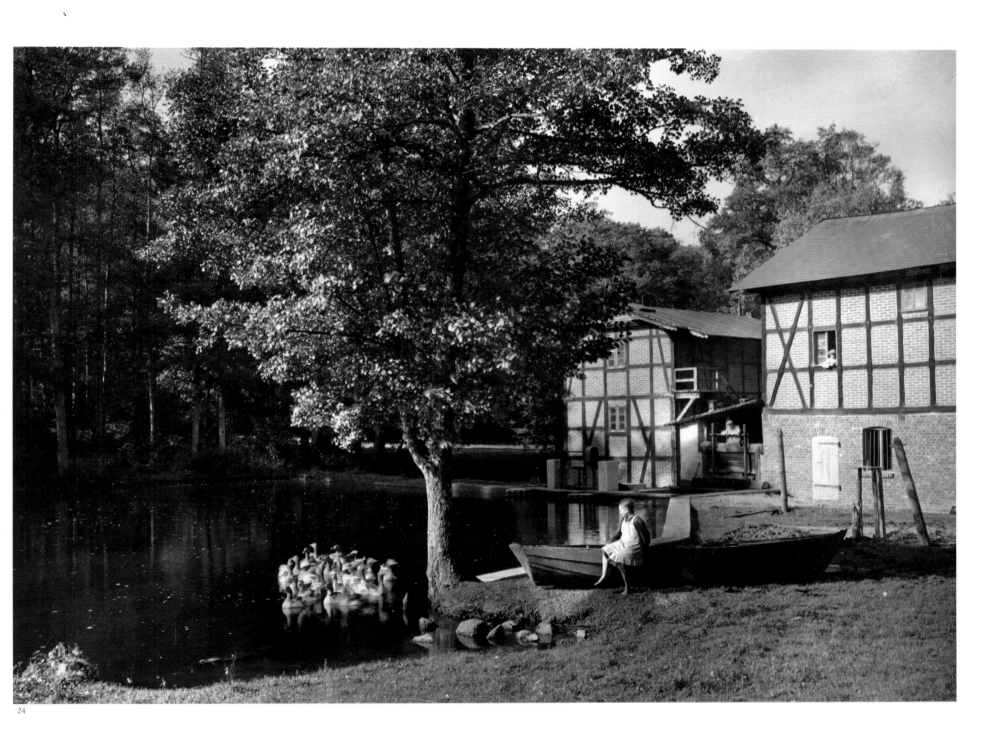

24

24. An old mill on the river Cejran near Wejherowo (photo from 1934) preserved its unique aura. Calm of the water that drives the wheel, two houses built in the typical Pomeranian style, all this means going back to the passed times. In the past such devices were placed on many rivers, since they milled flour for the local villages. A monotonous purr of the milling stones and the murmur of the water falling off the wheel constituted part of the village's silence.

Photo A. Świerkosz

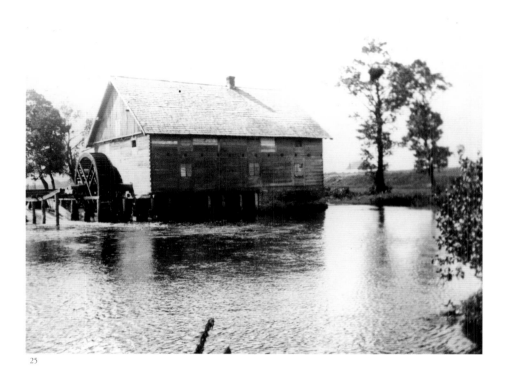

25

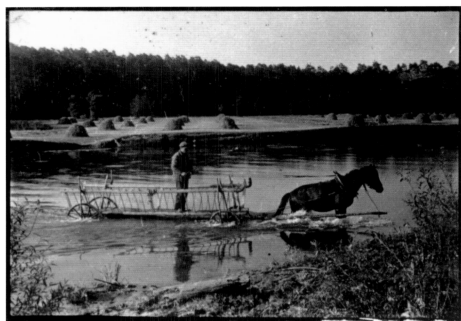

26

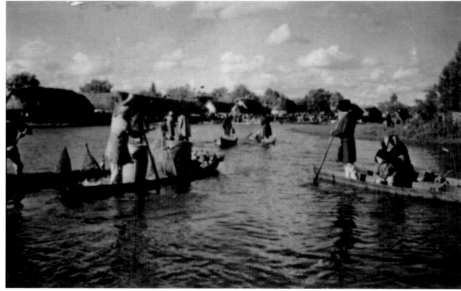

27

25. On the river at Rozprza (Łódź voivodship) there was a wooden mill. The whole mechanism was set in motion by a huge wheel. According to the old saying the miller would wake up at night only when the wheel stopped and suddenly there was silence.

26. A picture totally anachronic today: a rack wagon drawn by horses is crossing the river. But some time back, and actually not so long ago, for in the mid-1930s, this is what things looked like. And this is what the crossing of the Pilica near Spała looked like.

27. For centuries rivers had been major transportation routes, they united people and settlements. In Polesie it was the Prypeć which was the backbone for the flat country. There is traffic on the river, just as on a busy street. Numerous people in very primitive boats are heading towards the small town of Horodyszcze.

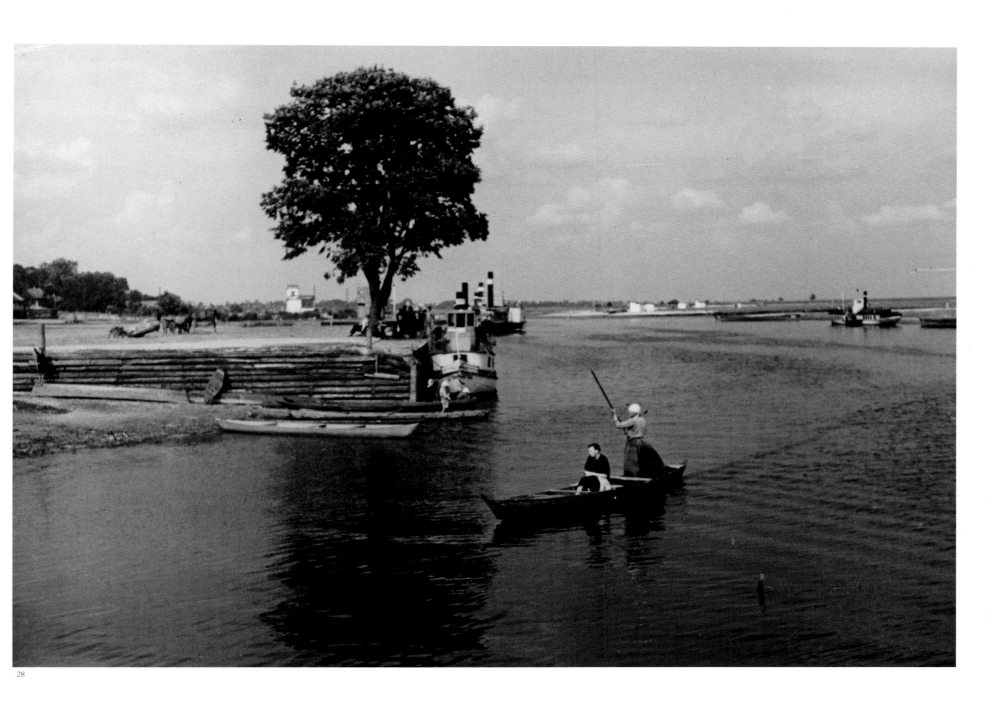

28

28. It is not generally remembered that in Pińsk in Polesie there was a port on the Pinia river for the fleet of the Polish Navy. It was not a significant military force, for it mainly served to defend the borderland, the land being dump, full of rivers, lakes, and marshes. The port also served some commercial purposes, to reload the fleet and its goods, and it also catered for passengers.

# People

18th-century Father Benedykt Chmielowski, author of the *New Athens* encyclopaedia, today a little bit satirically treated, defined an animal that we all know in a very concise way: "What a horse is everyone sees". This phrase, enriched with some satirical undertones, has already started circulating in every day's language. But was not Father Chmielowski a bit right? What can we say about the people, for instance? They are as they are! They used to be as they used to be… There is still, however, a possibility that new information can be found, and this may be searched for in scholarly publications and documents. A *Year Book* from 1939 may be useful in this respect. Let us then see what we can read in there.

In 1939 the population of Poland hardly exceeded 35 million. This is basic information. Let us then pass to the details, for after all we once used to be a multinational state. As late as in 1931 Polish was spoken by 68.9 percent of the population, Ukrainian by 10.1 percent, Ruthenian by 3.9 percent, Byelorussian by 3.1 percent, Russian by 0.4 percent, German by 2.3 percent and Jewish by 8.6 percent. The above were major national groups. The remaining 2.8 percent covered other ethnic communities: the Tartars, Armenians, Czechs, Slovakians, Hungarians, Lithuanians, Gypsies, Karaims, to mention merely the major and more numerous ones.

When it comes to declared professed religion, Roman Catholic Church had 64.8 percent of the followers among the country's population, Greek Catholic Church 10.4 percent, Orthodox Church 11.8 percent, Jewish religion was followed by 9.8 percent of the population, Protestant religion with all its variants by 2.6 percent. Other Christian denominations covered 0.5 percent of the population and 0.1 percent of the population were non-denominational. Clearly, the geographical arrangement of particular religious groups had its geographical justification. For example, the Tartars, apparently brought to Poland by the Lithuanian Duke Vytautas, inhabited mainly north-eastern regions, similarly as the Karaims. The Jews, who started settling on the Polish territory already in the 10th century, dwelled mainly in central Poland and the eastern regions of the country. So, judging even from this brief analysis, it is clear that for centuries we were a mix of nationalities, religions, customs, traditions. And let us emphasize that such a situation did not cause any significant political or moral conflicts. It was a truly peaceful and friendly coexistence. And this is something most praiseworthy. The Catholic and Orthodox churches, synagogues, Karaim *keneses,* Tartar mosques, Evangelical churches constituted a permanent feature of our native landscape, they adorned towns and filled with believers.

Economically speaking, the stratification of society was significant. In those days one could observe a coexistence of people truly wealthy, rich, the middle class and the poor, swarming in dark, humid basements, being jobless and living only on charity, begging. And of the latter there were really many. Let us also recall here another fact, though very sad, that in 1931 Poland's population was in more than 23 percent illiterate. In the Polesie voivodship this figure amounted to over 48 percent.

The last world war, the Yalta Agreement, and the post-World War II decades blurred the old times and it is thanks to the old photograms included in this album that we can evoke them, recall them, or simply imagine what life once looked like.

29. In Great Poland chimney-sweepers would go to work in top hats. Such was the custom. And this is the dress in which they are posing for a memento picture together with their "boss" seated on a chair. Photo I. Maciejak

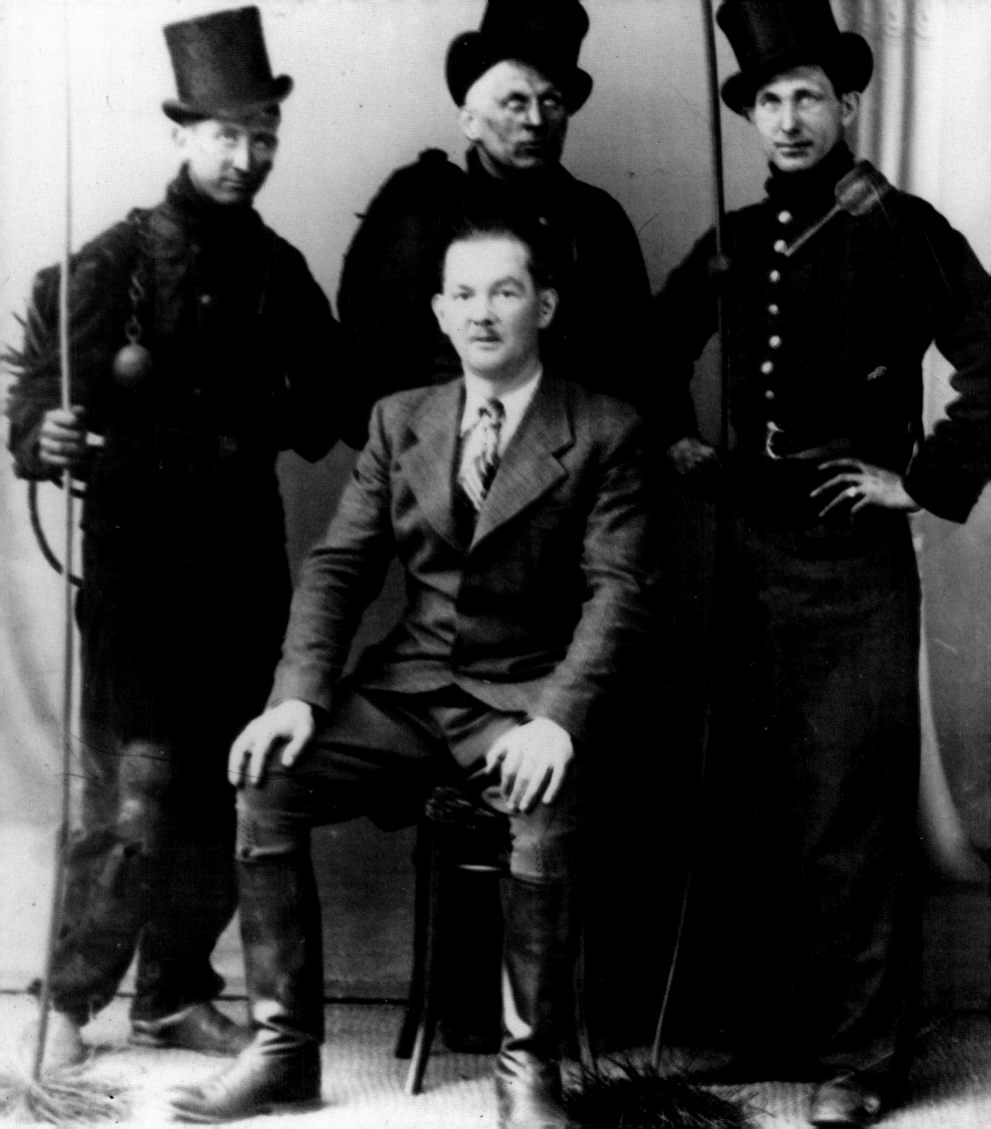

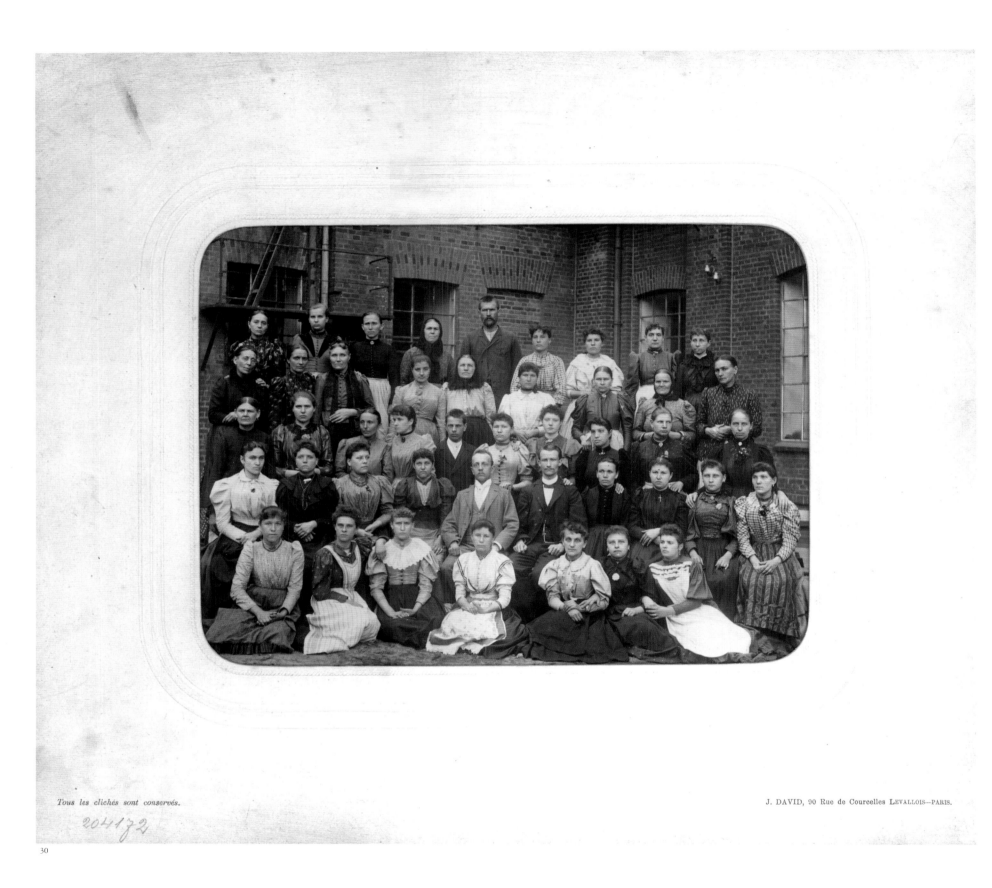

204172

30

30. A group of the Żyrardów Workshop workers at the beginning of the 20ᵗʰ century. Żyrardów meant, first of all, a linen factory. The workshop was established in 1829 and the name of the town is taken after the name of the Technology Director of the plant Philip de Girard.

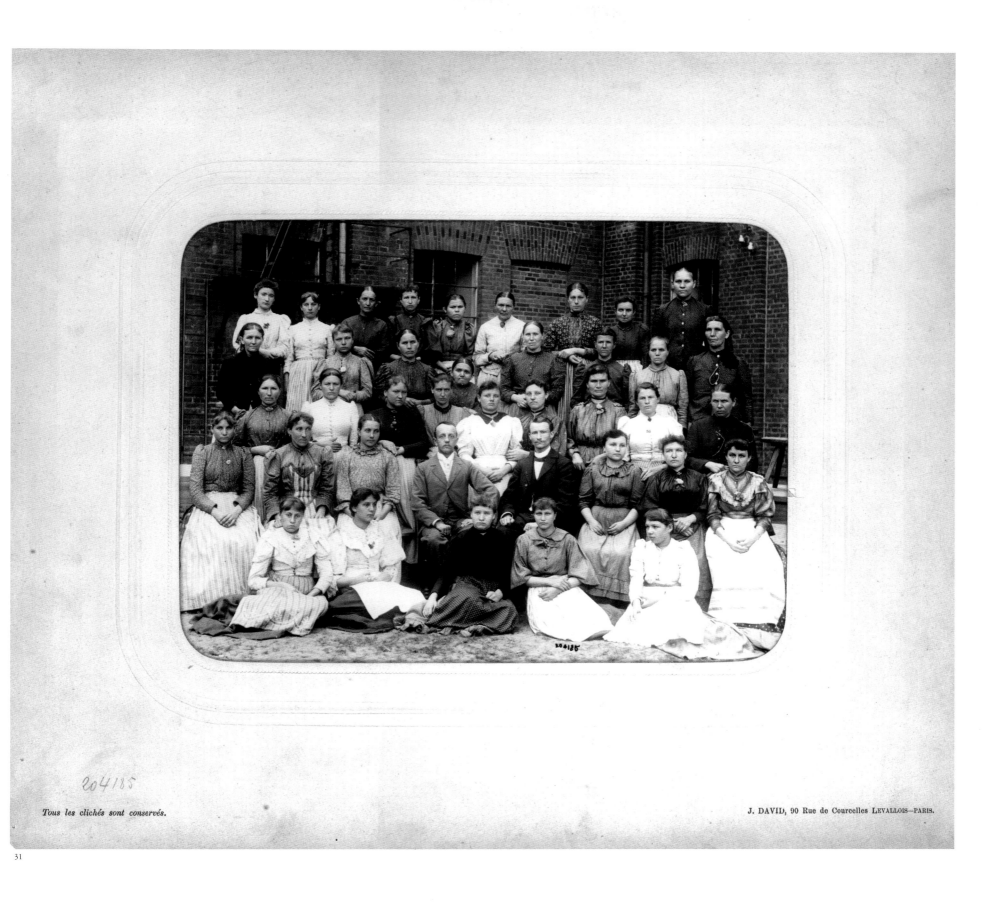

31

31. The workshop workers are posing for a memento photograph. In the second half of the 19th century the plant owners built here a whole settlement, with houses for the workers and supervisors, a church, and also other essential establishments.

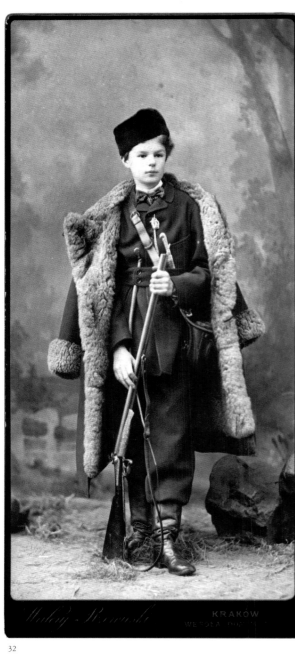

32

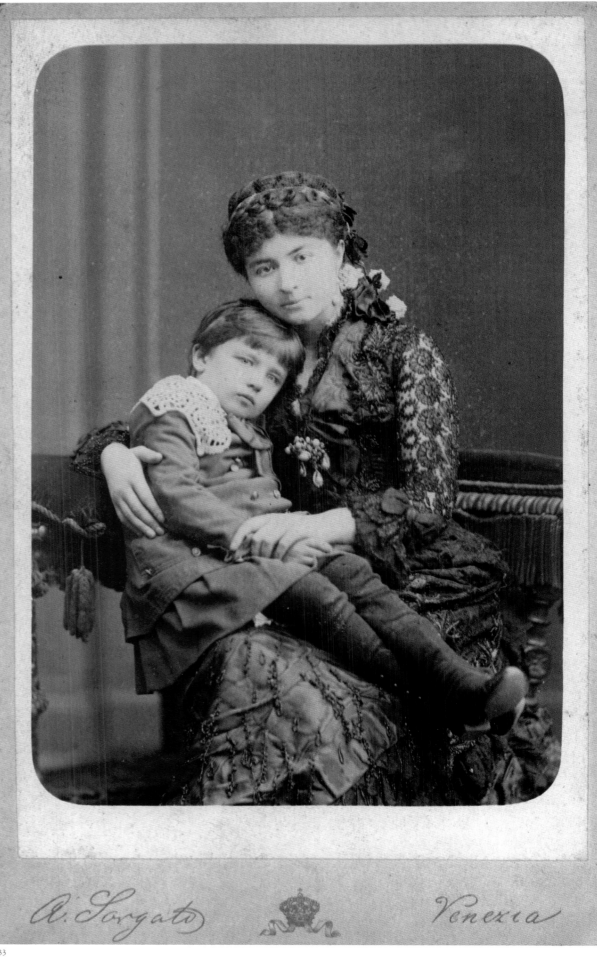

*A. Sorgato*      *Venezia*

33

32. Young Adam Krasiński in a rich hunting costume with a whole set of hunting accessories: dubble-barrelled gun, hunting knife, and even a dog-lead; he is posing for the photograph in Kraków's studio of Walery Rzewuski.

33. Maria Raczyński nee Krasiński, daughter of Zygmunt Krasiński, an illustrious poet of the Romanticism and of Eliza nee Branicki, is holding her son Karol on her knees. This is a very special picture, warm and tender, with a lot of charm. The photo was taken in Venice, at A. Sorgato's studio.

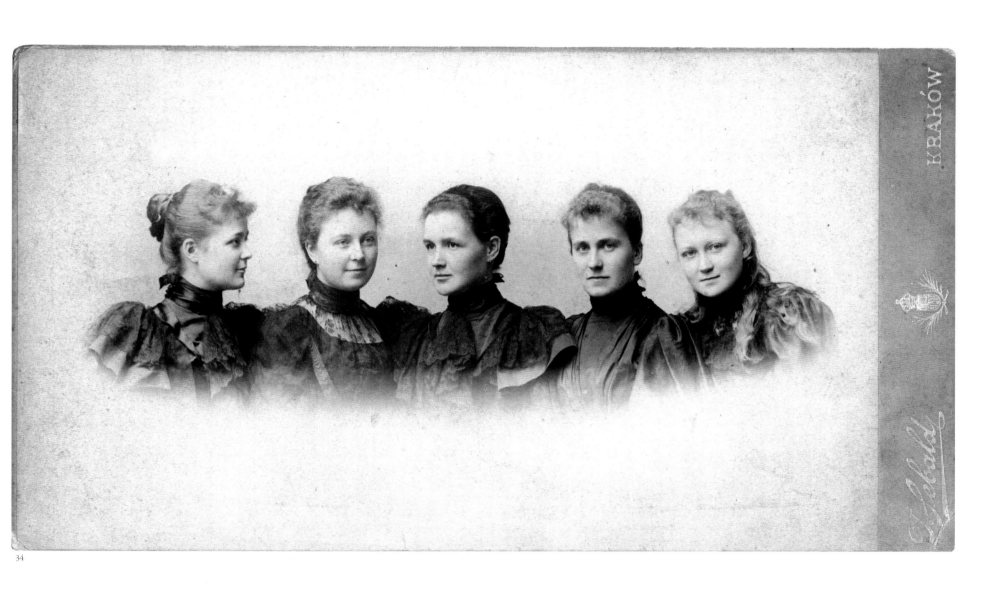

34. The portraits of five young women reveal the kind of fashion popular in the 1880s.

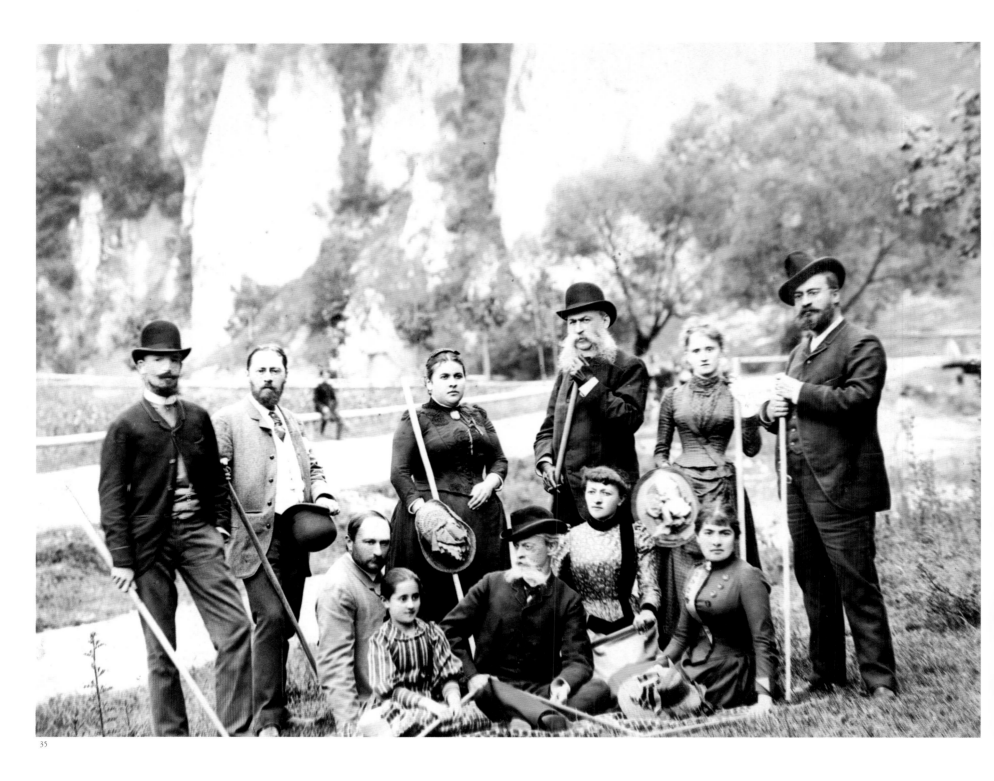

35

35. We might perhaps smile ironically looking at this photo, but this is exactly what the tourists looked like by the end of the 19th century. This is a group of hiking lovers in Ojców. Distinguished gentlemen in bowler hats, ladies in their long dresses, quite tight at waist as it was in vogue, and each holding an obligatory stick to lean on during the tedious climb.

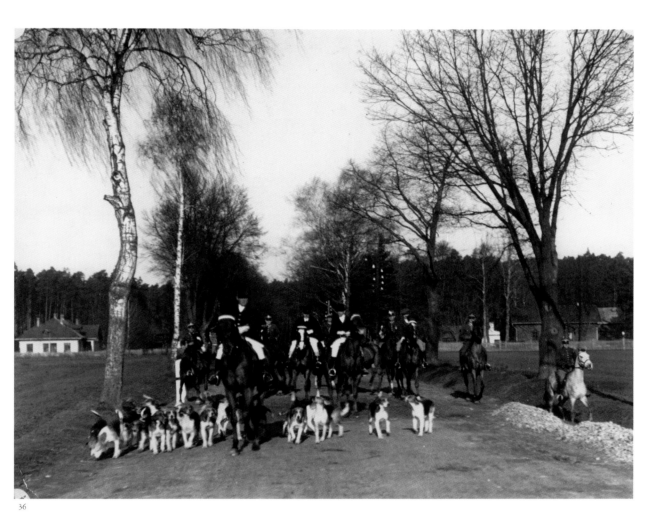

36

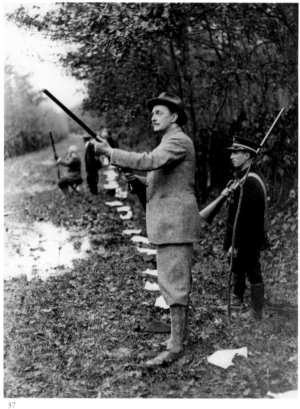

37

36. Hunting near Łańcut, a very popular entertainment in those times. Gentlemen on horseback are wearing appropriate costumes. In front of them a pack of hounds. Such a hunt was called a *par force* hunt: the game was chased until, exhausted, it became an easy prey for the hounds.

37. Hunters ready to fire. The battue is about to start and the hunting will begin. Adam Count Zamoyski can be seen in the foreground. Behind, a hunting assistant is waiting to hand him the second loaded shot-gun.

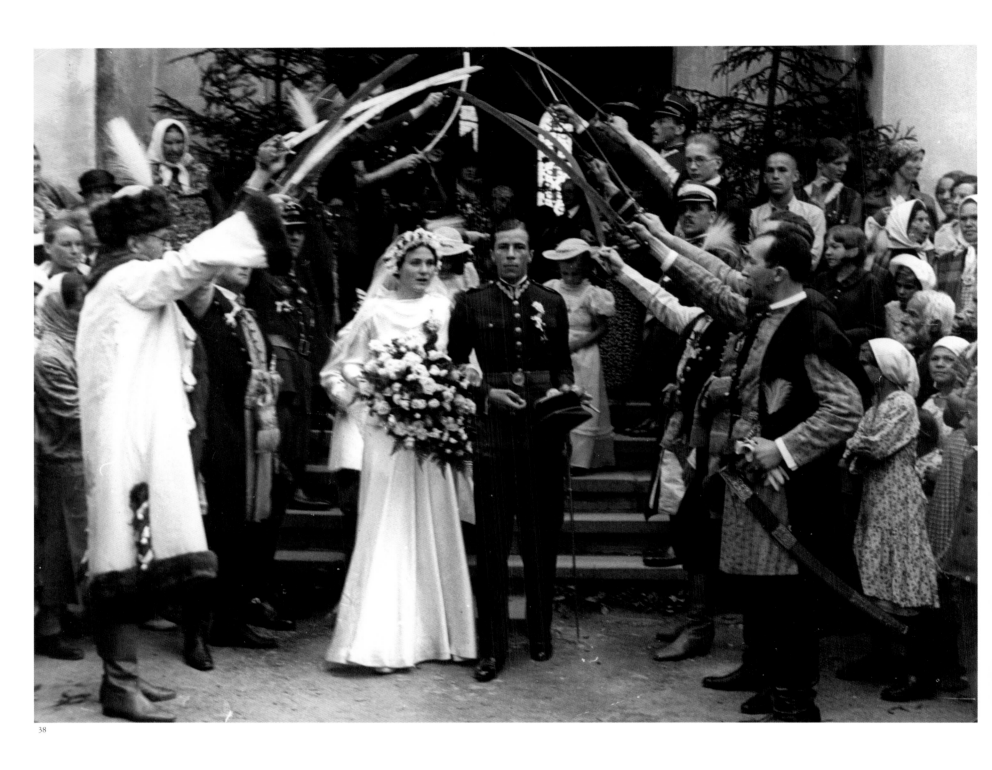

38

38. Prince Adam Czartoryski is marrying Countess Jadwiga Stadnicki obeying all the old rituals.
The newly weds, when leaving the church, are greeted by a lane of men wearing ancient nobility
robes and military uniforms, with their swords raised and crossed overhead. Most likely there are
carriages awaiting the newly weds and the honourable guests in front of the church. To the side,
a group of onlookers is amazed at the beautiful ceremony.

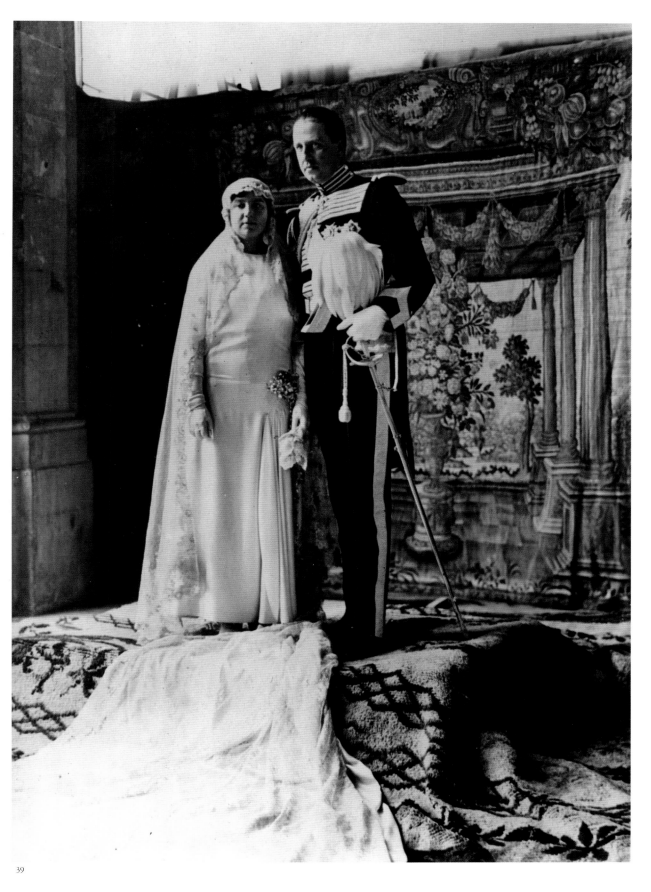

39

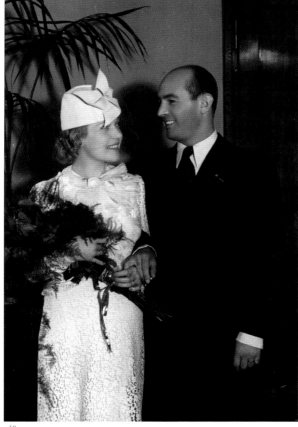

40

39. There were not so many weddings as exquisite as this one before World War II. In 1925, Count Jan Zamojski, the descendant of one of the grandest Polish families, was marrying Infanta Isabelle of Burbon, niece of the Spanish King Alfonso XIII. Well, these were relationships, these were traditions!

40. These are the bride and the groom adored by whole Poland. Jan Kiepura, one of the greatest tenors of the time, idol of the crowds and his wife, the Hungarian operetta singer and film actress, Martha Eggerth: they are both young, adoring one another, smart.

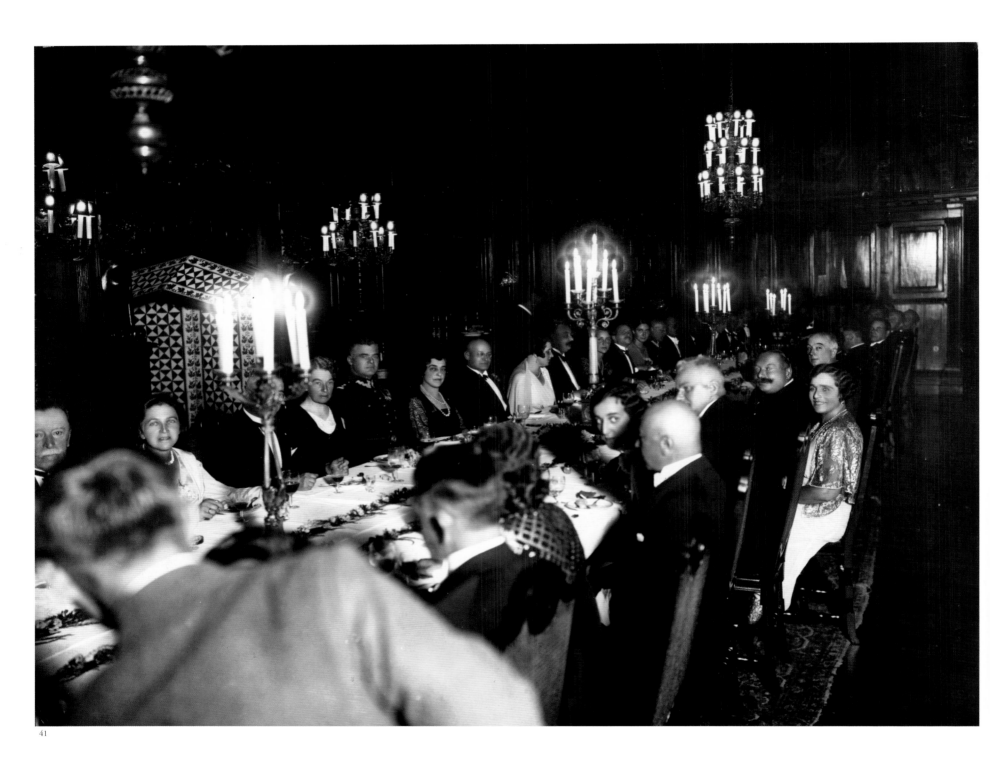

41

41. Nieśwież of the Radziwiłłs, a residence of a magnificent family was on a number of occasions a social meeting point for Polish aristocracy. One of such parties is being held in a grand hall lit by candelabrums and candles. It is all so noble, so orderly, and magnificent…

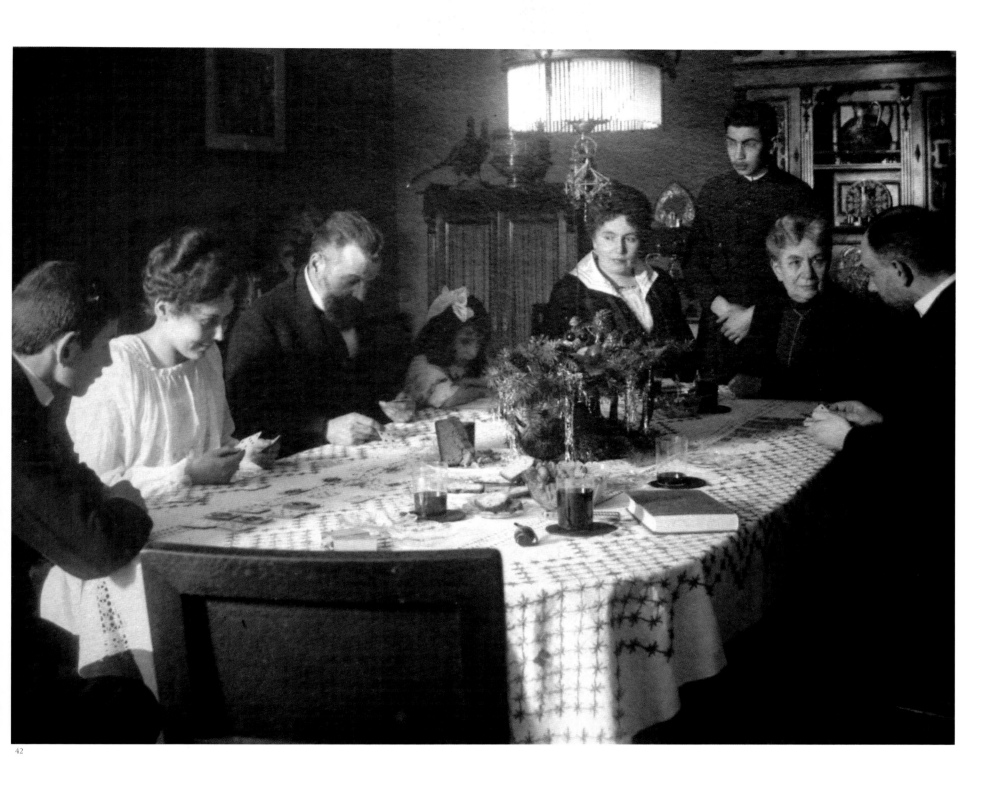

42

42. This photograph of the Steinborn family has a lot of charm to it. A wealthy multi-generation intelligentsia family has come round the table to have dinner together, to rejoice over the passing day and tomorrow. No one is posing here in any way: it is an ordinary night, white table cloth, some kind of a dish, and a peaceful conversation.

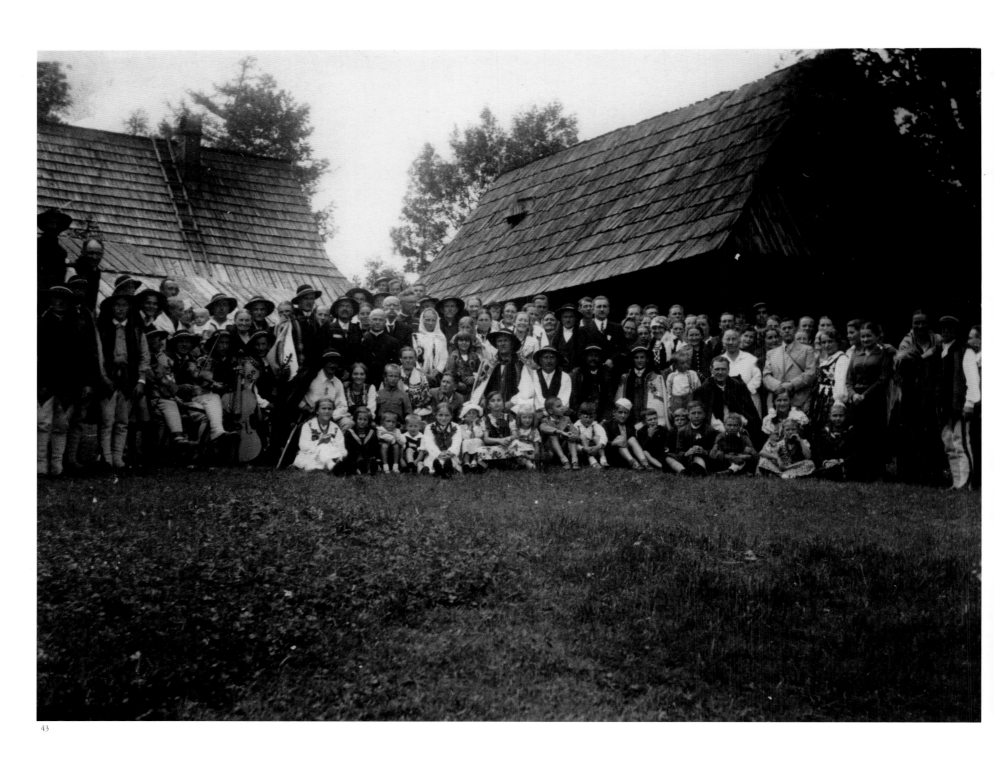

43

43. The Krzeptowski family is almost synonymous with the highlanders' culture, Podhale,
Zakopane. During a ceremonious family get-together they are posing for the photograph, some
wearing folk costumes, others dressed as "plainsmen", so that they would perpetuate their effigies
for ever. The background features picturesque mountaineers' architecture.

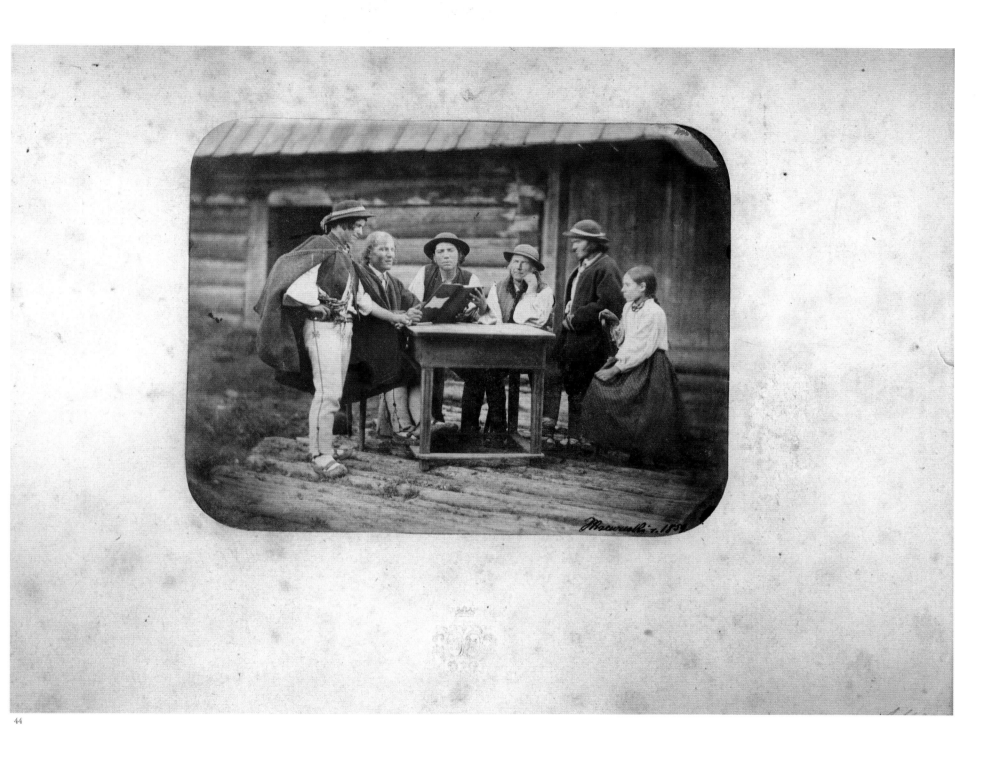

44

44. A group of mountaineers in their Sunday best seated at a table, most probably brought from the inside of a hut, is listening to one of them reading a book. A date under the photograph, not very clear, tells us that it was taking place in 188(?)9. The picture has something of the atmosphere of Young Poland, the period when highlanders' culture became inspiring and was widely admired. The scene looks very much artificial and posed. Is this the way that Kraków's artists perceived the mountaineers?

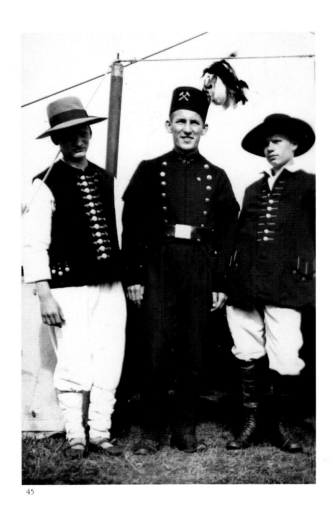

45

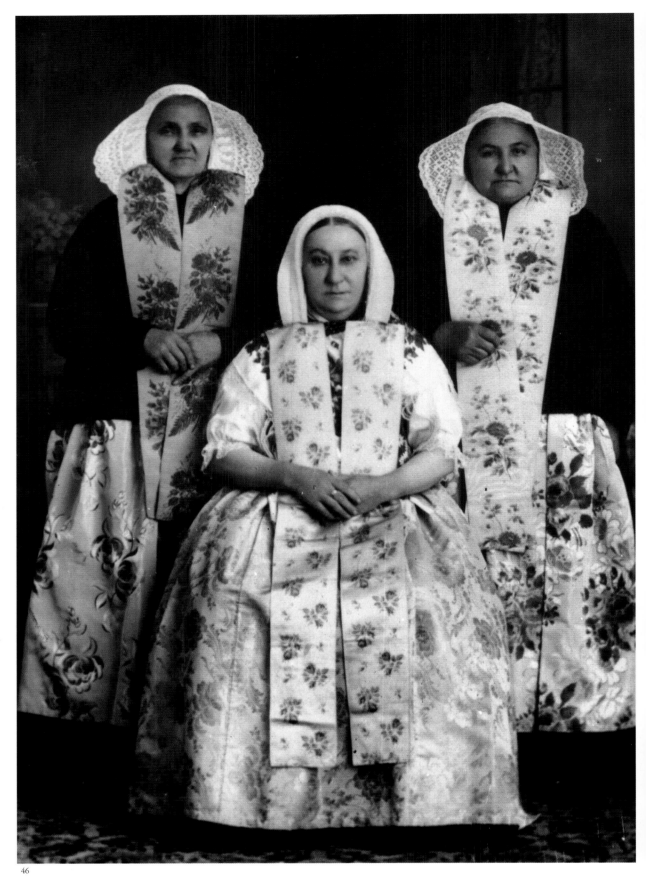

46

45. The Silesians: a miner wearing his gala uniform and two young men in folk costumes.

46. Three Silesian women are proudly presenting to the world their magnificent costumes made of floral skirts, but first of all the caps, beautiful like legendary butterflies. The photograph was taken in 1910.

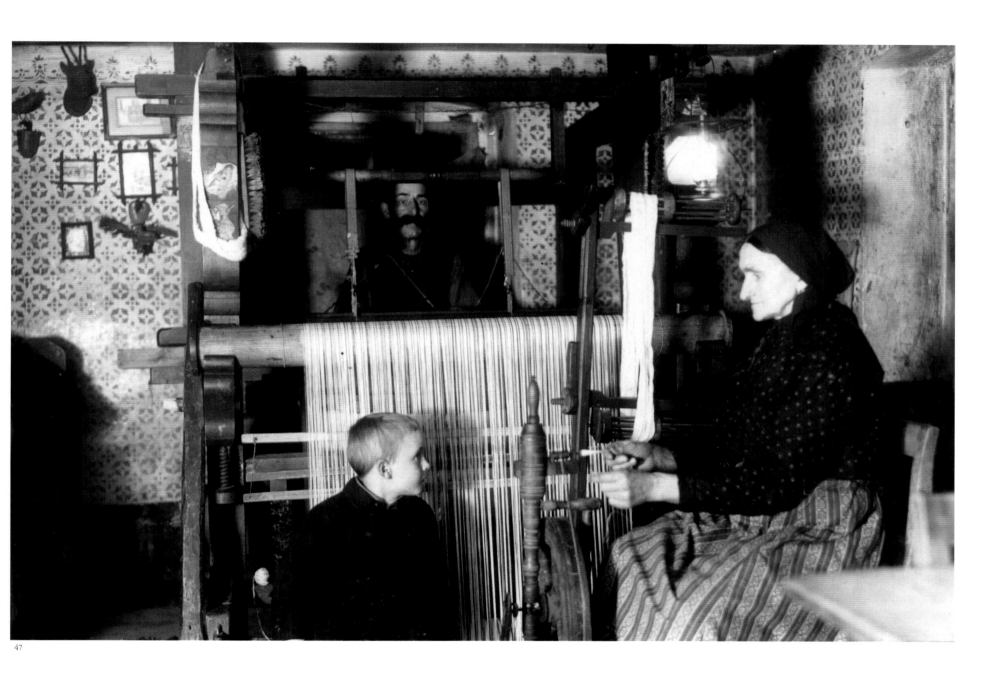

47

47. A vertical loom inside a Silesian home. Such was the kind of loom that for centuries women
all over Poland used to weave woolen material for clothes and ornamental tapestries. Today, such
a loom can only be seen in ethnographic museums.

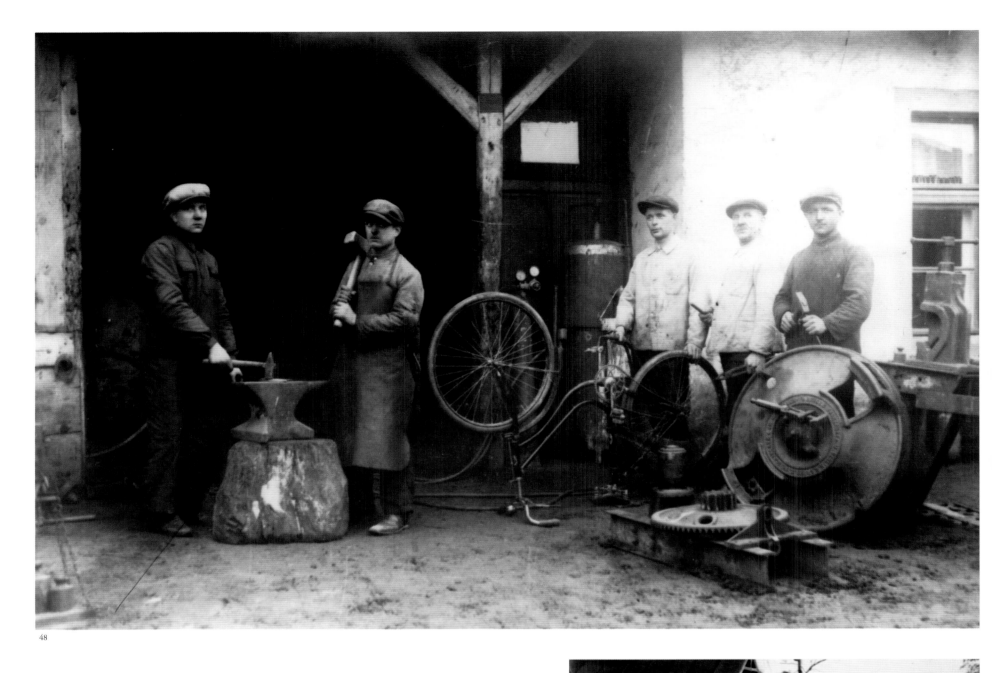

48

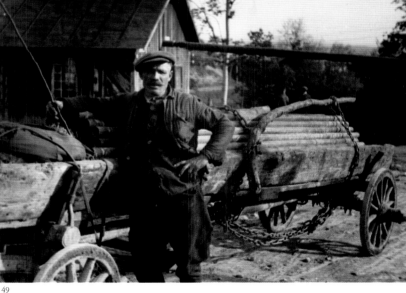

49

48. A blacksmith was someone very important in an old village — next to the miller, not to mention the vicar, organist or teacher (providing there was school in the village), he ranked among the local elite. And he was busy all the year round shoeing horses, making horse-shoes, repairing tools, which provided for his high standard of living. Blacksmith's was also a place where farmers used to meet to chat. Photo I. Maciejak

49. Borysław used to be the pre-war capital of Polish oil and natural gas industry. No wonder that many people, specially those living in the town, found jobs here. A proud smiling driver is leaning against the cart filled with pipes necessary for oil extraction. He is securely holding a whip and his figure emanates self-confidence and joy.

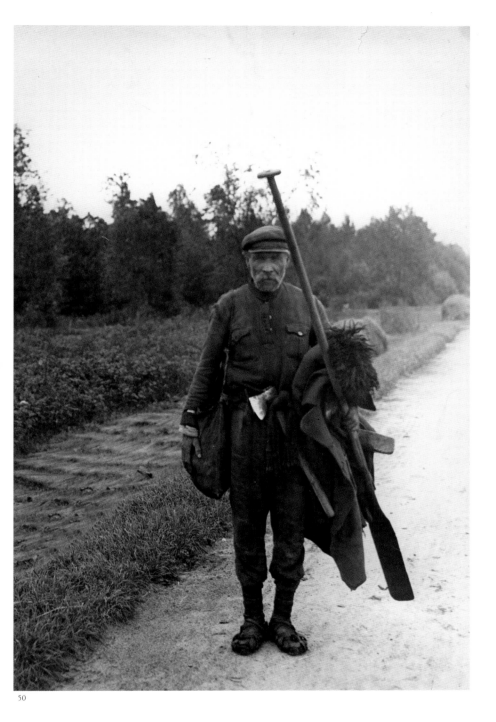

50

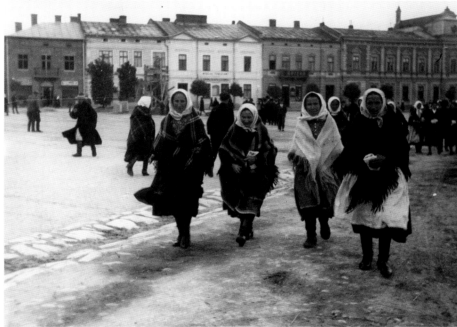

51

50. This is an inhabitant of marshy Polesie. He is wearing bark moccasins, feet cloth tied with straps, a warm jacket, and he is holding a paddle, a symbol of the typical occupations of the people from here, he has an axe tucked by the belt, a bag across the shoulder, and a grave concentrated look on his face which accounts for the tough kind of local life. Yet, there was this popular pre-war song: "The charms of Polesie"…

51. Gródek Jagielloński, a little town not far from Lviv. It was here that King Vladislaus Jagiełło died in 1434. Two-storeyed town houses, a cobbled market-square, and women coming from church walking slowly, with dignity. The striking elements of their clothes are large, heavy scarves in a chequerred pattern. This is the way women typically dressed in villages, little towns, and also poorer women in cities.

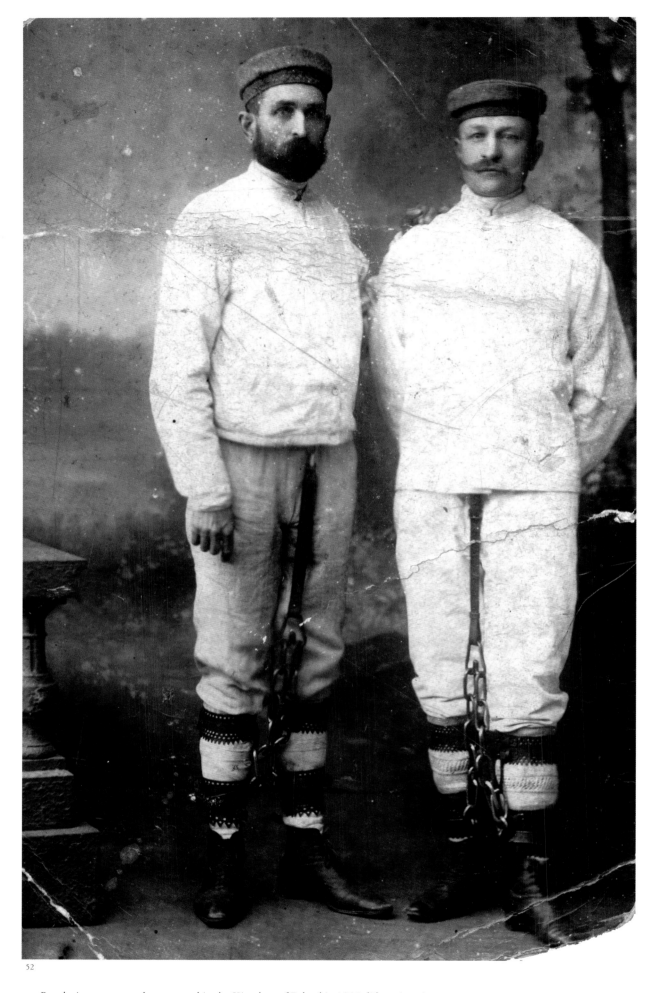

52

52. Revolutionary events that occurred in the Kingdom of Poland in 1905 did not imprint our historical awareness in any particular way. Yet, after all, they were not so trivial: strikes were organized in factories and schools, and in Łódź, during the so-called Łódź Insurgence, 300 people were slain. We can see two participants of these events: Adam and Karol Hozelmajer, already as exiles to Siberia, wearing convict's clothes and chains. The photo was taken in 1910.

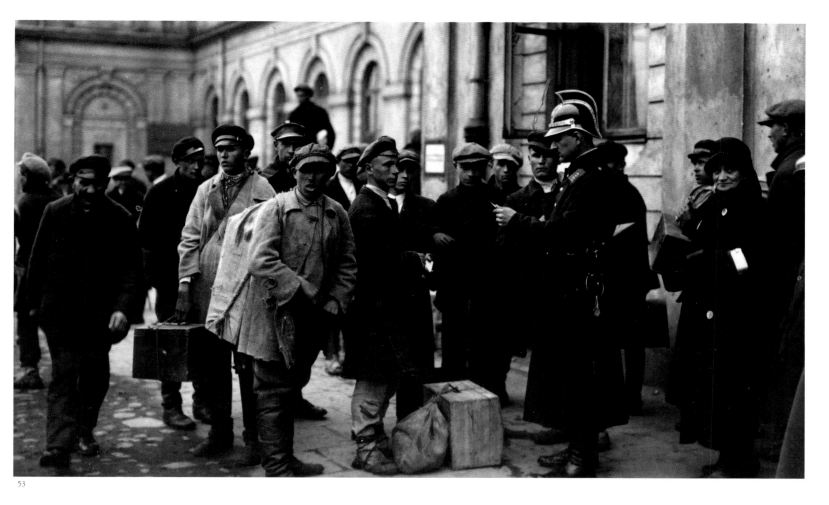

53

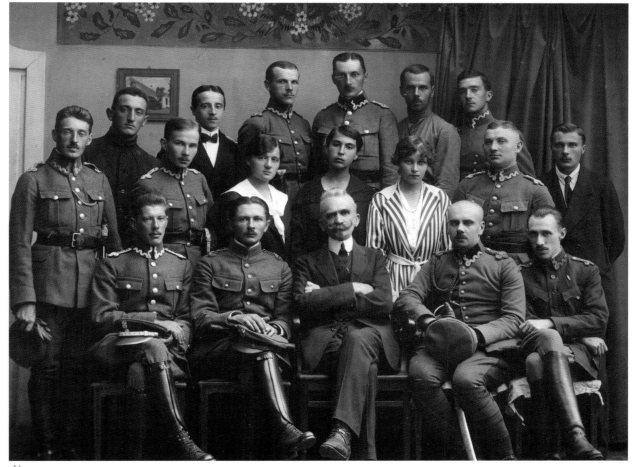

54

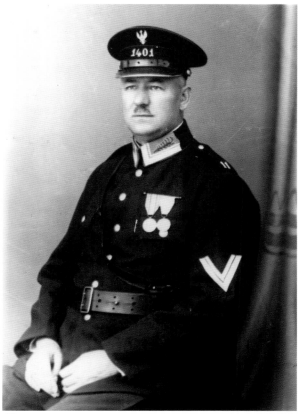

55

53. Young Polesie inhabitants from around Pińsk, army recruits, are awaiting at the Main Railway Station in Warsaw to be taken to their unit in October 1926.

54. Stanisław Haller (1872–1940), general of the Polish Army, is posing for a memento photograph among soldiers and friends.

55. A Polish policeman, senior foot inspector, in his navy-blue uniform, with medals awarded for his participation in the struggles for Poland's independence, in a dignified pose is on alert even in the photo. Prior to World War II a policeman had enjoyed unquestionable social respect. Photo I. Maciejak

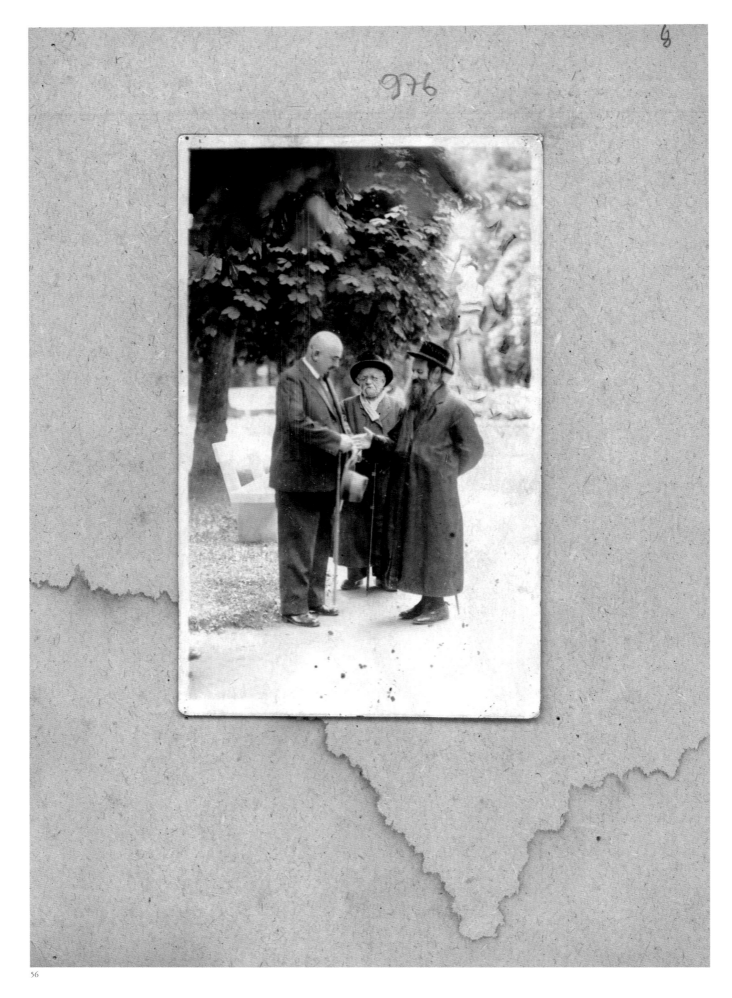

56

56. A chat in the park. Would it be an accidental encounter? Mayor Walenty Rybacki is
talking to Rabbi Eliasz Frankl and the President of the Jewish Community Szulim Aszkenazy.
The smile on the interlocutors' faces and peaceful gesture suggest that this is a friendly talk.
What significantly adds to the impact of this photograph is the date when it was taken: in
1939, just before the war calamity.

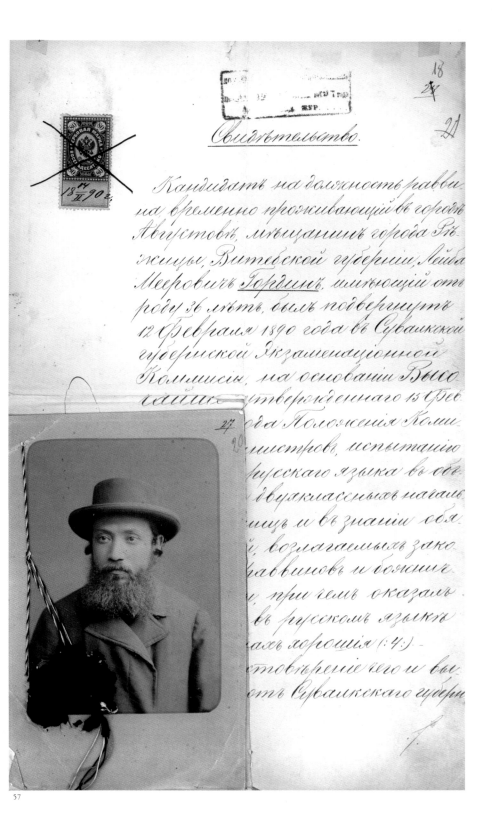

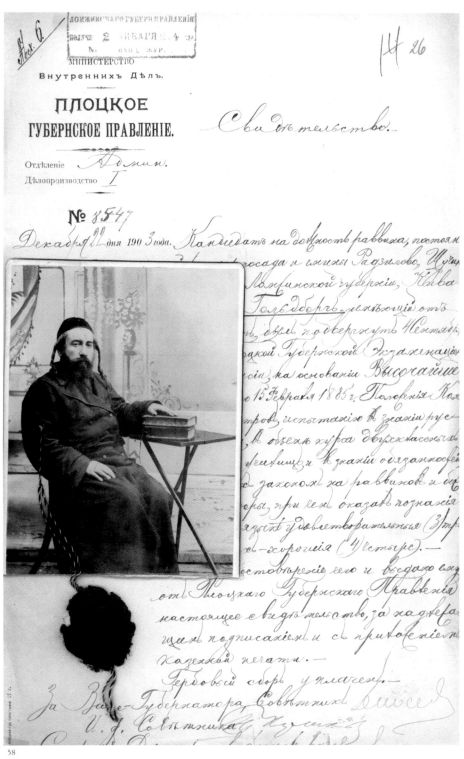

57, 58. The authorities of the tsarist Russia required that the future rabbis would speak Russian. Two preserved certificates with photographs issued in Płock on October 22, 1903 confirm that their holders passed appropriate exams.

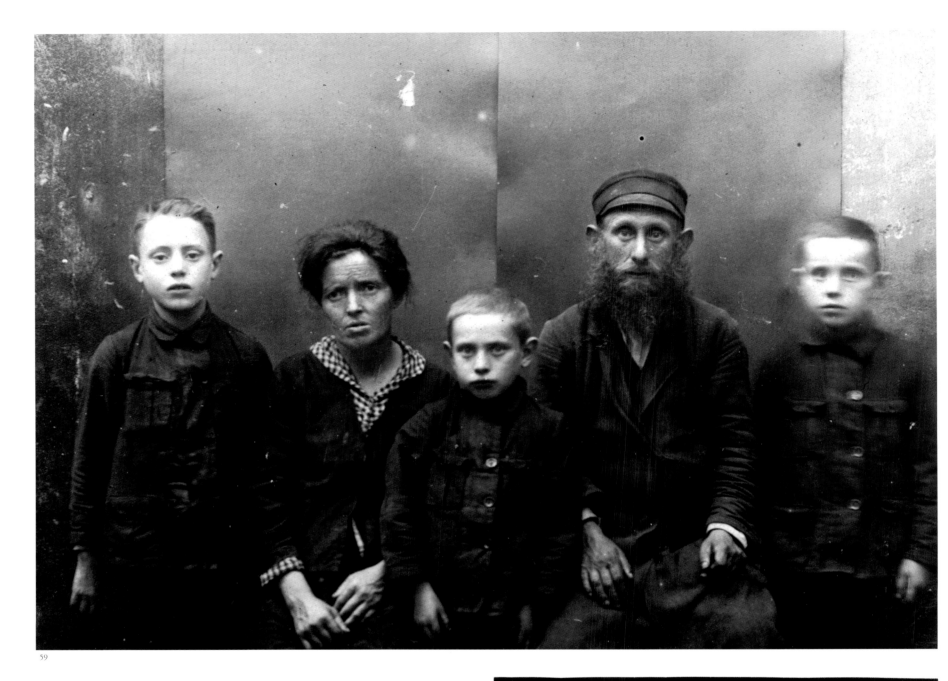

59

60

59. The Jewish community in the pre-war Poland was strongly differentiated. Next to wealthy merchants or industrialists, there lived poor people, in fact constituting the majority of the Jewish population, concerned with their day-to-day living. And even in this photograph for which they posed, they still reveal this concern on their faces. Petit shopkeepers, carters, having many children and dwelling in old houses, constituted an omnipresent element in our society.

60. In the Łódź heder Jewish boys are learning to read and are studying Hebrew, the Bible and the Talmud (c. 1916).

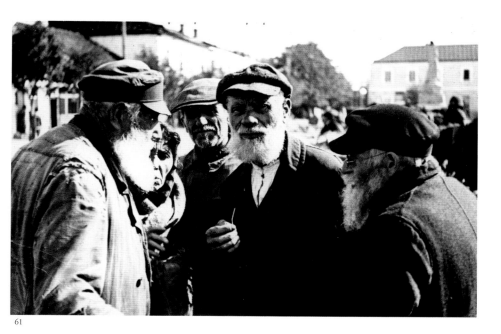

61

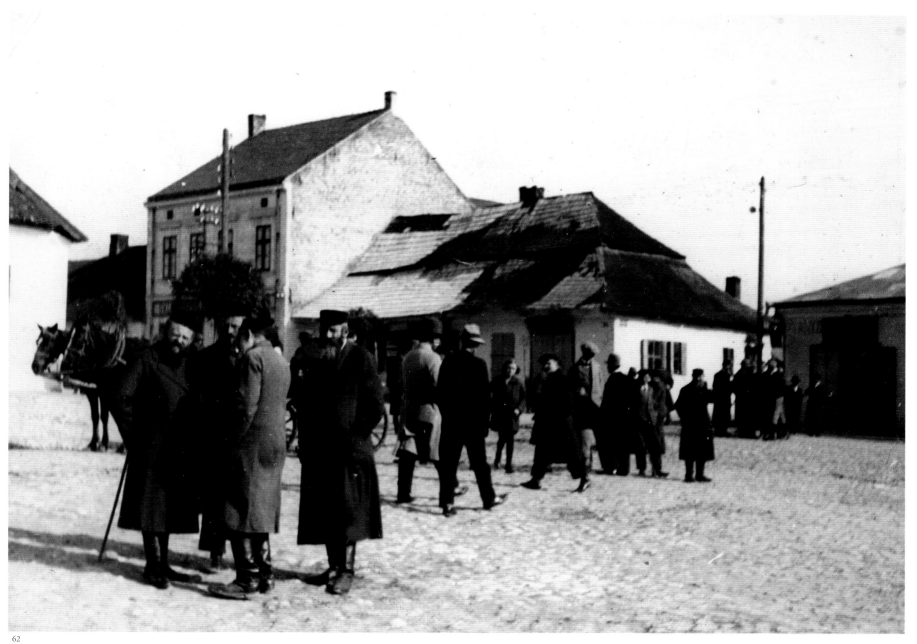

62

61. Nieśwież in the Novogrod voivodship does not only mean a magnificent castle of the Radziwiłłs with grand parties. It also means the Polish, Byelorussian, and Jewish population settled in the town.

62. Small towns of Central and Eastern Poland were inhabited by the Jews. They were tradesmen, agents, they prayed in synagogues. Here is a group of Jewish men, most certainly business people, in Miechów (Little Poland) seen against 18th-century houses of typically Polish roofs characteristic of the region. Such scenes are gone forever.

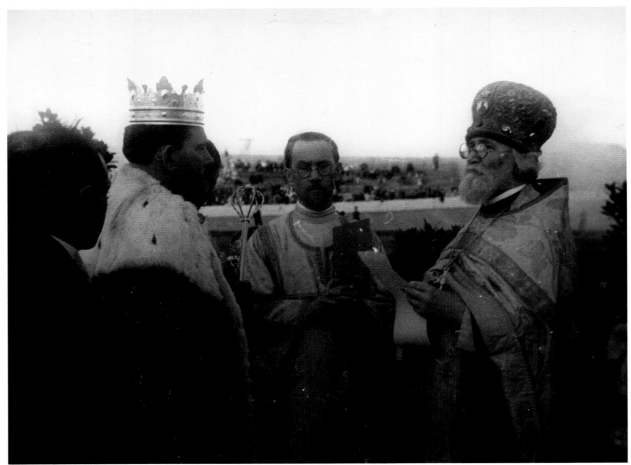

63

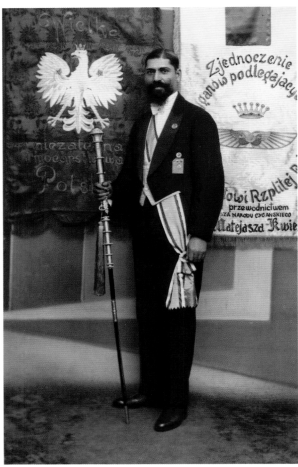

64

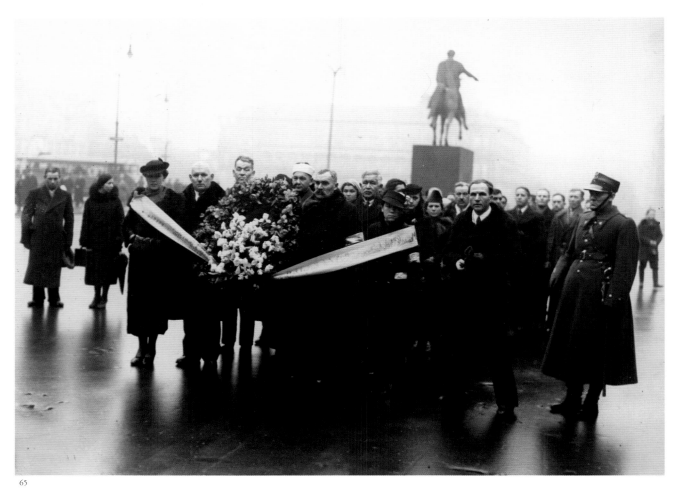

65

63. It is generally known that the Gypsies elected their king, which is a very beautiful tradition. It naturally climaxes with the coronation, carried out ceremoniously, with the insignia, and in the presence of the clergy. The election shown in the photograph took place in 1937. The history disaster was already approaching: it would annihilate the grand majority of the Gypsy people.

64. This is what a true Gypsy king looked like. He was Matejasz Kwiek, so full of genuine dignity! He is wearing his smart magnificent dress, holding an ornamental stick being the symbol of power and has two flags in the background: one of the Gypsy Unification and the other one with the national Polish symbol: White Eagle in a crown.

65. A small Tartar community, followers of Islam, had lived on the north-eastern territories of Poland already from the Middle Ages. They have remained there until this very day. The Tartars felt full members of our society, which is well testified by this photograph. On February 4, 1938 a delegation of the Tartar minority is laying a wreath at the Tomb of the Unknown Soldier.

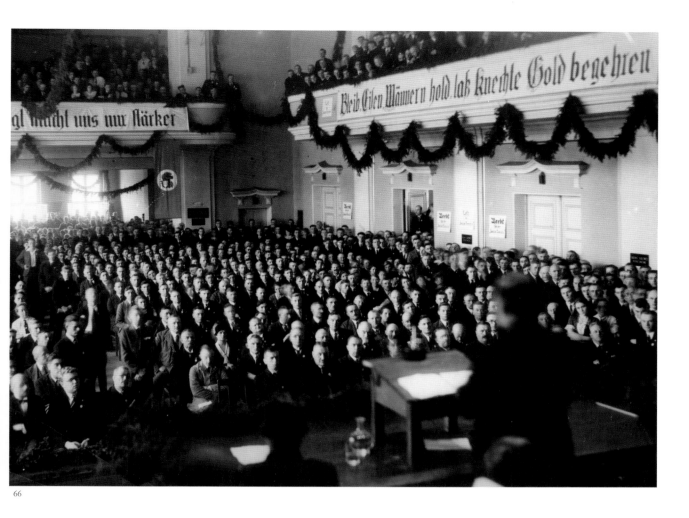

66

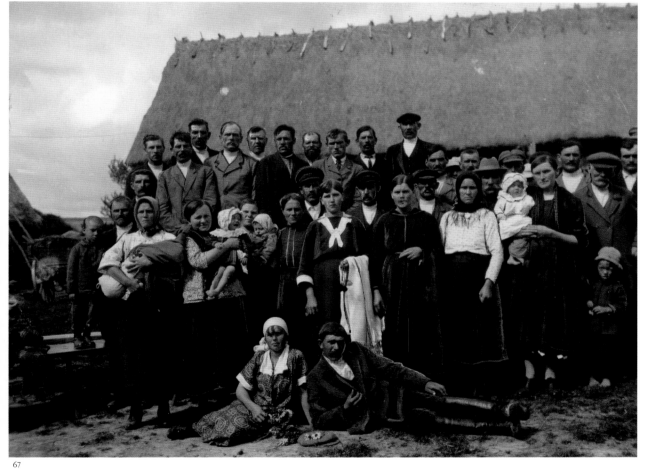

67

66. Members of the German population, quite numerous in the voivodships of Poznań, Pomerania, Silesia, just like any nation enjoyed full freedom in Poland. Their association, "Jungdeutsche Partei" held regular meetings, like this one taking place in Poznań on November 18, 1934. Dignified, well dressed, calm, they are seated in a decorated conference hall, discussing their own issues.

67. Volhynia was also inhabited by the people of German nationality: colonists cultivating this fertile land. Dressed not differently than other peasants from the area, seen against a thatched building, they are posing for some commemorative photograph.

# In the Country

"Peaceful and gay countryside, who will praise thou charm", is what Jan Kochanowski wrote in one of his poems. However, this quotation comes from sublime literature and was created centuries ago. Does the country continue to be peaceful and gay? Possibly so, but otherwise so many things have changed. Asphalt roads have cut it up, old towns have overgrown with surrounding blocks of flats on their outskirts, and even the landscape, built around, filled with new buildings is different. The old country in fact survived in some regions until the 1950s and 1960s, but later it thoroughly changed. We can see what it used to look like by visiting numerous open-air museums scattered across Poland and established to perpetuate the old landscape, so that young people could understand what "it once looked like".

Raised along the road, today mainly made of asphalt, brick houses with concrete walls surrounding the plot, garages, cars, ships, schools, discos, all these are the elements of the new face of the countryside. I believe we are still quite sentimental about it, though the aesthetics and atmosphere have been changing. After all, this is where the majority of our society live,

many of today's town people have their roots in farmhouses.

Change has been observed in every aspect, starting from the clothes worn and dishes served, to the ample chapter in our tradition, that is farming. Scythes, sickles, and flails have been replaced by machines, so many and so different that it is even hard to enumerate them. A horse has given way to a tractor, a primitive plough to a multi-ridge construction. Threshing-machines resembling archaic monsters clean up the field quickly and put ready threshed grain into trailers.

So it is only ethnographic museums, the open-air museums that we have mentioned, and last but not least, old photographs which can display the old countryside that has been lost forever. They allow one to imagine how hard the work of a farmer was, how much concern, effort, and sweat it required. But on the other hand, how much joy and peace it gave. Let us respect those old days, let us look on the past with emotion and believe that the country has remained beautiful. It does not only provide us with bread and other fruits of farmers' work, but also with relaxation and joy. Fields undulating in the wind, cattle herds in pasture,

are, after all, our everyday essential and unforgettable views to which we constantly return.

68. Girls wearing the Łowicz costume, with bouquets in hands, are so charming, though possibly slightly stressed by the whole situationvery; full skirts seem much larger than their owners.
Photo Z. Marcinowski

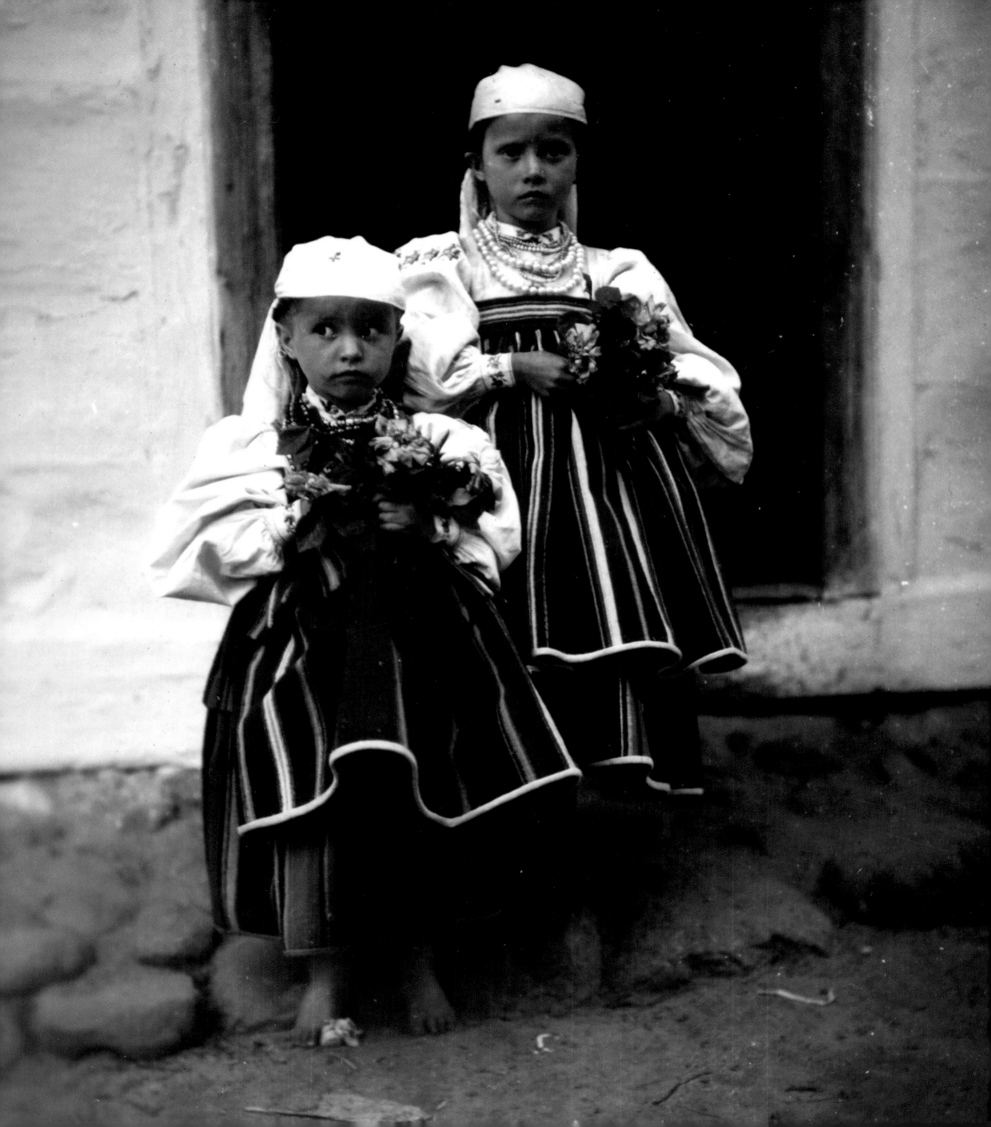

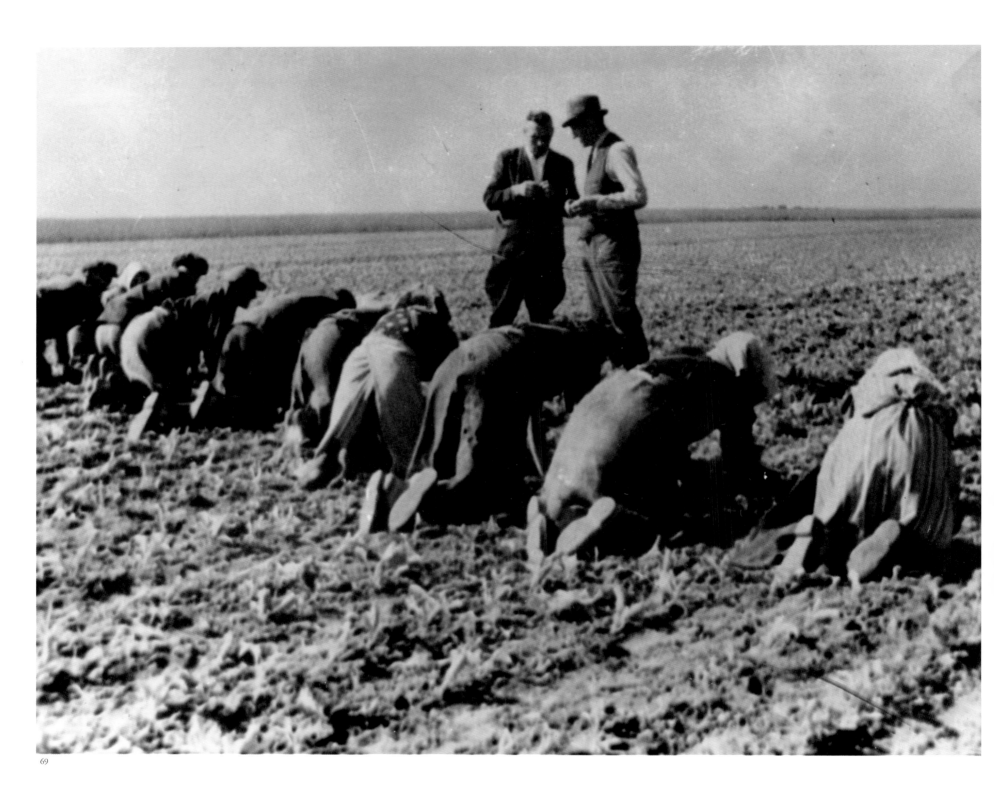

69.

69. Without all the specialized agricultural machines which today purr in the fields, farming was hard work and required many hands. This can be seen in the photograph whose author shot the work on beetroot seedlings.

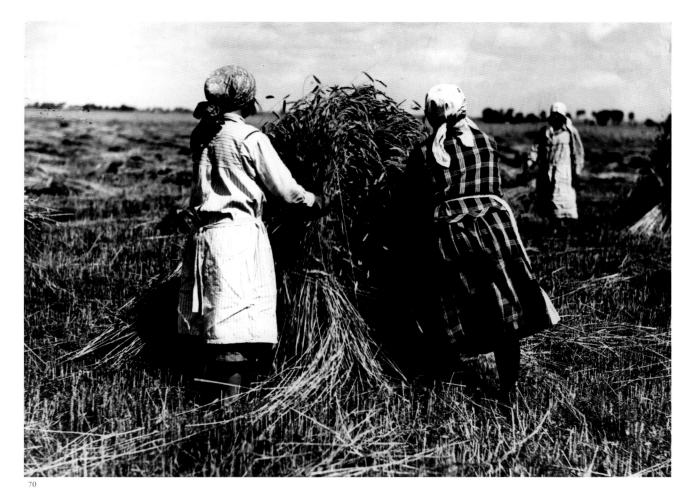

70

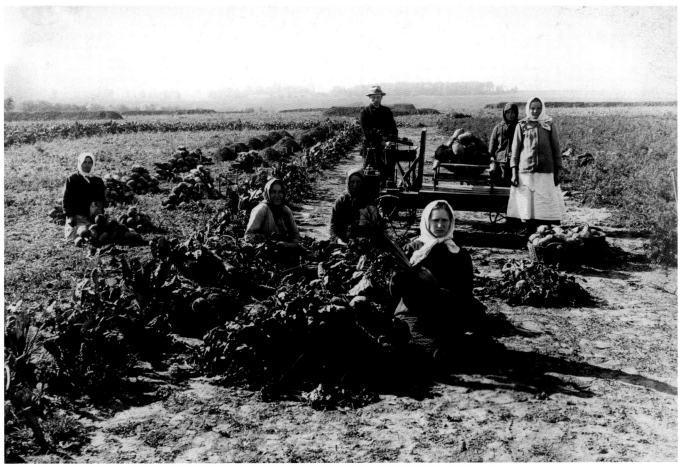

71

70. Until recently the scene from the photograph was very frequent, but today it has almost become anachronic. After the reapers have cut corn, women put it in sheaves. This is the way work was done in the fields at Count Grochalski's estate at Falenica near Warsaw in 1927.

71. Once the harvest was over, there came the time for the picking of mangel-wurzels and sugar beets, then potato lifting. There is always a lot of work to do, and it is hard and tedious. Women clearing the beetroot stopped for a moment and turned their faces towards the camera lens.

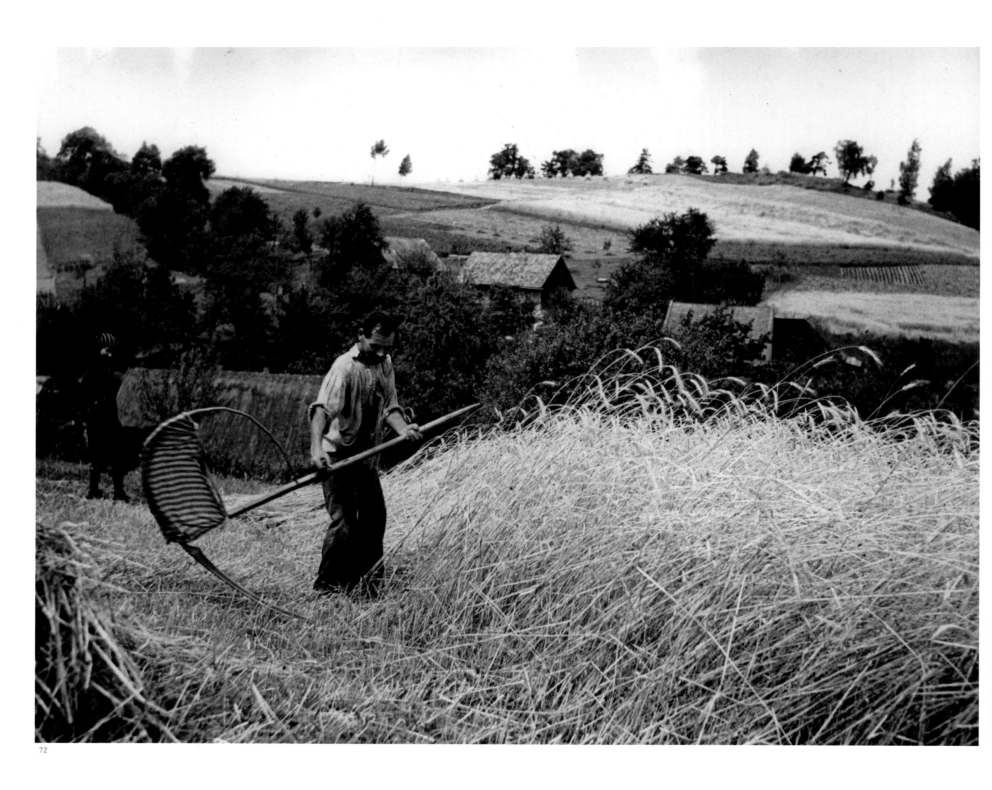

72

72. Ripe standing corn falls under the rhythmic strikes of a sharp scythe repeated for centuries and directed by skilled farmer's hands. The reapers are not aware of the fact that for many this would be the last harvest in their life-time. It is the summer of 1939.

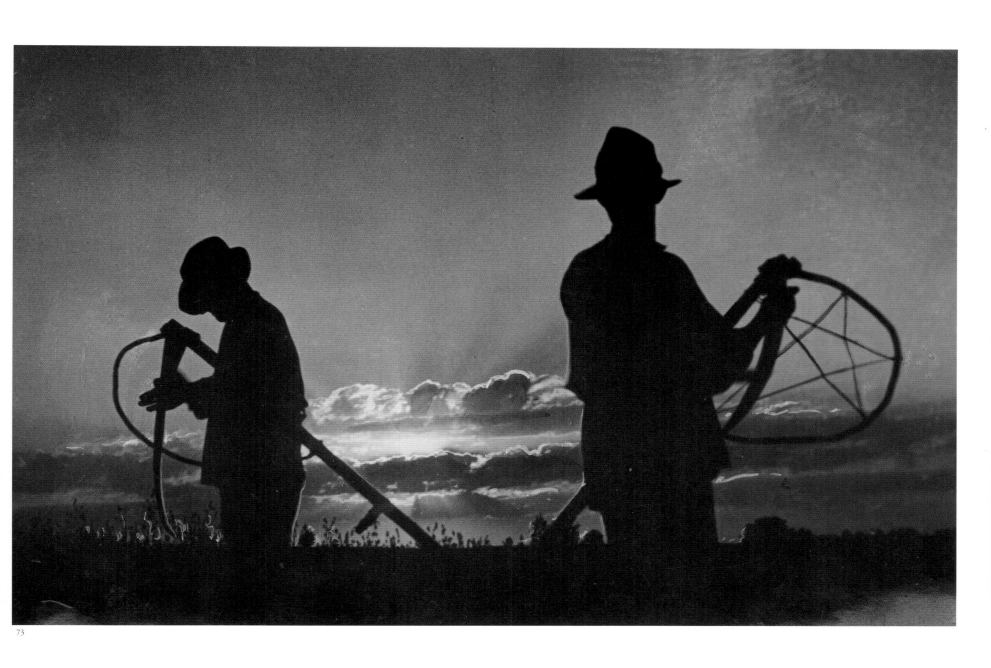

73

73. The photograph is ascetically modest. Two silhouettes of reapers seen against a darkening sky.
The scene seems almost motionless — perhaps it is a moment of rest after a tedious day's work,
a minute before the end of work. The picture is an unquestionable work of art. No wonder —
the photogram was taken by one of the best Polish artistic photographers Edward Hartwig.

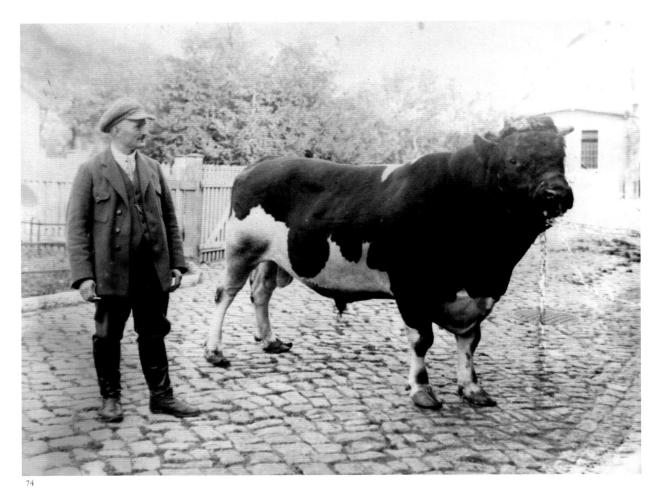

74

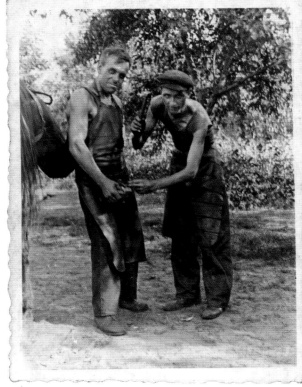

76

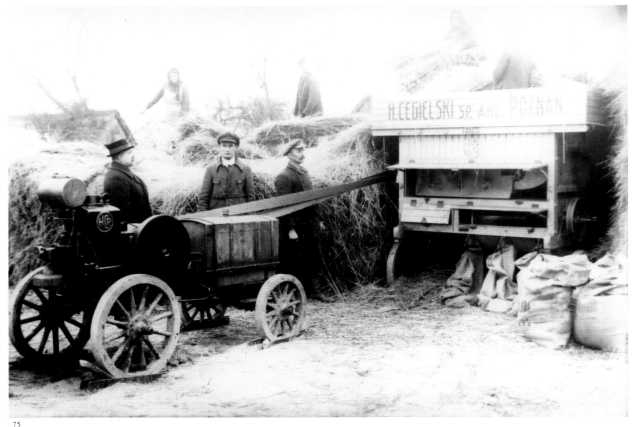

75

74. This is most possibly Great Poland boasting of effective economy; a proud farmer is showing his favourite animal. And the huge bull seems to be even prouder than the owner himself. What a specimen! Photo I. Maciejak

75. In the interwar period the face of the Polish country transformed. Agriculture machines drove onto the fields. A threshing machine manufactured by "H. Cegielski Stock Company. Poznań" is working really hard spitting corn. Old-fashioned flail was slowly discarded. Photo I. Maciejak

76. Once there used to be the blacksmith's in every larger village, in every little town. Not only were the horses shoed there, but it was there that broken machines were repaired. In the photo: a blacksmith at work.

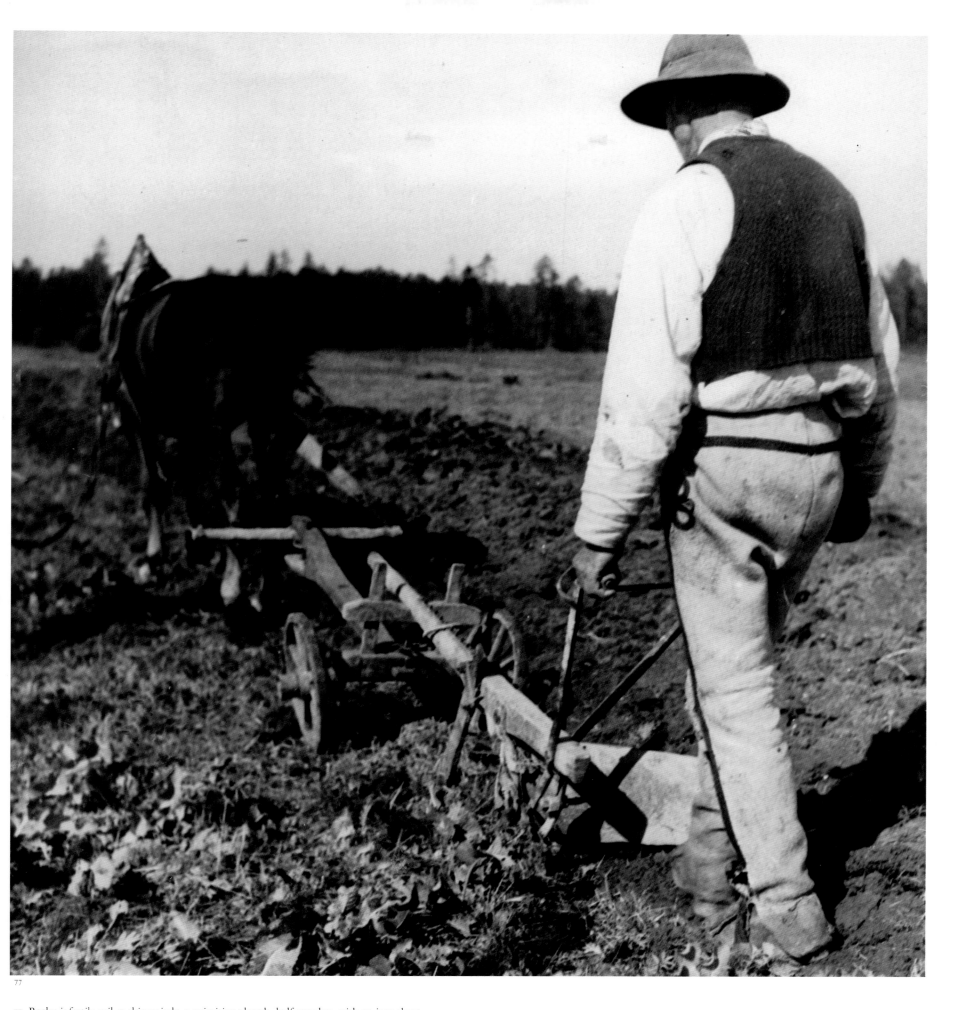

77

77. Rocky infertile soil, a skinny jade, a primitive plough, half-wooden, with an iron share, and a mountaineer behind it. Photograh taken in 1937. Photo Fr. Rozłucki

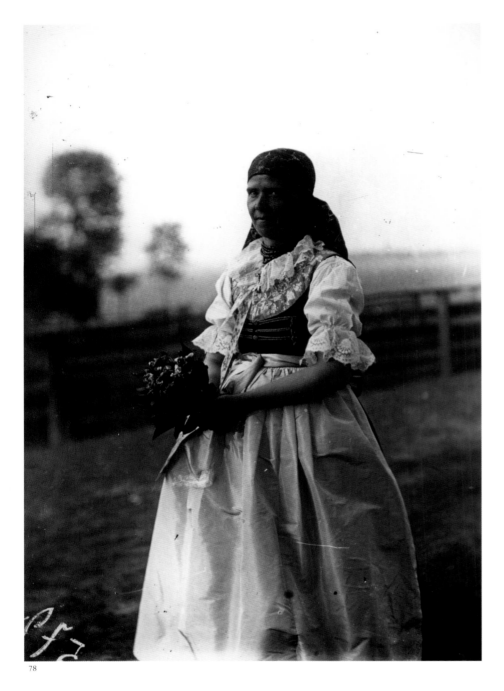

78

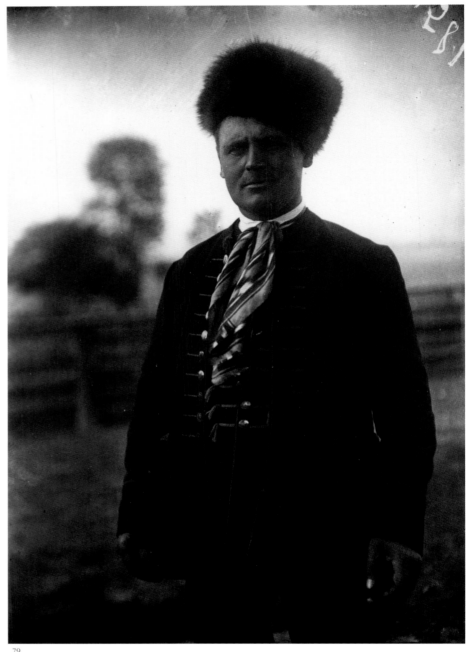

79

78. A Kashubian woman is putting on a long undulating skirt, a light embroidered blouse, ornamented corset, whereas all this is decorated with ribbons and bows. She would also wear black shoes and white socks.

79. The Kashubian men would wear overcoats or jackets ornamented with leather, white trousers or the most elegant ones of leather, most preferably of roe-deer, pulled inside widening knee-boots. They would wear regular hats or fur hats.

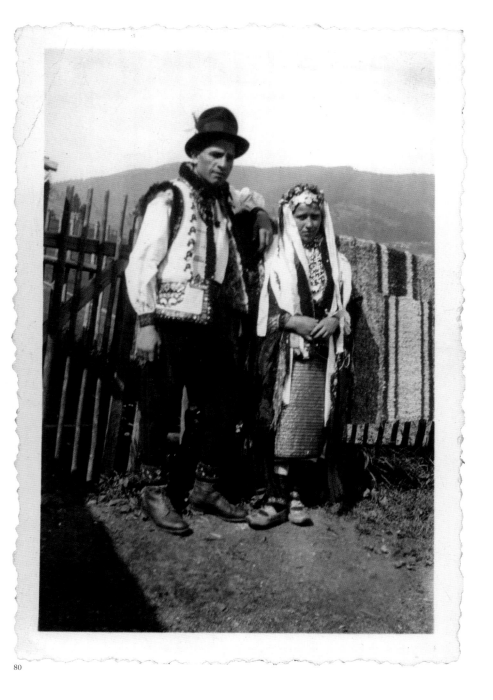

80

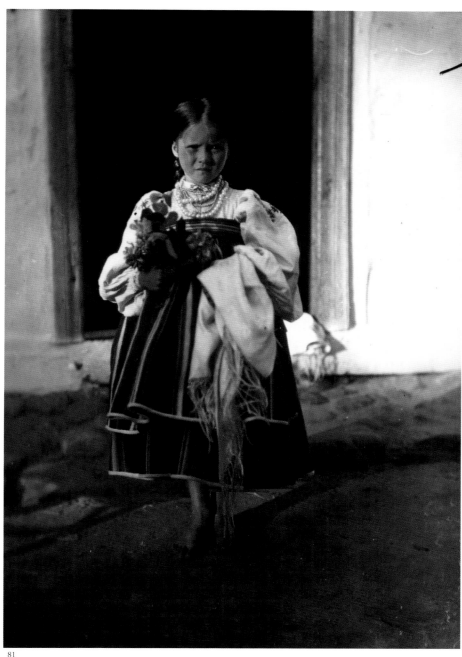

81

80. A Hucul wedding. A young couple in folk costumes is posing for this photograph in 1938.

81. A girl wearing her folk dress looks like a little toy. And only a grave look on her face testifies to the fact that she does not take her costume with leniency. Photo Z. Marcinkowski

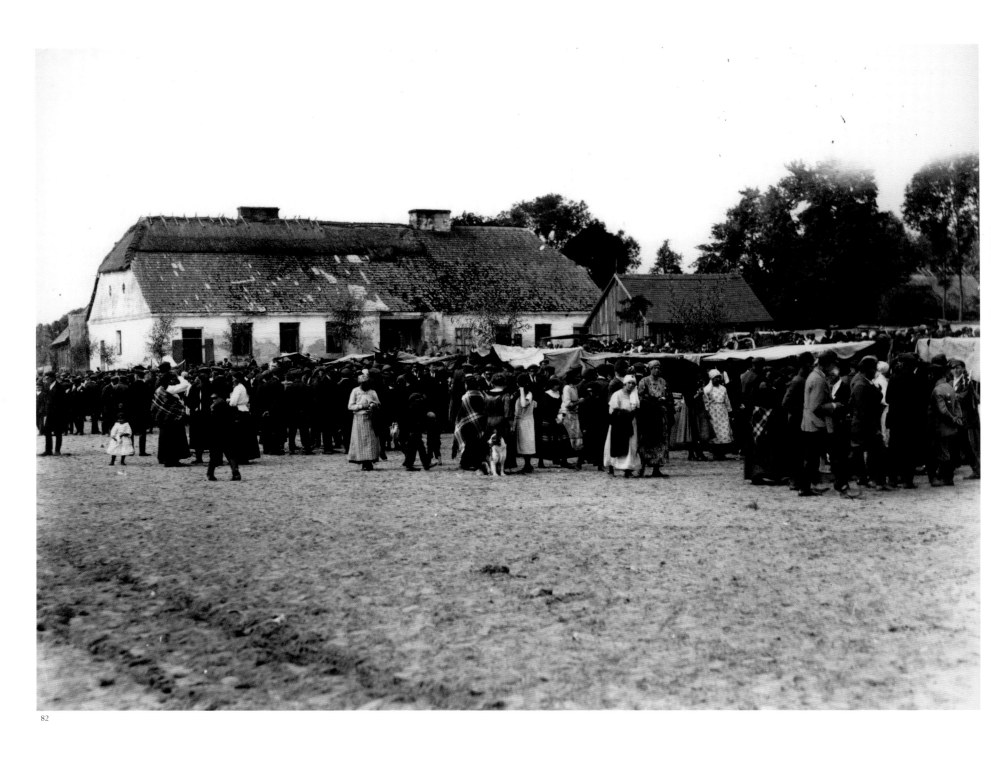

82

82. The clothes of market buyers at Glinianka near Kołbiela were so very diffeent. Women in double long skirts, aprons around their shoulders, scarves on their heads, men obligatorily in knee-long boots and in hats. Photo Z. Marcinkowski

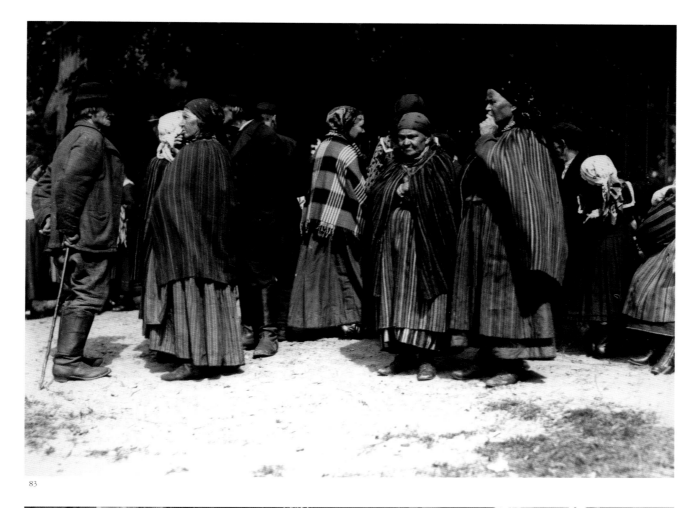

83

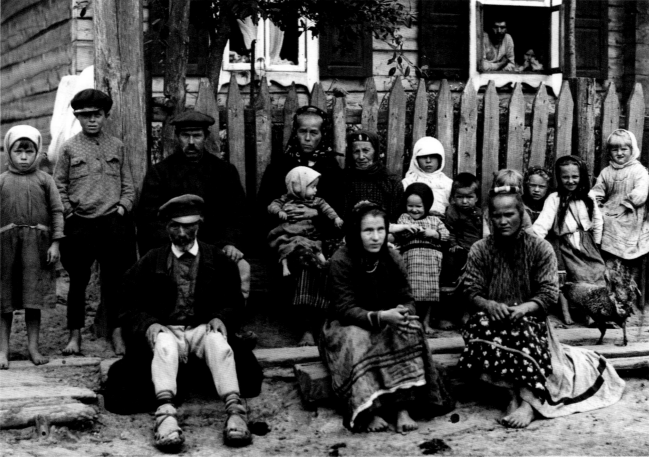

84

83. Some time ago a market day was the most important moment in a week. Not only because it provided the opportnhity to purchase essential goods, but what is more important, it was also a moment for a meeting, chat, exchange of information, and gossip. Photo Z. Marcinkowski

84. This is a sad photograph, but documenting perfectly well the state, appearance, and condition of the inhabitants of Eastern Poland. Motionless, perhaps fearsome and curious, they pose in their patched clothes. Only the elder man in a cap and bark slippers pretends to have a little bit more of self-confidence. This group portrait was executed at Morocz near Novogrodek in 1929.

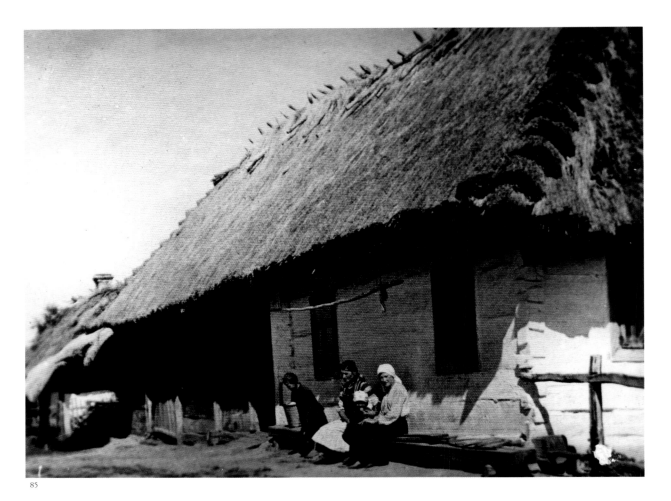

85

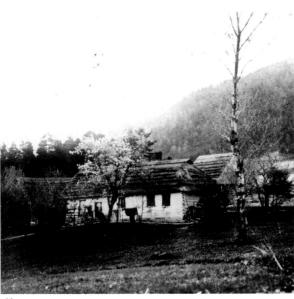

86

85. The village of Starosiele in Volhynia. A wooden thatched hut is typical of those territories. There are a couple of seated figures in front of it. Nothing special. Yet, this hut had its history. It is the one in which Commander (not Marshal yet) Józef Piłsudski quartered in 1916 whilst the legions under his command were struggling against the tsarist Russia.

86. This is not today's open-air museum. This is what the suburbs of Limanowa looked like. A wooden hut, farm buildings, everything seeming very idyllic, but also very poor.

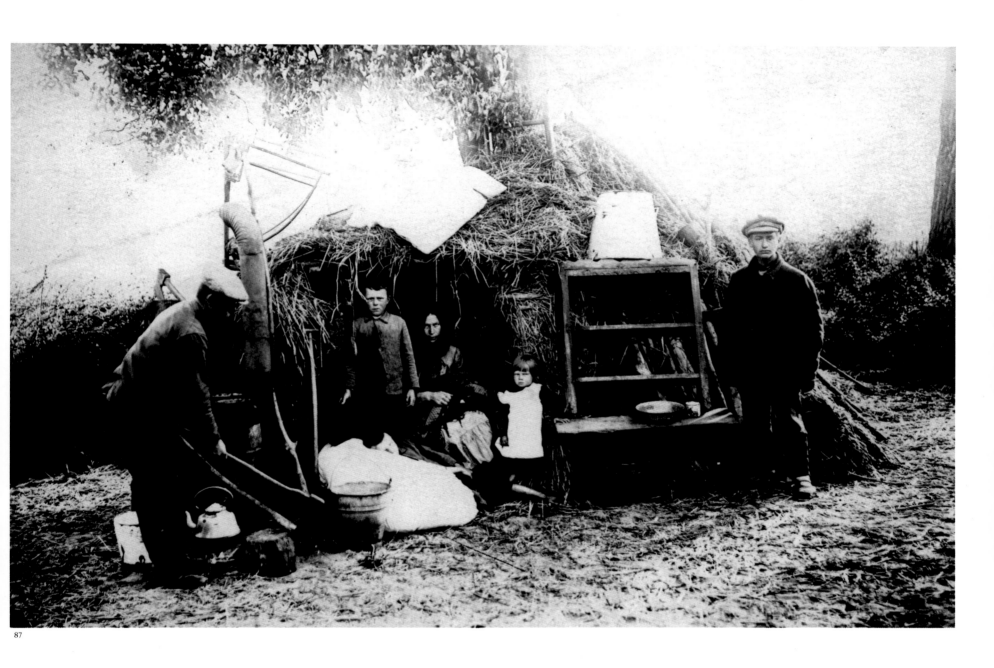

87

87. Very often the life in the country was neither peaceful, nor joyful. The pre-harvest period was usually very tough, specially if the previous harvest was not very good, and sometimes the situation got even tougher. This is the moment caught by the photograph: a peasant being evicted from the farm of Skoraczew in the Jarocin Commune (Great Poland).

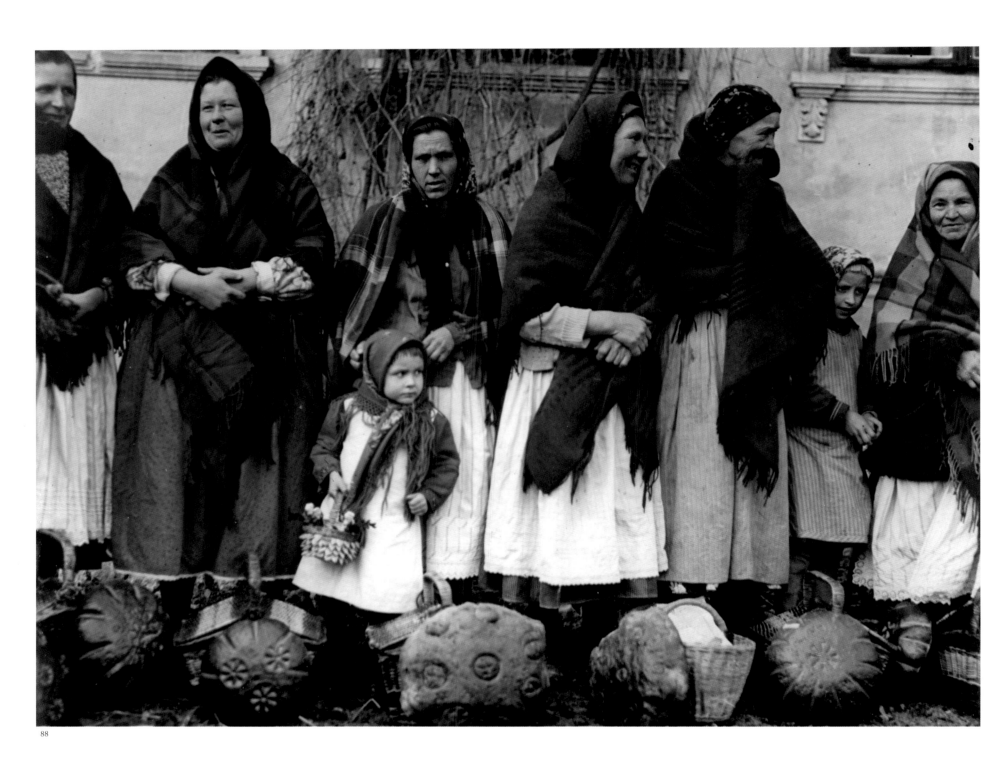

88

88. On Holy Saturday in Modlnica in Great Poland, just like in other villages, women would bring baskets to have food blessed following the old tradition. Let us notice that this is not happening in a church, but in front of a manor. The baskets are really impressive, possibly full of delicacies for Easter breakfast. The photograph was taken in 1937, but the custom has survived until today, though today's costumes are different and baskets somewhat smaller, more symbolic...

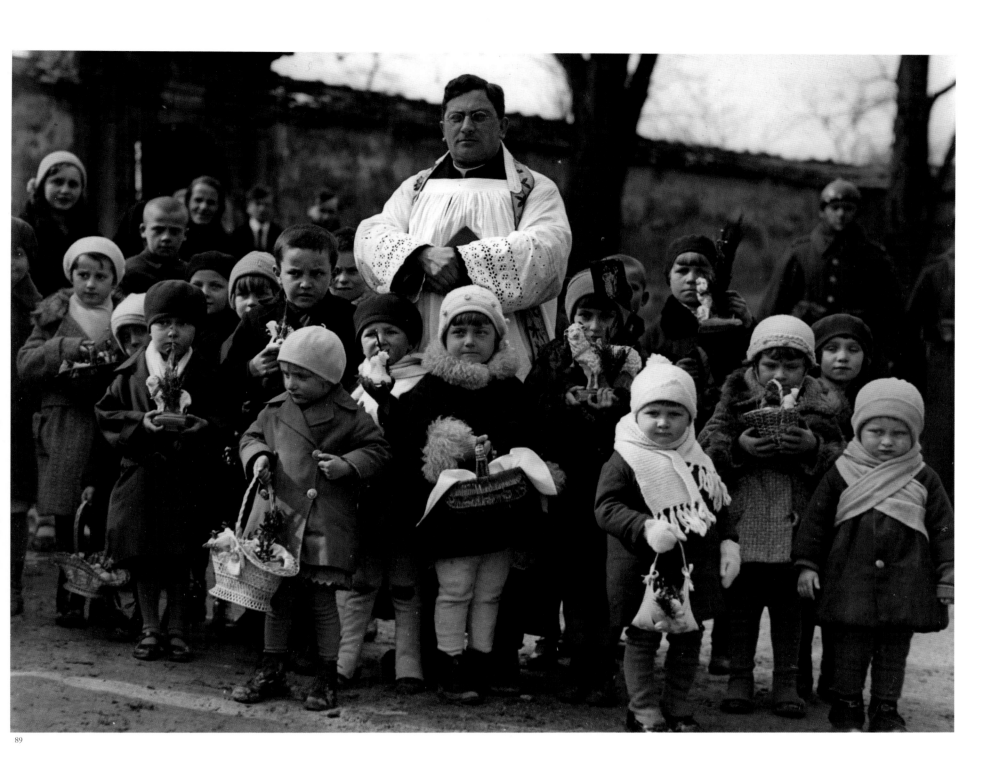

89

89. Holy Saturday in Niepołomice near Kraków, food blessing. A group of children are posing for
a photograph together with a priest. They are proudly showing their baskets.

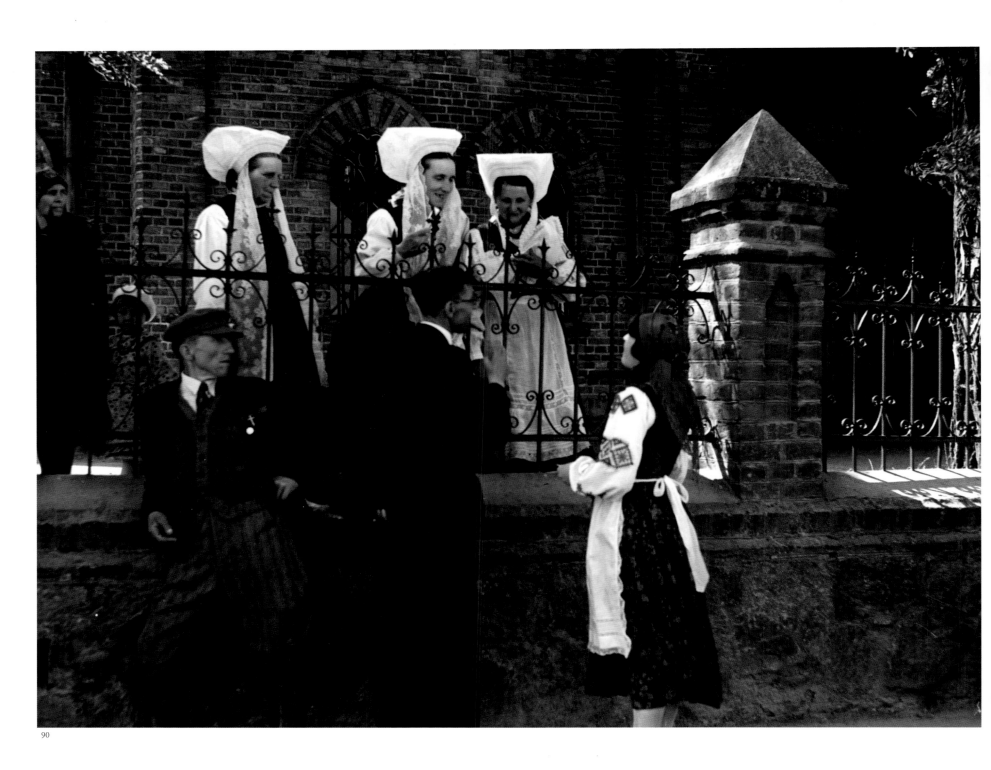

90

90. In Lisków in the Kalisz Land, after the Sunday Mass people calmly chat in front of the church.
Women in folk costumes, wearing exquisite caps resembling fantasy flowers, men in suits, stopped
in time in 1937, have survived until today in the photograph.

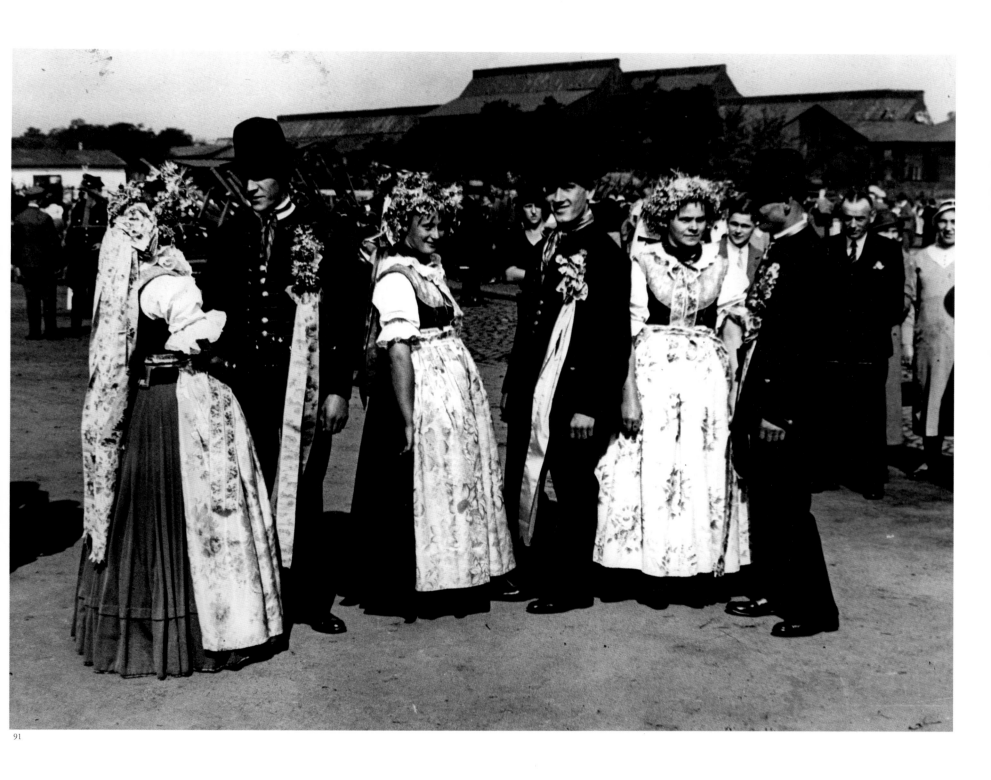

91

91. Upper Silesia brings mainly associations with mining, heavy industry, but actually it seems that the most beautiful folk costumes are the ones worn by Silesian women. Magnificent caps, lace collars, ribbons, colourful skirts, all these accompanied by the gracefulness of movements, beauty of the young age. Men are not equally dressy, but that was nothing unusual in other regions, either; they, in turn, boast of dignity, elegance. Such was the celebration of the harvest festival in Katowice in 1934. Photo Cz. Datka

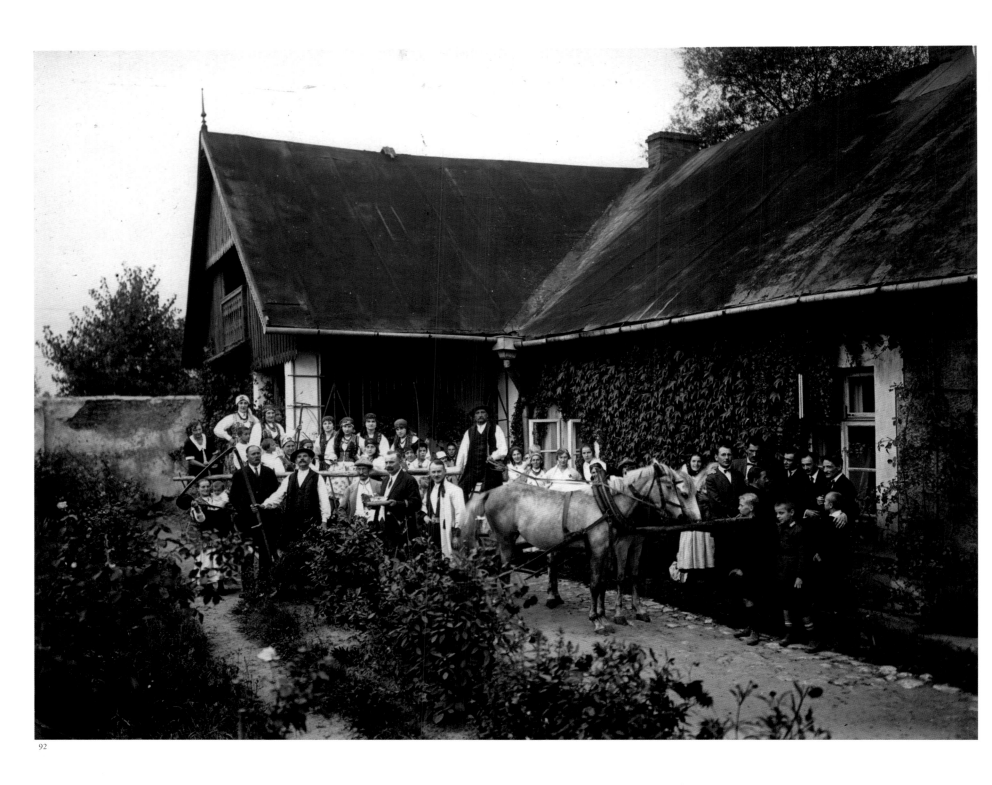

92

92. Bronowice near Kraków is famous for the most renown Polish wedding that was an impulse for Stanisław Wyspiański's play. Like in all the villages and little towns, here, too, harvest festivals were held. A rack wagon with dressy harvesters with a group of "gentlemen from town" next to it. There is joy with the work done, rest, laughter. And only the figure of the peasant with a scythe has something of Wyspiański's drama climate to him.

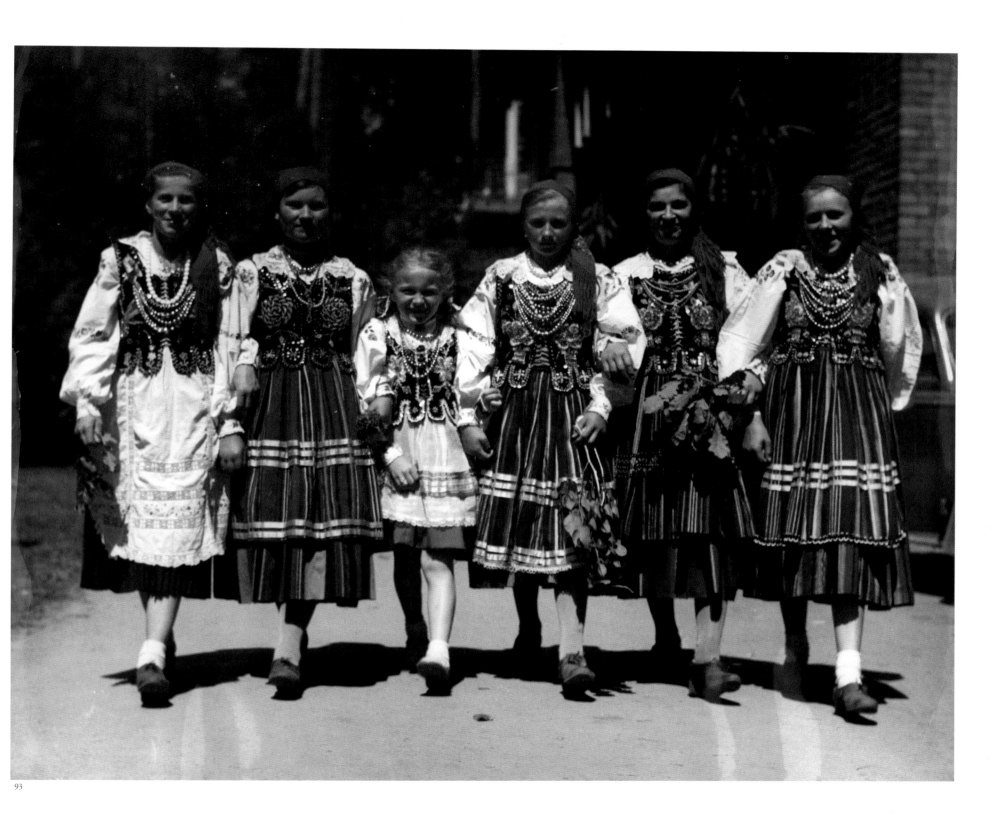

93

93. During the inter-war period the official harvest festival was held in Spała. Members of folk bands, smart girls and boys, and next to them there are distinguished guests, VIPs. And all that multiplicity of costume: from around Kraków, Łowicz, Silesia, the mountains, to the Hucul and Kashubian ones, as there were really numerous costumes, traditions, dialect, and customs in the multinational Poland.

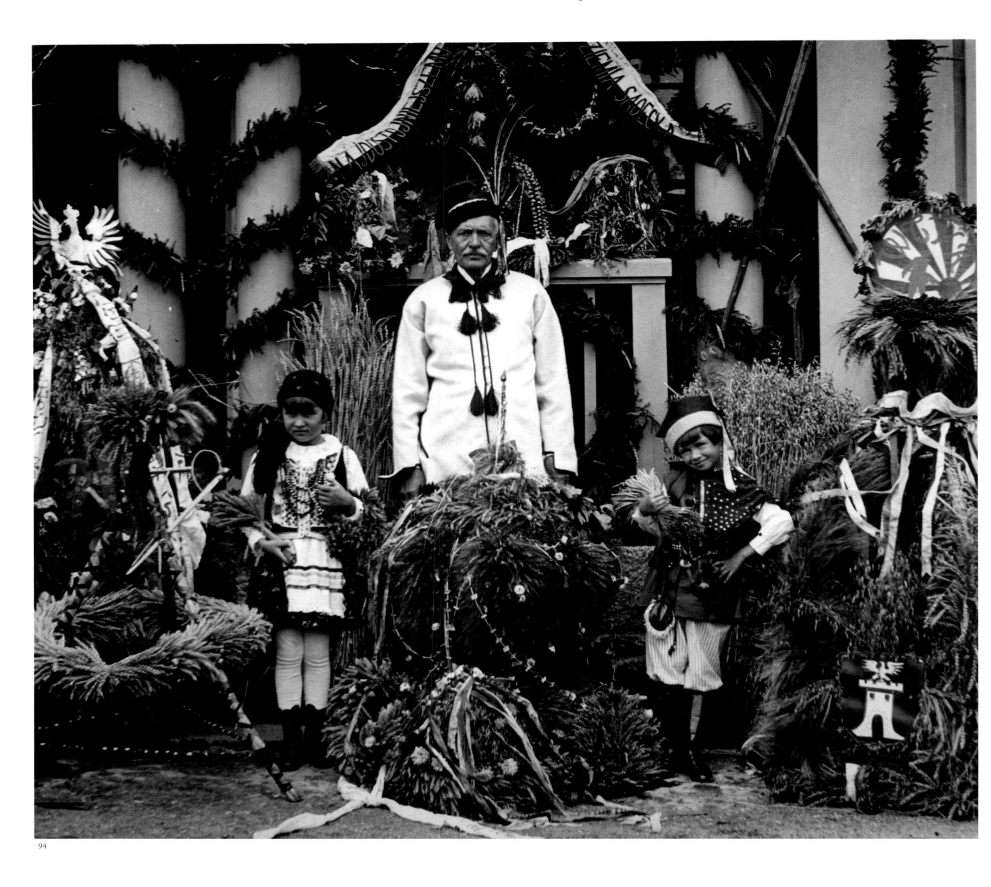

94

94. Harvest festival in Spała. Wonderful festival wreathes, true pieces of art set against a beautiful decoration, and among them like figures from a live picture there is an elderly man in Kraków peasant overcoat and children wearing exactly the same clothes — continuity of the tradition.

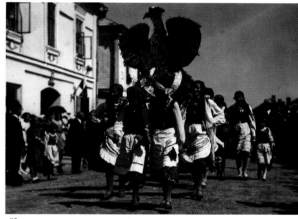

95

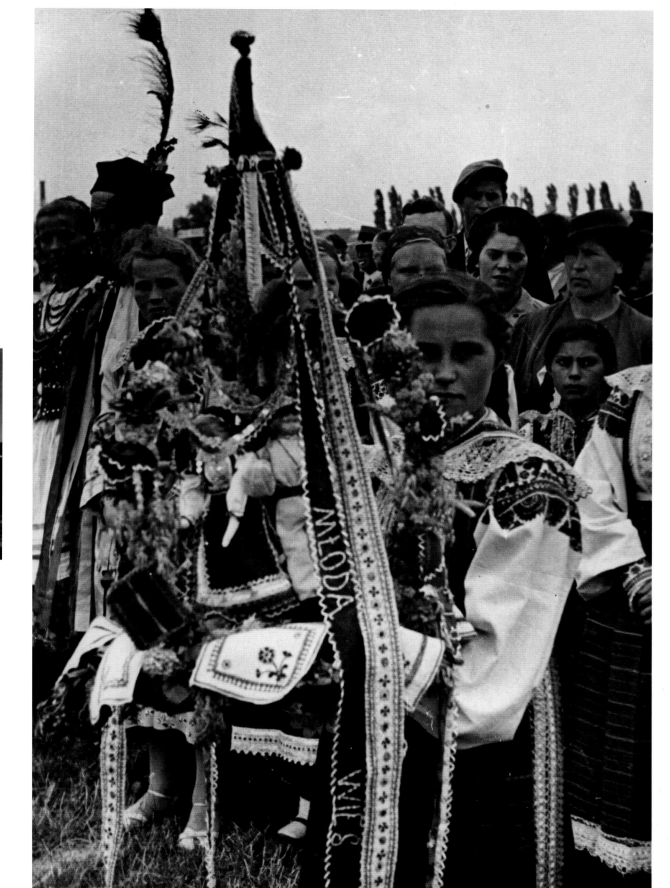

96

95. In Dąbrowa Tarnowska, a small town in Little Poland, the harvest festival was a big celebration. Girls wearing folk costumes are carrying a huge eagle made of corn. This is not merely a harvest celebration, but a ceremony of patriotic character.

96. Not many people remember today that not only the harvest was concluded with a great celebration. In the south-eastern corner of Poland vine was grown and vine-picking always ended with a sumptuous feast. In Zaleszczyki wine grapes were carried instead of sheaves in a procession. Wine produced in this area was highly regarded not only in Poland, but also abroad.

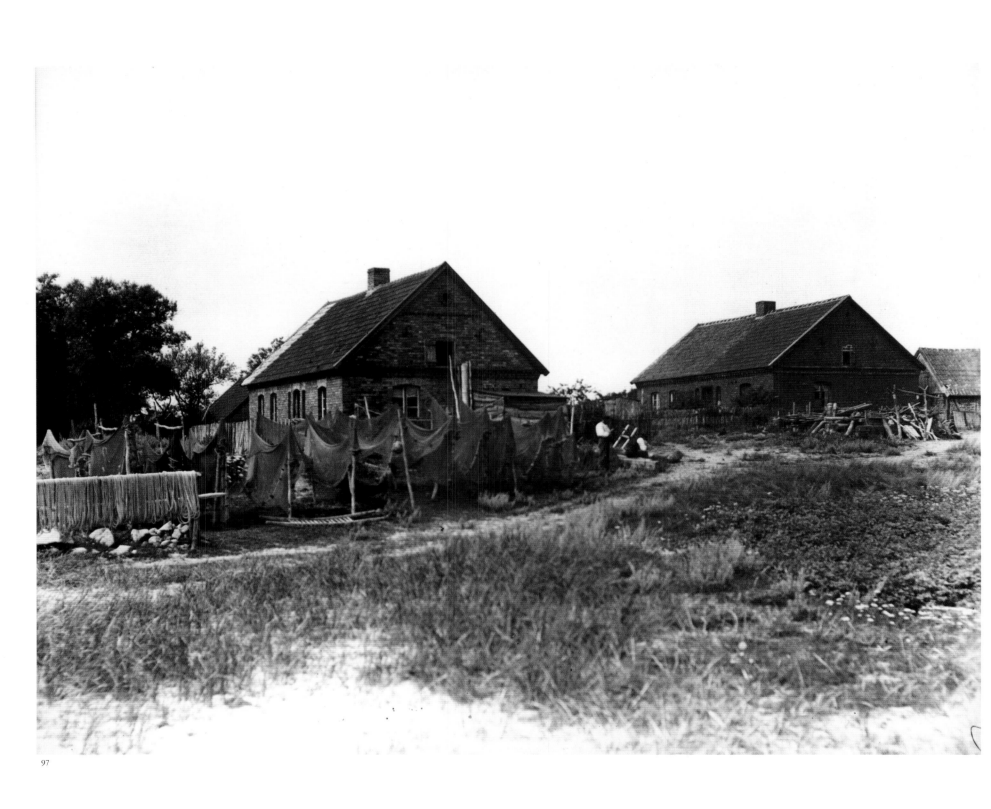

97

97. Fishermen's boats on the shore, nets are drying in front of the houses.

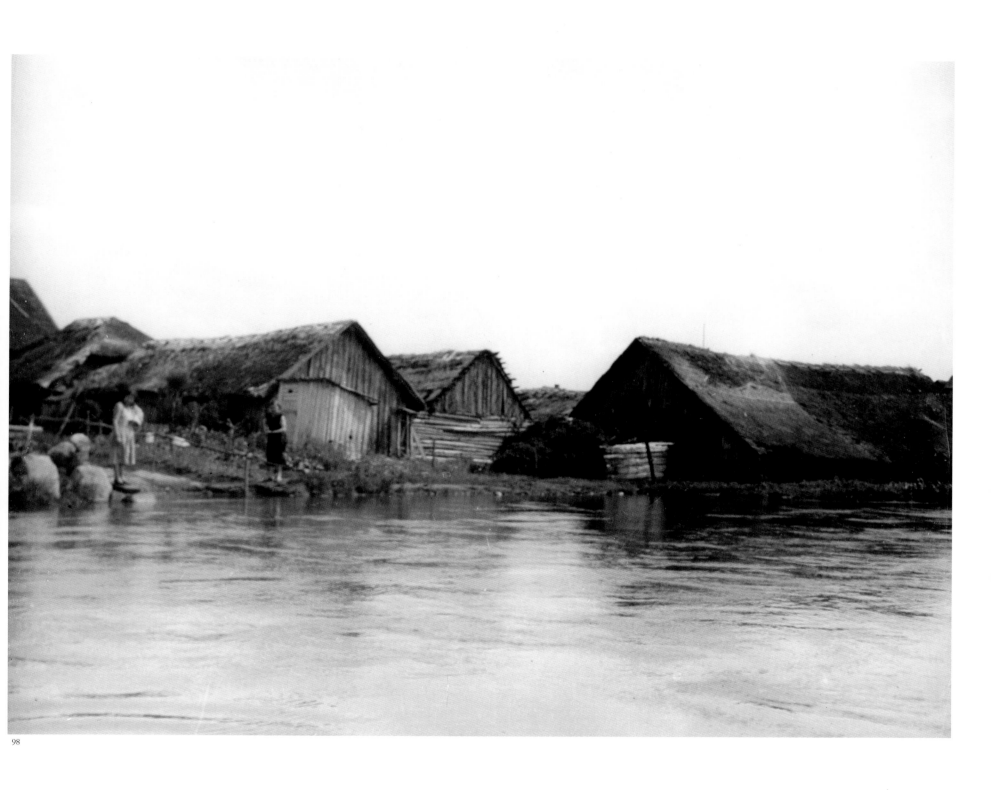

98

98. On the Drujka river, somewhere deep in the man-forsaken Vilnius Land there were also such
wooden buildings. The photograph emanates sadness and melancholy. Photo Wł. Grabski

# Town

Towns, localities, and helmets create this remembered and well fixed landscape of our country. Their genesis is in fact very similar. At first they were wooden castle-towns surrounded with earth and wooden ramparts and beside the castle-towns outbuildings where the servants lived were created. Commercial settlements were founded near communication tracts, river crossings, or on elevations, i.e. places easy to defend. When Christianity came, churches were built in castle-towns and outbuildings.

In the 13th and 14th centuries towns were founded in Poland in an organized way, with special privileges, for example in compliance with the Magdeburgian law. Their centre was made by a quadrilateral marketplace with straight streets leading from it, and further side streets leading from those. And so a regular urban lay-out was created. A parish church was raised next to the marketplace, and a town hall in the marketplace. Other churches of convent complexes were located a little bit away. The whole of it was encircled by defence walls, with some gates opening to transportation trails. And such a situation persisted throughout the whole Middle Ages.

Yet, people continued to flock to the town, so new suburbs were being built: houses spread outside the walls, towns grew bigger, new industrial plants were being built, and so were new settlements, whereas the old towns as if disappeared, shrank within agglomerations which were being constructed in a great number starting from the mid-19th century. The street arrangement changed, urban transportation developed, railway lines were introduced within town structures, which required broader and straighter streets. The inhabitants amounting already to hundreds of thousands filled in those human hives which continued to alter and enlarge. And finally, in the second half of the 20th century, our cities became surrounded by districts made of concrete blocks of flats, being very monotonous and, let us face it, ugly, grey, one very much like the other, so when wandering across a new residential district we can hardly distinguish if it is Warsaw, Łódź, Poznań or Kraków. And in town centres where life goes on without a stop, huge skyscrapers that disintegrate the old historic texture are raised.

Such is the historic imperative. One can hardly oppose it. But it is worth remembering that each old market-square, each old town is the town's nucleus, its historic heart and it is there that the town's beginnings are to be found.

Old photographs cannot be overestimated as for their importance in recalling old urban views. In them we can find houses and streets that we know, but also realise that everything used to look so much different, how different were the shops, advertisements, shop signs, people's clothing, cars, tramways, vehicles, and we may, perhaps, feel sentimental for a moment when we realise that hackney-coaches once used to be the main transportation means, and in winter sledges travelled along the streets which today are so busy and full of cars. All this is already in the past, so let us retain the memory of it, for those times will never come back.

99. Zamość ranks among unique urban complexes not only in Poland, but also in Europe. It was erected on the order of Jan Zamojski, Crown Commander-in-Chief, who commissioned the task to the architect brought from Italy Bernardo Morando. A town-fortress was built, with a regular street lay-out, beautiful town-hall, market-square, church, and the castle of the founder.

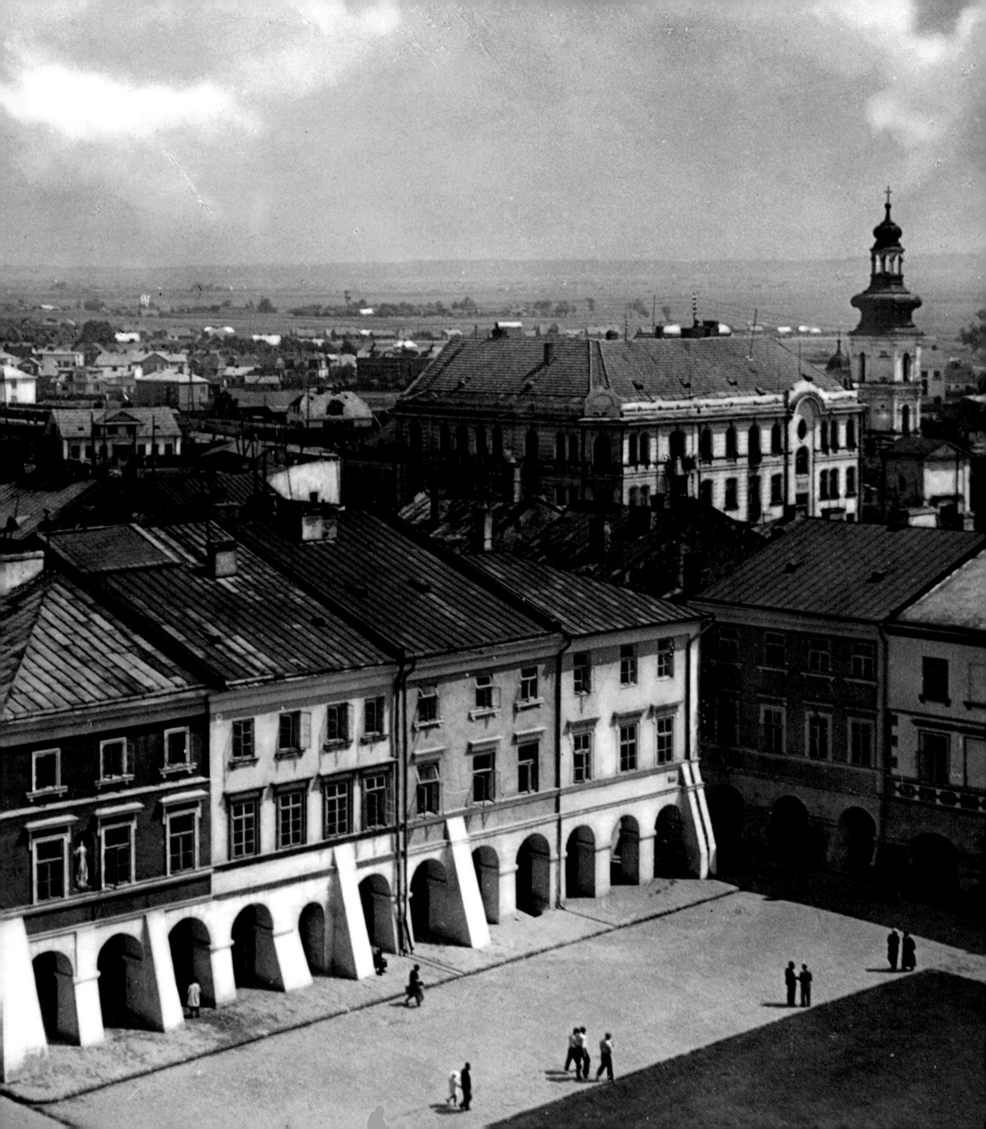

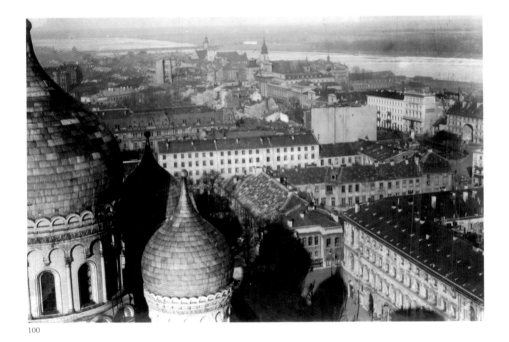

100

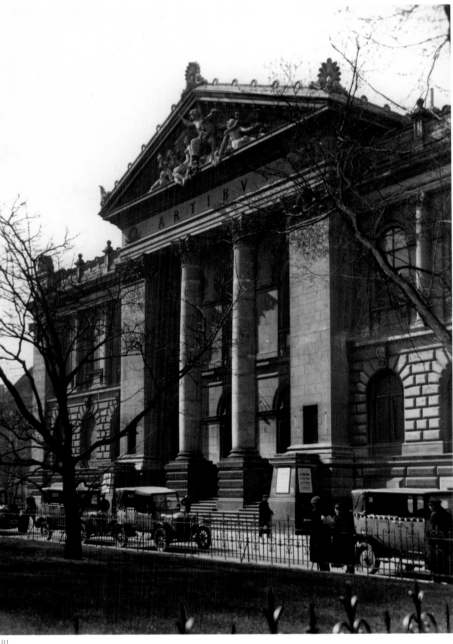

101

100. The cupolas of the huge Orthodox Church once raised on Saski Square in Warsaw, dominated not only over the square, but also over the whole centre of Warsaw.

101. The edifice of the Zachęta Gallery on Małachowskiego Square in Warsaw was built in 1898–1900 by the architect Stefan Szyller with the contribution of the Society for the Encouragement (Zachęta) of Fine Arts, active in 1860–1939, and bringing together artists and lovers of art. It was the major gallery in Warsaw. Actually, till today it continues to exhibit renown works of art by both Polish and foreign artists.

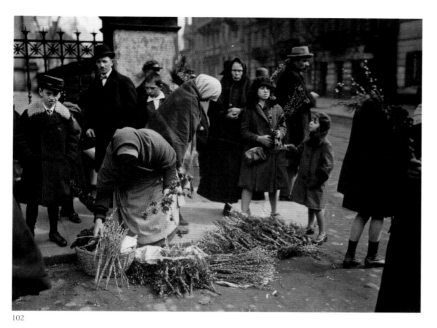

102

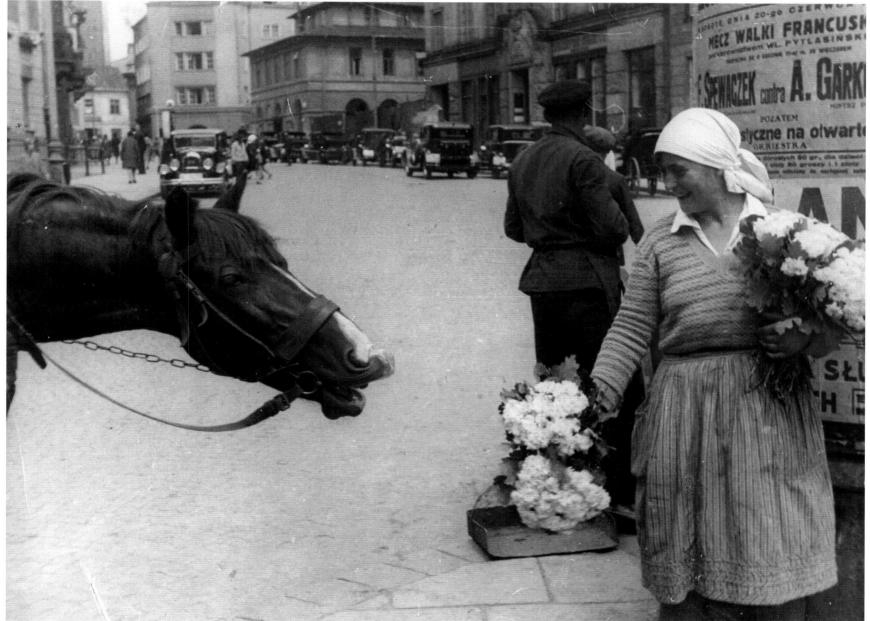

103

102. This must be Palm Sunday near one of the Warsaw churches. Country women are selling modest palms made of willow twigs and dried flowers. But which church was the picture taken at? Who would recognize the iron fence that goes round it? It is most likely gone, anyway, like so many other features of the old Warsaw.

103. What a lovely street scene! The hackney coach horse evidently took interest in a bunch of flowers that a Warsaw florist was holding. No wonder: the horse could smell a meadow and fresh grass. And all this was caught by a camera lens in Kopernika Street in 1931. This picture should have won the first prize in the first photographic show! Photo I. Jarmuski

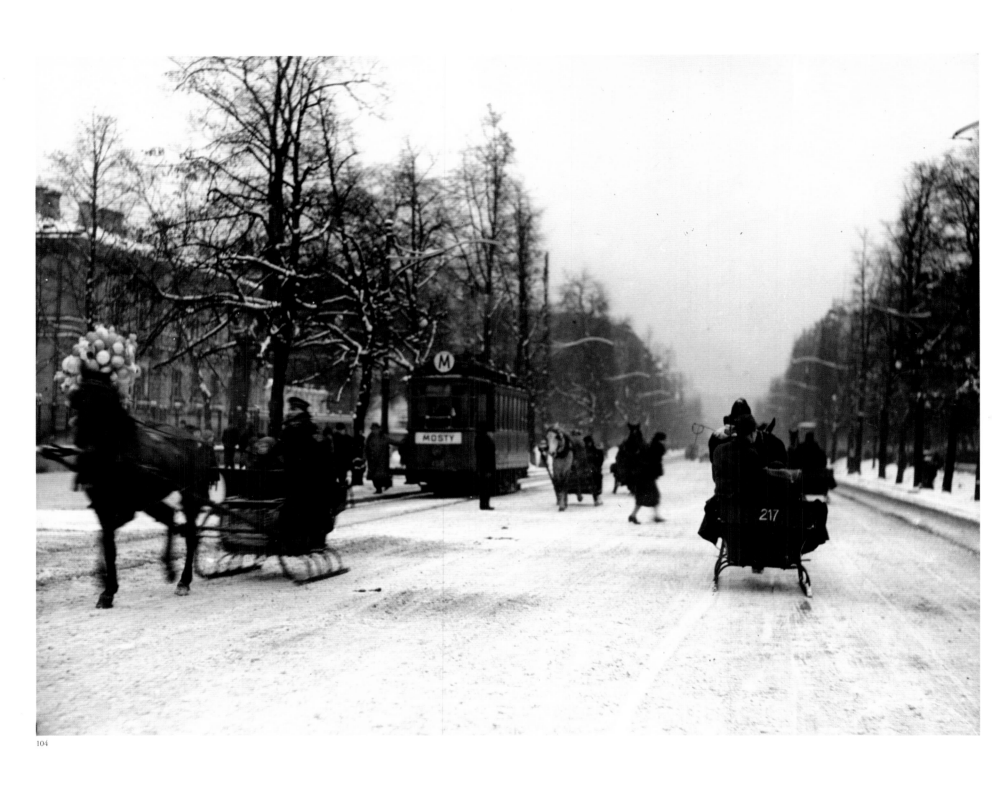

104

104. We, today's people, can hardly believe that what we see in this 1938 picture is Ujazdowskie Avenue in Warsaw. Everything is so calm, the street is covered with snow, and all along it only horse-drawn sledges. It is the same coachmen, who used to drive the hackney cart in the summer. Passengers, covered with a fur blanket, are seated in the sledges. There is only this old tramway that hints on the 20th century.

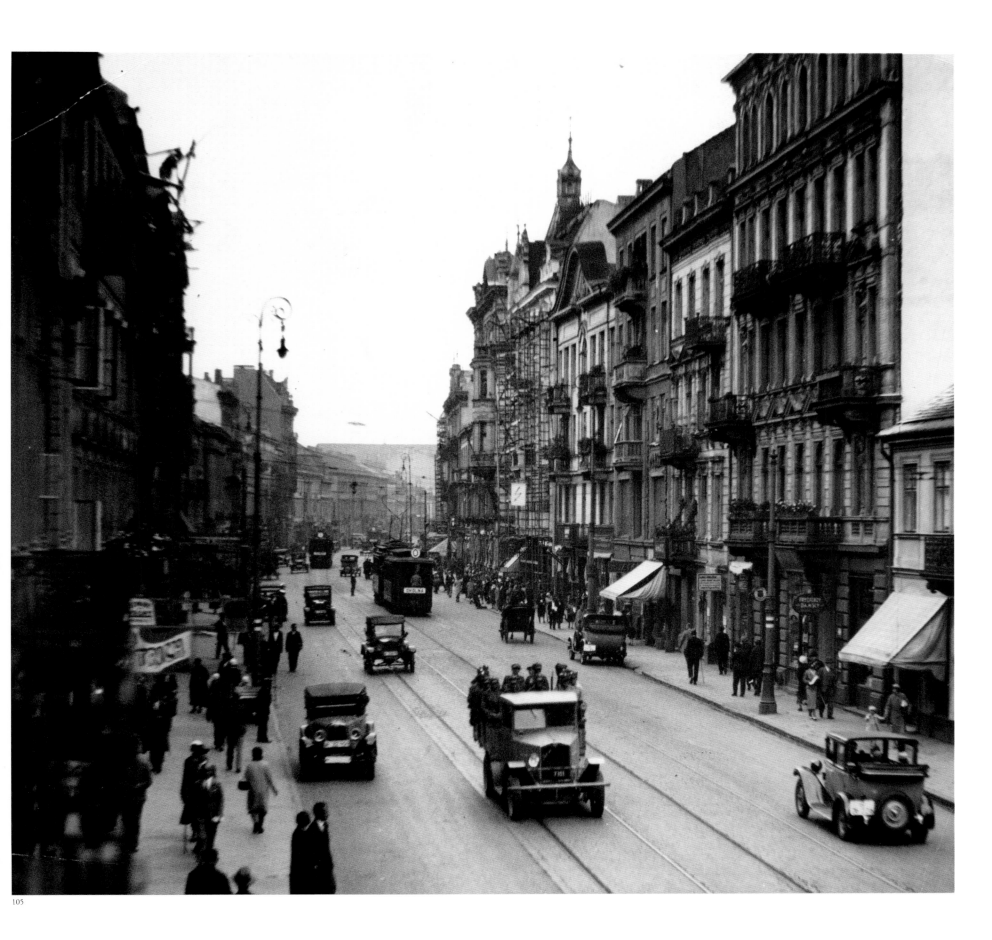

105

105. A wonderful, documentary photograph! This is what Nowy Świat Street used to look like before 1939. Destroyed during the last world war, and magnificently rebuilt after 1945, it refers with its present architecture to the views shown in the paintings by Bernardo Bellotto, called Canaletto, a painter working on the commissions of the last Polish King Stanislaus Augustus Poniatowski. Photo I. Jarumski

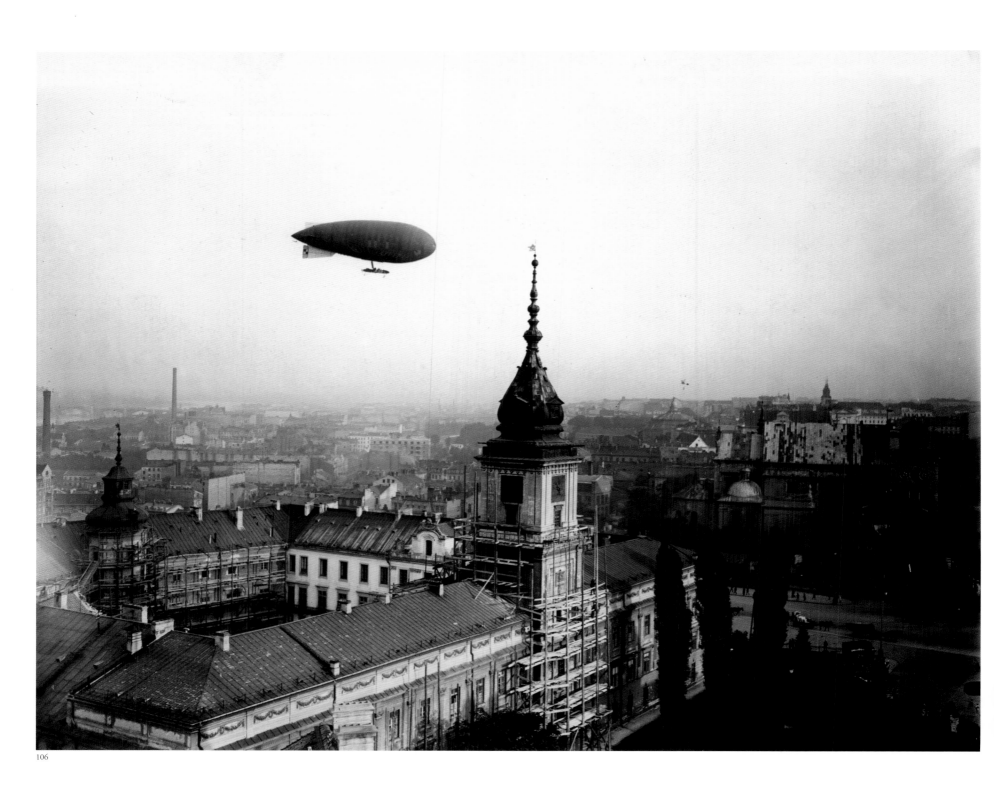

106.

106. Zamkowy Square in Warsaw, with the mass of the Royal Castle, St. Anne's Church, and the
view of the Powiśle District in the distance seems so much like today. However, if you take a closer
look, it will turn out that many things have changed. The Castle is no longer plastered today, there
are no more high poplar tress in front of it. There is no balustrade on the present W-Z Track,
for there is no track at all. Well. And it is difficult to see zeppelins floating above Warsaw today.

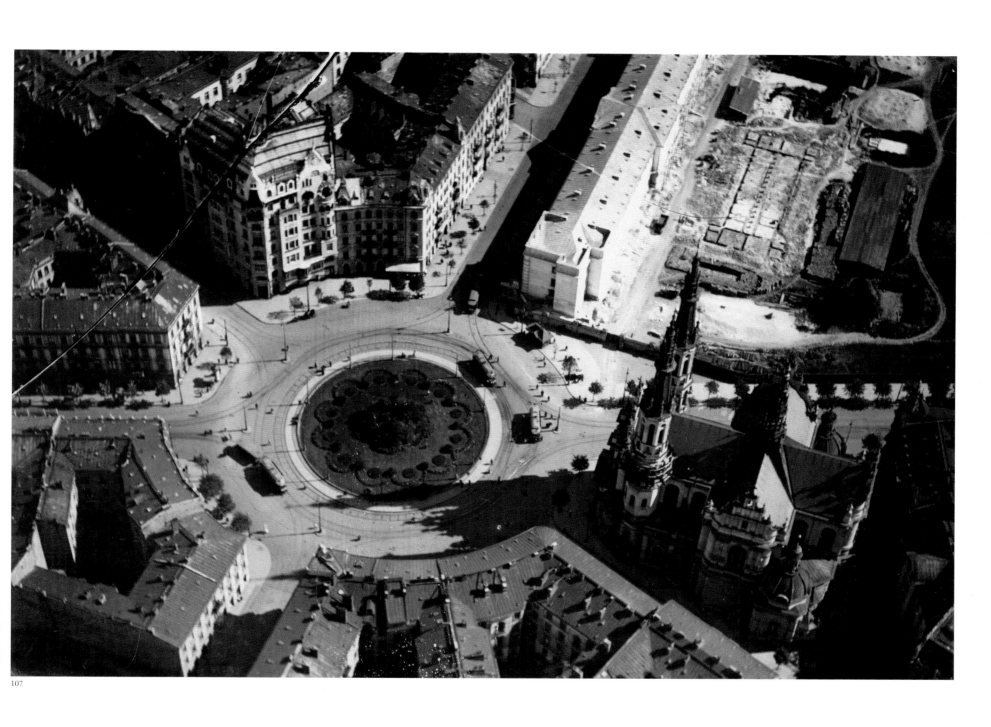

107

107. It seems that Zbawiciela Square in Warsaw, in this picture seen in the bird's eye perspective, has hardly changed since the pre-war years. But only because the urban lay-out has remained the same. However, once you take a closer look, you realize that this is not the same Warsaw any more!

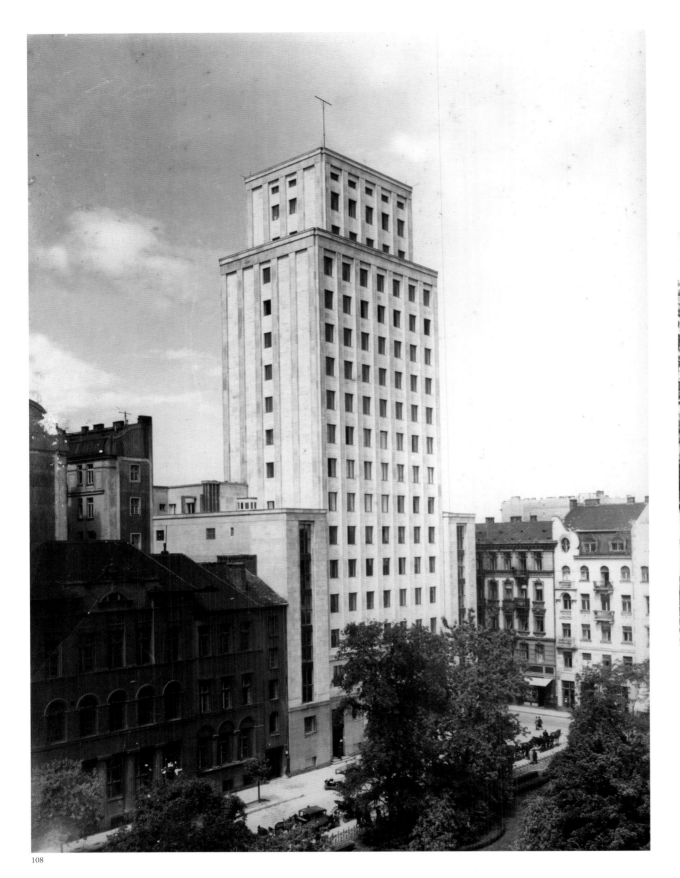

108

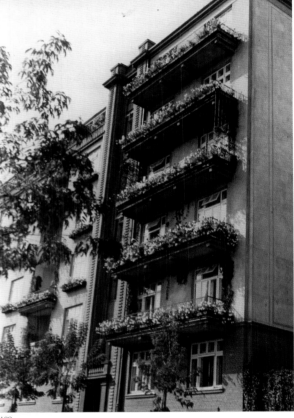

109

108. The 'Prudential' Insurance Society building on the corner of Napoleona and Świętokrzyska Streets had been the highest building in Warsaw before the Palace of Culture was raised. Simple in its form, in compliance with the then architectural concepts, it was raised in 1931–1933 after the design of Marcin Weinfeld and Prof. Stefan Bryła.

109. In the inter-war period Warsaw grew in modern architecture — they were not merely public buildings erected mainly in the centre, but also new residential houses, e.g. in the Mokotów and Żoliborz districts. Here is one example, a house in Willowa Street. Simple in its forms, of balanced proportions, it fits well in the surrounding architecture.

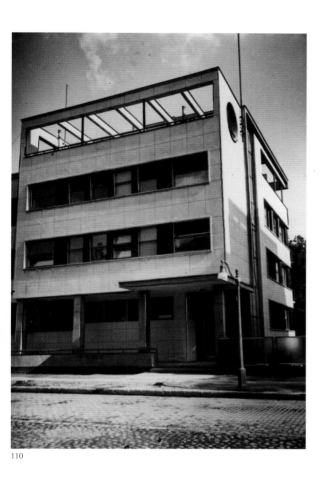

110

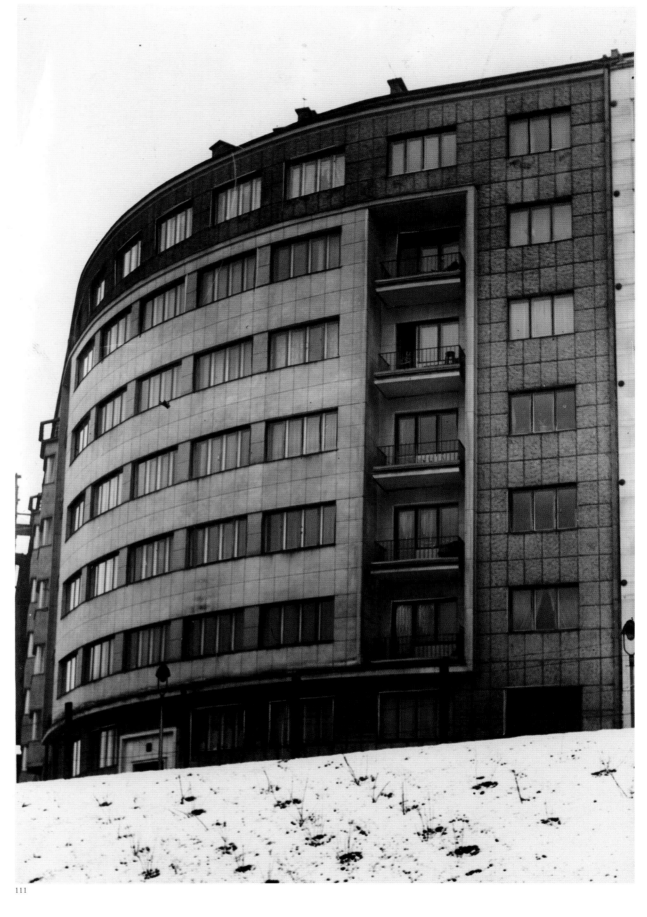

111

110. Frascati Street used to be quite an elitarian street in the inter-war period. At one point a road leading to the gardens of Prince Kazimierz Poniatowski, Great Chamberlain of the Crown, had cut through here. After the death of the last owner, namely Julia Branicka nee Potocki, the estate was split into smaller lots. It was then that the following streets: Frascati, Konopnickiej and Prusa were demarcated. Wealthy people would purchase the plots and the best architects of the times would raise town villas for them, like this one in the picture from 1938.

111. A modern functional residential building in Na Skarpie Avenue represents all the good qualities of residential housing that was created in this elitarian recesses in Warsaw by the end of the 1930s. No wonder — it was here that such architects as Bohdan Lachert, Bohdan Pniewski, Józef Szanajca, Józef Sigalin, who really left their mark in the history of Polish architecture, implemented their designs.

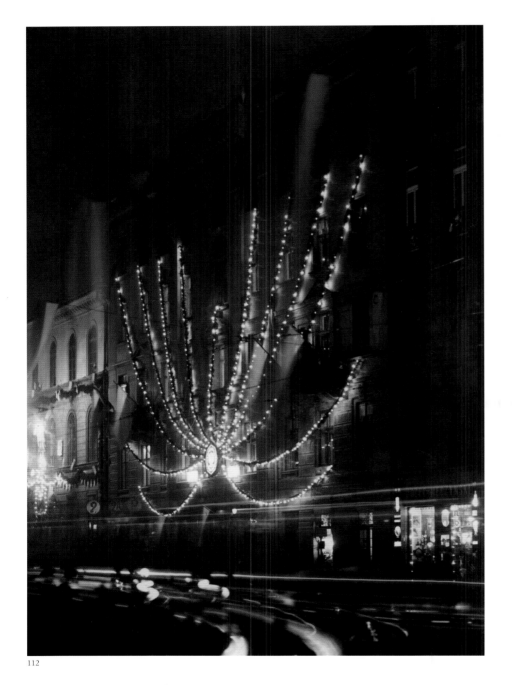

112

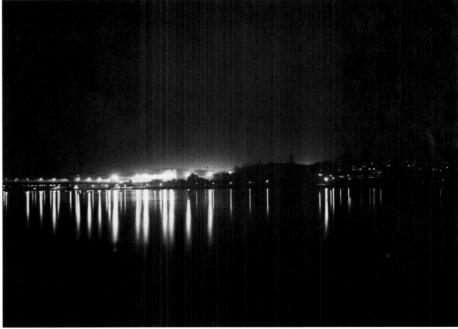

113

112. This is the way streets were decorated for Independence Day. In Nowy Świat Street in Warsaw an interesting decoration could be found on one of the buildings: a stylised national emblem, namely the eagle, was arranged from electric bulbs. Today, if seen against the colourful dazzling neons, the scenery might seem a bit poor, modest, but at that time it certainly did enchant the passers-by.

113. A night view of Warsaw from the side of the Praga District.

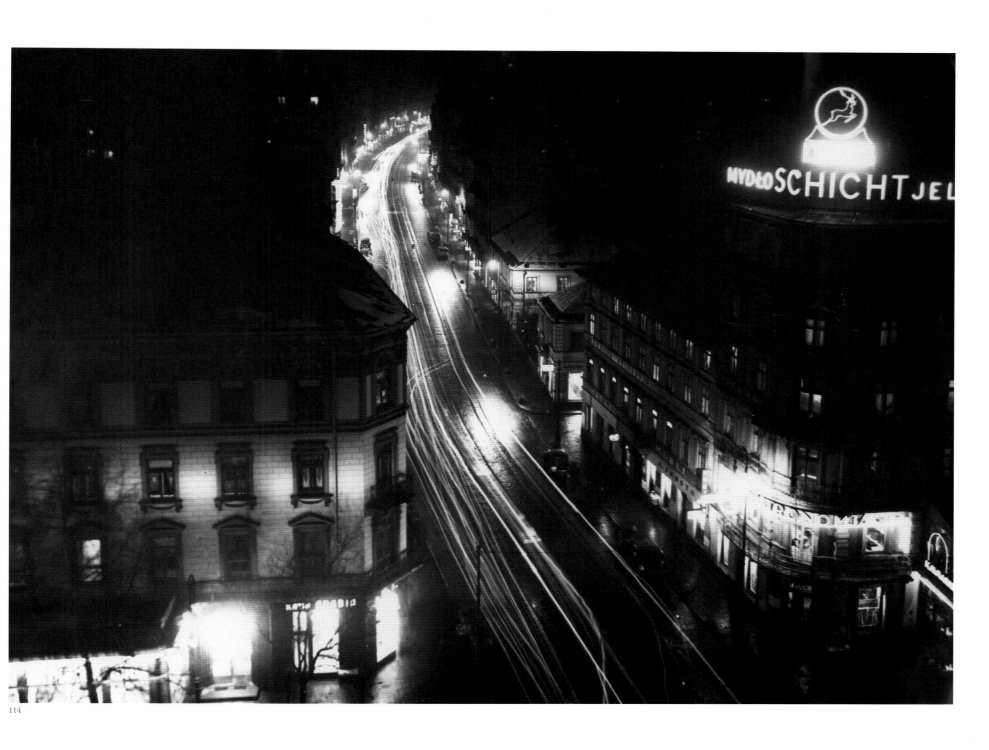

114. In 1934 Warsaw's Nowy Świat Street glittered with lights and neons. Photo J. Binek

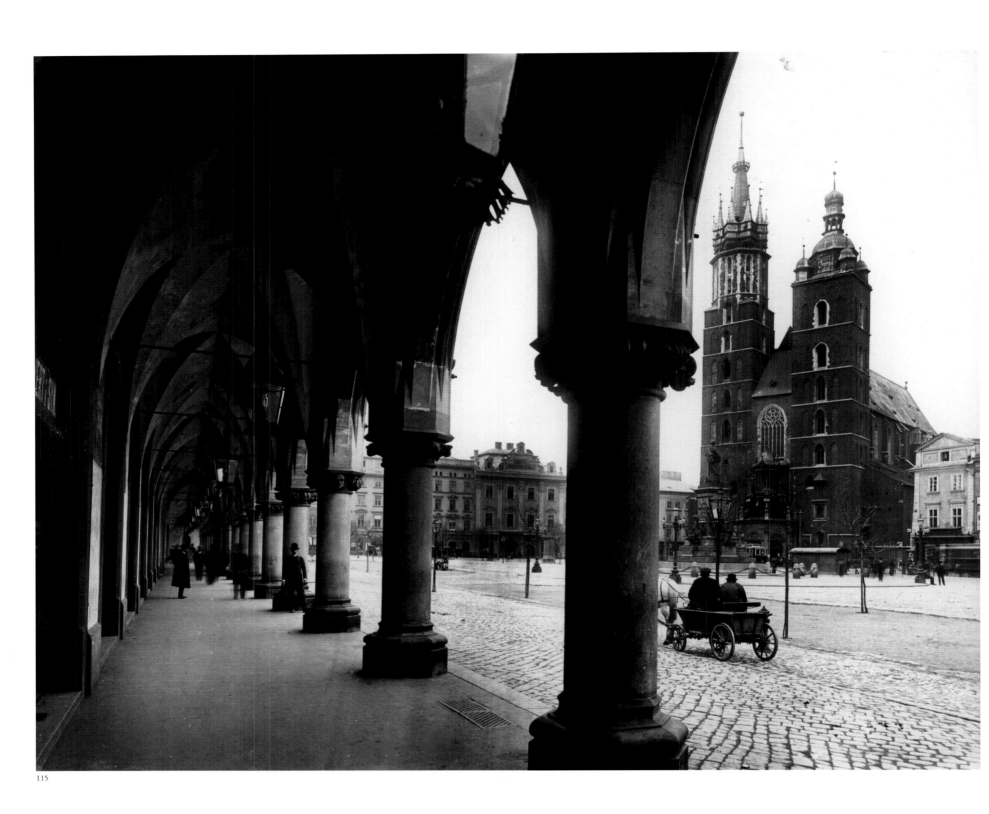

115

115. A walk under the arcades of Kraków's Cloth Hall, on the Main Market Square, was always a sort of an obligatory tour. From here the Marian Church looked excellent, and so did the town-houses; besides, one could always pop in to have a coffee at Noworoloski's Café, nick-name 'Noworol's', just like today.

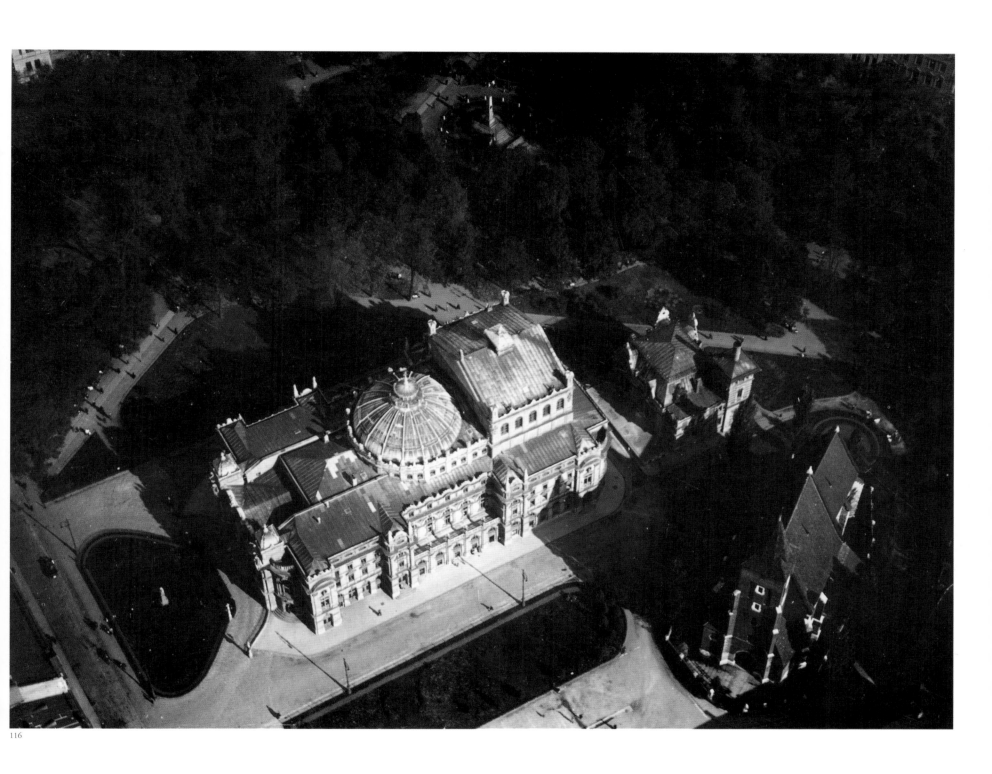

116

116. The Juliusz Słowacki Theatre in Kraków, formerly called the City Theatre, was inaugurated in 1893. This very characteristic building was designed by Jan Zawiejski. The picture, seen in bird's eye view, fully demonstrates the beauty of its architecture.

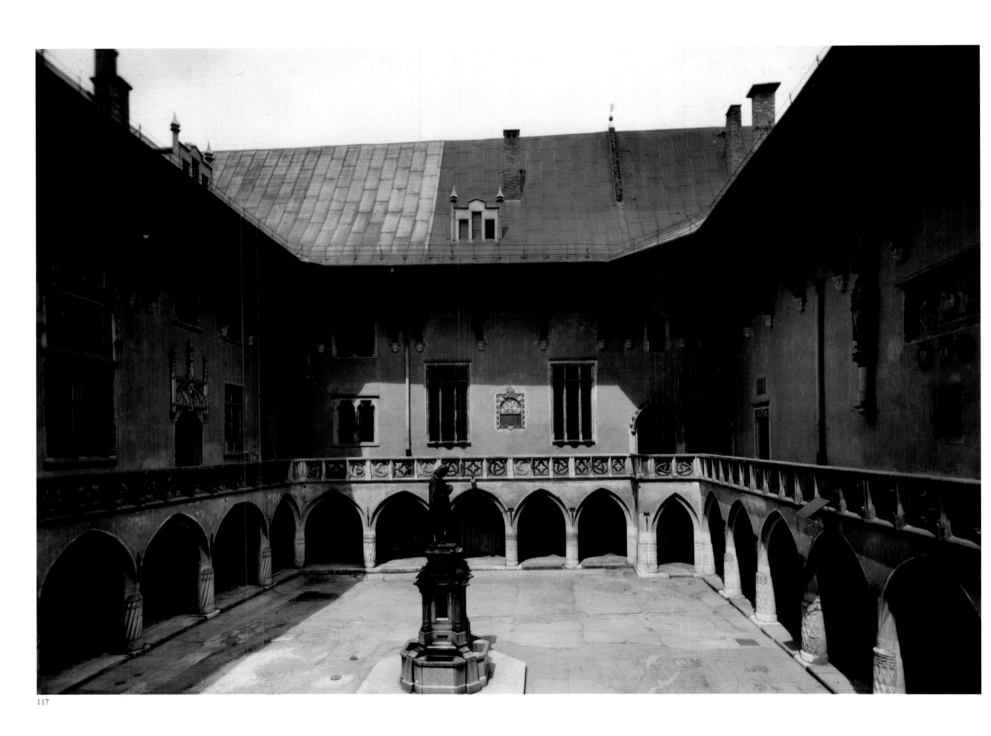

117

117. The Courtyard of the Collegium Maius in Kraków is one of the most perfect examples of late
Gothic art in Poland. A quadrilateral inner courtyard is surrounded by arcades with pointed arches.
The arcade columns are decorated with a stellar ornament.

118

119

118. The Collegium Maius of the Jagiellonian University, one of the oldest high education institutions in Europe, the first seat of Kraków's Academy established before the mid-15th century, was set up by bringing together some Gothic town-houses with some elements added.

119. Kraków. Collegium Novum, one of the major buildings of the Jagiellonian University.

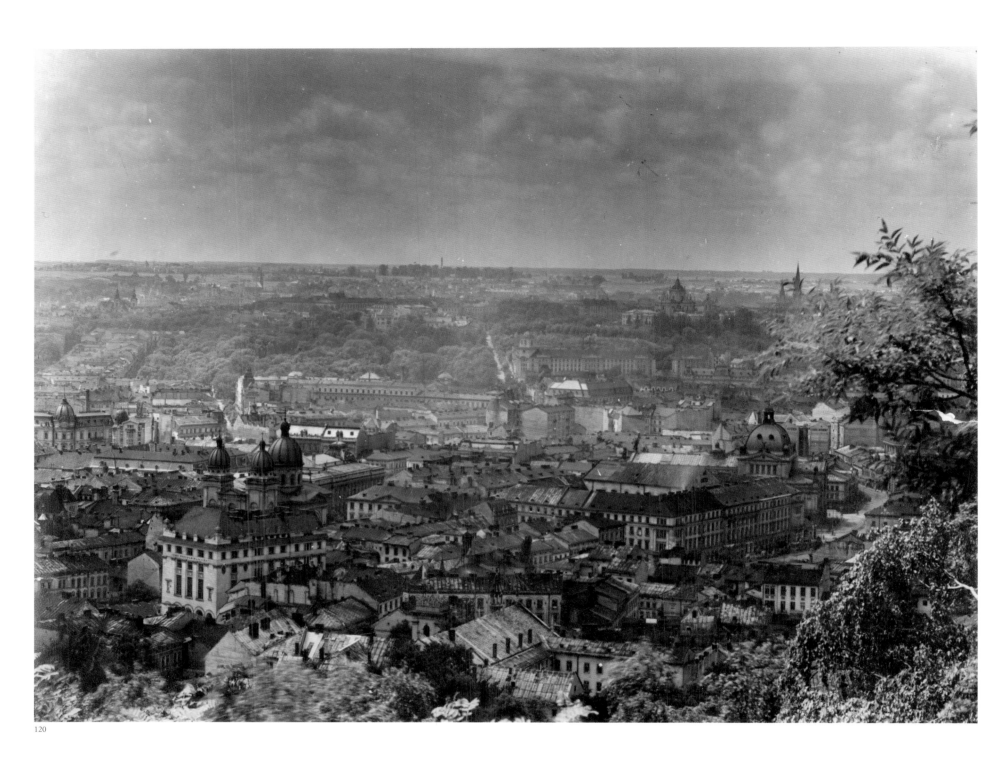

120

120. The panorama of Lviv from 1925. The city held an inherent position in our history. Founded in the 13th century, it belonged to the Crown starting from already 1349. The national mosaic of its inhabitants: Poles, Ruthenians, Ukrainians, Armenians, Jews, yielded a wonderful creative multiplicity. Lviv, faithful to Poland for centuries: 'semper fidelis', significantly contributed to the development of our culture, science, industry. It is also a great treasury of magnificent works of art, starting from Gothic, through the Baroque, until the 19th century.

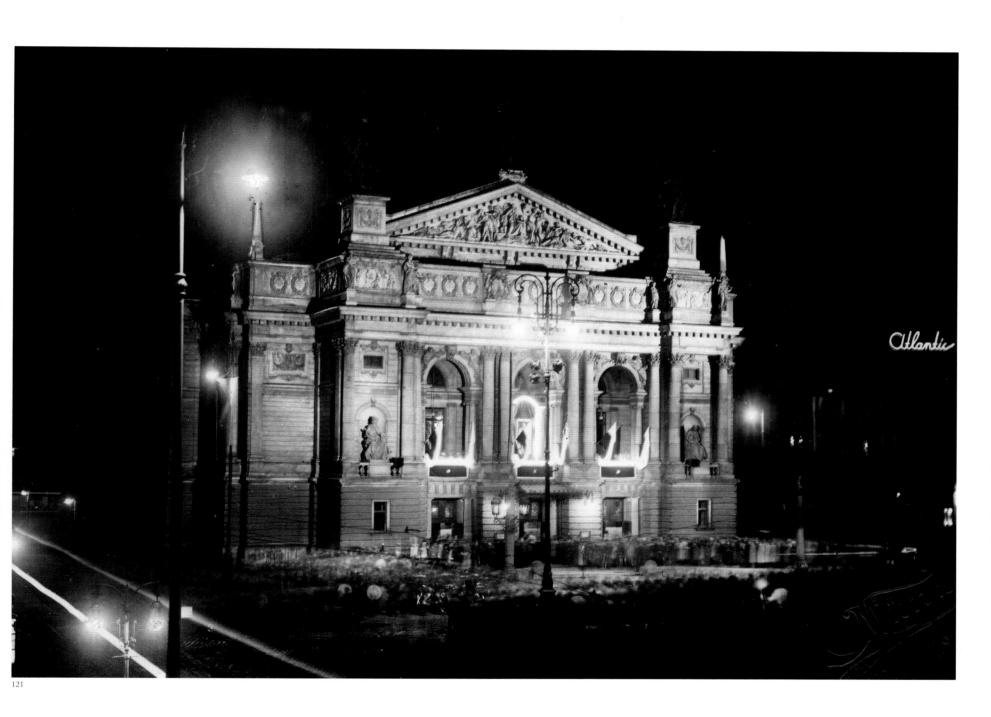

121

121. The Grand Theatre in Lviv is one of those buildings which have almost become the landmark of the city. An eclectic richly ornamented main façade, being a thoroughly conceived composition, places it among one of the most magnificent theatre buildings in this part of Europe. It was designed and erected by Zygmunt Gorgolewski in 1897–1900, and its interior was adorned by grand artists. The famous curtain is, for example, a work by Henryk Siemiradzki. Photo M. Münz

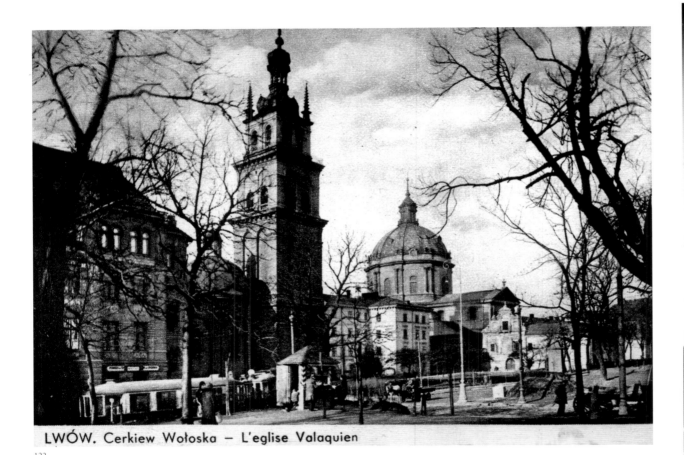

LWÓW. Cerkiew Wołoska – L'eglise Valaquien

122

123

122. Lviv is a city of wonderful works of architecture. The Orthodox Church called a Wołoska one, is among the particularly beautiful monuments. The first church, erected in 1559, was devoured by flames 12 years later. This Renaissance Orthodox Church, which is still there today, was raised in 1591–1629. Some really famous architects contributed to it, to name only a few Italians: Barbon of Padua, Paul Romanian. Their touch is clearly visible, since the church bears a lot of features of the Italian Renaissance architecture.

123. Once, in Liv, just like in other old towns, there was a Gothic-Renaissance town hall. Its tower, however, fell on the ground in 1829, and a painting has been preserved showing this event. The new town-hall was erected in 1835 after the design of Merkel and Treter; later one more storey was built on.

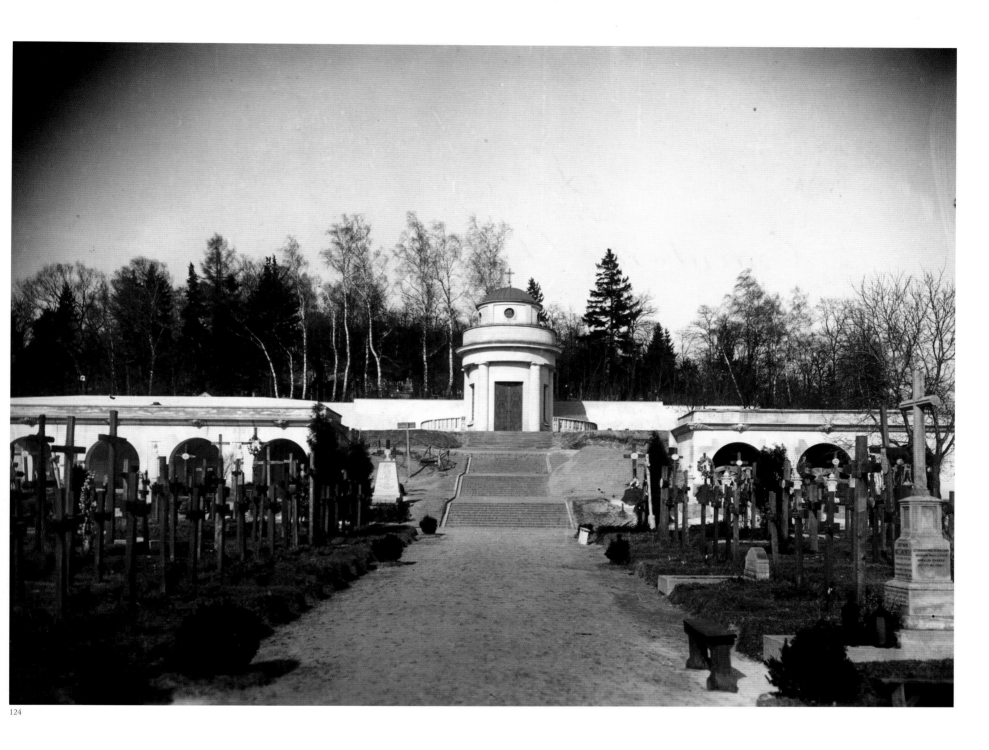

124

124. The Cemetery of the Defenders of Lviv was created in 1922. There the soldiers, or should we rather say, the youth, who fought against the Ukrainian troops to keep the city within the Polish boundaries were buried. The design of the cemetery was authored by Rudolf Indruch who, too, participated in the fights. It took quite a while to build, the original concept being altered a several times. Today the cemetery has been renovated a bit and is no longer such a ruin. Photo M. Münz

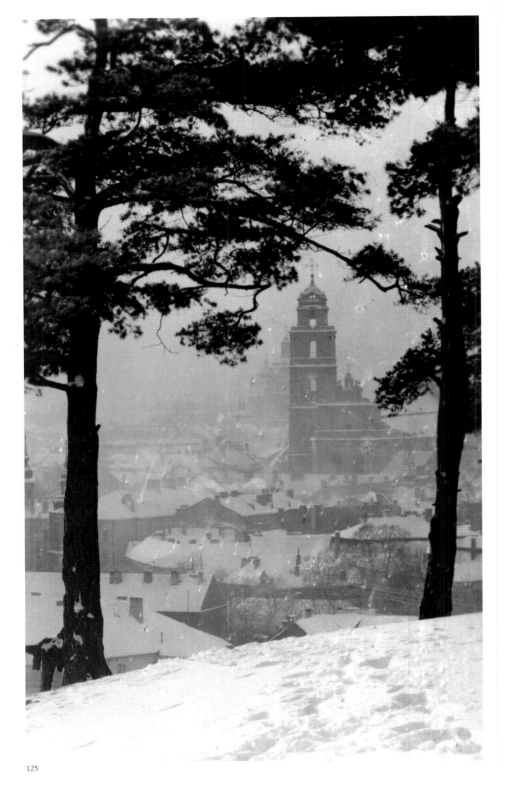

125

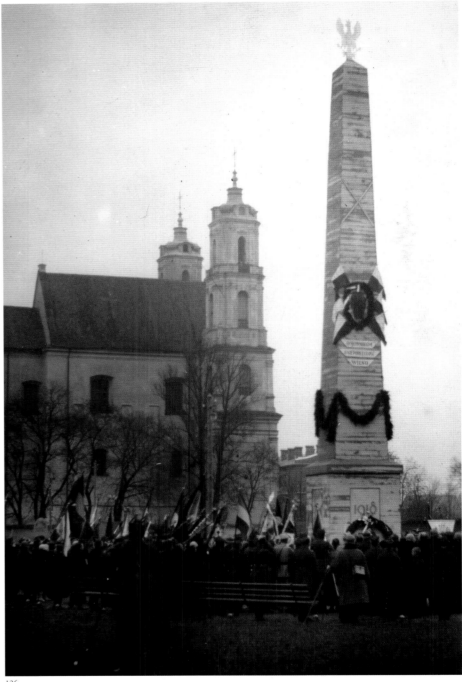

126

125. Vilnius, a view of the Hill of Three Crosses. In this part of the town what stands out is the parish church of St. John, also magnificent, originally Gothic, altered in the Baroque. Photo W. Żyliński

126. Łukiski Square in Vilnius has a few stages of its history. After the January Insurrection, a Russian Governor General Muraviev, commonly denominated as a Hangman, chose this very place for the execution of the Insurgence leaders. In the inter-war period it was also here that the famous Kaziukas fairs were held. The recent past has been remembered by an obelisk commemorating the defenders of Vilnius. Photo W. Żyliński

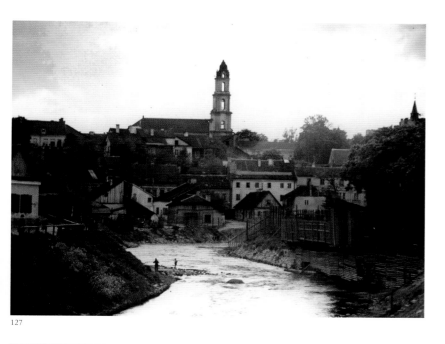

127

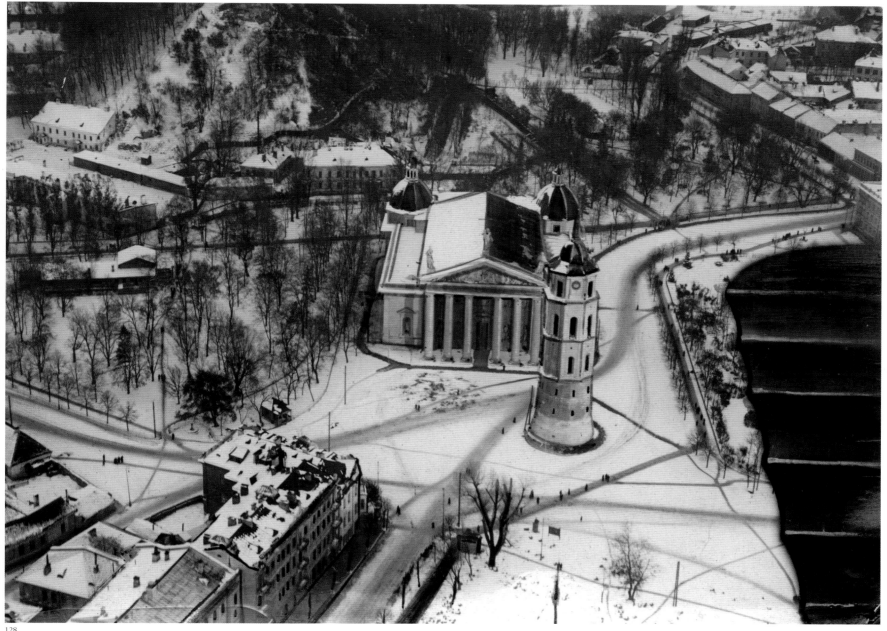

128

127. This is a fragment of Vilnius less known by the tourists, though it is located next to the Old Town. Little houses of the Safianiki district have perched on the rapid waters of the Vilenka River. As today's historian claim, and possibly in a well-grounded way, this was the part of town once inhabited by the craftsmen making morocco leather which was in great demand ('morocco' in Polish resembled the sound of the name of the district).

128. Does not the Vilnius Cathedral together with a bell-tower standing nearby look great in bird's eye view? The present architectonic form, perfectly Neo-Classicist, was bestowed on in by the Vilnius architect Wawrzyniec Gucewicz (1753–1798). The walls of the Cathedral are, in fact, far older, since they date back to the Middle Ages, and the lofty bell-tower was once a defensive tower by the Lower Castle (at that time it was not naturally so high).

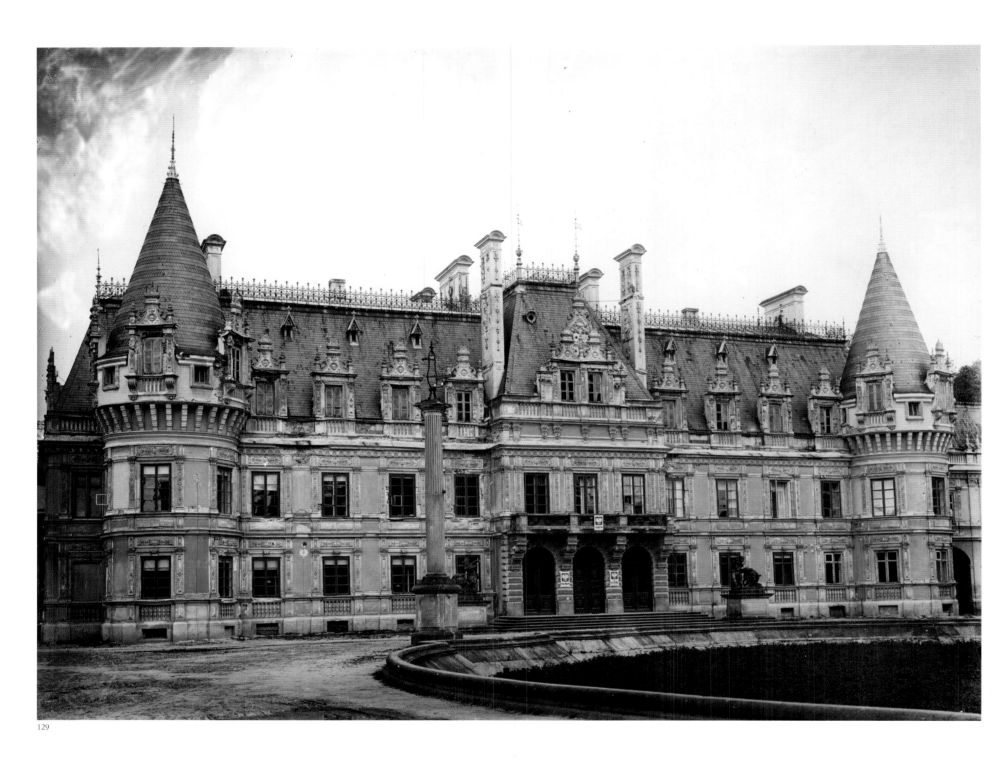

129.

129. Kozienice was once a small settlement in a great forest where Polish kings used to hunt. It was here that in a manor, almost certainly wooden at the time. Sigismund, later called the First or the Old, was born. Some centuries later king Stanislaus Augustus Poniatowski made a sumptuous palace be built here. By the end of the 19th century the old edifice was demolished, and only the beautiful wings of the outbuildings were left, whereas a new building in the so-called historical style, imitating French Renaissance, was raised.

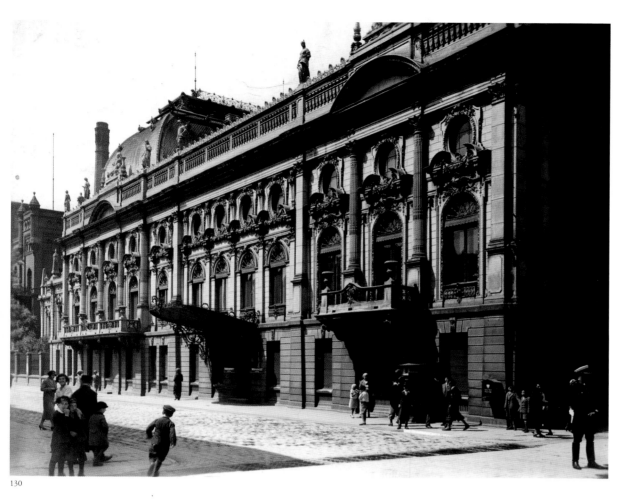

130

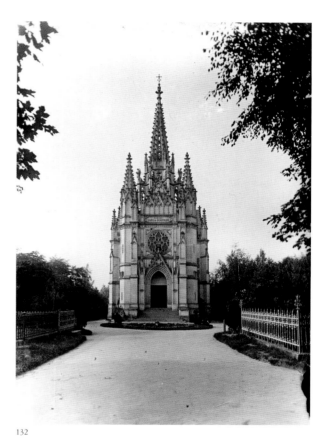

132

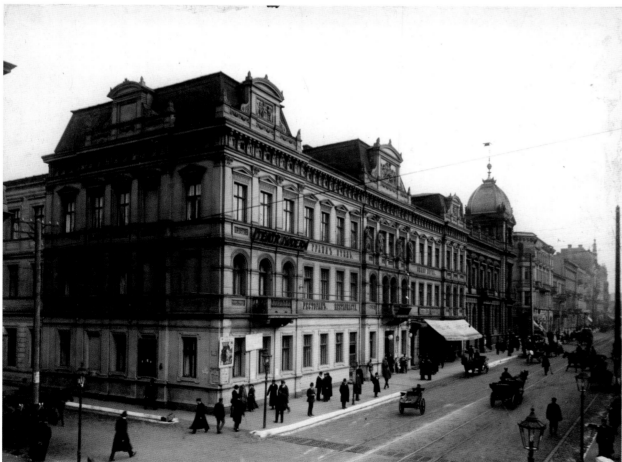

131

130. In the 19<sup>th</sup> century the great fortunes of the Łódź rich would be built over two or three generations. Kalman Poznański came to Łódź in 1834 as a stall-keeper. His son Israel was already a rich man doing business in cotton with almost all Russia. This is the family who had a glorious eclectic palace built with some Art Nouveau ornaments at 15 Ogrodowa Street.

131. The Grand Hotel in Piotrkowska Street in Łódź was highly renowned, so no wonder that it was being visited by illustrious guests. Built by Ludwik Meyer in 1887–1889, more strictly speaking it was turned into a hotel from an old factory building. Naturally, only the main walls could be used. The rest is already the decorative elevation of the hotel.

132. In the old Evangelical cemetery there is the mausoleum of the Schleiblers, a rich family of Łódź industrialists, owners of a cotton factory. A slender, delicate Neo-Gothic building impresses one with its form and decoration. It was raised after the design of Edward Lilpop and Józef Dziekoński in 1885–1888.

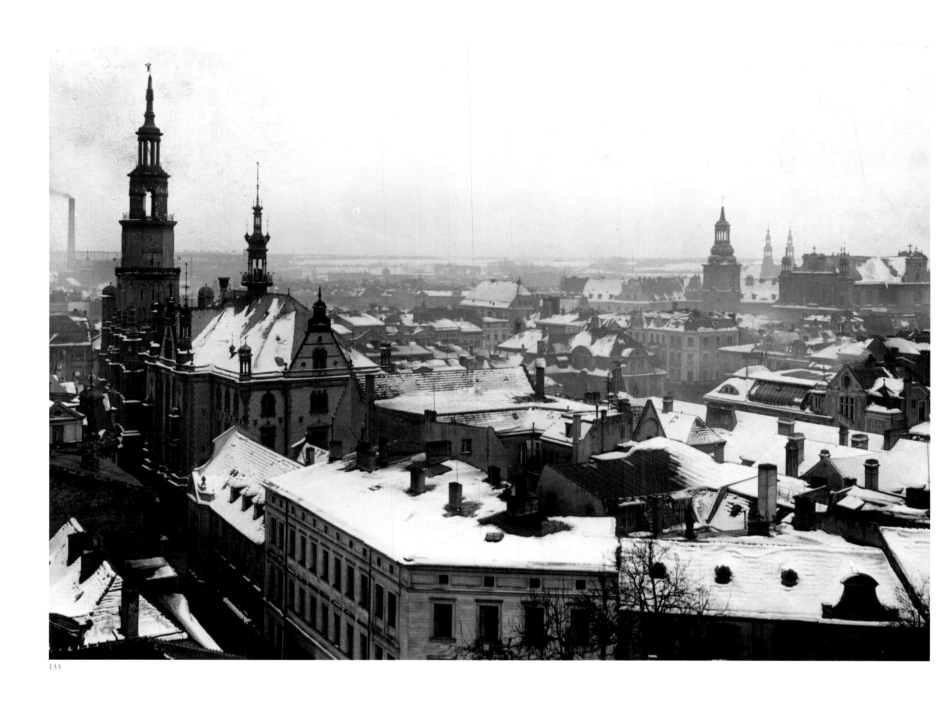

133

133. The Old Town in Poznań. The market-square surrounded by town houses,
a magnificent Renaissance Town Hall raised in 1550–1560 by the Italian architect
Giovanni Baptista di Quadro, all these form a monumental complex of high quality.
The photograph from 1929 shows us this fragment of the town before its renovation
which restored the old Renaissance and Baroque character. Photo R.S. Ulatowski

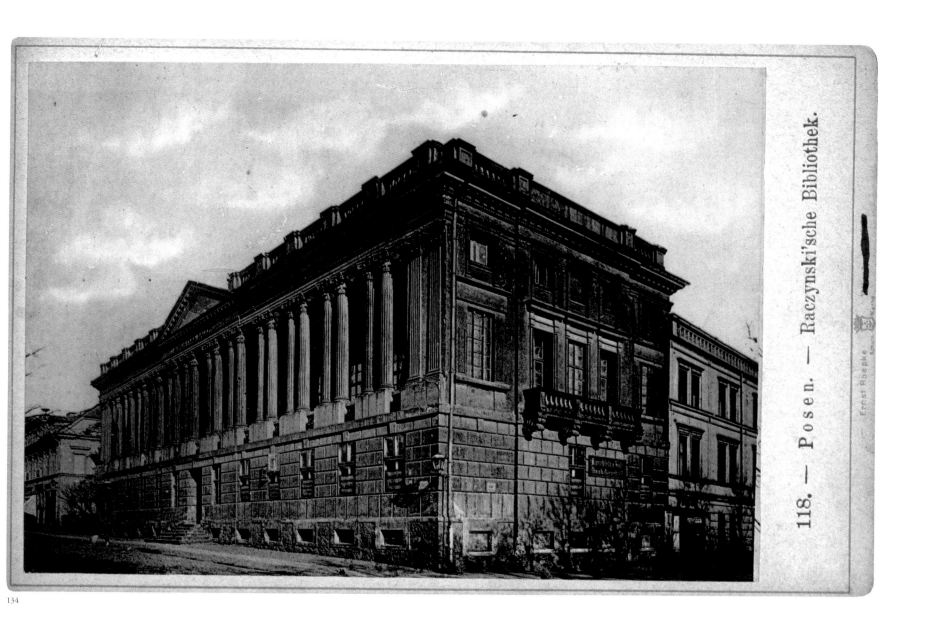

134

118. — Posen. — Raczynski'sche Bibliothek.

134. The Raczyński Library edifice on Wolności Square in Poznań has become a landmark of the city. Founded by Edward Raczyński, the Library was inaugurated on May 5, 1829. It is a historical monument, in Neo-Classical style, decorated with a row of cast-iron columns being the first-floor ornament. Currently, the Library houses special collections, old prints, illuminated books, and maps. This picture was taken in the memorable year 1918. Photo E. Roepke

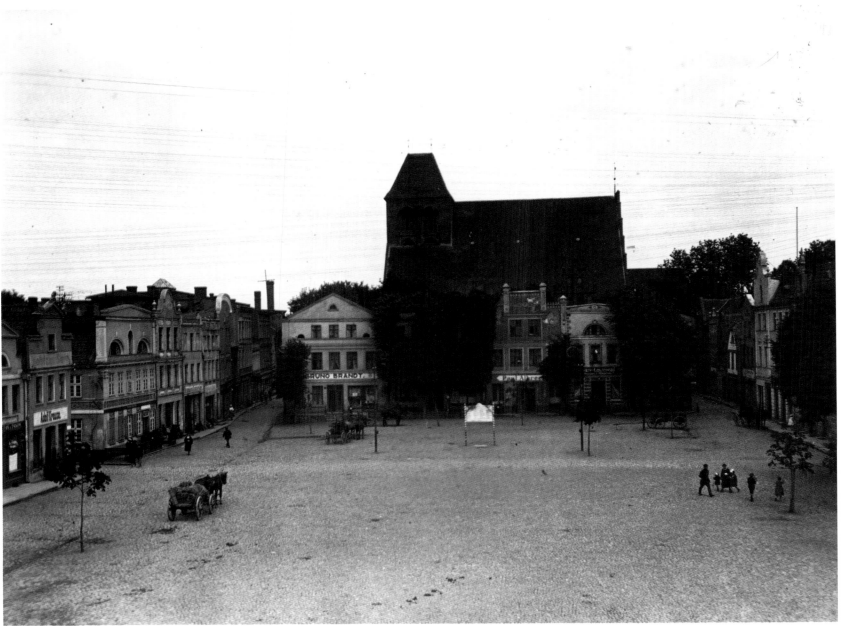

135

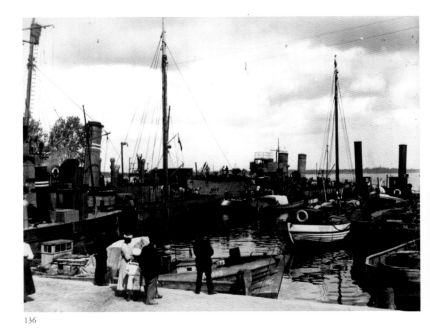

136

135. Puck, a town on the Bay of Gdańsk, presently known as a holiday place, spa, fishing port. However, it boasts of long history. At one time Puck belonged to the Dukes of Gdańsk. Already in the 13th century a parish church was raised here, whereas under the Vasas it housed a port for the Polish navy. On February 10, 1920 it was in Puck that Poland wedded the sea. The ceremony was carried out by Gen. Józef Haller who threw a ring into the waves. Photo Z. Marcinkowski

136. Over half a century ago the port in Puck was not very impressive. Into it there came only fishing boats and tugboats. Still, one could sense here a true flavour of the life on sea. Photo Z. Marcinkowski

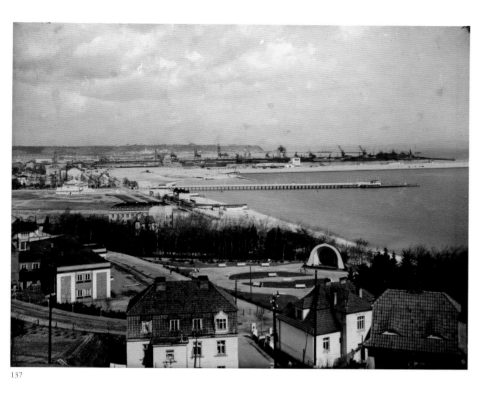

137

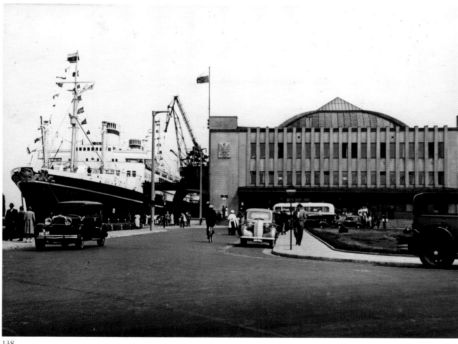

138

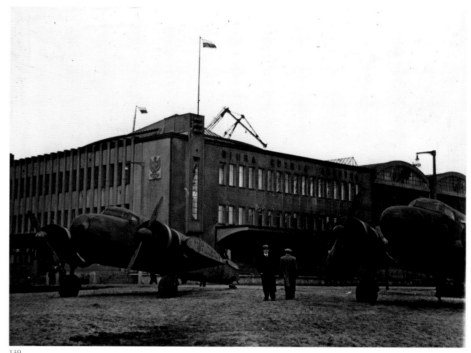

139

137. Gdynia was one of the most significant achievements of Poland in the inter-war period. In the place of a fishing village, on the decision of the Polish government, the construction of a port and town started in 1921. Eugeniusz Kwiatkowski (1888–1974), a great propagator of this project and who truly contributed to its implementation.

138. The significance and development of Gdynia can be best testified by a perfectly designed sea port (built in 1933). From here passenger boats embarked on their cruise to the ports of Europe and the United States of America. The photographer caught the 'Pilsudski' passenger boat at dock.

139. Harbour buildings in Gdynia. Beginning of the 1930s.

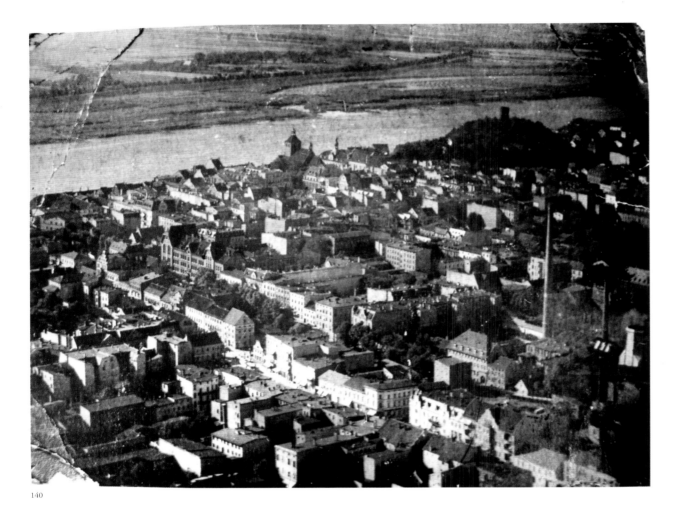

140

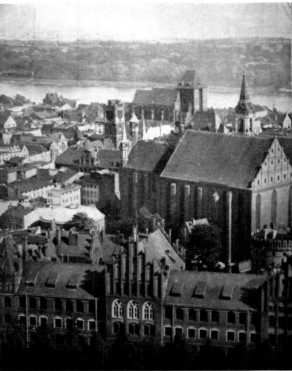

141

140. Grudziądz can trace its settlement records really far back. There was a castle-town here already in the 10th century, of which the first mention comes from 1218. Located on a river, it has fully related its life to the river. Until today, 17th- and 18th-century granaries have been preserved by the old town walls; it was there that goods transported along the river were stored, for trade was precisely the source of town's prosperity.

141. Toruń, founded by the Knights of the Cross in 1230, was the town of Nicolaus Copernicus and it was also a beautiful castle-town fitted within the course of the Vistula.

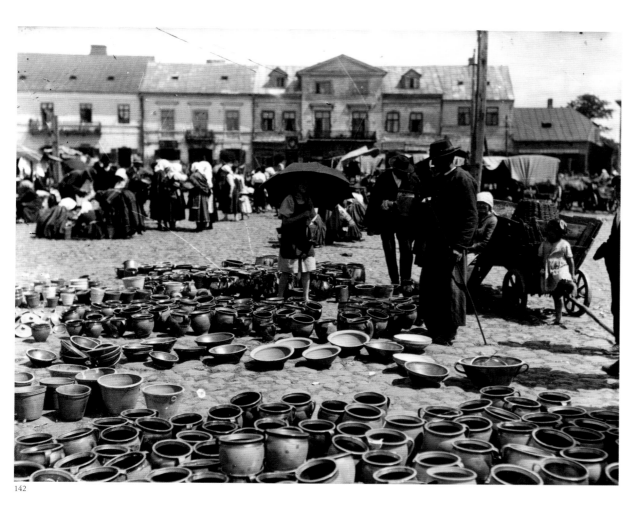

142

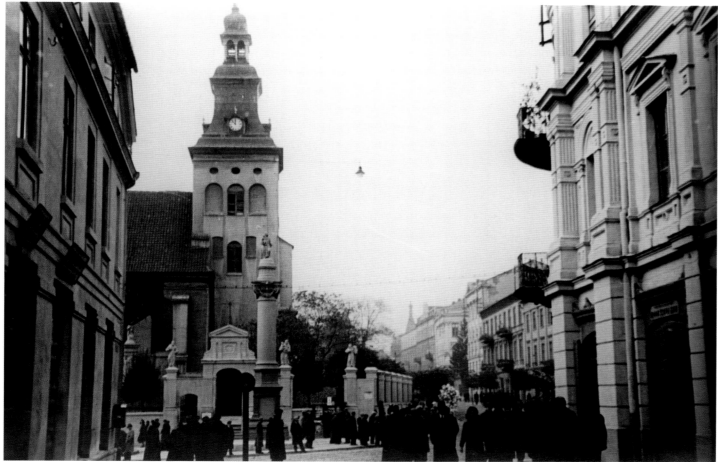

143

142. The market-square is filled on a market day with clay pots: they were once generally used dishes. Łowicz itself is a historical town full of beautiful buildings. It was established in the 12ᵗʰ century and for hundreds of years served as the residence of the Gniezno archbishops. There was once a castle here for the Primate of Poland to reside in; he was the first person in the country after the king. During the interregnum period he was the highest authority. Photo Z. Marcinkowski

143. Church of the Elevation of the Cross and the Bernardine Convent today rank among the most precious monuments of Piotrków Trybunalski, a charming town of extremely interesting history. An early Baroque complex was erected in 1626–1642 to be altered in the third quarter of the 17ᵗʰ century. A magnificent Baroque interior has been preserved until today.

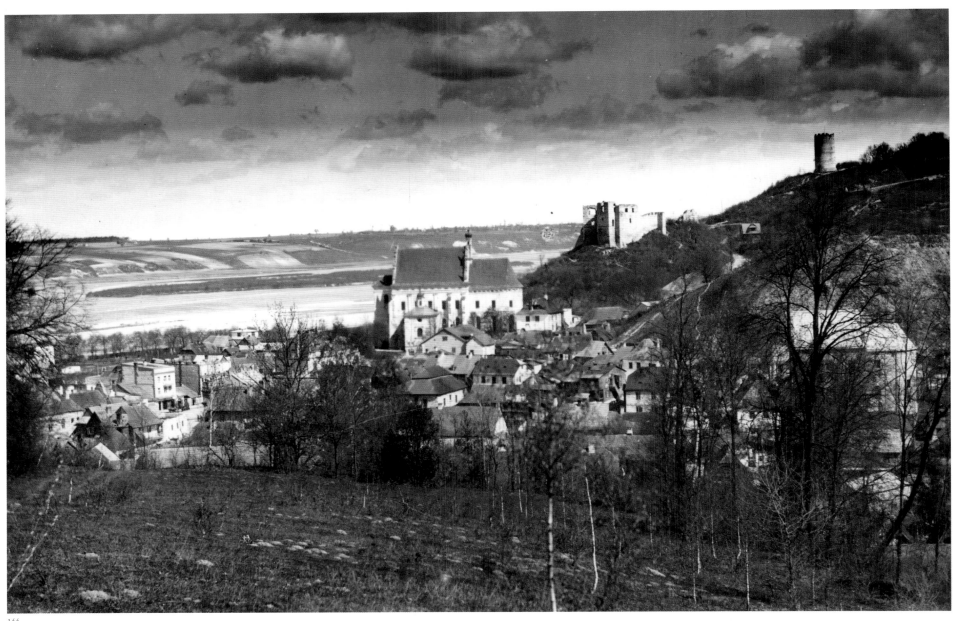

144

144. Kazimierz Dolny became a mecca for Polish painters, writers, and the whole of the artistic bohemia already in the inter-war period. This is the place where one was supposed to be seen, this is the place where one was obliged to paint landscape, discuss things. Yet, the town can boast of a far longer history. It owes its name to the son of Vladislaus the Short, namely Casimir the Great. Located on the Vistula, and thus placed on an important waterway, the town made its living on trade.

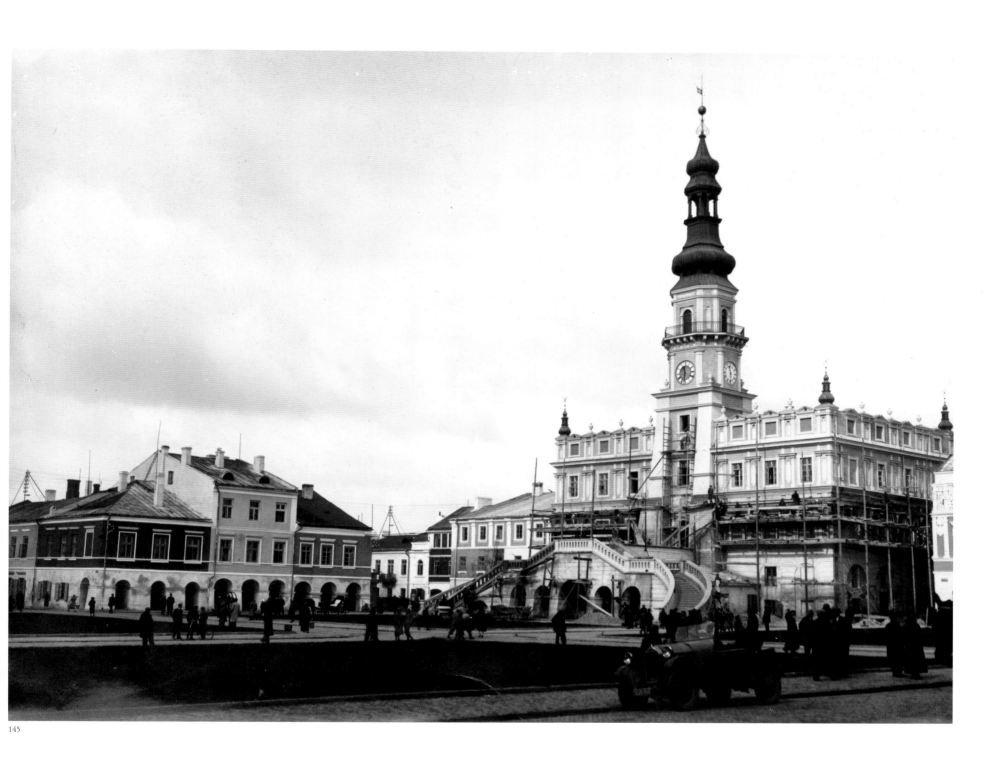

145

145. The Town Hall in Zamość with its lofty tower dominates over the Old Town. It was raised in 1591–1600 by the designer of the lay-out of the whole town complex Bernardo Morando. In later years, mainly in the 18th century, it was significantly altered: the tower was elevated and covered with a new Baroque cupola, a new monumental staircase was added. Until today the Town Hall has remained town's major landmark.

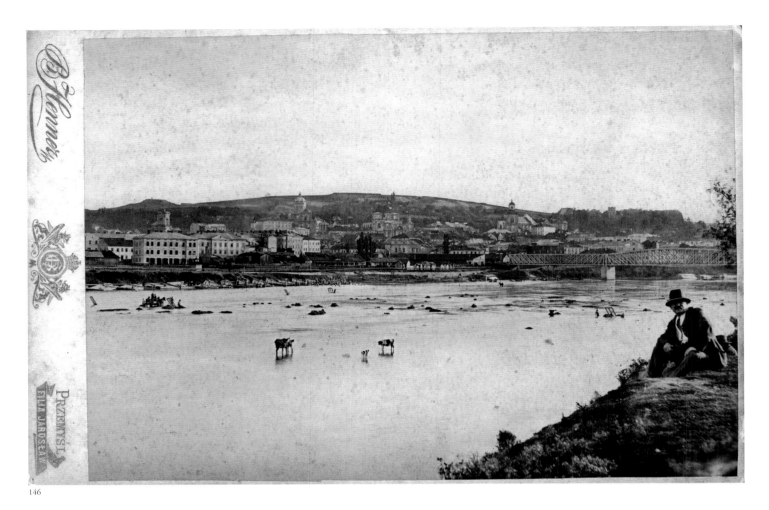

146

147

146. Located on the San river, Przemyśl's Old Town looks magnificent from the side of Zasań. When this picture was taken, nothing spoilt the panorama.

147. Przemyśl is one of the oldest towns in Poland, located along the trade trail leading from Kraków to Kiev. It is mentioned already in 981 in *Nestor's Chronicle*: "And so Vladimir went towards the Poles and conquered their castle-towns: Przemyśl and Czerwień". It is a city beautifully fitted in landscape, full of charming streets and recesses, and of perfect architectural monuments.

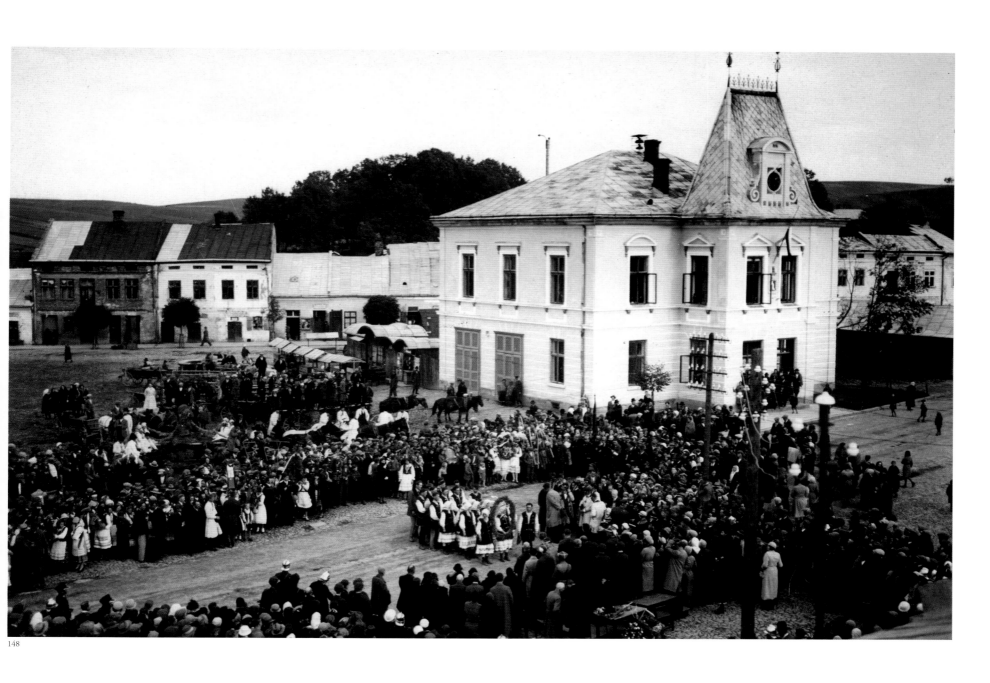

148

148. Lesko, a little town on the San river, has retained its character over the centuries. Once a property of the wealthy Kmita family, who erected a castle here, today it is a gate leading tourists into the Bieszczady Mountains. Its monuments, like the synagogues, a unique Jewish cemetery, and beautiful landscape, all attract tourists. In the inter-war period this was merely a sleepy Galician little town and this kind of aura has survived amidst the old buildings. The author of the photograph, J. Krzywowiąza, caught the harvest festival rituals taking place in Lesko.

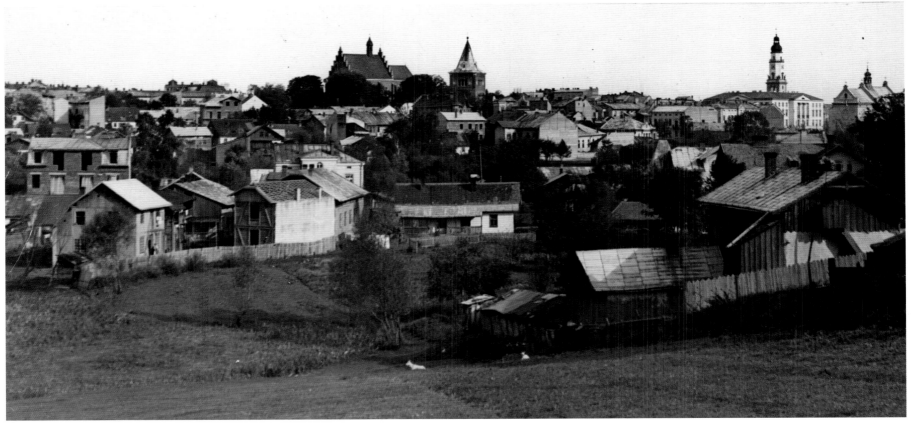

149

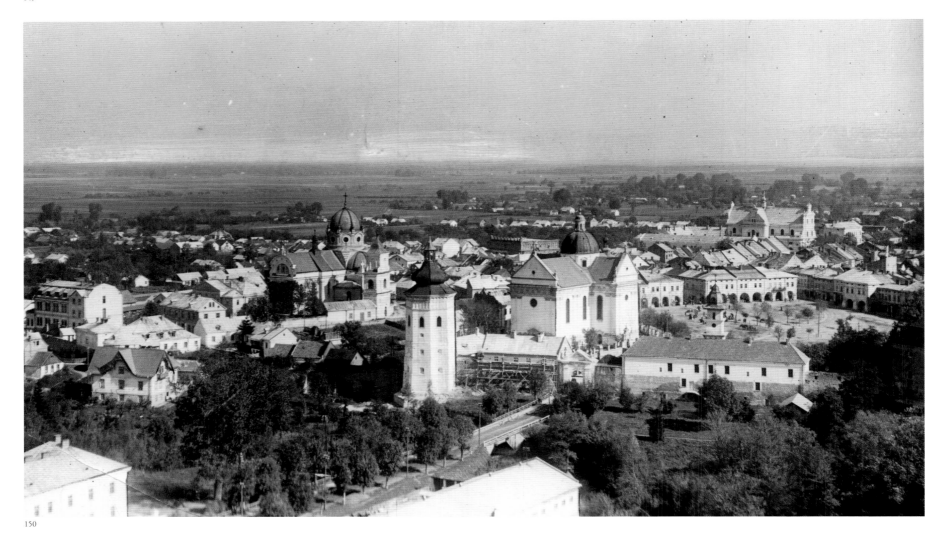

150

149. The photograph of Drohobycz from 1932 shows a panorama of a little town. One can distinguish in it the masses of churches, the town hall tower, and little, mostly wooden houses on the outskirts. It was here that Bruno Schulz (1892–1942) lived and created his art; he was one of the most interesting and genuine writers of the inter-war Poland, author of, among others, *Cinnamon Shops*.

150. Żółkiew, a small town near Lviv, is the seat of the Polish wealthy family of the Żółkiewskis, Daniłowiczes, Sobieskis. It was here that Stanisław Żółkiewski (1547–1620), Kiev Voivode, a courageous hetman, later the Grand Chancellor of the Crown, lived — he perished in the Battle of Cecora. The town is full of monuments still recalling those times, to mention only the magnificent church with the tombs of the lords of the estate, or the castle where King John III Sobieski used to spend a lot of time.

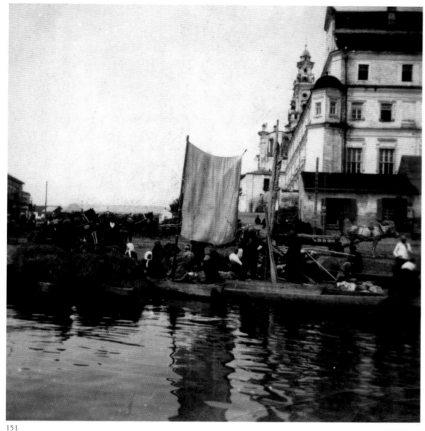

151

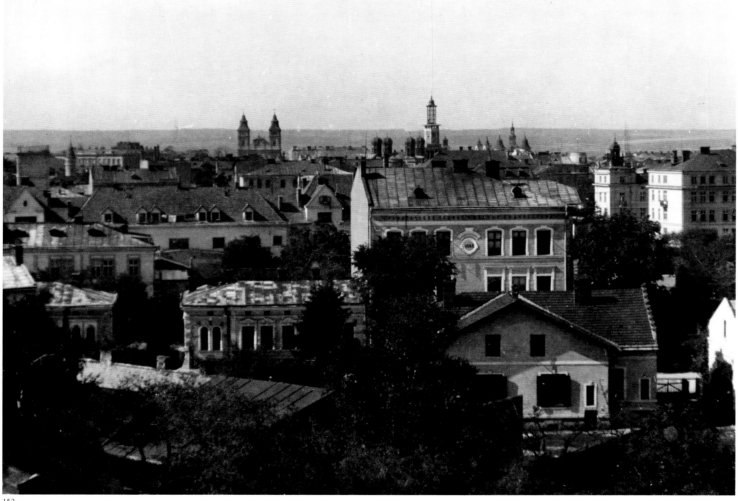

152

151. A market day in Pińsk, a town placed within the dump country, the country of meadows, rivers, and streams. Peasants with their produce come closer to the embankment, and so trade is taking place between water and land.

152. Stanisławów: such was the name of this town, when the photographer tried to capture its panorama in the picture. The surrounding land belonged to the wealthy family of the Potockis. It was them who located a new town within the old village of Zabłotów in 1662 and they called it Stanisławów to honour Stanisław Potocki, nick-named Rewera, the Grand Hetman of the Crown. In the 17th and 18th centuries it was an active commercial centre placed in the Sub-Carpathians.

# Abodes

Abode is a beautiful word standing for a dwelling place. And it is very friendly in its human contents. There can also be seats, thus not only houses, castles, palaces, towns, but there can be a seat of an institution, for example of a ministry. There is yet another word from this group — habitation, which in its Polish equivalent stands in the jargon of some regions for a farm. But the same Polish word also stands for the habitat of wild birds, unique plants, and this meaning is beautiful. Or should we, perhaps, return to the word nest: stork nest and family nest. But for our purpose let us decide that abode is a place in which our history, our power, culture, have persisted, namely mansions, castles, palaces. Churches and convents will be discussed in a different chapter.

The oldest abodes of the representatives of the power were palatia, just like the one at Ostrów Lednicki near Poznań in the 10th and 11th centuries. Then, during the whole Middle Ages defensive castles were erected, they were encircled with walls, with dwelling and farm buildings within them and with the tower of "last defence". This was the place where having cut off the entrance, the besieged could defend for a long time. There is a saying that King Casimir the Great found Poland built in wood and left it in brick. This saying has quite a lot of truth to it, since thanks to the King's wisdom and political awareness several dozen new fortresses were built and the other older ones were rebuilt. Around the same time the construction of smaller defensive abodes began, those being already in private hands and raised either by wealthy knights' families, e.g. the Dębno castle, or by the bishops.

The times of the Renaissance introduced a new way of building lords' abodes. They were free standing buildings, surrounded by the green, but also by ramparts. The Renaissance twist in mind, as well as a new way of raging wars, led to such changes in residential architecture. A change in the defence of such abodes was also observed, and so the bastion system was created, e.g. at the Krzyżtopór Castle or the Łańcut one. The end to those buildings came in the mid-17th century during the Swedish Deluge. The Swedish armies, having conquered almost all of the country, destroyed the majority of the castles, putting them on fire and devastating. With the onset of the Baroque the old defence system was no longer justified. The wealthy of this world raised their palaces surrounded by French-style parks, such as Nieborów near Łowicz, the castles in Krasiczyn, Baranów Sandomierski and many other localities. What later changed was merely the architectonic style, the decoration of the interior, yet the principle remained the same.

A group apart was made up by manors, abodes of the gentry. At first they were defensive, closed, like a little castle in Szymbark, and finally a specific style of a manor, a spread out dwelling house with a porch supported by columns was conceived. And this is the image that has been retained in our awareness for good.

The above, let us put it straight, is certainly not even a draft of an essay on Polish lordly abodes, for their description, even in most general detail, would take up many printed pages. This is merely a brief introduction into this interesting subject in our history. A commentary to the photographs presented in our album.

153. The manor at Tuhanowicze forms an important part of the history of our romantic literature. It stands for Maryla Wereszczakówna, later Putkamerowa, an unfulfilled, but certainly ardent romantic love of Adam Mickiewicz. Though modest, the manor emanates special atmosphere. Photo J. Bułhak

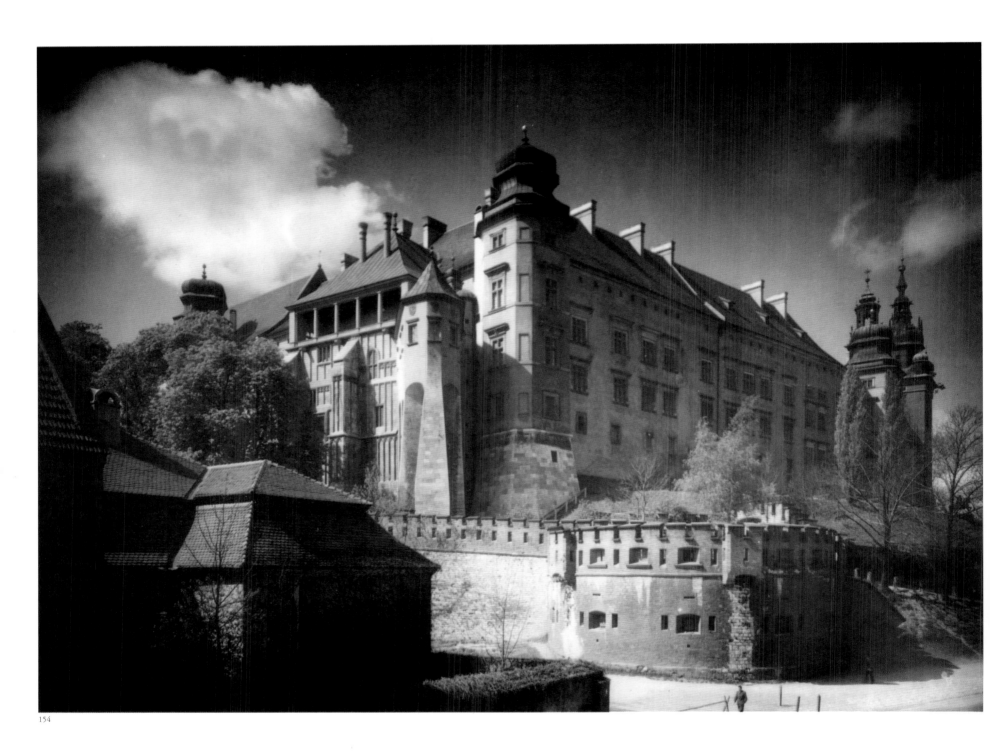

154

154. Is there anyone among us who does not recognize this sight? The Wawel, the castle of the
Polish kings, the Cathedral with the royal tombs, all this is so close to our hearts. The view of Hen's
Foot Tower, Cathedral towers, towering castle buildings and fortifications reproduced in thousands
of photographs, drawings, and paintings, is one of the most Polish, most national sights.

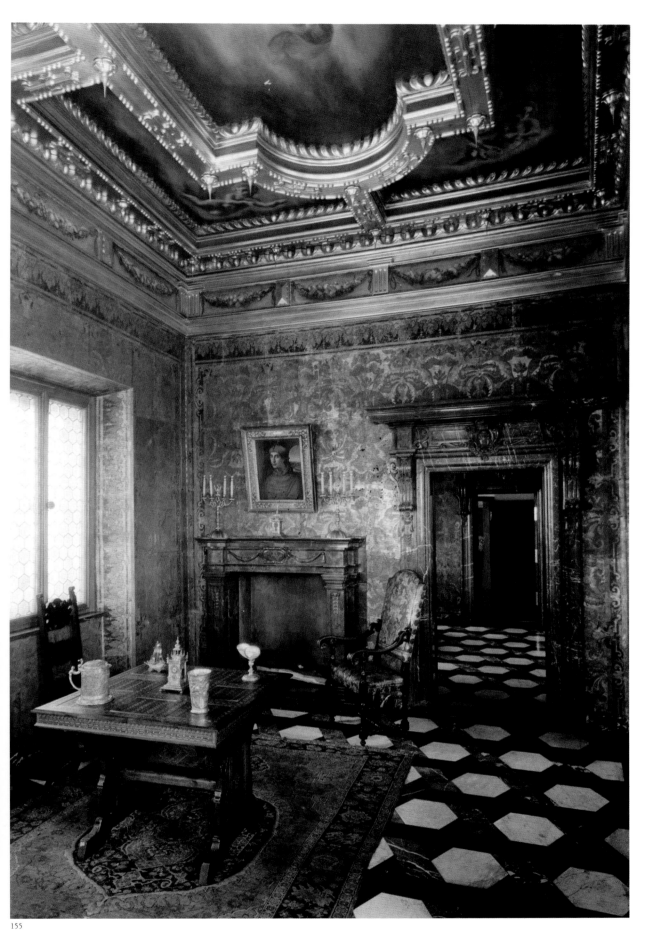

155

156

155. The Wawel — initially the residence of Polish dukes, and then the royalties, raised in the place of a former castle-town, took on its current shape in Gothic and Renaissance. A magnificent royal residence with the famous arcaded courtyard, boasts of glorious interiors and rich art collections, to mention merely the collection of the 16th-century Arras tapestries and the armoury. The Wawel impresses one with a decorative character of the chambers and elegance of their decor.

156. The Sigismund Chapel impresses, first of all, with its apparent simplicity, which, however, bears a logical and sophisticated Renaissance form. It is the first mature work of this artistic period erected in Poland. Authored by the Florentine Bartolomeo Berecci, it was completed in 1533 to house the tombs of the last Jagiellons.

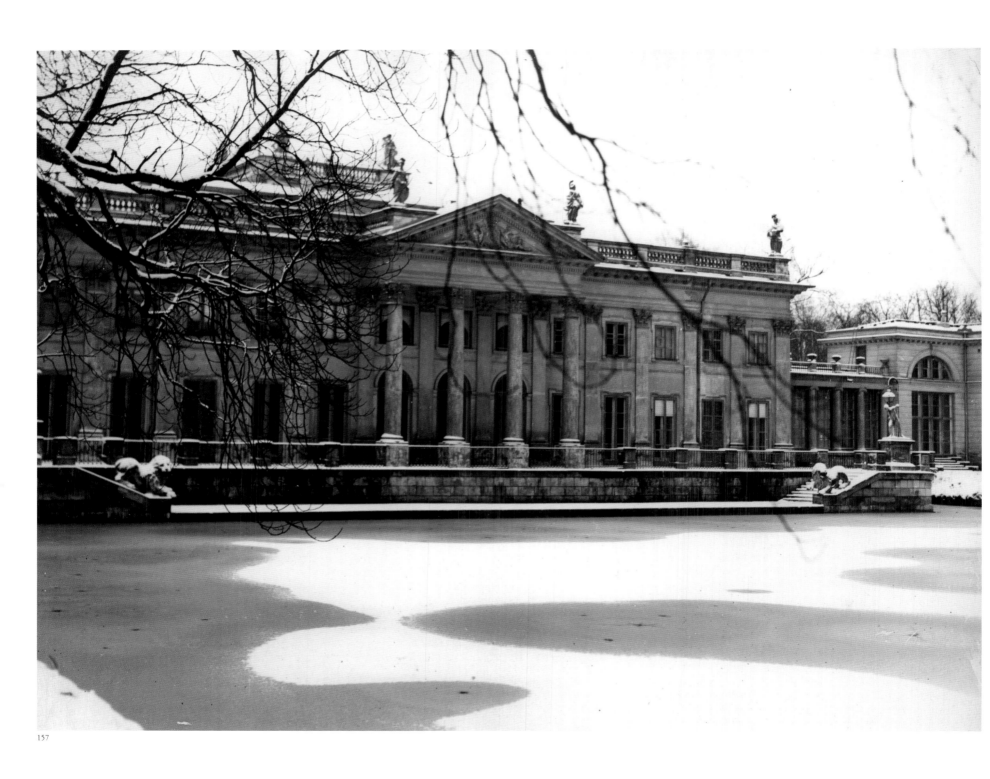

157

157. The Palace on the Water in the Warsaw Łazienki Park is one of the particularly charming historical places of the Polish capital. The renown architect Tylman of Gameren erected the Łazienki, meaning the Baths, for Sebastian Herakliusz Lubomirski. However, it was only King Stanislaus Augustus Poniatowski who bestowed the complex with its present beautiful appearance.

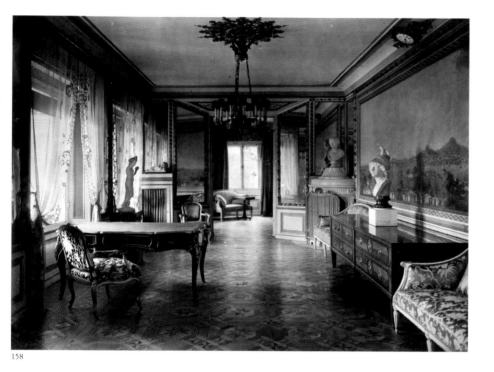

158

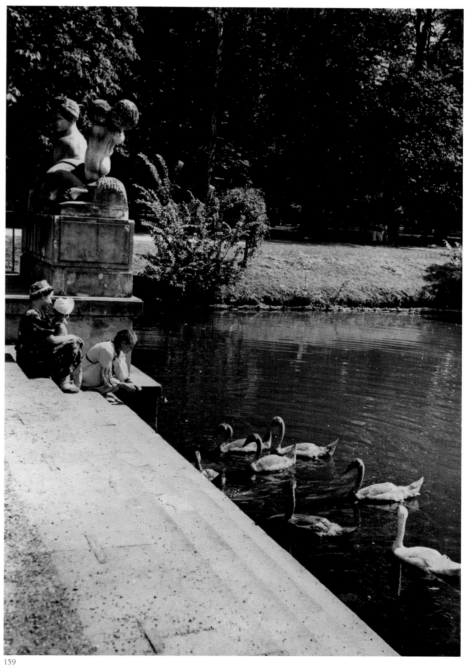

159

158. The interior of the Łazienki Palace impresses with Neo-Classicist furbishing. Beautiful furniture, sculptures, paintings, are what we can see in this photograph from 1926. These are the drawing-rooms in which King Stanislaus Augustus hosted his famous Thursday dinners participated by the luminaries of our Enlightenment.

159. In this photograph taken in 1936 the Łazienki Park and the pond by the Palace look almost identical as today. These are exactly the paths and this is exactly the same water where Mr. Wokulski met Miss Izabela Łęcka in the memorable novel *The Doll* by Bolesław Prus. Young couples in love continue to walk along these paths today.

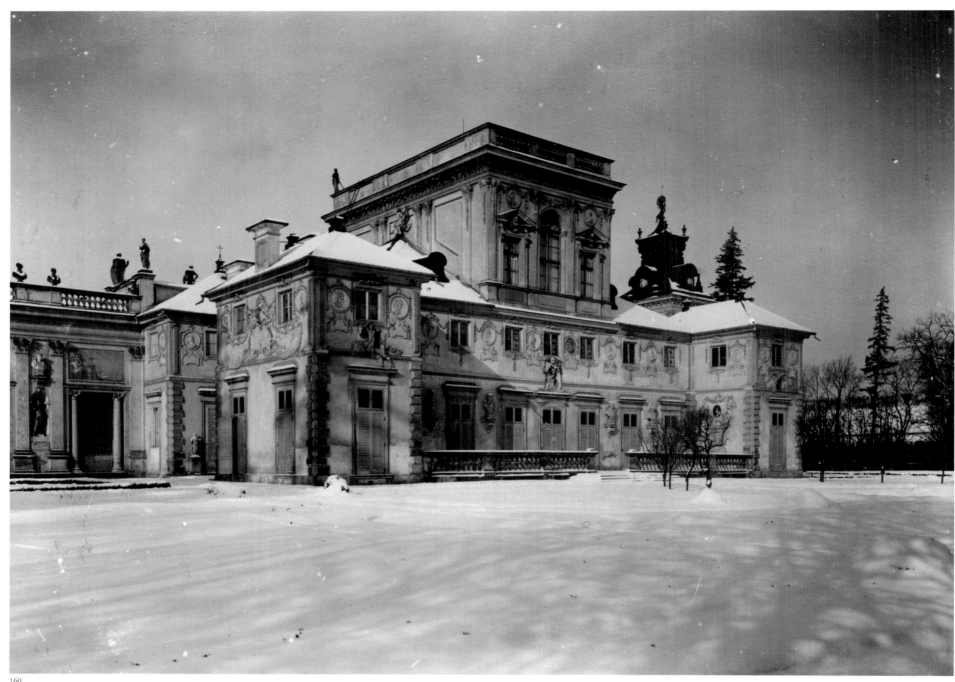

160

160. King John III Sobieski had the Palace in Wilanów erected as his summer residence after the design of Augustyn Locci in around 1680. After 1692, a gallery was added and so was a storey on the main building; later, wings were built on. It was being adorned by the most excellent artists, like the sculptor Slüter, the painters Michael Angelo Palloni and Jerzy Eleuter Sieminginowski. It constituted an accomplished work of Baroque architecture, surrounded by a geometric and romantic park.

Photo Z. Marcinkowski

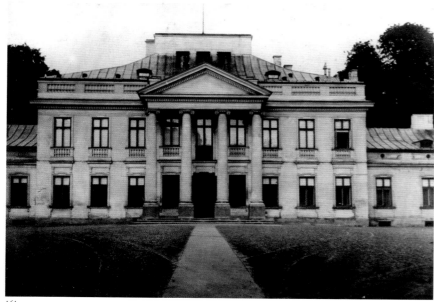

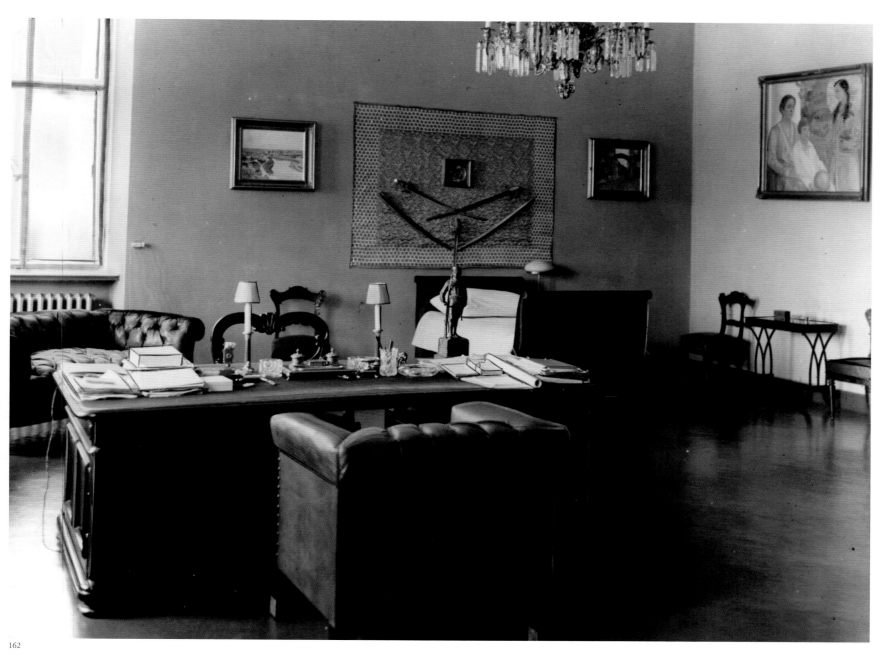

161. The Belvedere Palace in Warsaw was erected in 1818–1822 in the place of a former ceramic workshop established by King Stanislaus Augutus Poniatowski. Designed within the old walls by the renown architect of Neo-Classicism Jakub Kubicki, it was to serve as the residence of the Grand Duke Konstantin Pavlovich. It was here, in the nearby Łazienki Park and in the very same palace, that the first acts of the November Insurgence took place. After 1918, the palace became one of the most representational government buildings in Warsaw.

162. It was at the Belvedere that Marshal Józef Piłsudski had his residence. He received some eminent guests from Poland and from abroad in his reception rooms. The Marshal's study is very modest, yet imbued with dignity. It is decorated with paintings and swords, symbols of the military and the gentry.

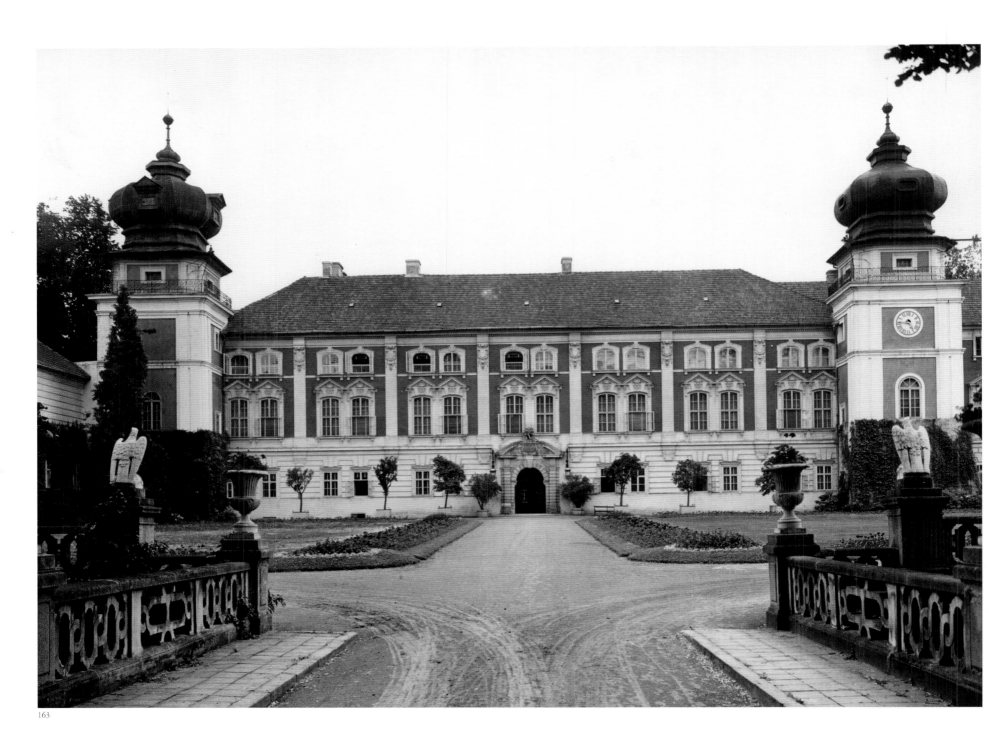

163

163. The Łańcut castle, initially owned by the Lubomirskis, and later the Potockis, ranks among the most magnificent magnate residences in Poland. It was raised in the 17th century by Stanisław Lubomirski, and later significantly altered by Elżbieta, Princess Lubomirski, who bestowed the palace with its beautiful Neo-Classicist furbishing. The Potockis owned it until 1944. It currently houses a museum, very popular with Polish and international tourists. Photo H. Poddębski

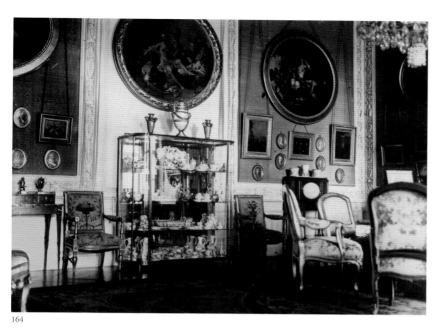

164

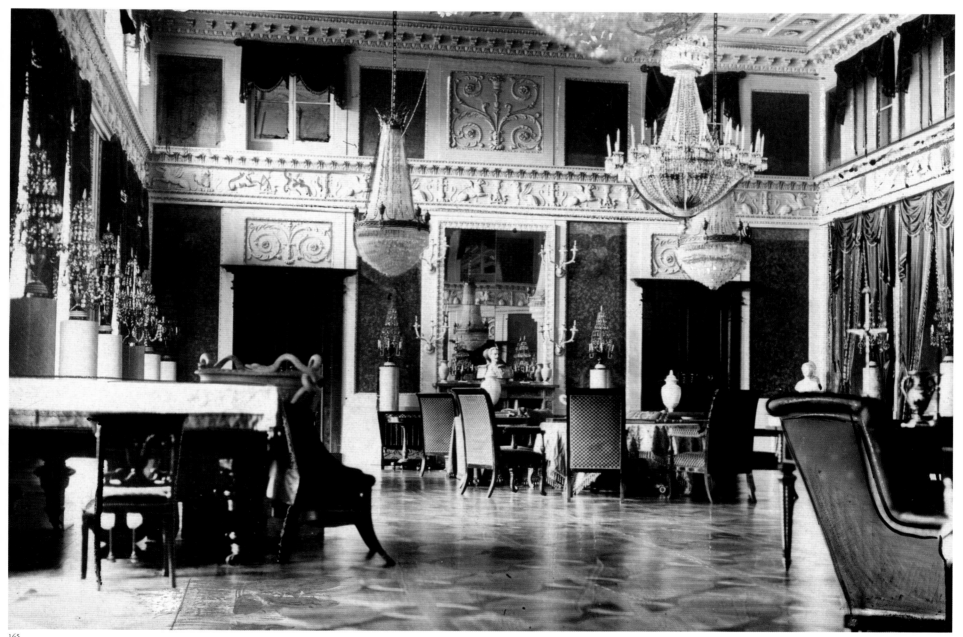

165

164. Boucher's drawing room in the Łańcut Castle-Museum, has essentially retained its character and the architecture of interior created by the most excellent designers of the Enlightenment: Szymon Bogumił Zug and Jan Christian Kamsetzer. This is the room that housed the most exquisite paintings from the Łańcut collection: the paintings by Watteau and Le Nain, and five Boucher's works. The owner of the castle Alfred Potocki carried them with him when leaving his family residence in 1944.

165. The Ball-Room in the Łańcut Castle looks so different today, since it has been adapted to house numerous important concerts. In this preserved photograph we can see that although beautiful, it was also very 'residential'. Rich furniture, as exquisite as it was, slightly obscured the glorious architecture of the interior designed by the architect Christian Piotr Aigner and the stucco-worker Fryderyk Bauman around 1800.

166

Pozdrowienie z Krasiczyna      Zamek

24924. Nakładem M. G. Rosenfelda, Przemyślu.

167

166. It was through this gate decorated with the Szreniawa coat-of-arm that one entered the palace of the Lubormiski Princes in Przeworsk in the Sub-Carpathians. The palace and the estate were a gift which Izabella Lubomirska nee Czartoryski, the Lady of Łańcut and other equally wealthy estates, offered to her foster child Henryk Lubomirski. The edifice was raised in Neo-Classicist style at the beginning of the 19th century on the foundations of some older premises. It was surrounded, just like today, by a huge park.

167. Courtyard of the Krasiczyn Palace.

168. The Krasicki Castle in Krasiczyn is one of the most accomplished works of Renaissance architecture on the Polish territory. It has a quadrilateral lay-out with four towers: Divine, Royal, Papal, and of the Gentry on the corners, and an entrance gate. The castle courtyard features some attractive loggias. Raised in 1592–1614, it was designed by, among others, the architect Gelazzo Appiani. The whole castle is decorated with exquisite attics and the walls are covered with graffiti. There is a magnificent park around it, full of monumental trees.

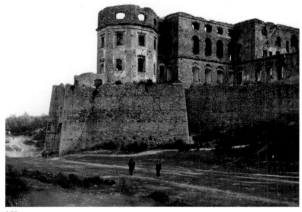

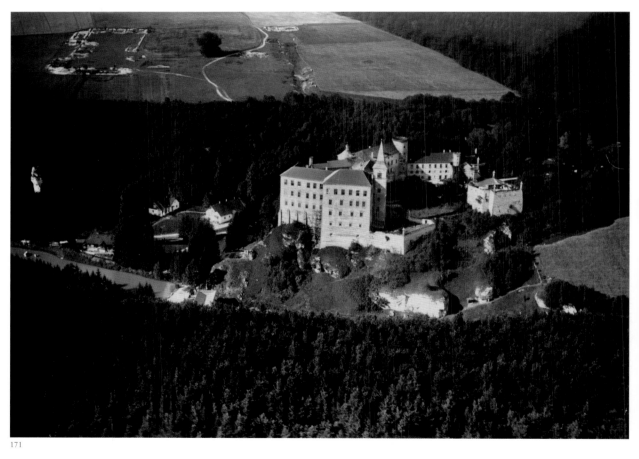

169

170

171

169. The Krzyżtopór Castle near Ujazd in the Kielce Land was once regarded to be one of the most magnificent magnate residences in Poland. Raised by Voivode Krzysztof Ossoliński in 1627–1644 after the design of Warzyniec Senes, it was an exquisite palace, surrounded by bastioned-trace fortifications. It was damaged during the Swedish invasion in the mid-17th century.

170. The Castle in Wiśnicz Nowy, the residence of the Kmita family, and later of the Lubomirskis, used to be a powerful defence castle in Little Poland. Raised in the 16th and 17th centuries by, among others, the architect Jan Baptysta Trapolo, it has a quadrangle lay-out, flanked by cylindrical towers and rises on a hill, today wooded.

171. The Gothic-Renaissance castle at Pieskowa Skała near Ojców was initially a royal property. Vladislaus Jagiełło gave it to the Szafraniec family, and later it changed hands to become the property of the Zebrzydowskis.

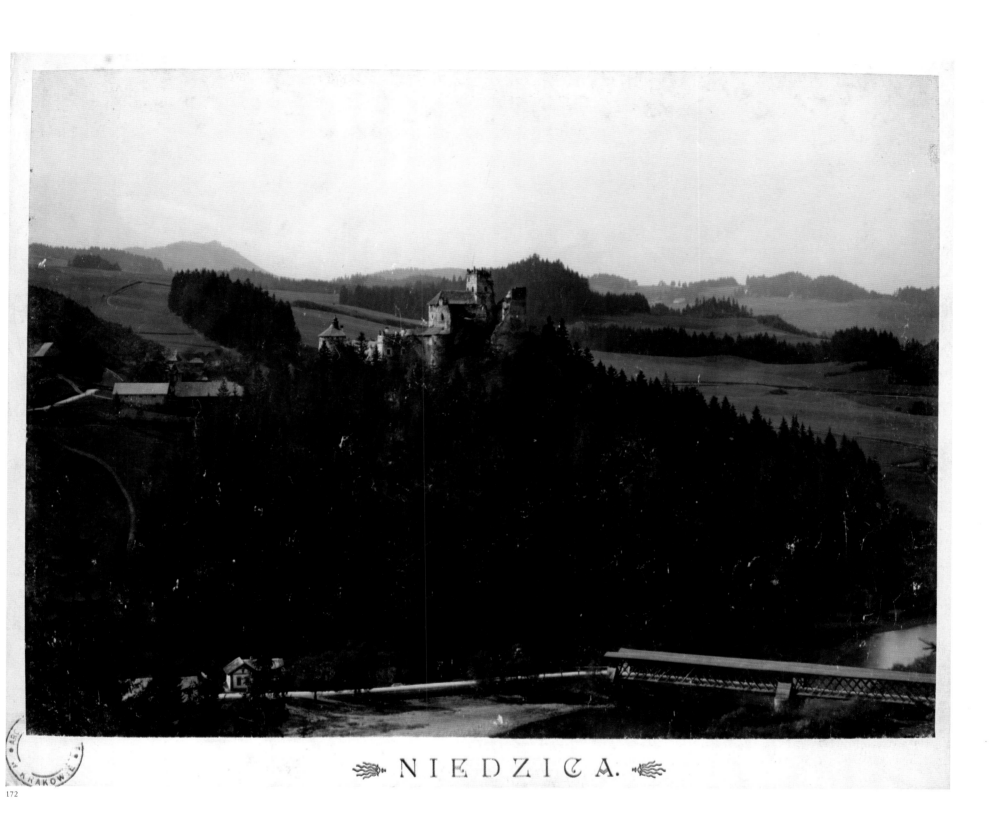

~~❧~~ N I E D Z I C A. ~~❧~~

172

172. The Niedzica Castle, elevated over the rapid Dunajec river and surrounded by the Sub-Tatras, is one of the most picturesque defence buildings in the area. It once belonged to the Berzevicz family, and then to the Horwarths. The Upper Castle was built in stages starting from the 13th to the 14th century and altered in around 1635. The Middle and Lower Castles were built in the 17th century.

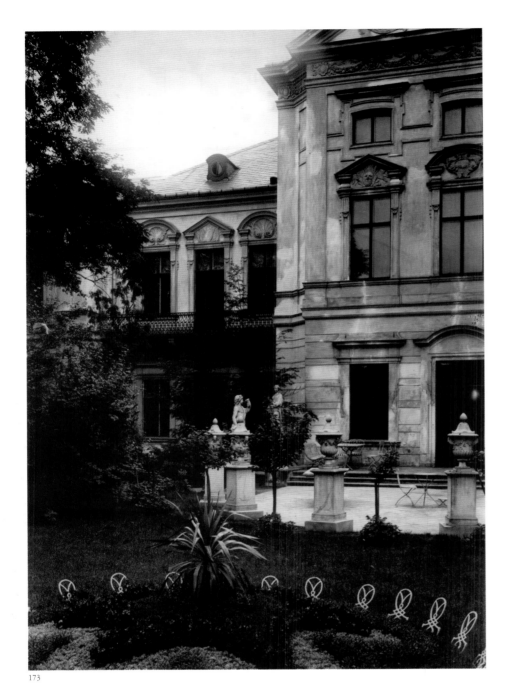

173

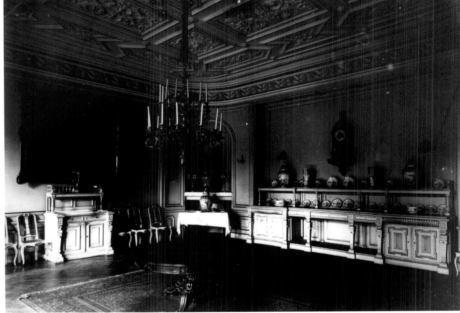

174

173. The Baroque Palace of the Przebendowskis in Warsaw, which later became the property of the Radziwiłłs, was raised in 1728 by the known Baroque architect Jan Zygmunt Deybel. It was quite obviously surrounded by a beautiful garden complex, since it was, after all, a property of a grand aristocratic family. Today, squeezed in the fork of Solidarności Street, it has lost much of its charm. Photo Z. Marcinkowski

174. This is what the interiors of the Warsaw Palace of the Przebendowskis had looked like before they were destroyed and subsequently reconstructed. Rich stucco ceilings, Neo-Classicists furniture, interesting collections… Photo Z. Marcinkowski

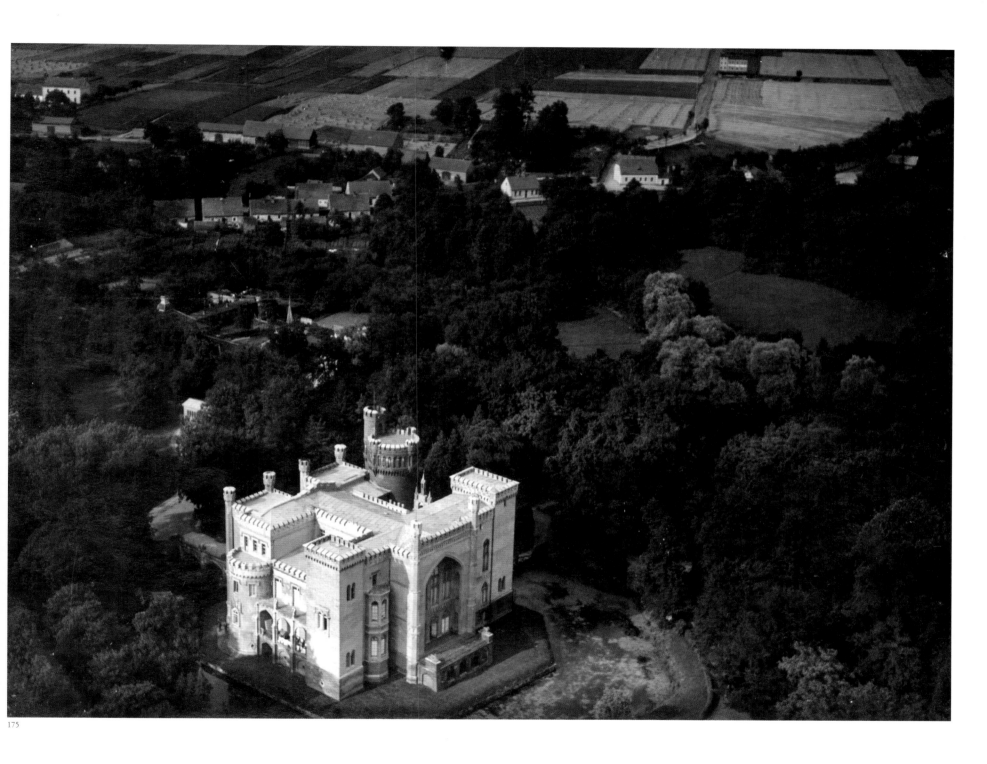

175

175. On the spot of the former castle of the Górkas in Kórnik near Poznań, Tytus and Jan Działyński raised a new Neo-Gothic edifice in 1845–1860. It was designed by the renown German architect Karol Fryderyk Schinkel. The design was slightly altered during the construction works. One should bear in mind, however, that the building was meant neither as a castle, nor as a palace, but it was to serve as a library and a museum for different collections. Around, there is a vast park and the famous arboretum.

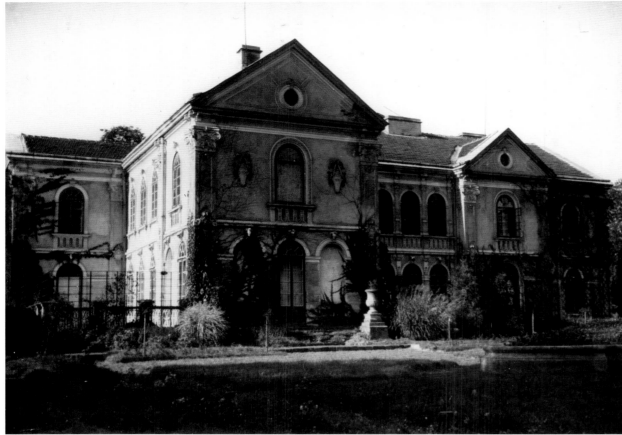

176

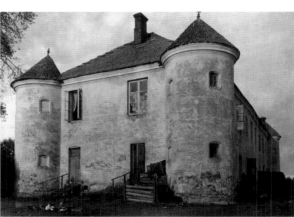

178

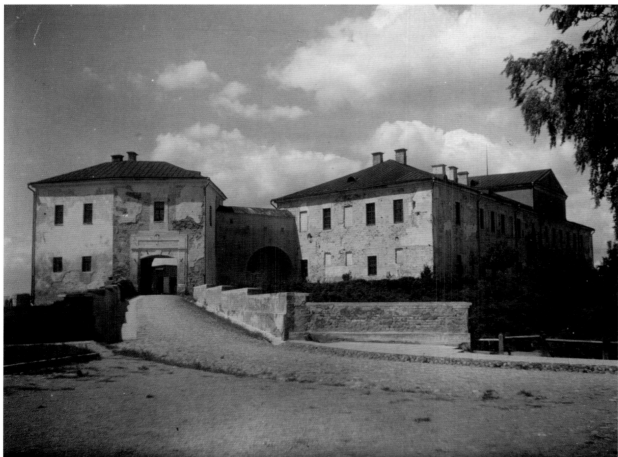

177

176. The palace at Beńkowa Wisznia, the family estate of the Fredros, was built around the mid-19th century, possibly on the place of some former building. It was here that one of our greatest comedy writers, the outstanding playwright Aleksander Count Fredro (1793–1876) used to work and write (when he was not staying in Lviv).

177. Grodno can boast of long history, just like the castle here. Stephen Batory (1533–1585) used to often stay in Grodno, and he actually died here. The castle is also famous for one more historic event: it was here that on November 25, the last King of Poland Stanislaus Augustus Poniatowski signed his abdication and left for St. Petersburg to never return to his homeland.

178. An old 17th-century fortified manor at Gojcieniszki near Lida is one of the powerful and safe gentry homes which were once quite numerous on this territory constantly endangered with invasions and attacks. The cylindrical towers on the corners of the building were quite typical. This is what the manor looked like in 1934 when the photograph was shot by Jan Bułhak.

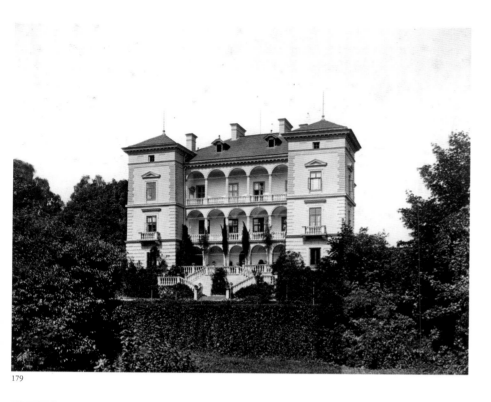

179

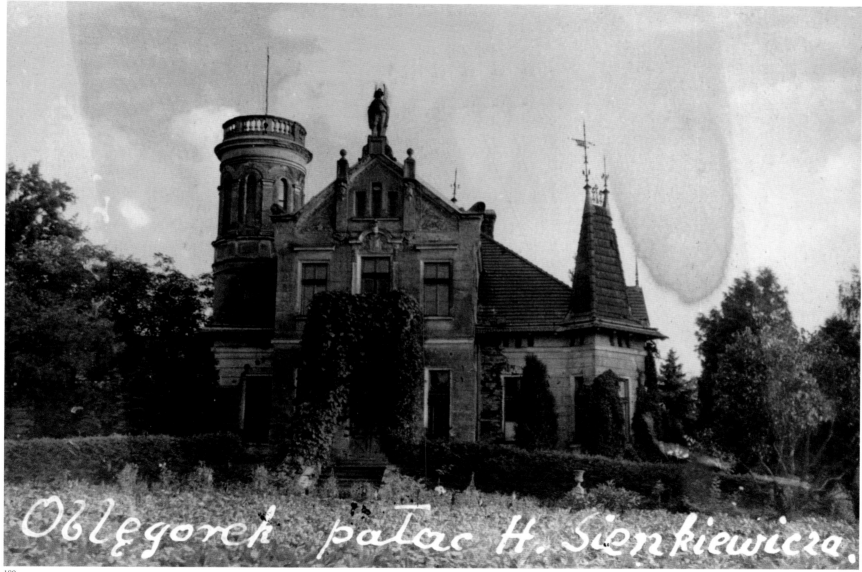

180

179. The villa at Wola Justowa (Justowska) in Kraków was the home of Jost Ludwig Deitz, namely Justus Ludwik Decius (c. 1485–1545), an economist and historian, royal adviser, mint administrator, reformer of the Polish monetary system, which he had built for himself. During the Renaissance such villas were popular in Italy, specially in beautiful Tuscany. Located outside the city walls, surrounded by nature, they did not only express a certain philosophy of life, humanism, but were also a place of many academic and cultural meetings.

180. There used to be a hunting mansion at Oblęgorek once, and in 1880 the Tarłos had a new building erected here. Such were the beginnings of Henryk Sienkiewicz's home. When in 1900 the writer celebrated 25 years of his artistic work, the whole nation made a collection and with the acquired funds the manor was purchased, renovated, altered, and given to the writer on his Jubilee. Such was the way in which the nation honoured its writer. This is the summer home where Sienkiewicz stayed starting from the holidays in 1906 until 1914.

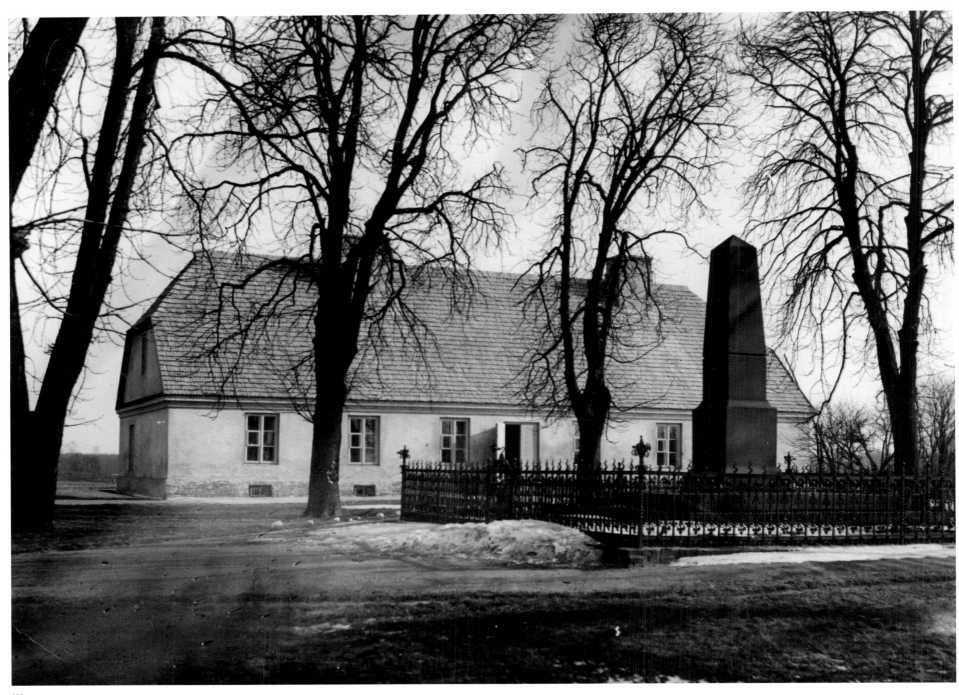

181

181. A manor, or more justly an outbuilding at Żelazowa Wola, has become related to the person of our grandest composer Fryderyk Chopin, since this is the place where he was born in 1810. During the interwar period the building was renovated and the interior designed by the architect Lech Niemojewski. Today, Żelazowa Wola attracts the lovers of Chopin's music.

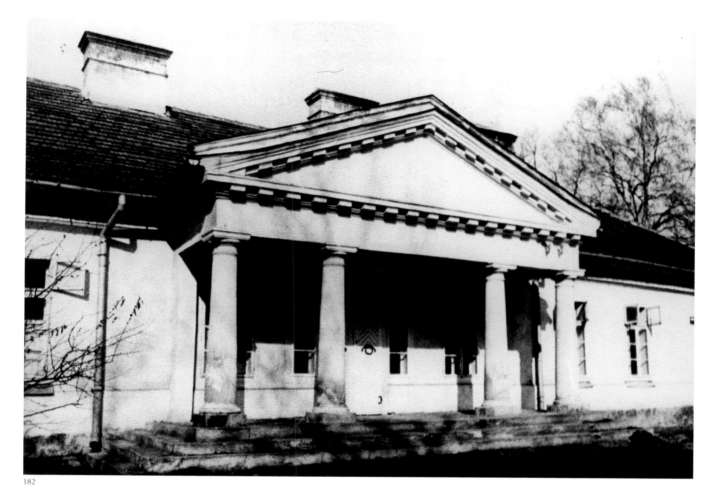

182

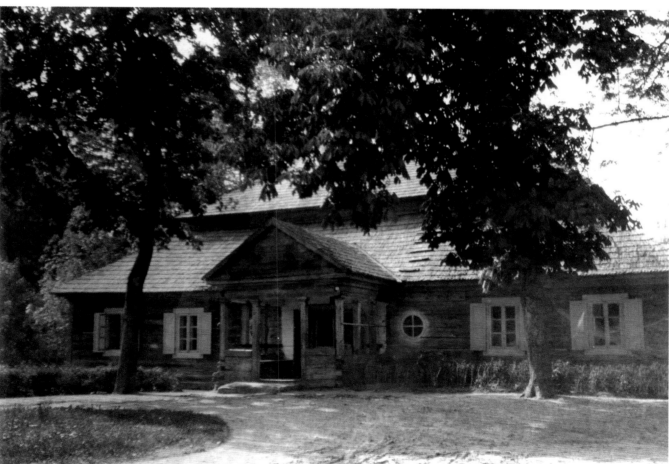

183

182. Today's manor at Lusławice, built at the beginning of the 19th century is a classicising building in the shape characteristic of the period. Jacek Malczewski, a great Polish painter, used to visit Lusławice. Today, the manor together with the park is the property of one of Polish most illustrious composers Krzysztof Penderecki.

183. The Mereczowszczyzna manor is the place where Tadeusz Kościuszko was born on February 12, 1746; he was a great hero in the struggle for the independence of the United States of America, organizer and leader of the Insurrection, Commander of the National Military Forces. A modest wooden manor of Baroque features has not, unfortunately, survived until our times: it was burnt down in 1943.

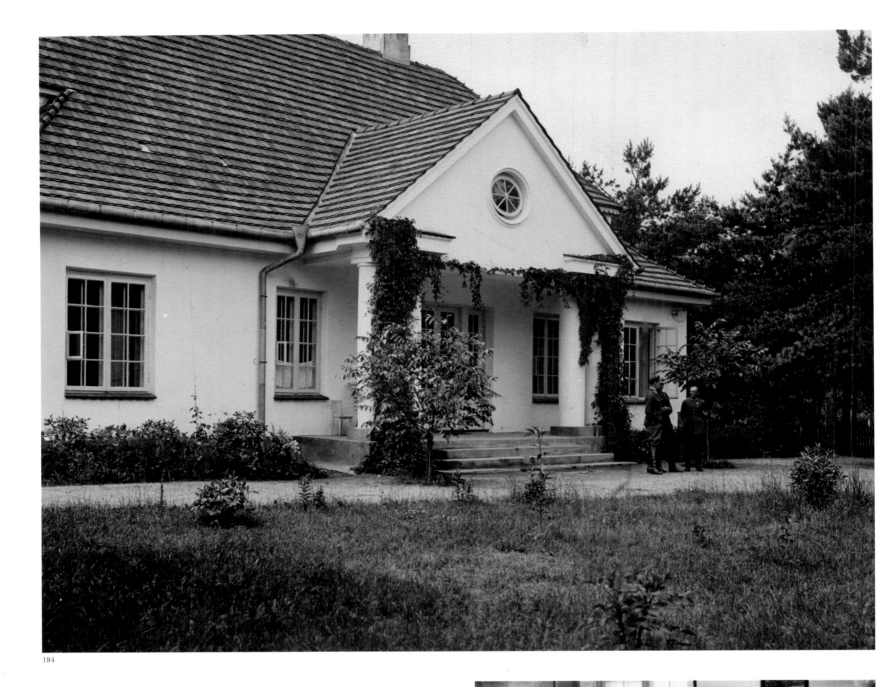

184

185

184. Sulejówek near Warsaw has been strongly associated with the person of Marshal Józef Piłsudski. During a certain period of his life it was his favourite dwelling place. The Milusin villa, designed by the architect Kazimierz Skórewicz, was a gift from the 'Polish Soldiers' Committee'. The official presentation of the villa took place on June 13, 1923.

185. The study of Marshal Józef Piłsudski in his Milusin Villa in Sulejówek impresses with its modest character. It is by no means a ceremonious hall, worthy of such a grand host, but an intellectual's working room. There is a comfortable desk, settee, some armchairs, some plants, all contributing to cosy atmosphere, full of graveness and peace.

186

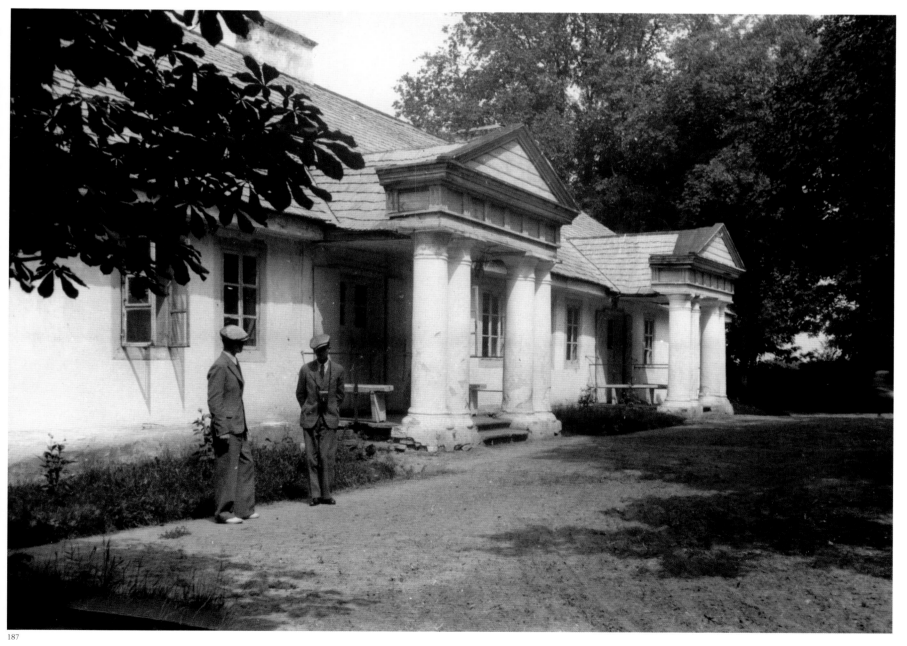

187

186. The Library in the Ordas's manor at Nowoszyce in Drohiczyn. This is likely the working environment of Napoleon Orda (1807–1883), an excellent painter and draughtsman, whom the history of Polish art owes so much. He executed hundreds of drawings presenting historical buildings, views of cities and towns, castles, and churches. Later, his works turned into lithographs and reached the people who were interested in Polish history. Until today lithographs by Napoleon Orda are among the most searched for by art collectors.

187. This is what a Neo-Classicist 19th-century manor at Nowoszyce looked like in 1937. It belonged to the well-known family of the Ordas. A one-storey long building with two symmetric porches decorated with beautiful columns supporting pediments, recalls one of the old times.

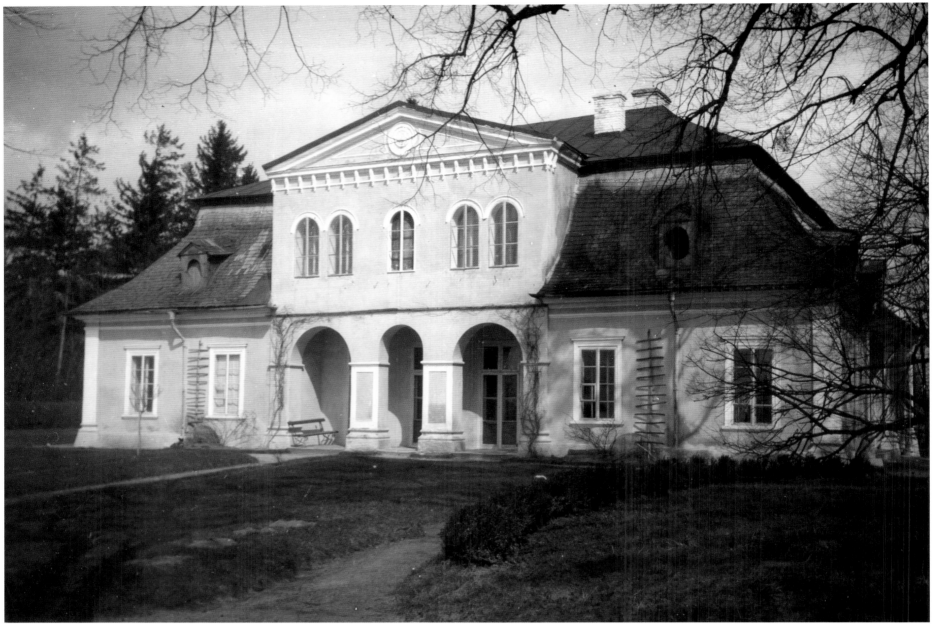

188

189

188. This is one of the examples of a manor of the gentry, a home of a many-generation family, living in such houses for up to several hundred years. The manor at Stronibaby near Tarnopol was built, judging from its architectonic style, some time in the 2nd half of the 18th century, and later slightly altered already in the 19th century. There used to be so many of such manors in the territories of the Polish-Lithuanian Commonwealth. And only so few have survived!

189. Interiors, rooms in manors and mansions, judging form the photographic records, were quite modest. They featured good quality solid furniture, such that would last a few generations. The walls were adorned with the owners' portraits, and first of all of the honourable ancestors. Such was the decor of the little drawing-room at Stronibaby.

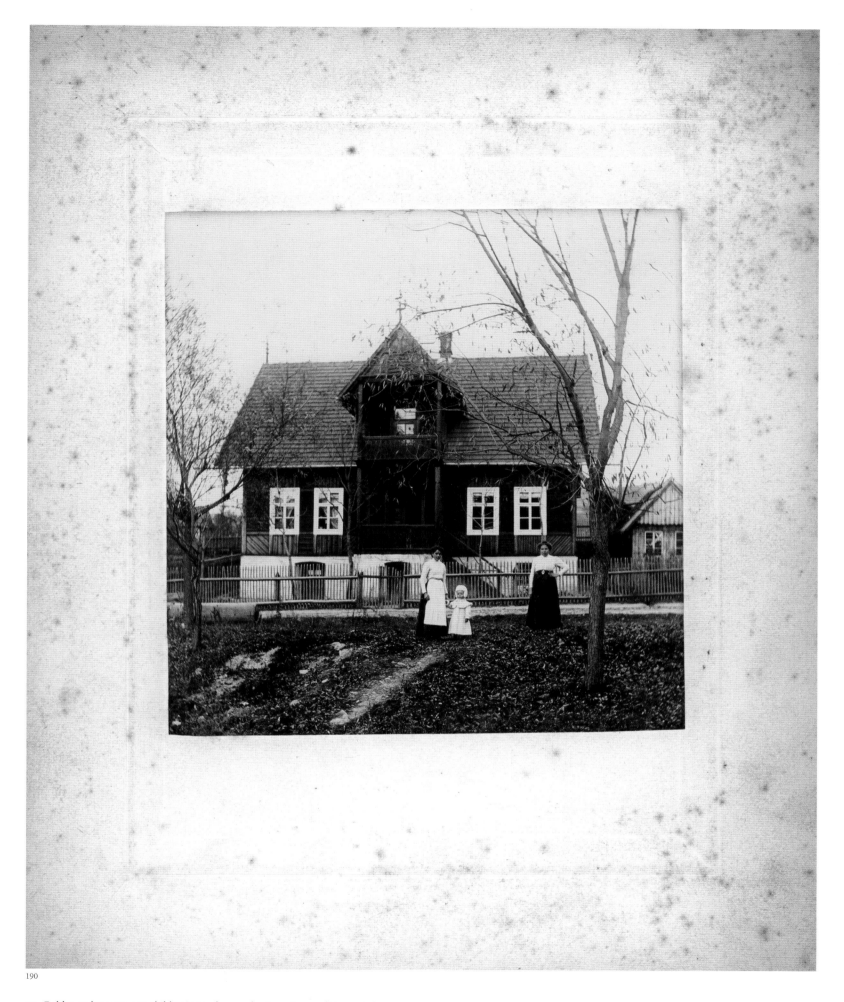

190

190. Rabka, today a renown children's spa, known for its curing qualities and clean air, was popular already in the 19<sup>th</sup> century, and visitors used to stay in such modest, partially wooden houses.

# Faith

Faith and religion have been present since the beginning of the history of humankind. Our nation, fitted within the Latin culture for a thousand years, have been Christian in their majority, and first of all Catholic. Yet, for centuries we have boasted of our religious tolerance, which is a very beautiful feature. One can say that we have prevented religious wars that pestered some of the West European countries.

Catholic and Protestant churches, Orthodox and Greek Catholic ones, synagogues, mosques, and Karaim churches have been permanently set in our historical landscape. In all those churches God was praised, prayers were said, thanks given, and mercy begged for. They were not merely a place for religious cult, but also perfect pieces of art and architecture, ornaments to towns and villages in which they were raised. This richness of religions in the old Poland, but even that Poland prior to World War II, constituted an excellent mosaics of celebrations, holidays, and rites. It may have happened that in a little town on the eastern edge of the Polish-Lithuanian Commonwealth different funeral processions went along the streets at the same time: one being Catholic, the other Orthodox, and possibly another one, taking the dead to their respective cemeteries. Wedding processions of various beliefs would also cross each other's way. But what needs to be stressed is that apart from, fortunately, some very few antagonisms, all this would take place in peace and order.

It is hard to imagine the old Poland without folk saints, crosses of the Passion placed at crossroads, May services to honour the Virgin sung by wayside shrines in the midst of the fields, and the perfume of flowers. In bigger and smaller towns, as well as in villages, each major Church holiday had its unique character: Palm Sunday, for example, with the customary blessing of the palms, visiting Christ's graves, Easter Sunday dawn masses, Nativity scenes, midnight masses at Christmas, Corpus Cristi processions, pilgrimages to numerous sanctuaries, to Jasna Góra in Częstochowa, to Pointed Gate in Vilnius. Each region had its distinct holy place. They have not only taken their place in the historical customs, but they persist, also inside us. And one could go on enumerating such signs of faith and religious passion, but statistics are not our main purpose here. And what about ceremonies and services of other religions? Jewish and Muslim holidays also had their unique setting.

Old photographs are the most magnificent recording of the time, which, unfortunately, in many cases, is already in the past. The paper has recorded not merely the already destroyed churches and cemeteries, but also faces of praying people with their eyes fixed on the sacrum.

191. Palm Sunday means that Easters is very near, and the tradition of preparing palms commemorating Jesus entering Jerusalem is very characteristic of our folklore. There are large palms, some very richly ornamented, but also more modest ones, although equally beautiful to the boys from Kraków's suburbs when they raise them high on that spring day in 1927.

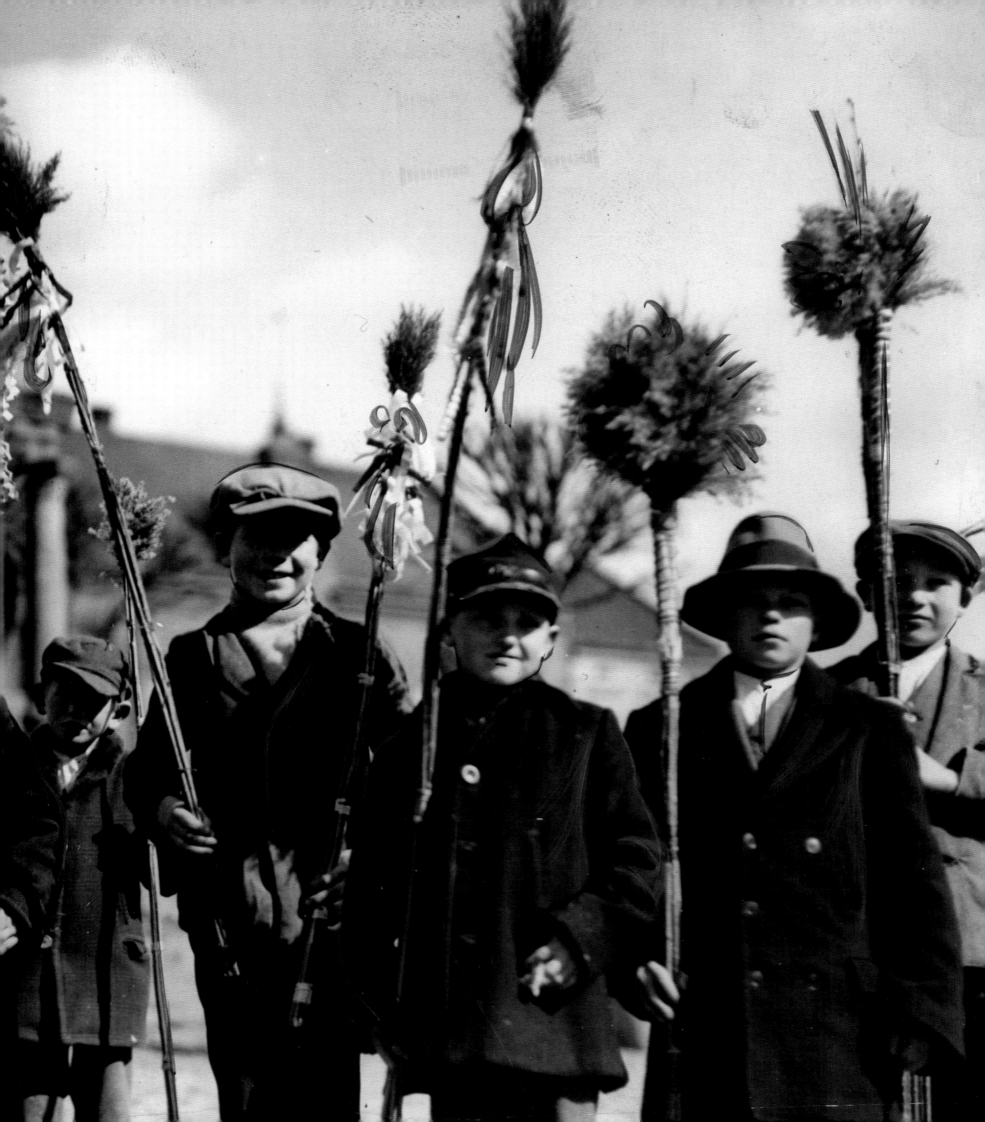

192

193

192, 193. Nothing but poetry can express the beauty of wooden shrines. Today there are not many of them left amidst corn and vast fields. They have been destroyed by time, unwise people, and even by wrongly conceived modernity. Pity...

194

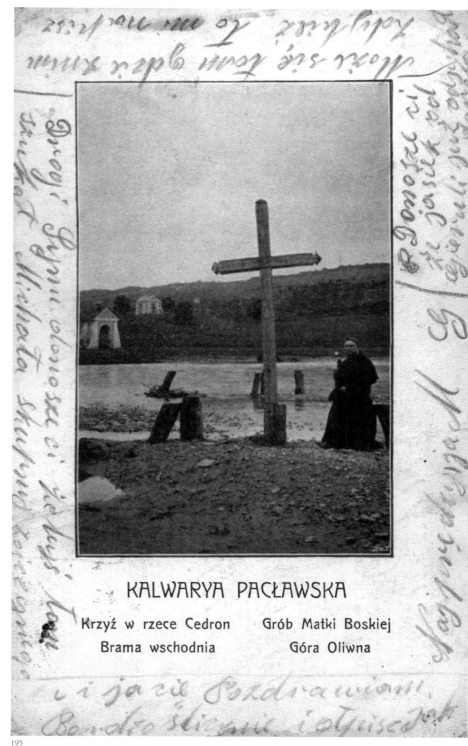

KALWARYA PACŁAWSKA

Krzyż w rzece Cedron      Grób Matki Boskiej

Brama wschodnia      Góra Oliwna

195

194. A column commemorating the victory at Beresteczko in 1651 was in 1910, i.e. when this photograph was taken, in Witów, near the Norbertine Abbey.

195. On Przemyśl Plateau, in a beautiful country and among woods, on a hill at whose foot there is the river Wiar, we come across Kalwaria Pacławska. The first founder of this Kalwaria — Calvary modelled on the way of Passion in Jerusalem — was Andrzej Maksymialian Fredro in 1665. The new Baroque church was built by Szczepan Józef Dwernicki in the 1770s. The miraculous effigy of Our Lady in the church was saved from Kamieniec Podolski when it was captured by the Turks. The sanctuary is composed of the church, convent, and 43 chapels picturesquely scattered around.

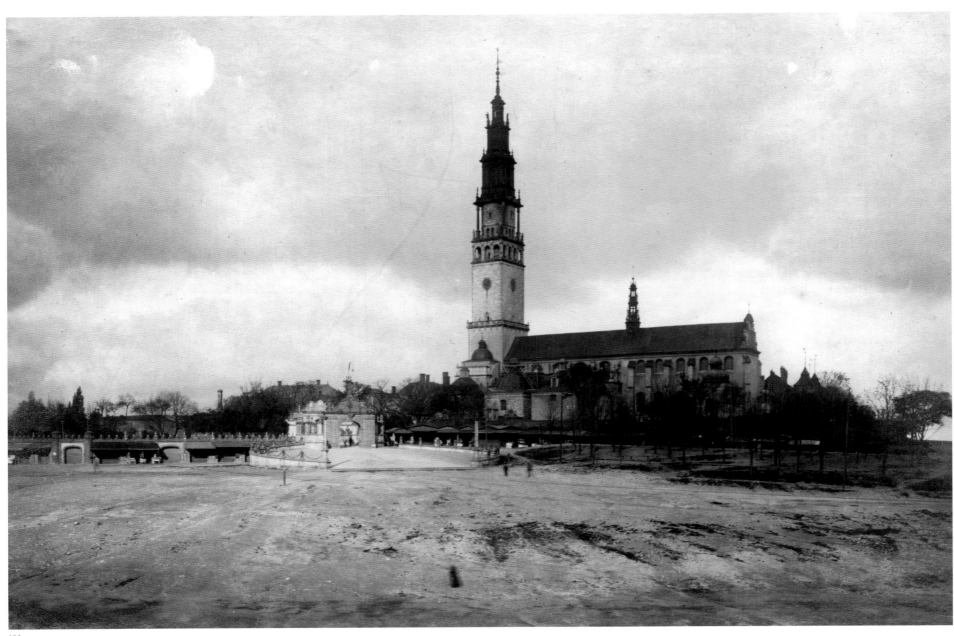

196

196. The sanctuary of Our Lady of Częstochowa at Jasna Góry is the holiest of all places for the Poles. The miraculous effigy of Our Lady has for centuries attracted crowds of the faithful. The Pauline Convent and church were founded by Vladislaus, Duke of Opole. A high, soaring spire surrounded by the convent buildings towers over the landscape around.

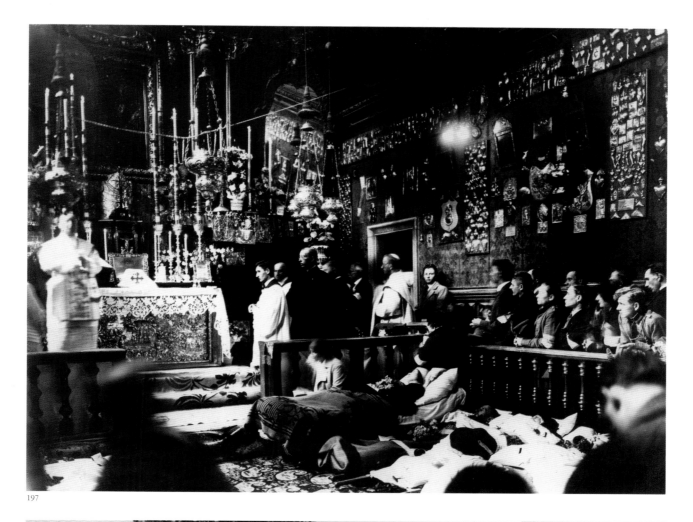

197

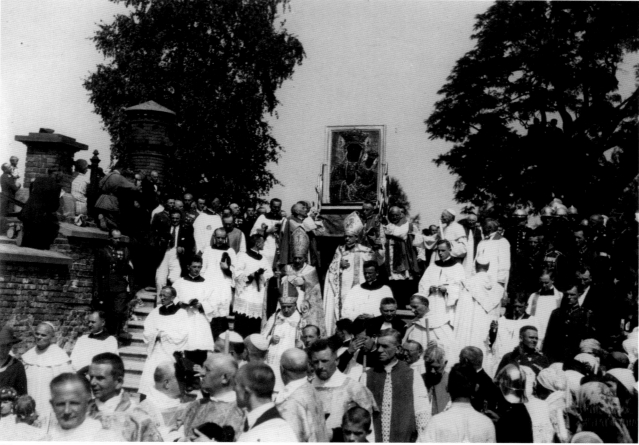

198

197. The incurables gathered before the effigy of Our Lady of Częstochowa. They were brought here by their firm faith in the miraculous power of this painting and endless magnanimity of Our Lady. During the Holy Mass celebrated in the Jasna Góra chapel they are praying to Her, their Protector.

198. The celebration of the 550 years of the presence of the miraculous effigy of Our Lady of Częstochowa which took place in the 1930s, bore a very sublime, religious, and patriotic character. It was a great celebration for whole Catholic Poland.

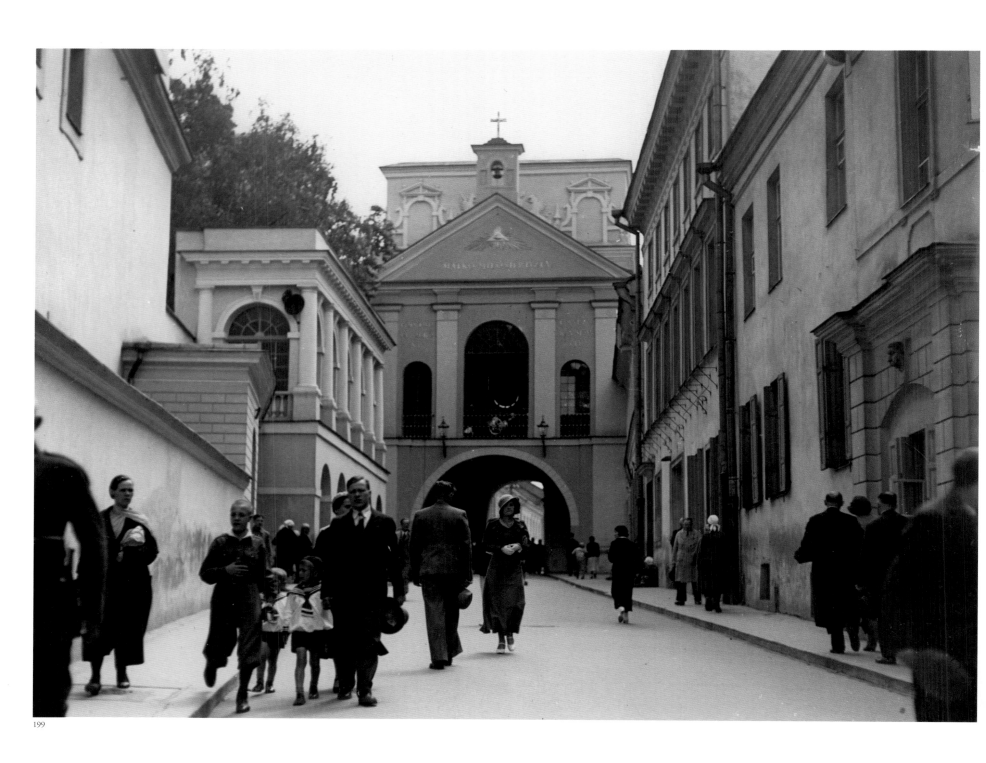

199. 'To the Holy Virgin shining in the Pointed Gate', is what Adam Mickiewicz wrote in his
invocation to *Master Thaddeus,* because the effigy of Our Lady of Ostra Brama was venerated almost
as much as Our Lady of Częstochowa, specially by those who inhabited the former Polish
borderlands. The first was called the Queen of Poland, the latter, the Duchess of Lithuania. The
chapel with the miraculous painting of Our Lady had an uncommon location in an old town gate,
the so-called Pointed Gate, a preserved fragment of town fortifications.

200

201

200. A lit up painting showing Our Virgin of the Pointed Gate: one can easily see how just were Mickiewicz's words…

201. The effigy of Our Lady of the Pointed Gate was often reproduced in prayer books or on feretories — it was one of the most venerated holy effigies in the Polish-Lithuanian Commonwealth.

202

203

202. Kalwaria Zebrzydowska is a sanctuary which has for centuries attracted pilgrimages of the faithful. There are particularly solemn and impressive processions held here on Good Friday and on August 15, the latter being shown in this photograph from 1937. Zebrzydowska Calvary, the first in Poland, was founded by Mikołaj Zebrzydowski, Grand Marshal of the Crown at the beginning of the 17th century.

203. The Benedictine Convent at on Łysiec in the Świętokrzyskie Mountains was one of the older monastic centres in our country. It was here that the relics of the Holy Cross were worshiped. From Nowa Słupia at the foot of the mountains groups or people are walking up. Maybe they are hurrying for some Church service.

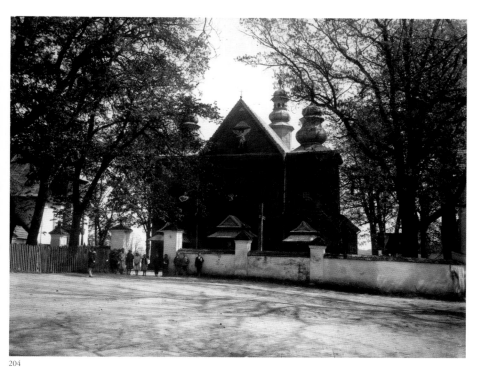

204

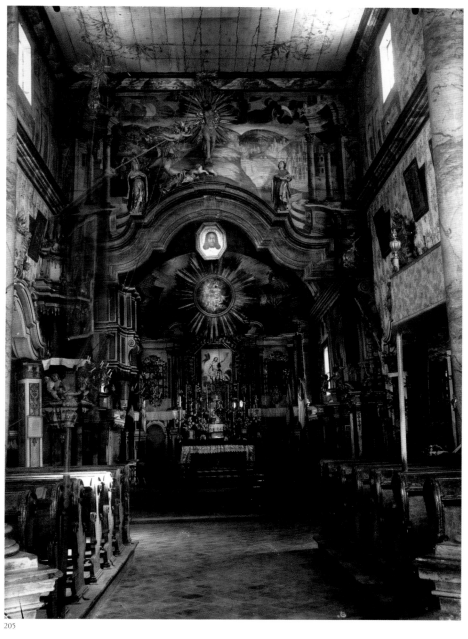

205

204. The wooden church ar Szalowa near Gorlice raised in 1739 is a Baroque building, imitating, to a certain extent, churches of that period. The façade is flanked on both sides by two towers with ornamental cupolas. Encircled by a brick plastered wall and framed in the green of high trees, it ravishes, emanating the charm of old wooden churches.

205. The interior of the wooden Szalowa church has also retained its Baroque décor. One does admire beautiful tromp l'oeil polychrome adorning numerous and richly decorated Rococo and Baroque altars, as well as sculpture furbishing.

206

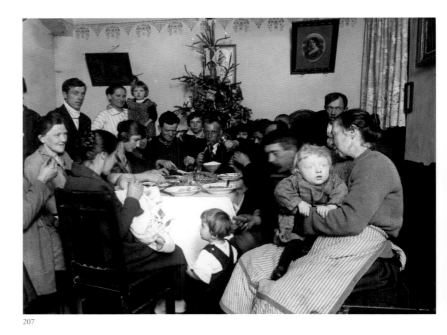

207

206. In Poland the tradition of arranging Nativities, or stables, as they are called in some regions, can be traced back to the Middle Ages. The oldest testimony of this custom are the figures placed by the Clare Nuns in the Church of St. Andrew in Kraków in the 14th century. So it is at least since then that in town and country churches there have been appearing small feeding troughs, shepherds, and angels.

207. Christmas Eve supper is the meal prepared in all Christian homes, starting from the wealthiest to the poorest. This is what a family of petit burghers, clerks, or possibly craftsmen looked like at their Christmas Eve table in 1926.

208

209

208. According to the Catholic tradition reaching many centuries back, the faithful visit Jesus' Grave in churches on Good Friday. In towns they make a kind of pilgrimage from one church to another in order to pray by the Grave and occasionally also to admire beautiful artistic decoration, which is only natural. The bigger the number of visited churches, the greater one's merits for heaven.

209. Easter table loaded with delicacies. There is a pig's head, a goose or turkey, there are cakes, some alcohol, and all this is beautifully decorated with a patriotic touch, namely the white eagle in the background. A proud housewife from Strzyżów in the Sub-Carpathians is posing for the photo.

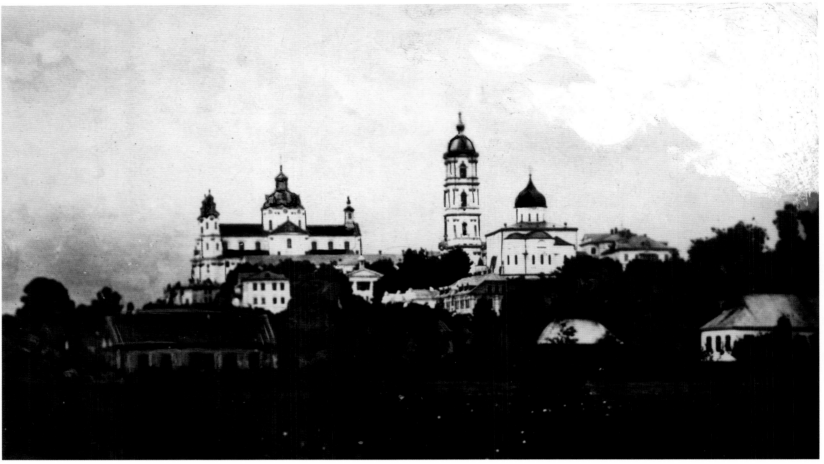

210

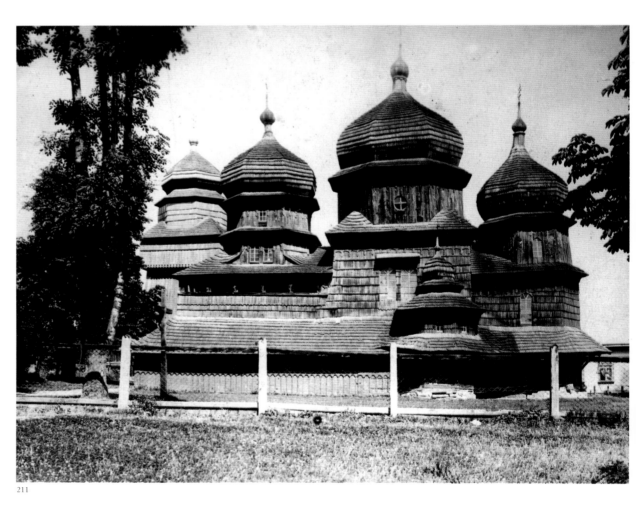

211

210. The origins of Pochaiev Lavra, Ławra Poczajowska, can be traced as far back as the mid-13th century. After the Mongol army had fully devastated Kiev in 1240, some of the monks from there fled to hide in the Pochaiev caves. This is one of the major sanctuaries in Volhynia, this is where the devout monk Job was active and his grave is to be found in the church. The Baroque church and surrounding buildings were raised in 1771–1783.

211. Wooden architecture of Orthodox churches is equally wonderful to tourists and experts. It enchants with the beauty of great carpentry. The Orthodox Church of St. Yur in Drohobycz raised in 1657 from some older building timber and crowned with three cupolas, ranks among the most excellent monuments of that architecture.

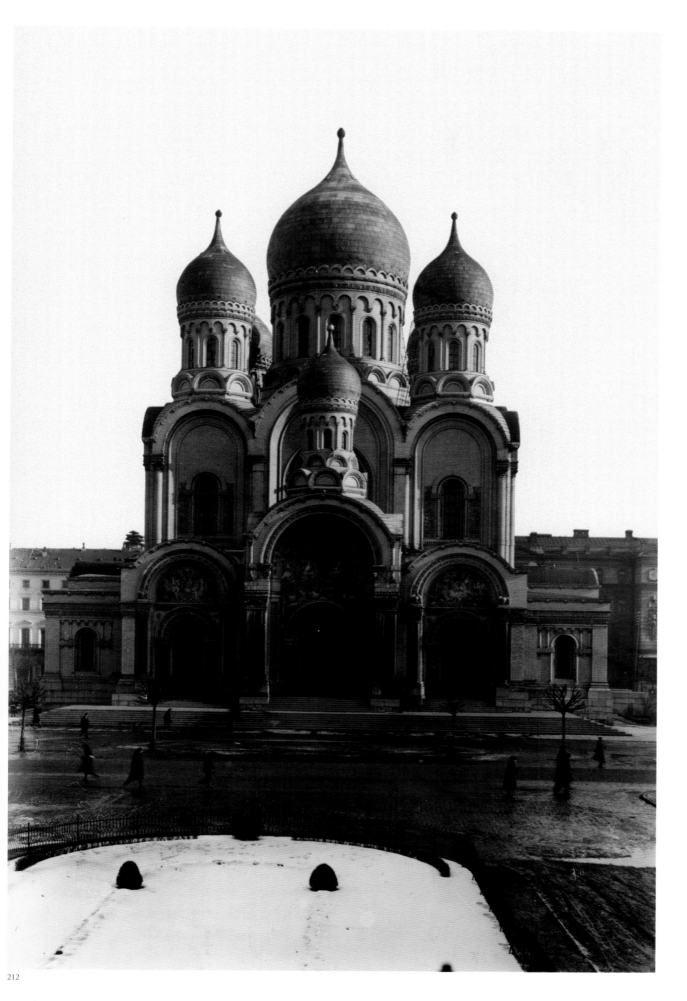

212

212. The Orthodox church on Saski Square in Warsaw was raised by the tsarist authorities as the symbol of the Russian character of the "Country on the Vistula', as the former territories of the Kingdom of Poland were called; it was erected to commemorate the three hundred years of the tsarist Romav family. Consecrated in 1913, it was demolished in 1923, in the already independent Poland, on the decision of the Council of Ministers of the Republic of Poland. Precisely because it was meant to symbolize the tsarist imperialism.

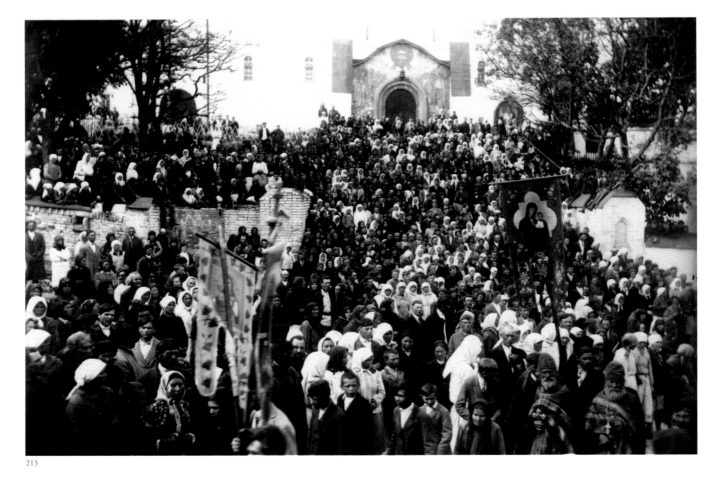

213

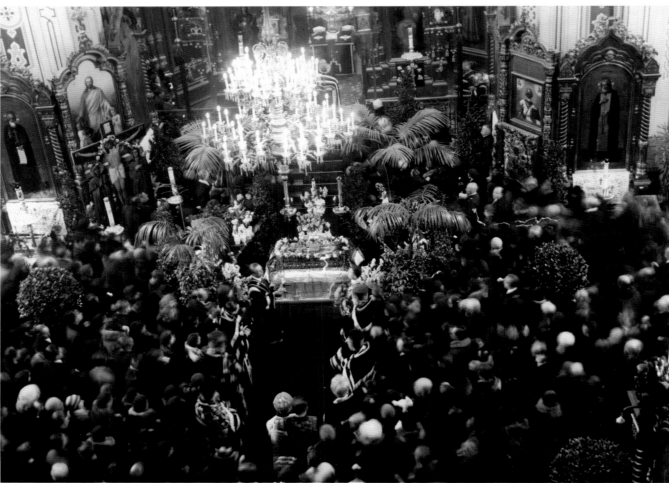

214

213. Lavra is a Russian word of Greek origin meaning 'Monastery'. Starting from 1597 Pochaiev Lavra was a sanctuary of the icon of Our Lady of Poczajów. This picture from 1930 shows pious pilgrims, Orthodox followers, heading for the Lavra.

214. A Good Friday service in an Orthodox church in Warsaw in 1931. The faithful have flocked in a great number to pray before the magnificent iconostasis glittering with gold.

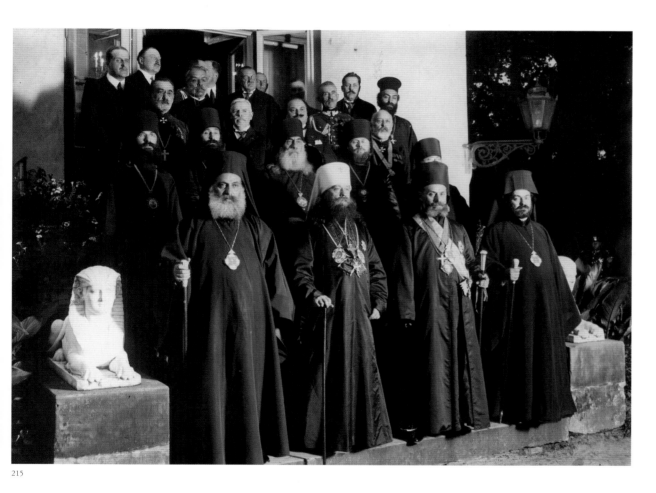

215

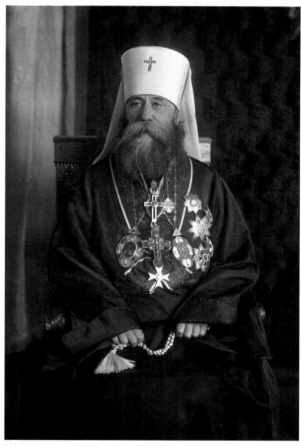

216

215. On November 13, 1924 the Patriarch of Constantinople Gregory VII made the Orthodox Church in Poland autocephalous, which implied autonomy in actions, teaching, and administration. Hence the Orthodox Church was no longer subordinated to Moscow. On September 17, 1925 this significant act was ceremoniously proclaimed. High hierarchs of the Polish Orthodox Church and all the invited guests commemorated that day with a memento photograph.

216. Portrait of the Metropolitan of the Orthodox Church in Poland Dionizy (Konstanty Waledyński).

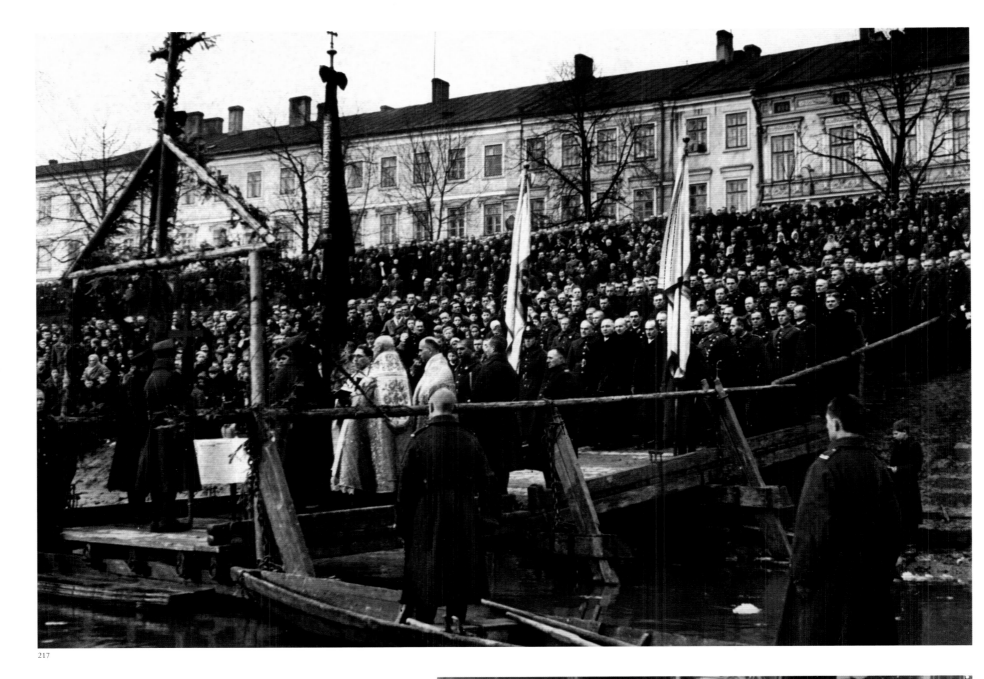

217

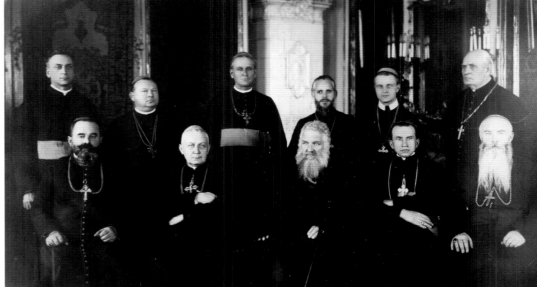

218

217. The Holiday of the Jordan, namely Theophany, or also Epiphany, is celebrated in the Orthodox and Greek Catholic Churches after New Year to commemorate Jesus' baptism in the river Jordan. This is the time when water is blessed by immersing a cross in it three times. The Jordan in the photo is in Przemyśl in 1936.

218. A conference of the Greek Catholic bishops was held in Lviv in December 1927. Among the present we can see Archbishop Metropolitan of Lviv Roman Andrzej Szeptycki (1865–1944) and the Przemyśl Bishop Jozefat Kocyłowski, beatified by Pope John Paul II during his pilgrimage to Ukraine in 2001.

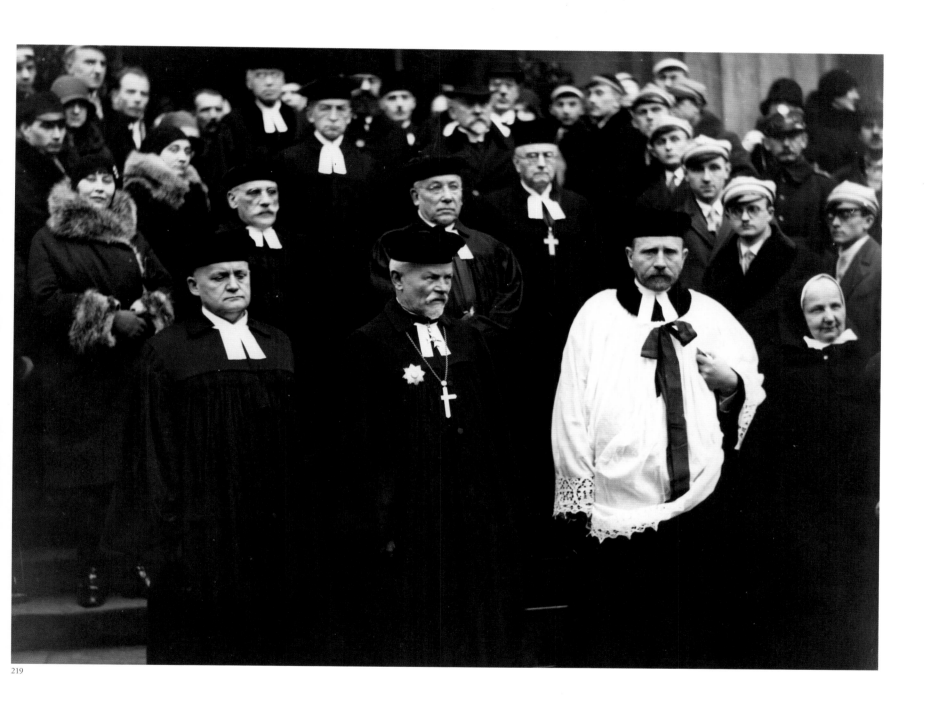

219

219. Bishop Juliusz Bursche (1862–1942) is a personality of great merits representing the Evangelical-Augsburgian Church in Poland. In the picture we can see him surrounded by the ministers and faithful on the day that he is celebrating 25 years of his superintendency.

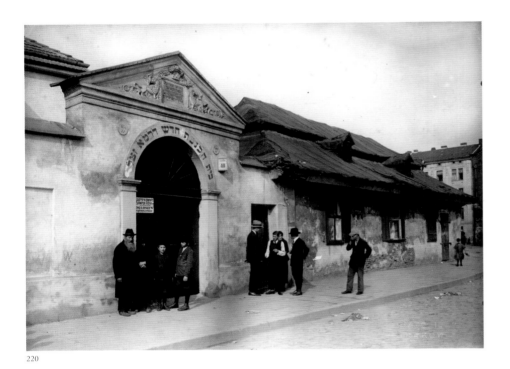

220

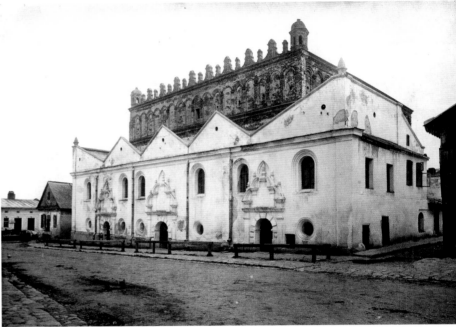

221

220. Kazimierz, a district in Kraków, boasts of old Jewish tradition. It was founded by King Casimir the Great and starting from that time until the Holocaust it was inhabited by the Jews. This accounts for quite a number of synagogues here: the Old Synagogue, being high Gothic, R'emuh Synagogue erected in the second half of the 16th century, High Synagogue coming from 1590, and that of Isaac from 1640. The photo shows a Baroque gate leading into R'emuh Synagogue bearing a religious inscription on the tympanum.

221. One of the most beautiful synagogues on the territories of the old Poland is to be found in Żółkiew. This is a High Renaissance building clearly referring with its style to the lay monuments of architecture of the period, which have been preserved in our country in quite a big number. Specially the attic of the main building reminds one of the decoration of the Krasiczyn walls. It is important to note that the walls of the synagogues are decorated with the coat-of-arms of King John III Sobieski.

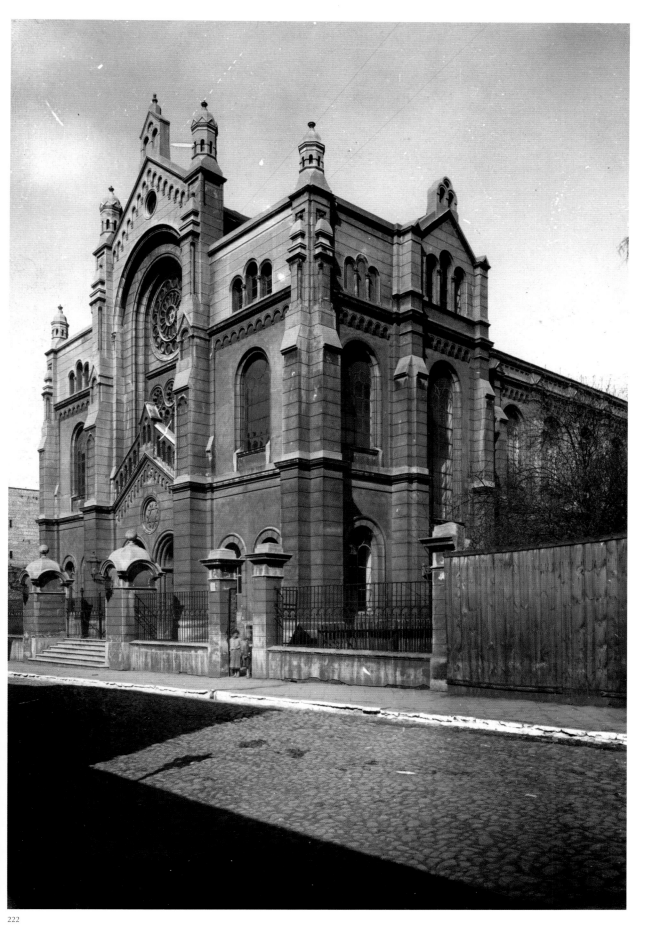

222

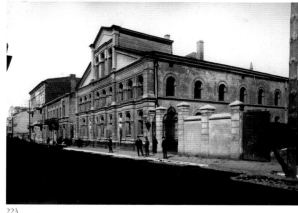

223

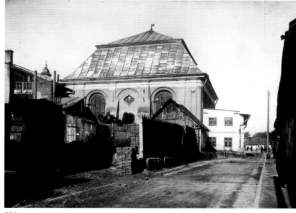

224

222. Synagogue in Wółczańska Street in Łódź was raised in 1899–1904 after the design of the architect Gustaw Landau Gutenteger. Combining various features of mock Romanesque, it differs significantly from the traditional forms of Jewish synagogues. It was burnt down and dismantled in 1940.

223. In Łódź, too, just like in many other Polish towns, the Nazis did not only murder thousands of people, but they also destroyed the majority of the material testimony of the old culture, particularly Jewish. Once there used to be a 19-th-century Wilker Shul Synagogue in Zachodnia Street. There is no single trace of it: a busy street runs here.

224. The no-longer existing synagogue in Przeworsk in the Sub-Carpathians was built in the 18th century. One can see what it looked like in the photo from 1935. Amidst wooden destroyed buildings it demonstrates its Baroque form, walls separated by panels, a mansard roof, the interior covered with polychrome, and a brick lectern.

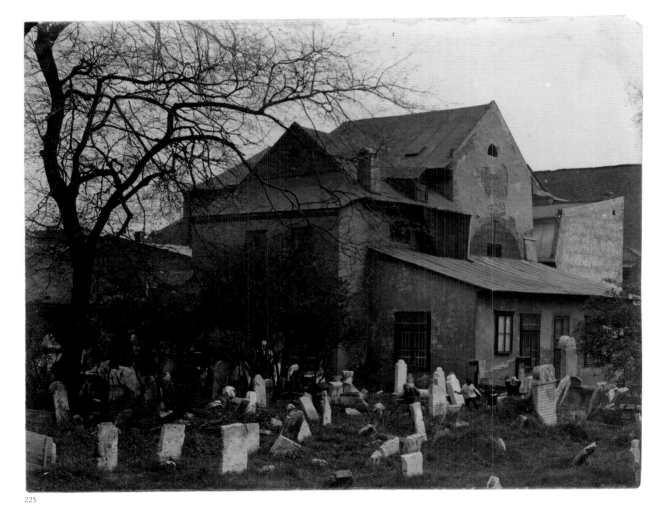

225.

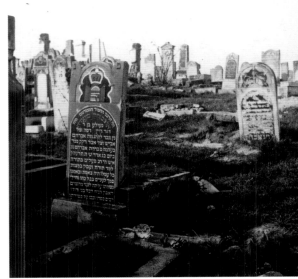

226

227

228

225. Jewish cemetery by the New Synagogue in Kraków.

226, 227, 228. Jewish cemeteries are, unfortunately, among the very few material mementos left over by the great culture that from the early Middle Ages was created on our territories by the Jews. During almost all that time representatives of the Jewish people used to live on peaceful terms with the Poles and all other nations, they contributed to our history, and were present in a great number on the pages of our literature, to mention only the Jew Jankiel playing the cymbals in Mickiewicz's *Master Thaddeus*.

230

229

231

229, 230, 231.  In the pictures we can see Jewish standing tombstones (matzewas) with inscriptions
referring to the dead and including symbolic signs.

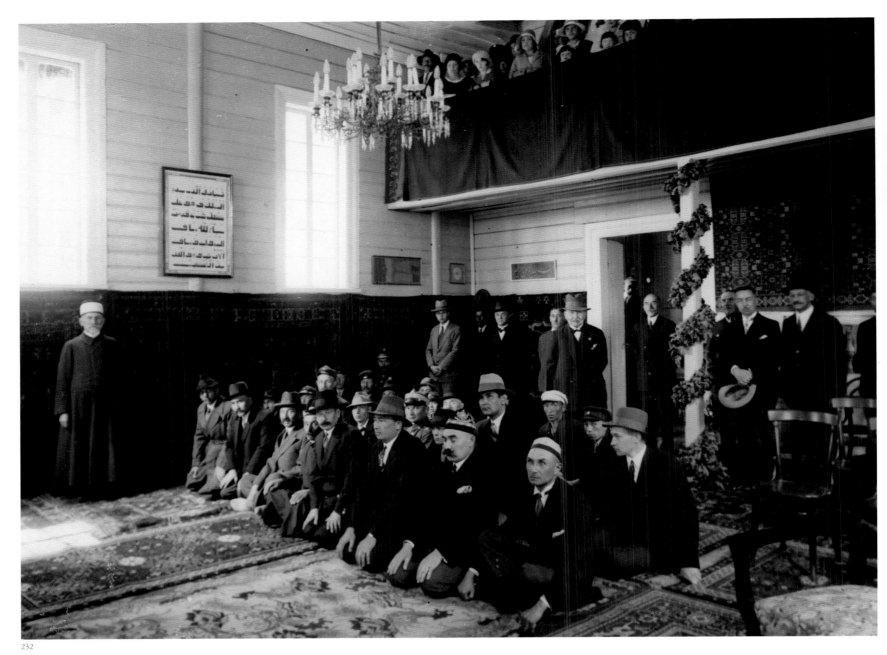

232

233

232. There used to be a mosque in Łukiska Street in Vilnius. Still in the 19<sup>th</sup> century it was a glorious wooden building with small minarets and arcades. It was later replaced by a brick building, almost styleless. The Muslims, quite numerous on those territories, came here in different periods of time; tradition has it that they were originally brought here by the Grand Duke of Lithuania Vytautas.

233. Cemeteries are witnesses to history — this is an old truth confirmed by many cities in the world. A multinational Warsaw had quite a number of such necropolises. Next to the Catholic cemeteries, there were also Protestant, Orthodox, and Jewish ones; and in Tatarska Street there was a small Muslim cemetery. Established in 1867, it was already in use under the partitions, and it was there that Muslim soldiers from the Russian army were buried. The cemetery also served the Polish Tartars living in Warsaw and outside it.

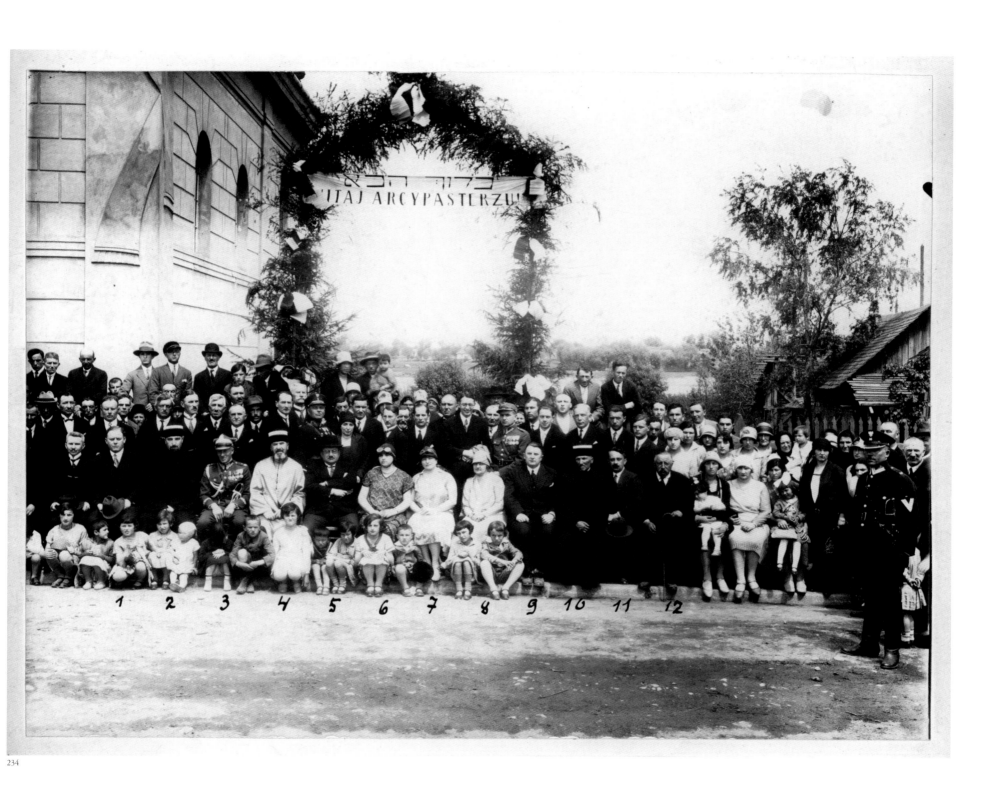

234.

234. The Karaims were a minor national-denominational group brought to the Vilnius Land in the 14th century by Duke Vytautas. They used to live in Troki and Vilnius, and also near Łuck and Ołyko. Their religion was based on the Old Testament, they had their own language and culture. Today a small group of the Karaims still lives in Warsaw and Wrocław. This picture taken most probably during a Karaim Congress in Vilnius on April 26, 1936 shows the Karaim leader Szapszał Seraj surrounded by the invited guests, e.g. Gen. Łukowski, Deputy Niedźwiecki, and the Karaim clergy.

# Events

Documenting of important, but also every day events, has already a long tradition. Its traces can be found in ancient reliefs, in the visual arts of the Middle Ages and of later centuries. In the 19th century such function was taken over to a great extent by lithography. It was only the invention of photography, its further speedy development and perfecting that allowed to record various events, from a portrait and landscape to historic and political events. Today we cannot imagine reliable information without this medium.

Old portraits of the participants of the January Insurrection, family or event photographs, views of towns and villages, monumental buildings rendered in document photography, even if slightly artistically transformed, give us the fullest picture of the past. They do not cheat, they show the then world as it was, for the photographic record is a guarantee of realism of the perpetuated event.

And actually the times in Polish history documented by photography were sometimes tough, and sometimes extremely interesting. Archival pictures take us through the period of the partitions, formation of independent Poland, to the complicated period of the 1920s and 1930s. Out of the political and social chaos suddenly, not suddenly out of nothing, but from the urge for the truth, there came into existence an independent state, with its great ups and moments of difficulties that followed. This is the time of awakening, of organizing administration, recreating national economy, the period of the Great Poland Insurrection, the period of plebiscites, Silesian insurrections, and of the world economy crisis. It was also the period of a great economic progress, which is best testified by the construction of Gdynia, a Baltic port that was to counterbalance the domination of Gdańsk, or the construction of the big Central Industrial Area, unfortunately not fully implemented. It was also the time of building from the scratch of the Polish general education system, development of Polish culture and a slow, though clearly visible, enriching of the whole society. Yet, the then European policy, actually totally independent from us, as well as a certain isolation of Poland not very powerful at the time, eventually led to the disaster of World War II. And with this came the end of that Second Republic of Poland. It was occupied by two powers that for years had been hostile to us, whereas the Molotov-Ribbentrop Pact in a barbarian way deprived this country of any opportunity to develop and made it sink in total stagnation for half a century.

Old photographs have naturally been able to only fragmentarily evoke that time which the elder miss, whereas the younger ones think of as if it were a period almost as distant as the January Insurrection. *Hic transit gloria mundi.*

235. Opening of the Parliament session in December 1938. The welcoming speech was delivered by Prime Minister Franciszek Sławoj-Składkowski.

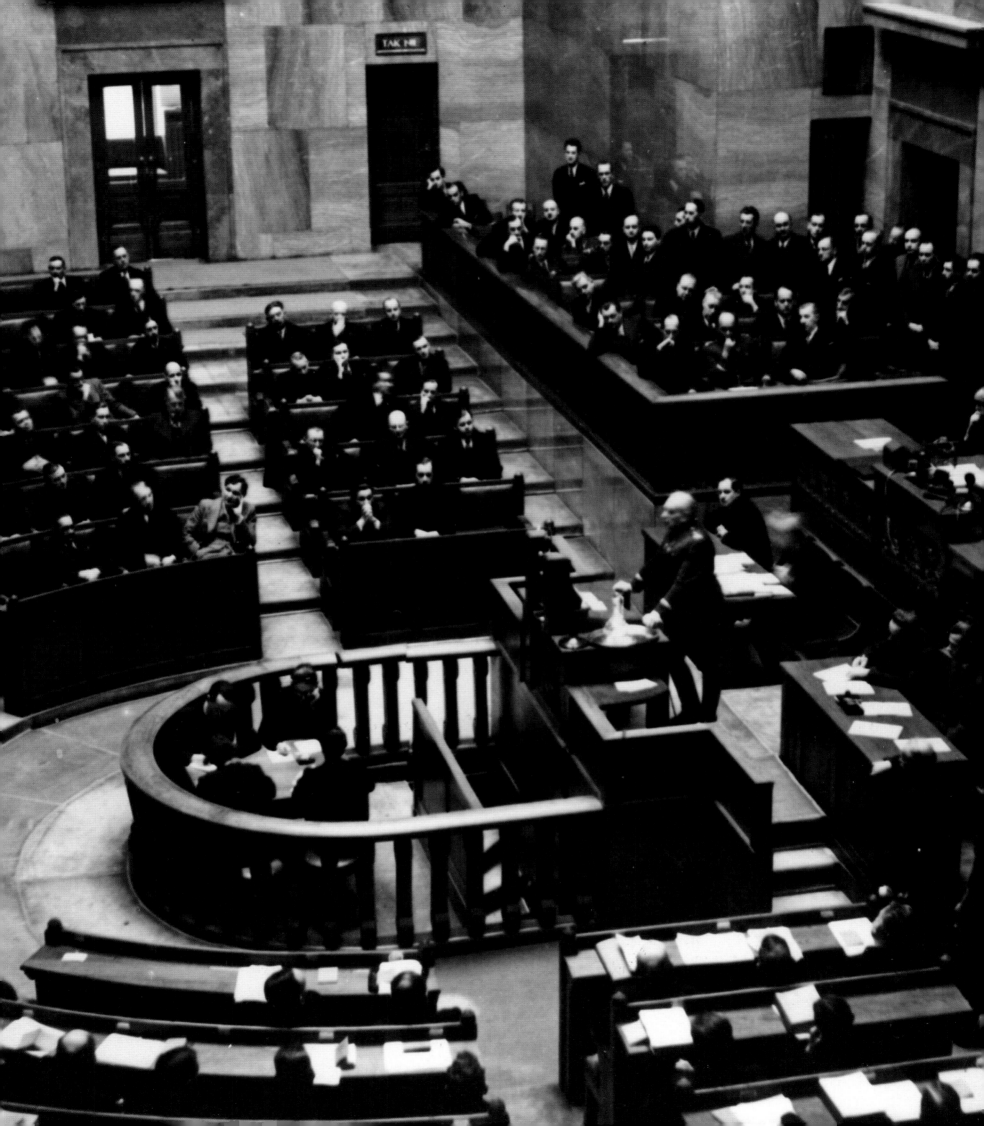

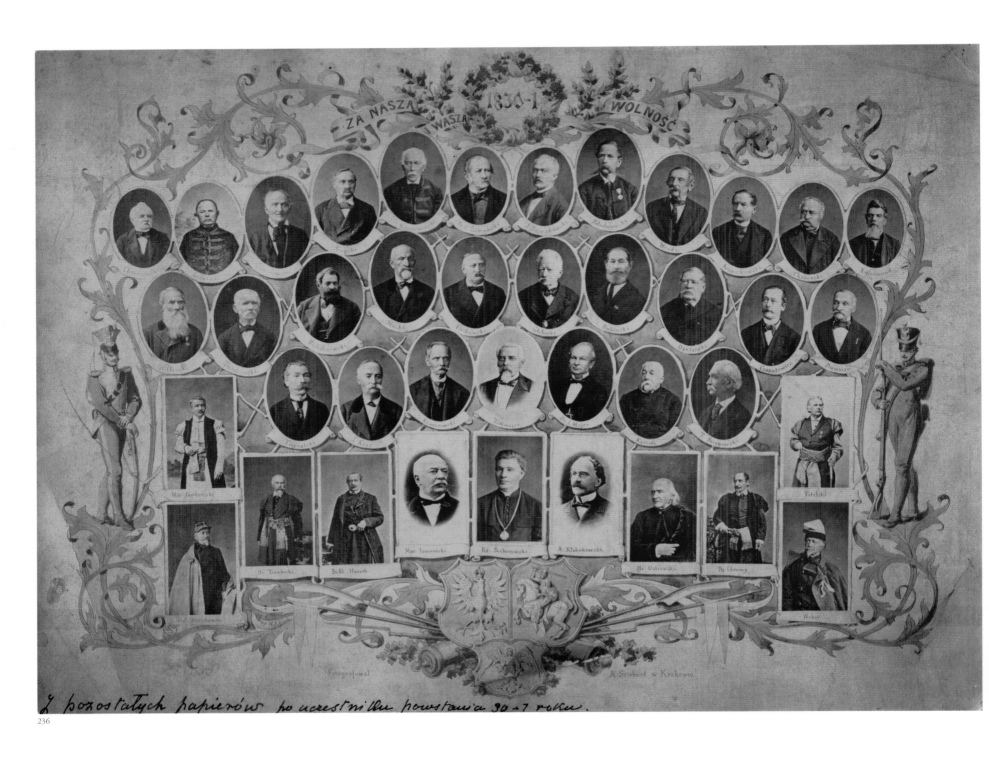

236. Until today a collective picture, tableau, of 39 participants of the November Insurrection, being a great effort of the Polish nation to regain independence, has been preserved in the collections. This is a beautiful historic picture, taking us back into the old time. On a decorative chart ornamented with military symbols, coat-of-arms, acanthus twigs, portraits of distinguished and heroic men are placed in oval frames. They are already old, tired with life — the photo may have been taken around the 1880s or possibly slightly earlier in the famous Kraków's studio of Awit Szubert.

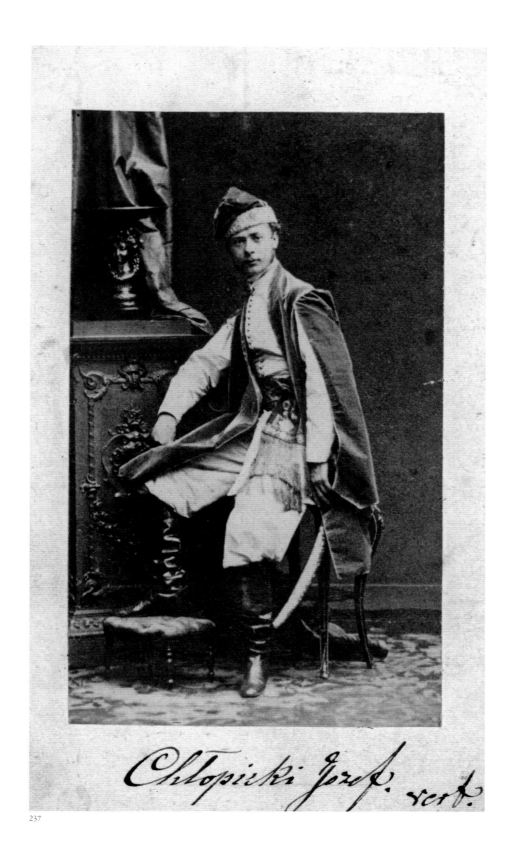

237

237. Young Józef Chłopicki in nobleman's dress, with a traditional Turkish sabre, a proud member of a family with great patriotic traditions.

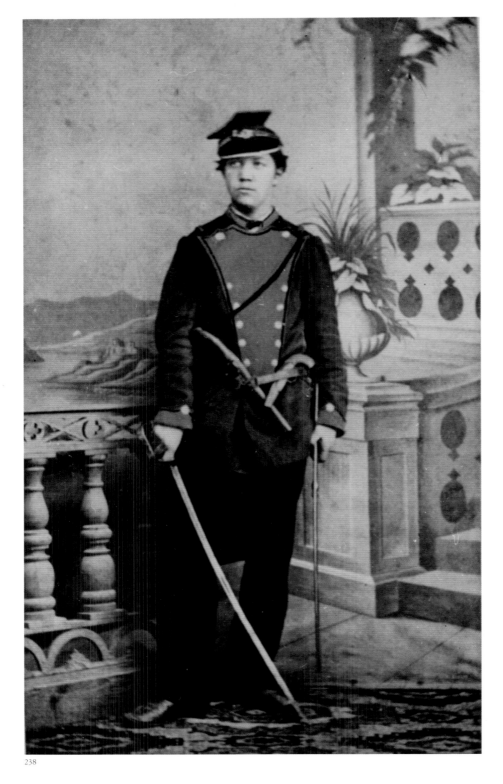

238

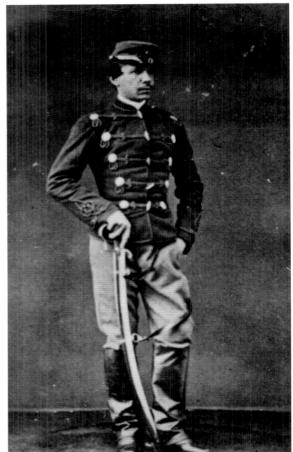

239

240

238. The January Uprising was on the most dramatic moments in Polish history. The archival photos have preserved the faces of its participants. Makary Drohomirecki, leader of the insurgents' party in the Kalisz Voivodship, perished on February 12, 1863.

239. Colonel Teodor Cieszkowski, commander of the insurrection troops in the Kalisz Voivodship was killed at Broszencin on April 10, 1863.

240. Edward Jurgens, member of the National Government, leader of the political group of the intelligentsia and Warsaw's liberal middle class. He perished at Warsaw's Citadel on August 2, 1863.

241. Władysław Dunin, organizer of the insurgent troops in the Kalisz Voivodship.

242. Jarosław Grotttger, born in 1849, injured in the Wieluń Voivodship. He survived and the picture was taken in a later period.

243. Jan Jeziorański (1835–1864), member of the National Government, executed at Warsaw's Citadel together with Romuald Traugutt.

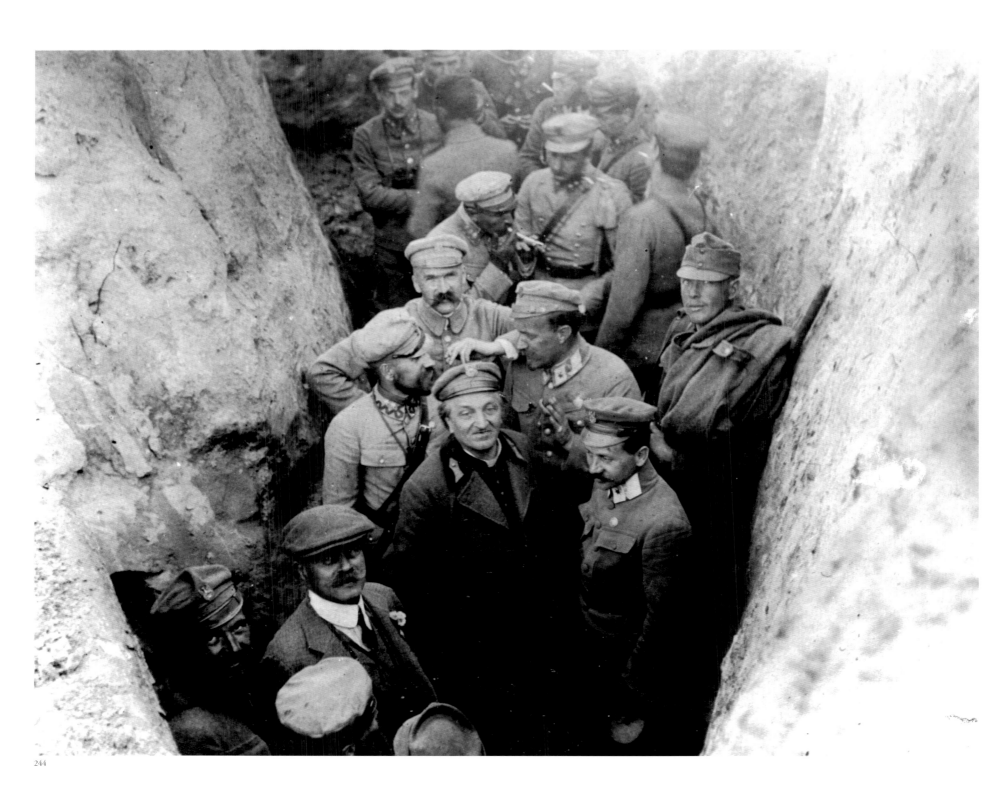

244

244. Legionaries in trenches. Among them Field Bishop Władysław Bandurski,
Commander Józef Piłsudski and higher ranking officers.

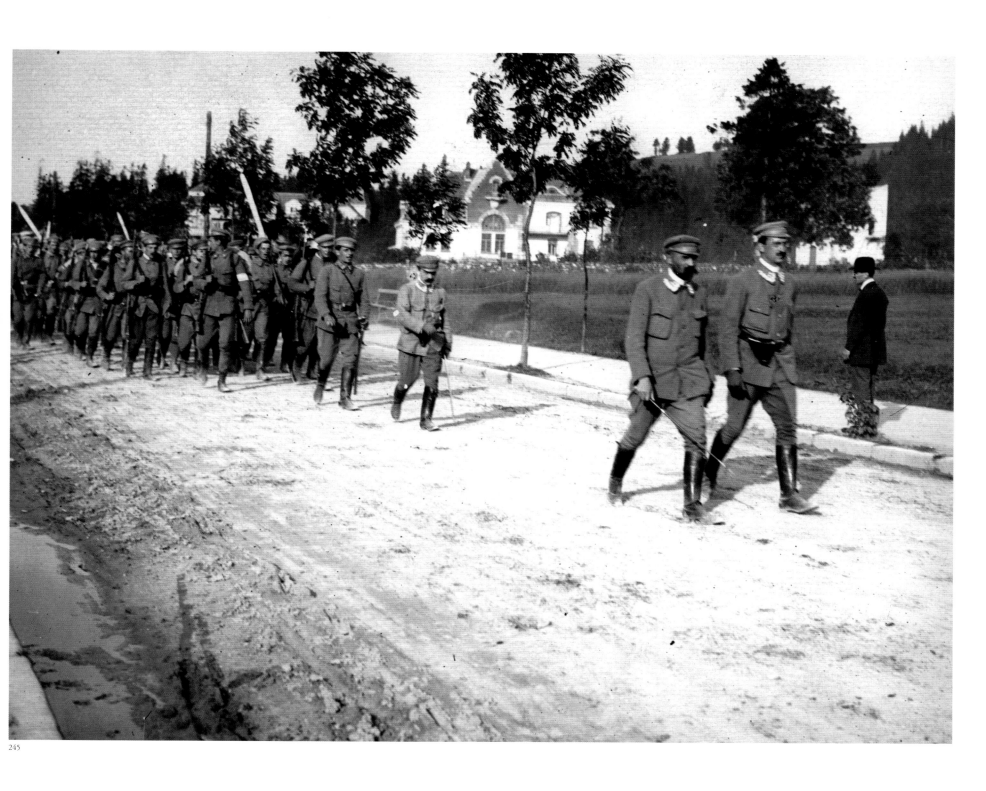

245

245. Riflemen's Squad is marching with Commander Józef Piłsudski and Kazimierz
Sosnkowski, Chief of Staff and Commander's Deputy at the head. The soldiers wearing
their uniforms and special traditional Polish caps, are under arms. One of them is
carrying a folded standard. Such were the troops that brought Poland independence
after 123 years of having been deprived of liberty.

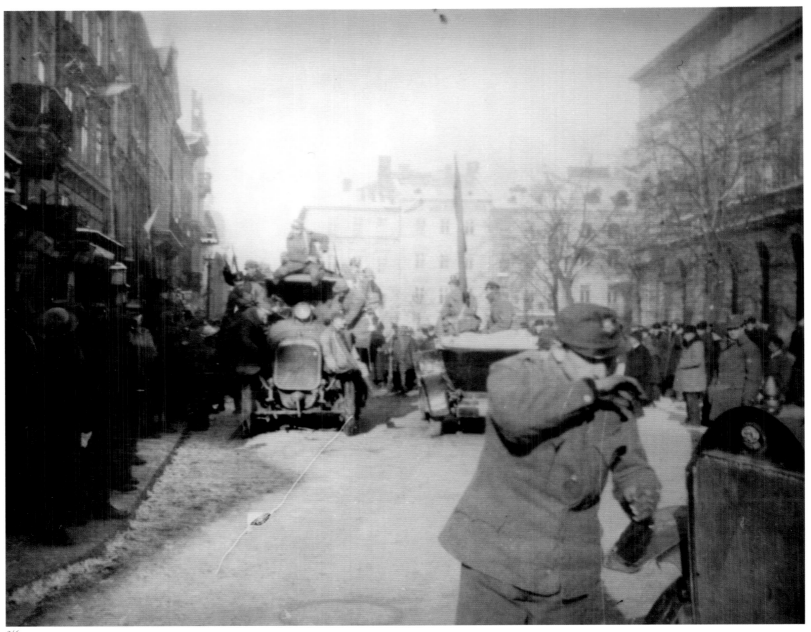

246

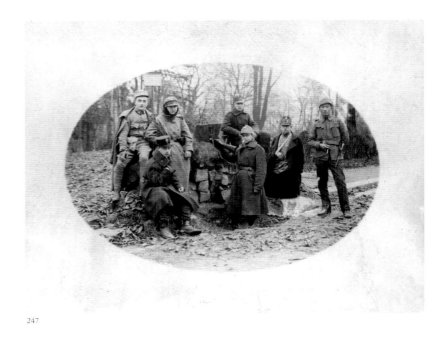

247

246. Also the army became involved in the defence of Lviv in November 1918. Citizens are welcoming regular troops on the market-square.

247. The defence of Lviv in November 1918 has taken its inherent place in our history, first of all due to the participation of voluntary troops, mainly the Lviv Eaglets It was thanks to their heroism and the sacrifice of their lives that their beloved city was defended and incorporated into Poland. One can clearly see the young that they were in the picture showing a group of Lviv Eaglets in the Garden of the Jesuits.

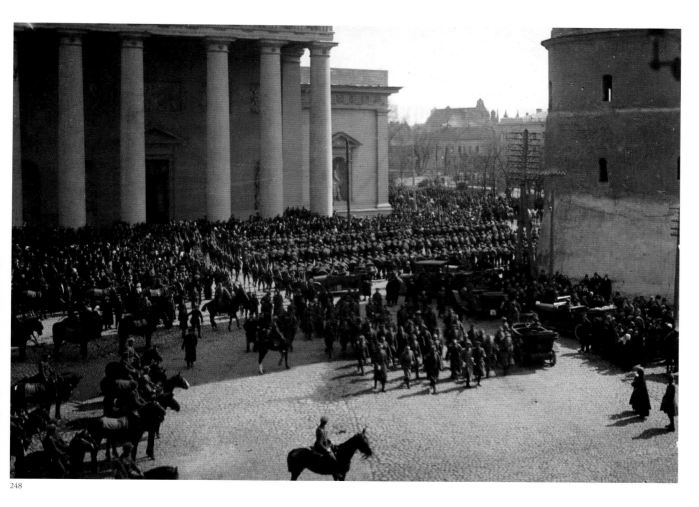

248

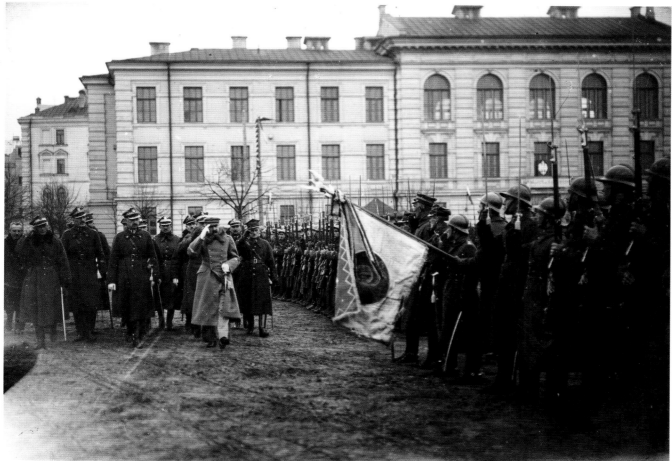

249

248. On the square in front of the Vilnius Cathedral Polish troops are preparing for a parade in 1919. Around them we can see the city population who were happily, almost enthusiastically welcoming the soldiers and their commanders; this attitude is widely confirmed by written records and memoires. Photo I. Siemaszko

249. After Vilnius had been captured in 1919, Commander Józef Piłsudski together with his staff are inspecting the troops, saluting the regiment flag lowered before him. Photo J. Bułhak.

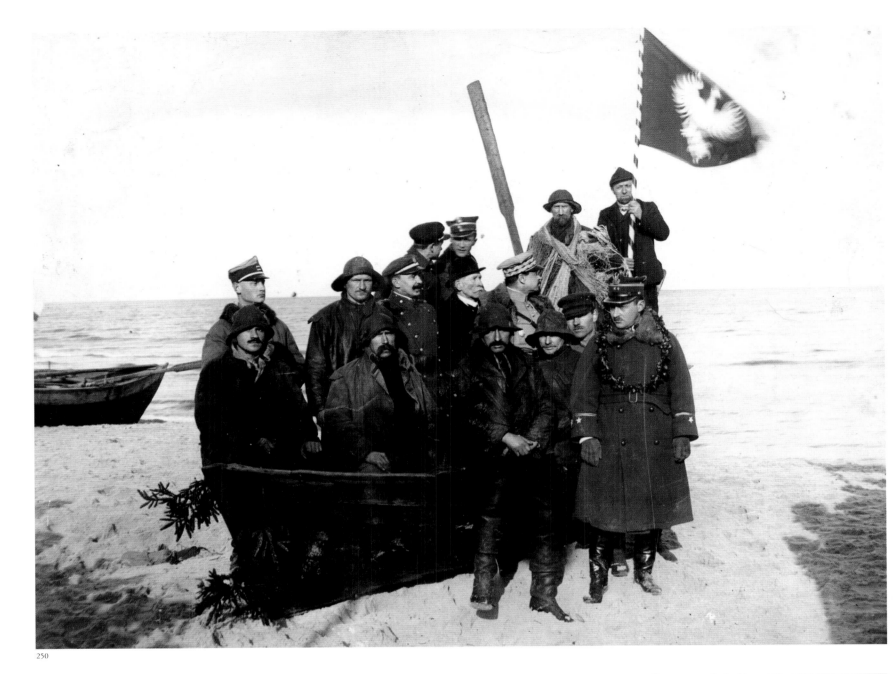

250

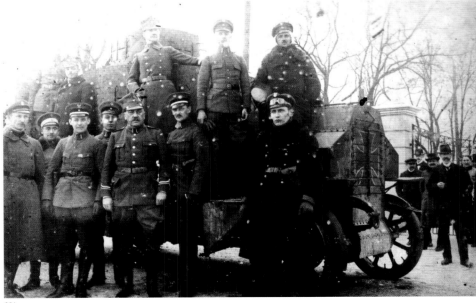

251

250. The wedding the sea ceremony took place in Puck on February 10, 1920. According to a contemporary testimony, Gen. Józef Haller rode his horse onto the ice near the shore and threw a ring into the waves. It was a symbolic, but also a very beautiful event. In the photo Gen. Haller together with the officers and local fishermen is posing for a memento photograph on a boat pulled ashore for the purpose.

251. During the Great Poland Insurrection, on February 7, 1919 the Rogozin Company captured a German armoured vehicle near Chodzież. The command of the Northern Insurgents' front together with Gen. Kazimierz Grudzielski had their picture taken against the vehicle.

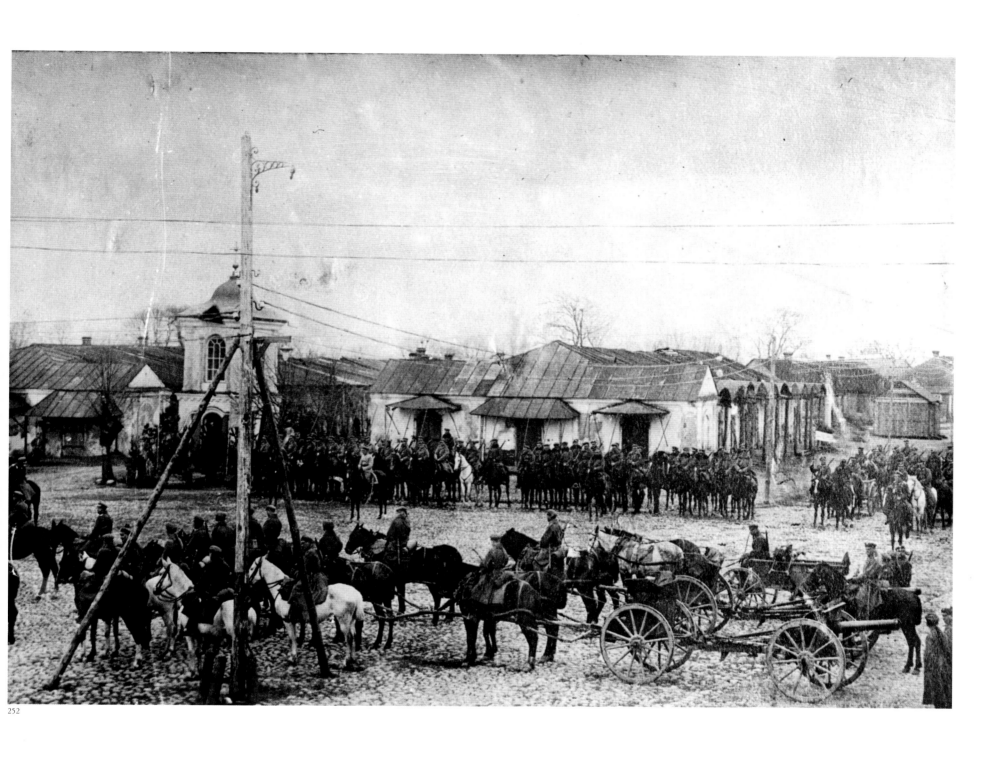

252

252. The Polish-Bolshevik war of 1919–1920 was one of the most challenging, yet at the same time victorious moments in our history, climaxed with the battle of Warsaw in 1920. In Pińsk, in Polesie, Polish troops, meaning cavalry and artillery, are getting ready in 1919 for the battle against the Red Army which, according to Lenin's strategic assumptions, was to launch a victorious march to the West.

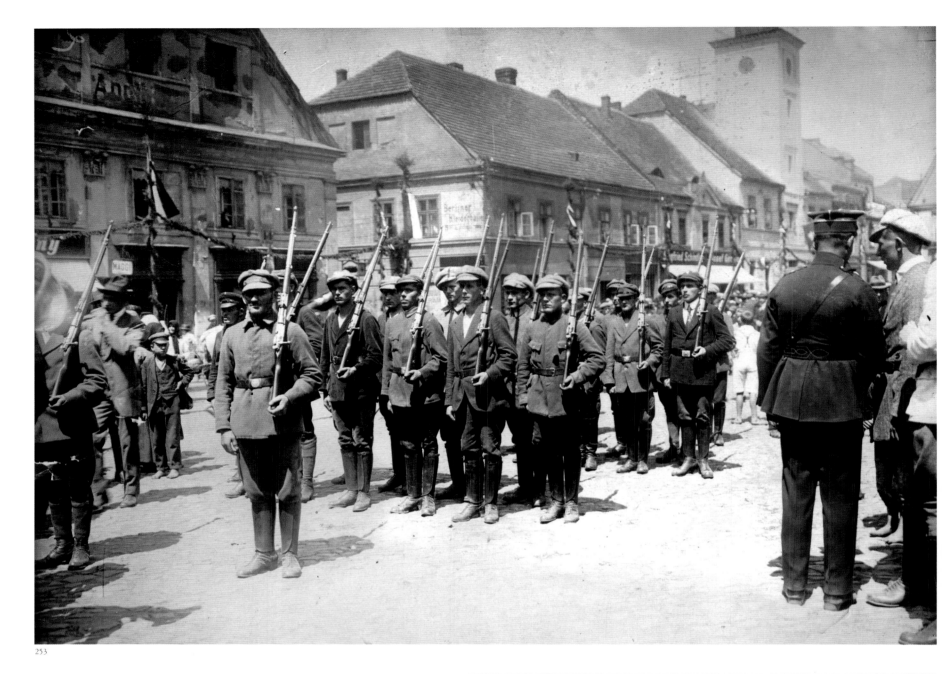

253

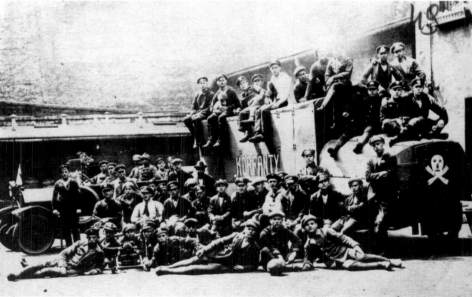

254

253. The 3rd Silesian Uprising broke out on the night of May 2, 1921. It was the reaction of the Polish population to the concept of the Inter-alliance Committee which propagated the idea that all Silesia be granted to the Germans. The fights broke out, e.g. on St. Anne's Mount, and they were fierce fights for every inch of ground. In the result of the battle Poland was granted Katowice, Chorzów, and some communes. On Rybnik's market-square insurgents' troops are standing ready to fight.

254. During the 3rd Silesian Uprising its participants struggling for the land to be incorporated into Mother Country are posing on the captured armoured vehicle called 'Korfanty'. The patron of the vehicle, Wincenty Korfanty (1873–1939) used to be a nationalist activist, leader of the insurrection in Upper Silesia, who doggedly fought for the Polish identity of these territories.

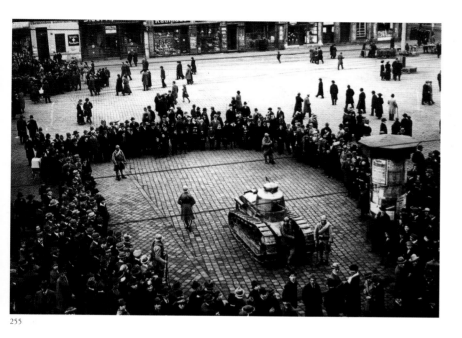

255

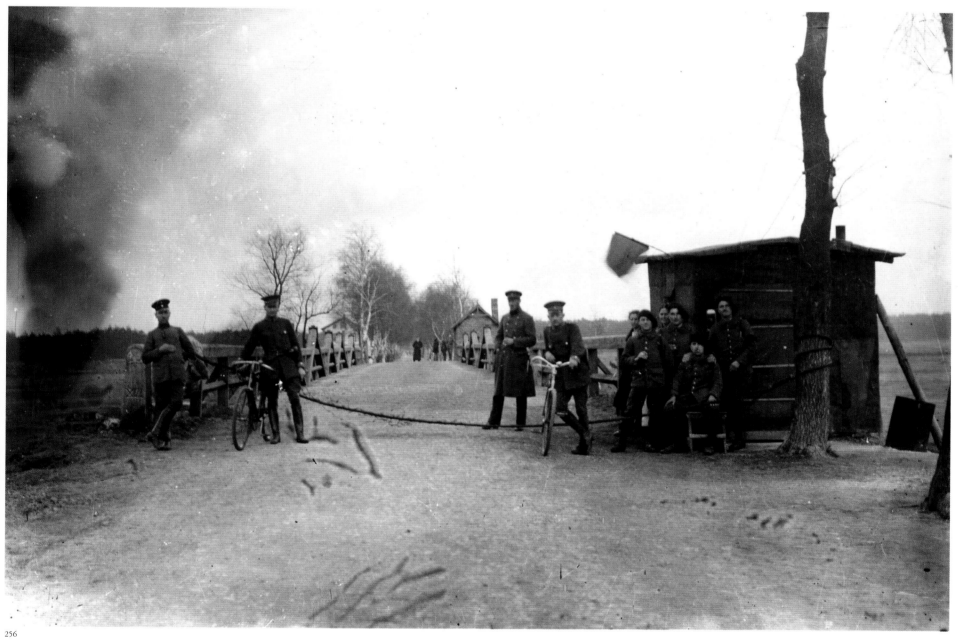

256

255. According to the Treaty of Versailles there was going to be a plebiscite held in Upper Silesia to decide who that territory should belong to: Germany or Poland. As we know, at that stage Poland was granted merely a small fragment of it. It was because of the plebiscite in May 1921 that French troops were stationed in Katowice.

256. The frontier separating the two countries: Poland and Germany in 1920–1921, still before the plebiscite, did not look so sinister. Here is a stand on a river, possibly the Przemsza; it is a wooden insignificant building, no barriers, just some rope hanging. The soldiers are clearly bored. One can sense that the situation is merely transitory: after all, just of few kilometres away from here the Silesians are getting ready to start the 3rd Uprising to defend the Polish identity of this land.

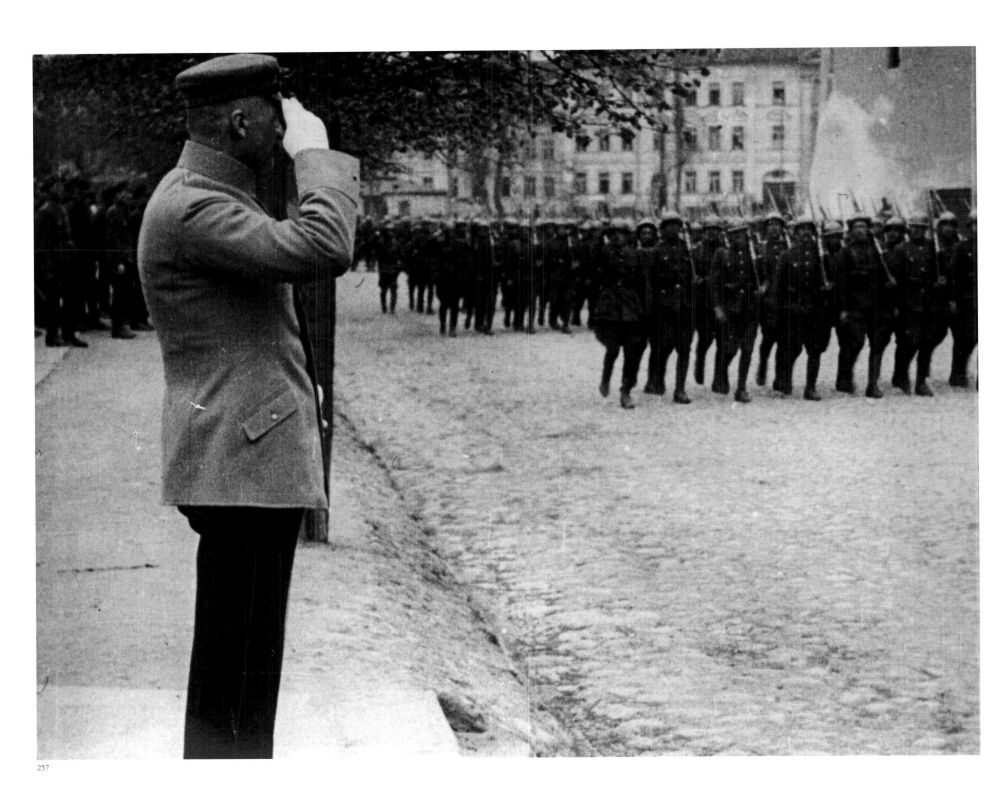

257

257. On February 20, 1922 the Vilnius Parliament passed a resolution incorporating the whole of Vilnius territory into Poland. On April 18 of the same year the parade of the Polish troops took place on Katedralny Square in the recaptured city. Photo J. Bułhak

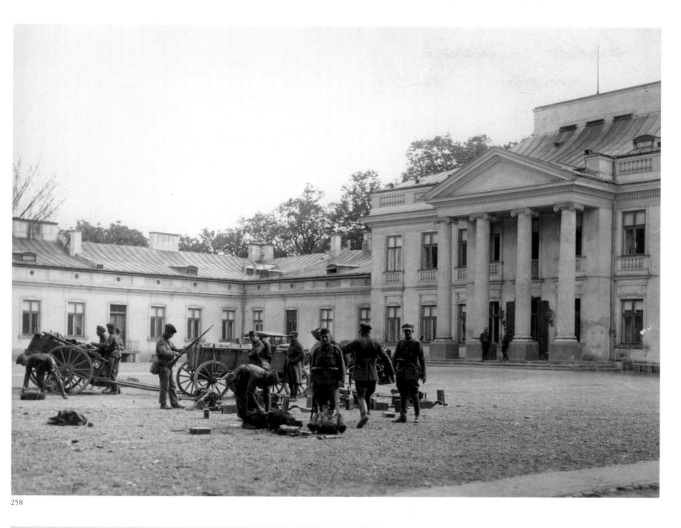

258

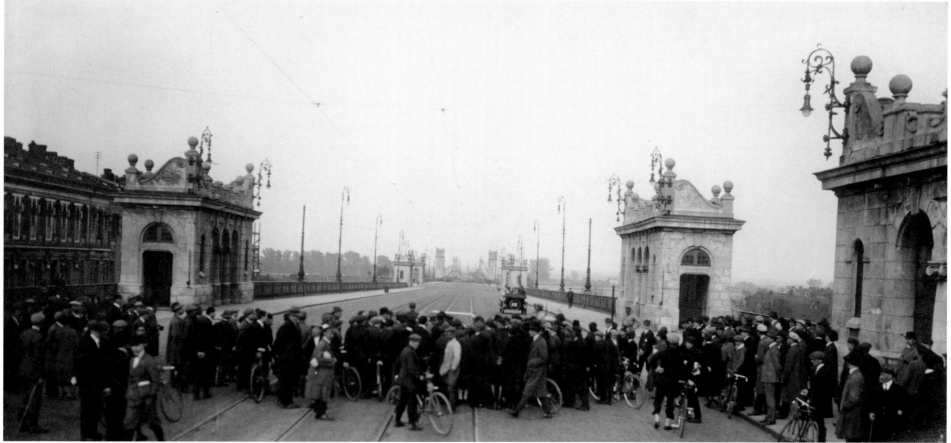

259

258. During the difficult moments of the May coup d'etat in 1926, a group of soldiers is getting ready for the fights in the courtyard in front of the Belvedere.

259. The May coup d'etat, being a military coup carried out by Józef Piłsudski took place on May 12–16, 1926. Commanding his loyal army, Piłsudski left Rembertów for Warsaw and after three days' fights, he captured the capital taking over power in the country. Here is Poniatowski Bridge in Warsaw: on the one side of the river there is a group of civilians in arm-bands, soldiers, and on the other side of the river, in the distance — their adversaries.

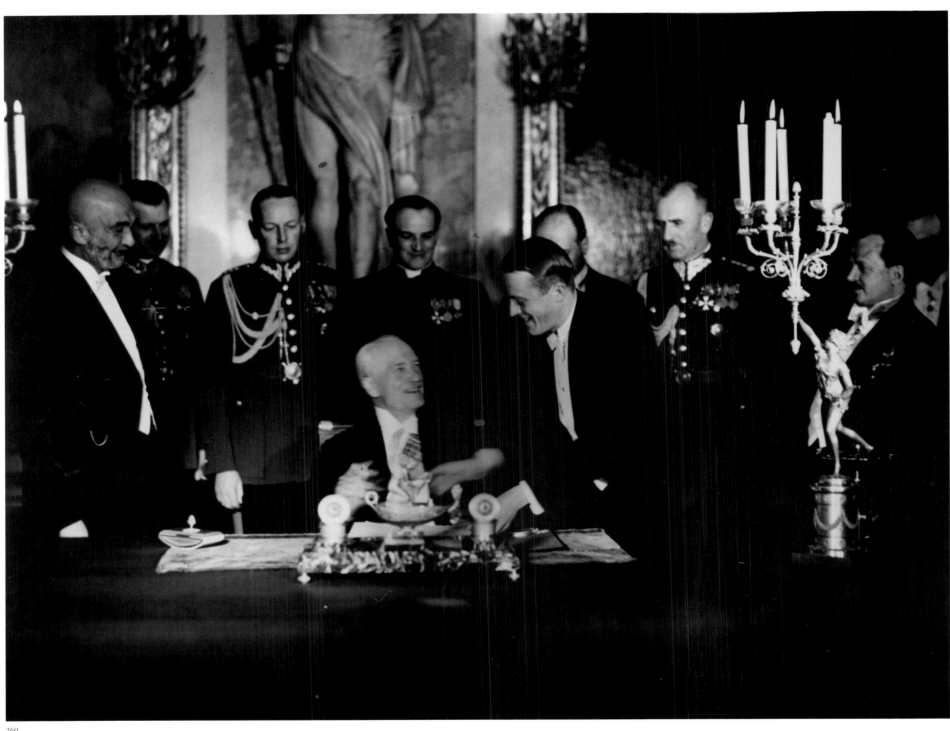

260

260. Ceremonious signing of the new constitution on April 23, 1935 by President of the Republic of
Poland Ignacy Mościcki in the presence of many dignitaries. The Constitution, known in Poland as
the April Constitution instituted the presidential system in Poland, curbing the power of both
Seym and Senate. It was the president who appointed the government, the Commander-in-Chief,
and the Inspector of the Armed Forces. He was given the rights to issue decrees.

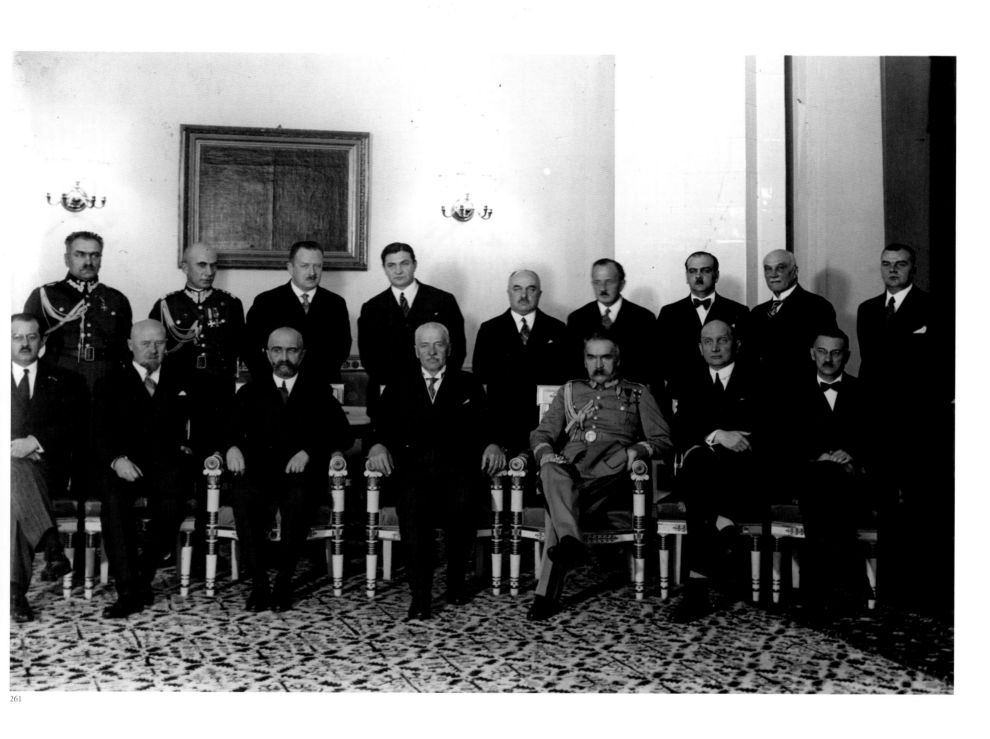

261

261. On December 5, 1930 the ceremony of administering and oath of the new government of Walery Sławek took place in Warsaw. The ceremony was attended by Marshal Józef Piłsudski, President Ignacy Mościcki, the Prime Minister and ministers. Walery Sławek (1879–1939) was the founder of the BBWR (Non-party Block of the Cooperation with the Government), one of the authors of the April Constitution, and Speaker of the Seym in 1938. After the death of Józef Piłsudski he was pushed off the political scene. In 1939 he committed suicide.

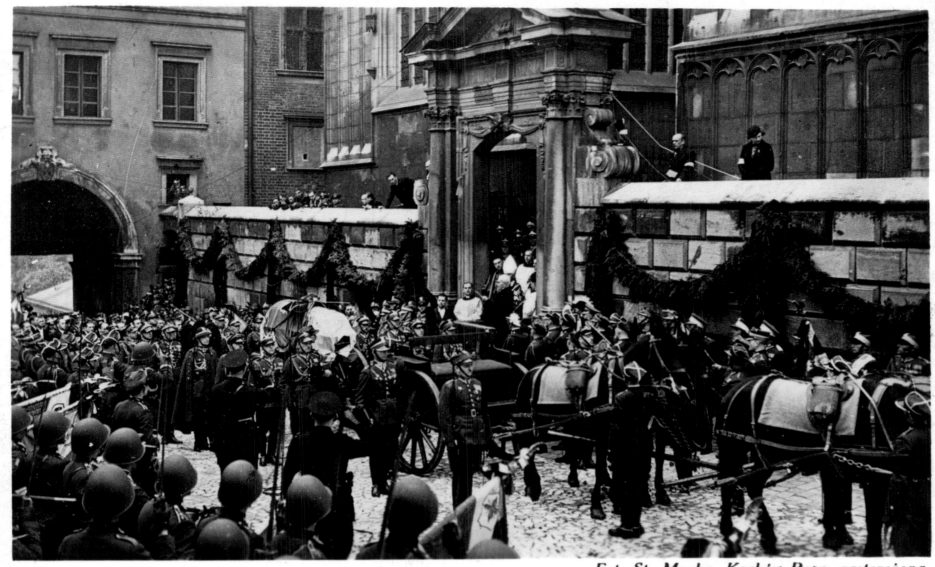

Fot. St. Mucha, Kraków. Repr. zastrzeżona.

262

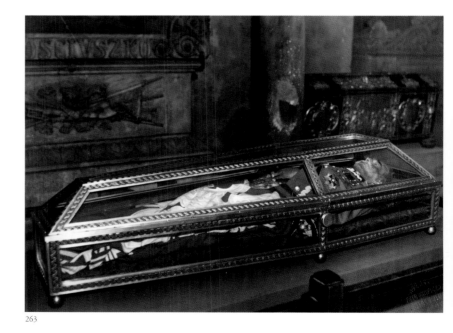

263

262. The funeral procession with Marshal Józef Piłsudski's coffin on a gun-carriage at the entrance to the Wawel Cathedral. After the funeral ceremonies, the Marshal's body is to be placed in the burial crypts.

263. After a ceremonious funeral in 1935, the body of late Marshal Józef Piłsudski placed inside a crystal coffin, was deposited for some brief time in St. Leonard's Crypt in the Wawel Cathedral. Only after the necessary alteration works had been carried out, it was transferred to the crypt under the Tower of Silver Bells, where it has remained until today.

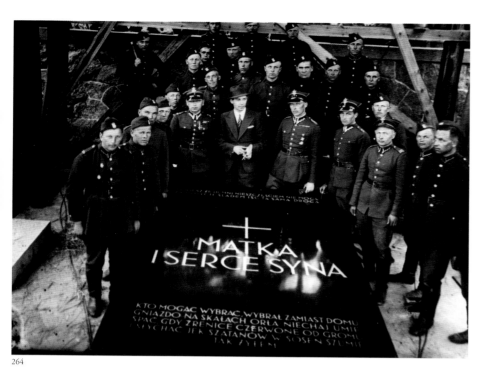

264

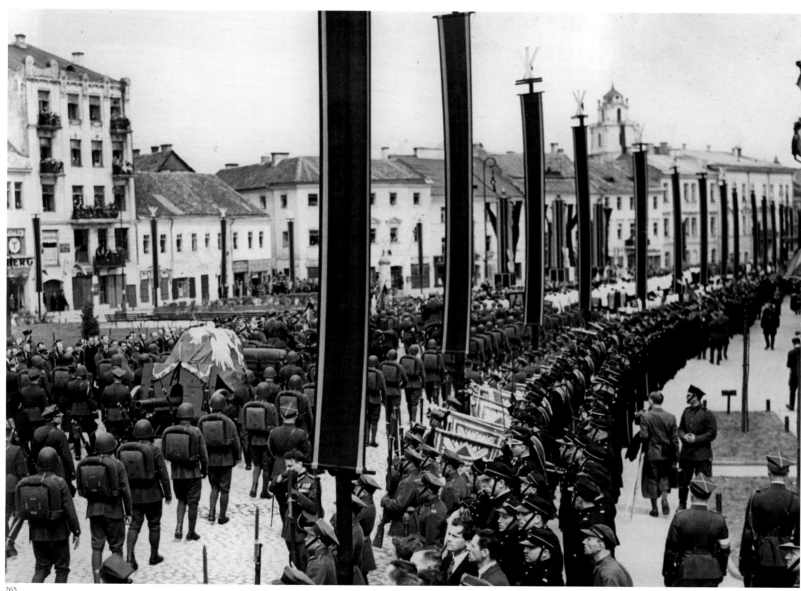

265

264. A ceremonious deposition of the urn with Marshal Józef Piłsudski's heart and the ashes of his Mother Maria Piłsudska nee Billewicz at Rossa Cemetery in Vilnius took place on May 12, 1936. A large rectangle tombstone of black Volhynia granite with the inscription: 'Mother and her son's heart', accompanied by quotes from Julisz Słowacki's poems, is the central element of this military necropolis.

265. On May 12, 1936, the funeral procession with the heart of Marshal Józef Piłsudski marched along the streets of Vilnius. The urn was placed on a gun-carriage, and the funeral rites were celebrated with all the military honours. The inhabitants of Vilnius flocked in large crowds to bid farewell to their liberator. After a religious service, the heart was deposited in the cemetery by the ashes of Marshal's mother.

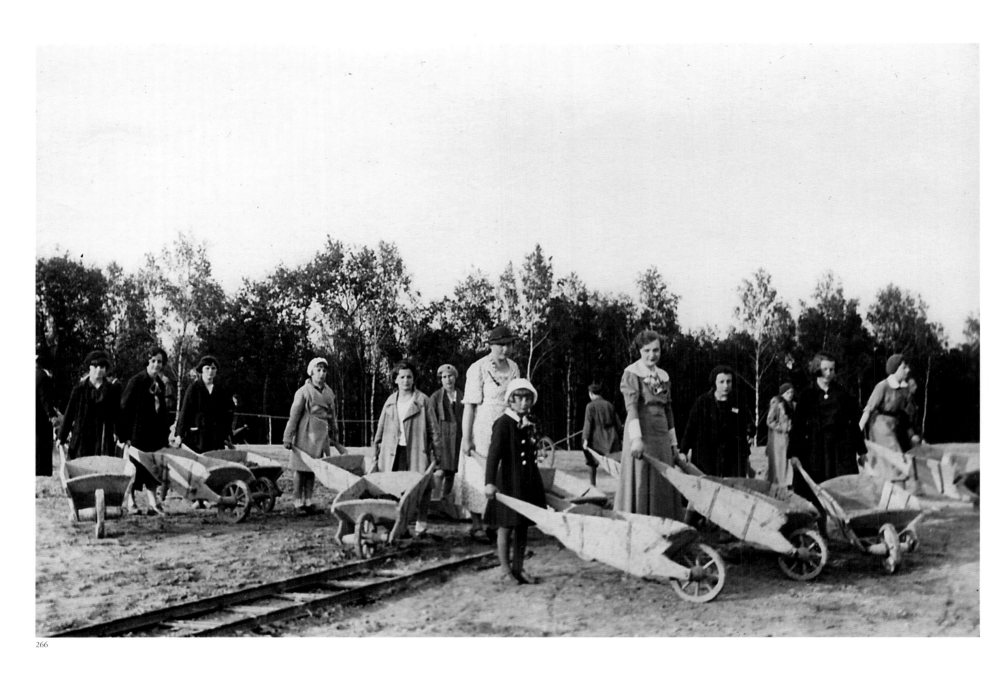

266

266. On Sowiniec hill in Kraków works on heaping the Mound of Liberty on the initiative of the Association of Polish Legionaries were started already in 1934. However, after Marshal Józef Piłsudski had died in 1935, it was decided that this Mound being made right then was to commemorate him. Inside it samples of soil from all the World War I battlefields in which Polish soldiers had fought were placed. The works were completed on July 9, 1937.

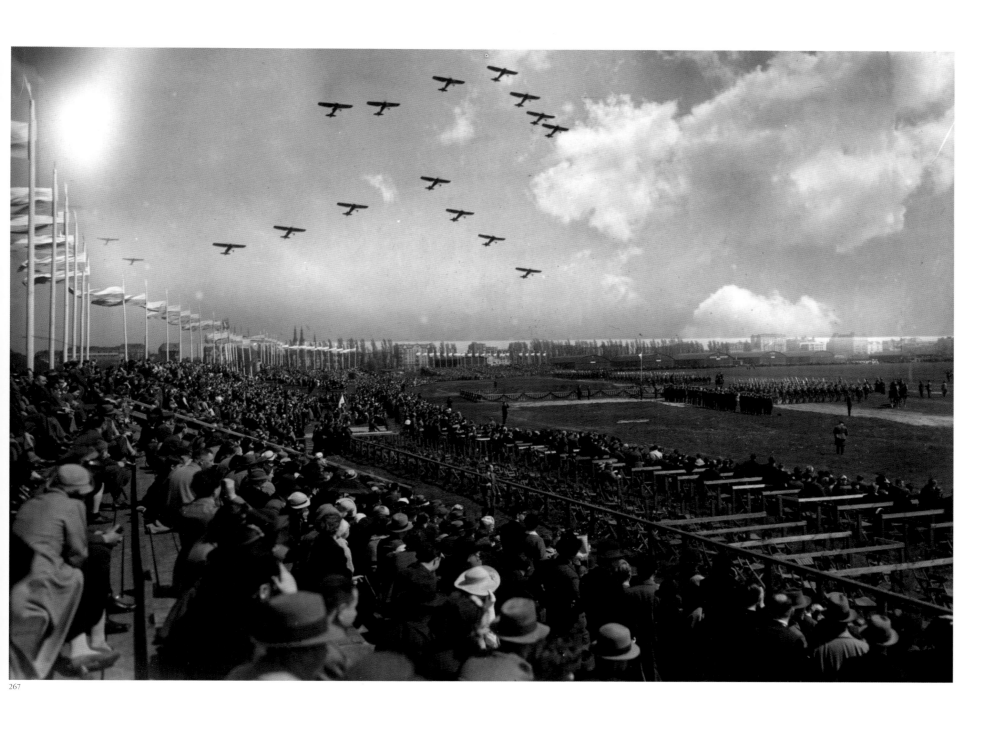

267

267. Celebrating May 3, which commemorates the anniversary of the proclamation of the first
modern constitution in Europe in 1791, attracted crowds of Varsovians.

# Economy

The time encompassed by the photographs in the present album, namely about seventy years, starting from the January Insurrection to the outbreak of World War II, was a period so significant for the economy of the country, that almost impossible to describe in brief. Poland that had previously been torn by the partitioning powers, was faced with an incredibly challenging task: of uniting the state, establishing new administration, education, and economy. It was a titanic effort, for the three partition zones had undergone a totally different economic development starting from the end of the 18th century. Galicia that constituted the northern fragment of the Austro-Hungarian Empire was actually beyond any technical and agrarian transformations, it continued its dreamy existence which hardly changed at all when compared to the old times. Within the Prussian partition zone steelworks and mining were developing in the region of Upper Silesia. Great Poland was already initiating a period of intensive modernization of agriculture. The former Kingdom of Poland, also called the Congress Kingdom, meant textile industry in Łódź and Żyrardów,

it also meant Warsaw's industrial plants. After World War I and the regaining of independence, almost all the existing industry was in ruin and everything had to be started from the scratch. Hardly had the things begun to get a bit under control, new wars broke out, like the one with Ukraine, Soviet Russia, or the Silesian Insurrections. And after a few years of relative peace, we were affected by the world crisis.

Yet, despite all those difficulties and obstacles, intensive works to improve Polish economy were carried out. Important milestones on the difficult way to industrialize the country and improve the quality of life of its citizens were the law passed by the Seym to build a port in Gdynia, previously a small fishermen's village, which until 1939 was one of the most modern ports in Europe, and the monetary reform carried out by Władysław Grabski, which changed the marks into zlotys and stabilized the Polish currency. And subsequently, in the 1930s great economic effort of the authorities could be observed, namely starting of the construction of the port in Gdynia, which was to oppose the domineering position of Gdańsk, and the establishment in

1936 of the Central Industrial Area covering the Kielce, Rzeszów, and Lublin provinces. The latter was an accomplishment truly worthy of the 20th century. Unfortunately, the outbreak of World War II in 1939 interrupted the implementation of the grand project. According to the pre-war statistics, industrial and agrarian production was growing, society were becoming richer. The national product was increasing, and so was the standard of living of the Polish citizens. One can only imagine now what the Polish economy would look like today, had it not been for the war and its aftermath.

268. Characteristic landscape of Upper Silesia: industry, mines, chimneys.

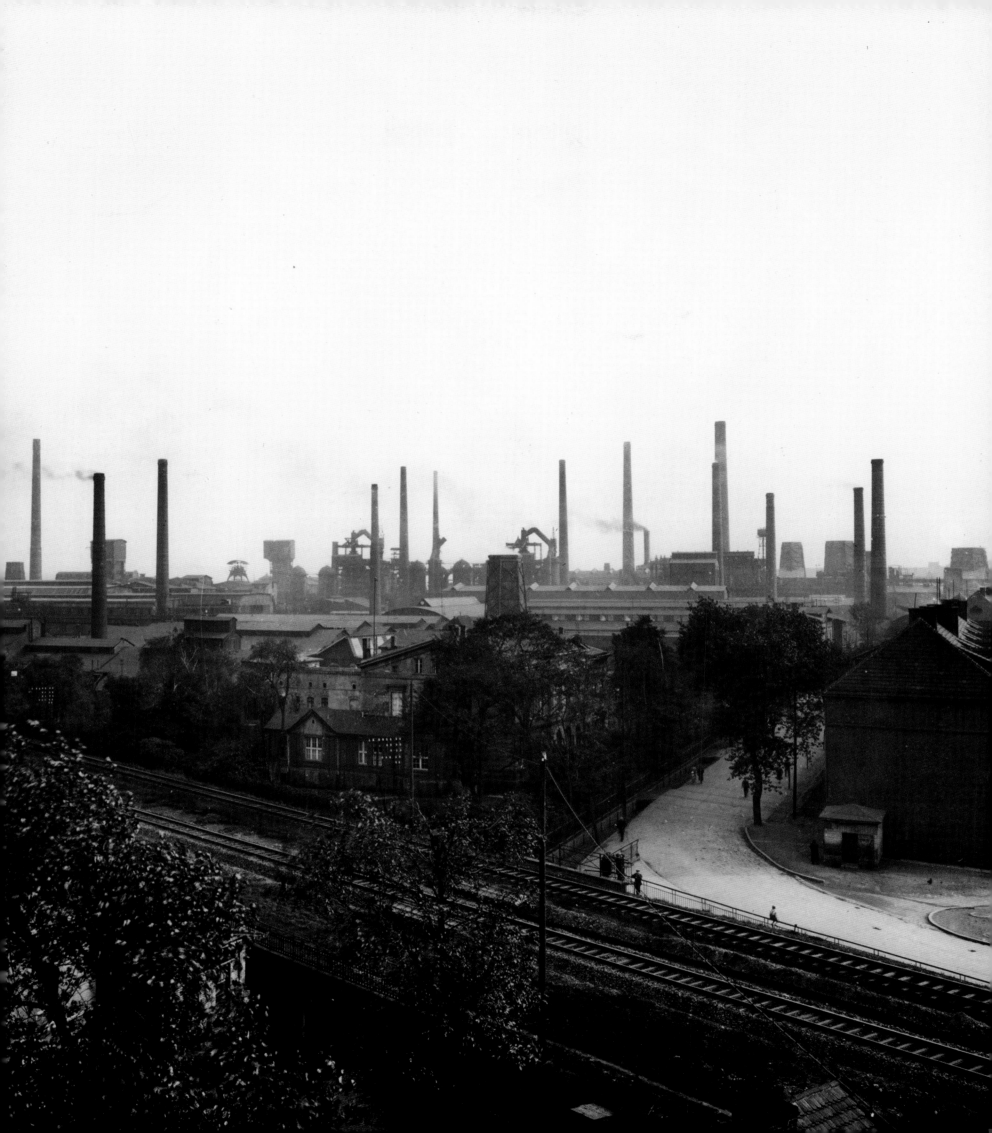

269. Breeding pure-blood horses was a strong tradition among the gentry and aristocracy. At Albigowa near Łańcut a stud was founded by a great horse-riding lover Count Roman Potocki. He was also the one who collected historical carriages, today constituting a large part of the collection of the Łańcut Museum in the famous residency. Alfred, successor to Roman Potocki, continued the tradition initiated by his father.

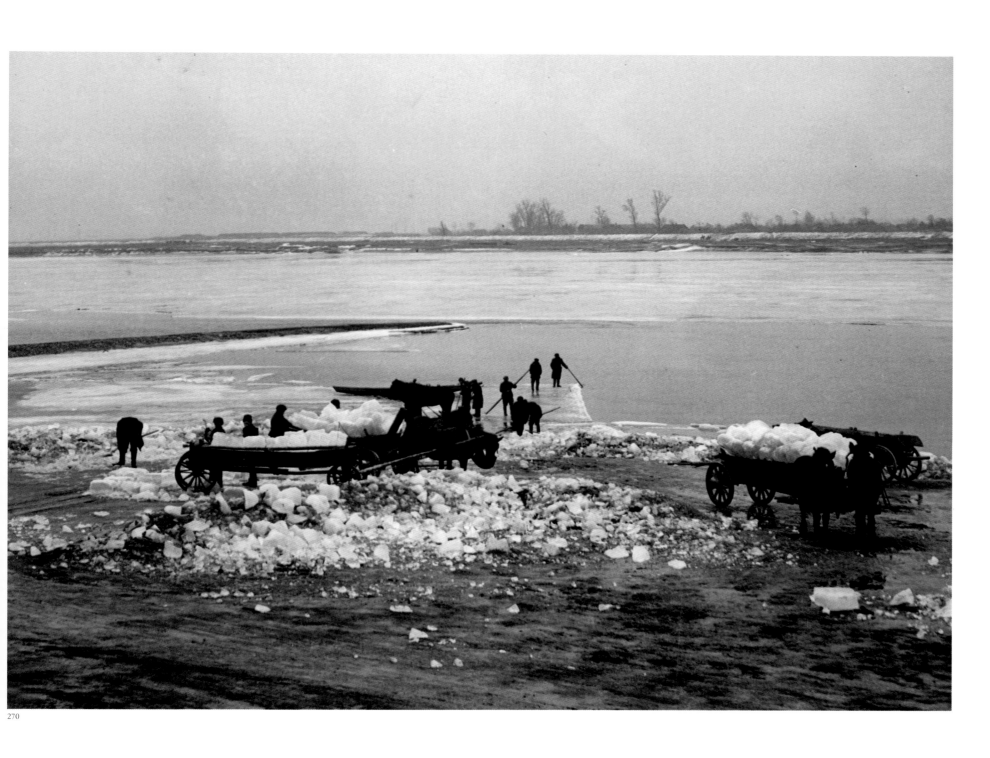

270.

270. The sight from 1935 seems today totally anachronic, yet this is exactly what it all looked like.
In winter ice was cut on rivers and lakes, huge cubicles were loaded onto carriages and transported
to deep cellars where they were stored separated by hay and this is how they lasted till summer.
In those days ice was used to cool the goods, since there were naturally no fridges.

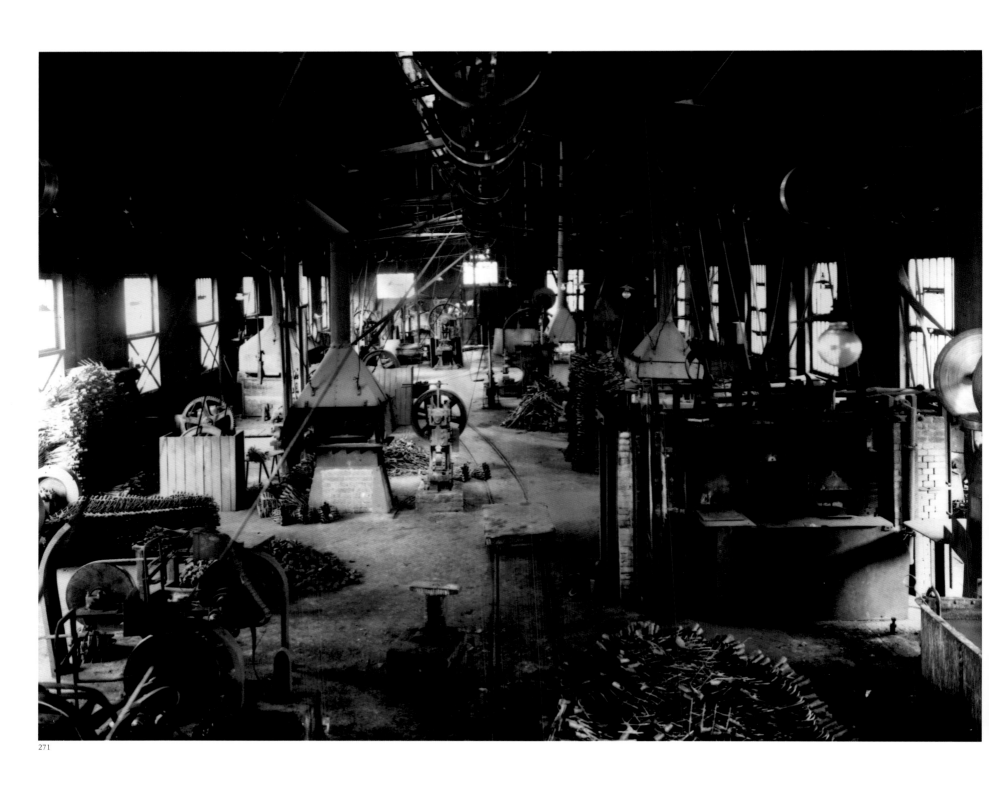

271. In Radomosko there were some significant industrial plants. One of them was the 'Metalurgia' Metallurgical Industry Stock Company. In this 1929 photo one can see the department manufacturing hay-forks and shovels.

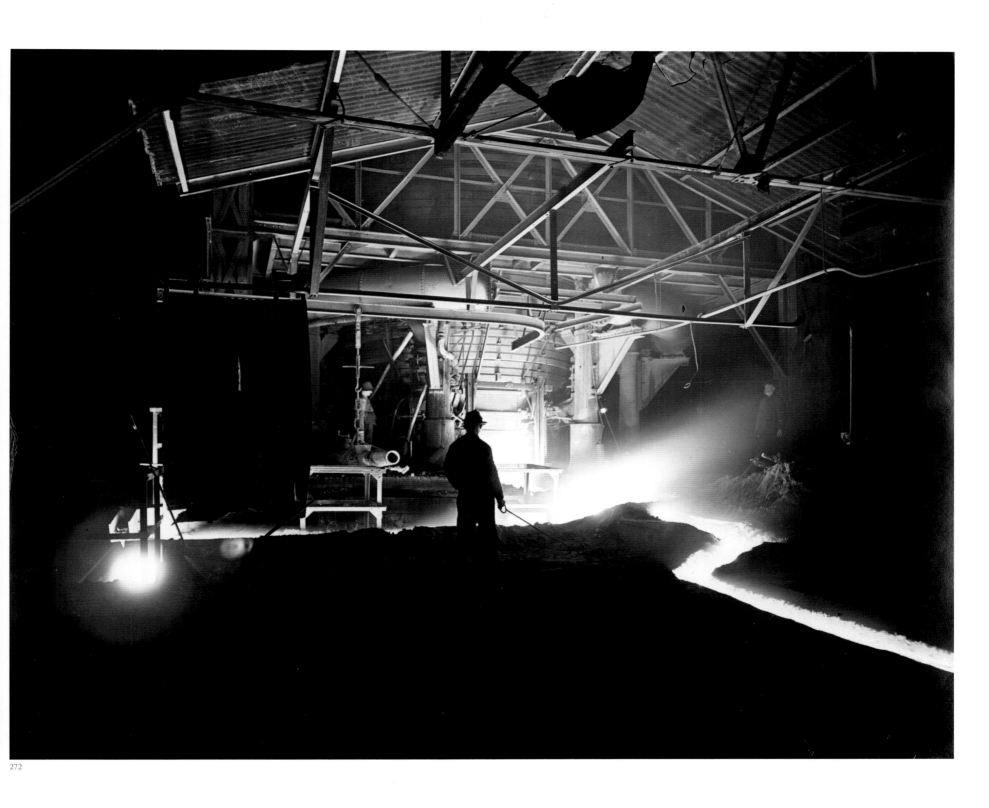

272

272. In the old village of Świętochłowice, that had once belonged to the Silesian Piasts, an important mining and industry centre was founded. Pig-iron is being discharged in 'Falwa' Steelworks.

Photo J. Holas

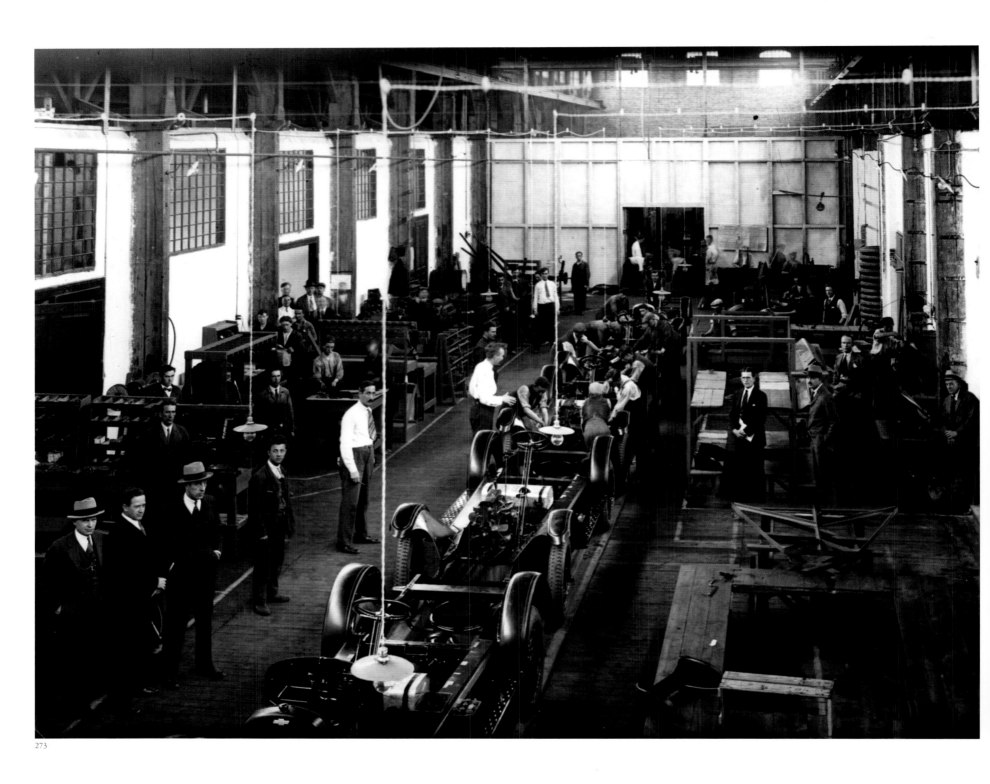

273

273. "Lilpop, Rau, Loewenstein" joint-stock Company owned three large plants in the Warsaw district of Wola where motor vehicles were made, e.g. tractors. In the 1930s even assembly lines were started to assembly "General Motors" licensed car, featured in the picture.

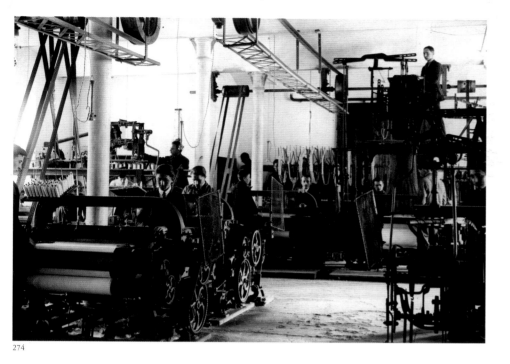

274

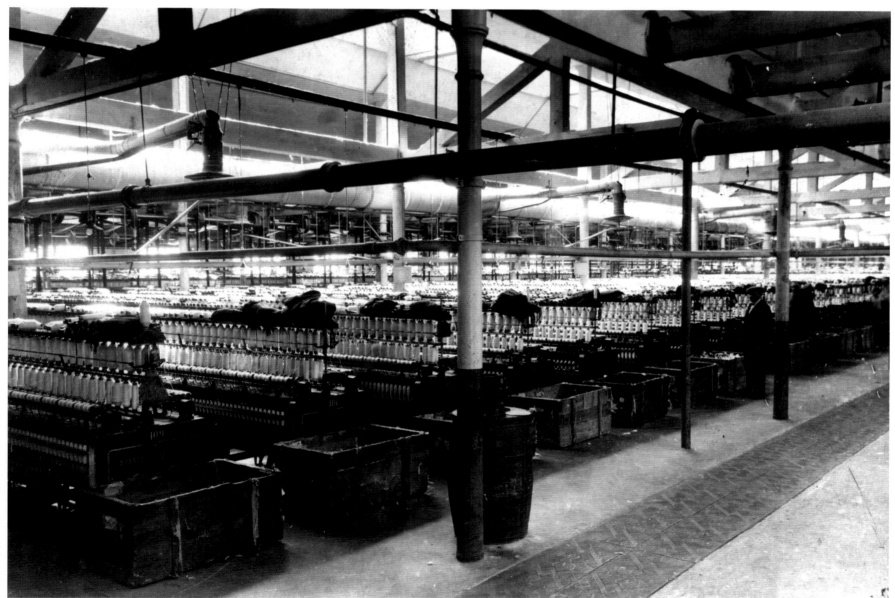

275

274. By the end of the 19th century Żyrardów was a linen production centre, known even outside Europe. The whole town made the living on the industry boasting of high quality of the product. The picture from 1934 shows a very busy production hall.

275. Łódź was once called Polish Manchester. It was here that starting from the second half of the 19th century Polish textile industry developed really fast, finding broad markets both in the expanded territory of tsarist Russia and in the West.
It constituted a kind of Promised Land with all its proud wealth and poverty, as it was perfectly described by Reymont and later filmed by Andrzej Wajda. This is what automated production hall of the Widzew Workshop looked like in May 1938.

276

277

276. In Bóbrka near Krosno oil used to be once extracted on a larger scale. One can see characteristic shafts Today the Krosno Museum houses the largest in Europe collection of oil lamps. The tradition of Ignacy Łukasiewicz (1822–1882) is a certain responsibility.

277. In Borysław oil shafts were in operation already in 1862. All that area, just like the Krosno-Jasło region, was oil-bearing land. The museum in Bóbrka clearly illustrates the way of extracting and processing this useful resource. In 1926, Eugeniusz Kwiatkowski, the then Minister of Industry and Commerce, ceremoniously inaugurated one the oil shafts.

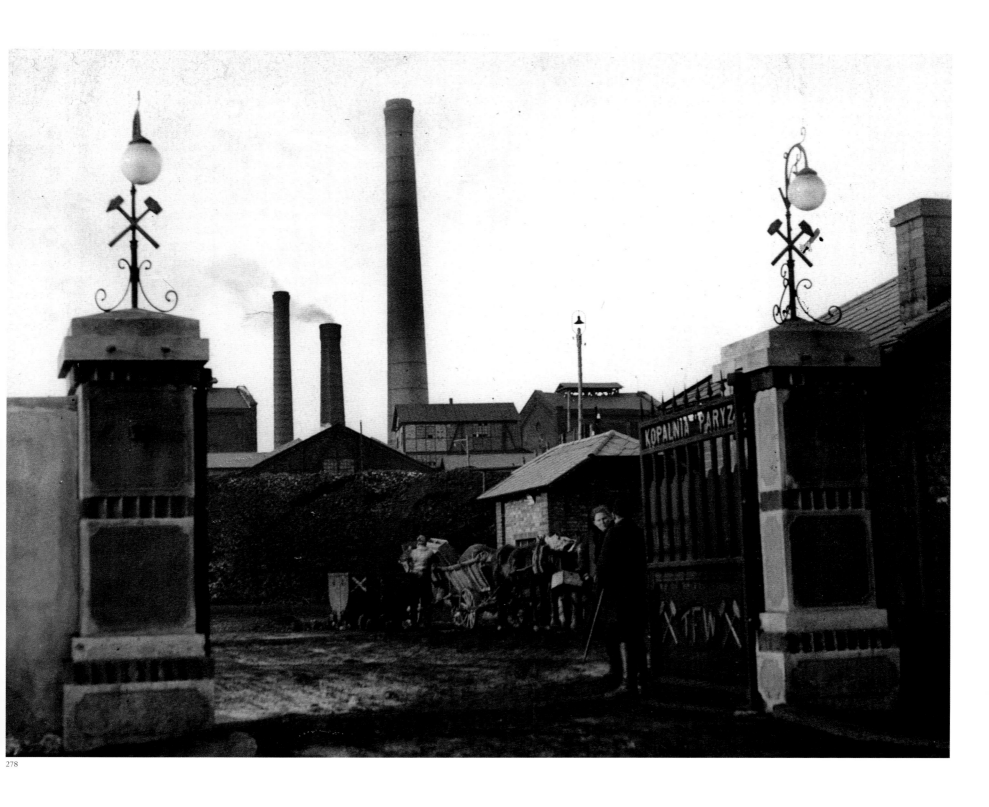

278

278. Dąbrowa Górnicza which was granted town rights in 1916 was an old centre of pit-coal mining in the Dąbrowa Coal-Mining Basin. Mines were run here starting from 1785; there were also steelworks here. In the picture we see the entrance gate to 'Paryż' coal mine.

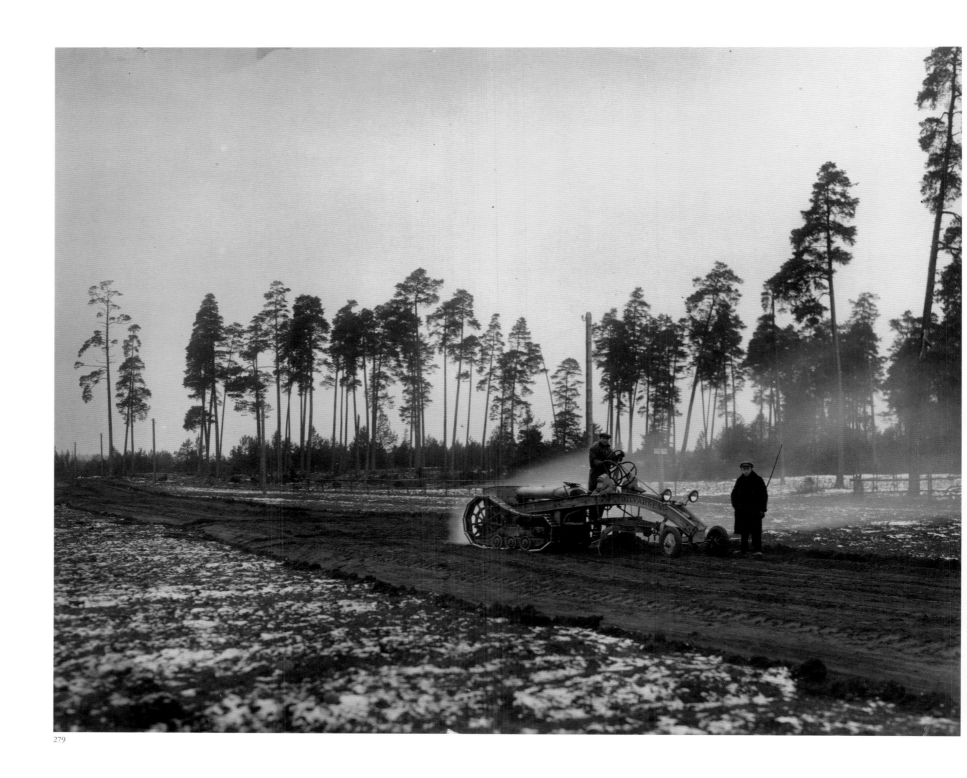

279.

279. Lanes, tracts, roads — their quality and maintenance always were an important issue for country's economy. Here we see what the levelling of the beaten tract between Nieśwież and Novogrodek looked like. Shovels and axes had been replaced by machines. As much as archaic they look to us, at that time they signified real progress.

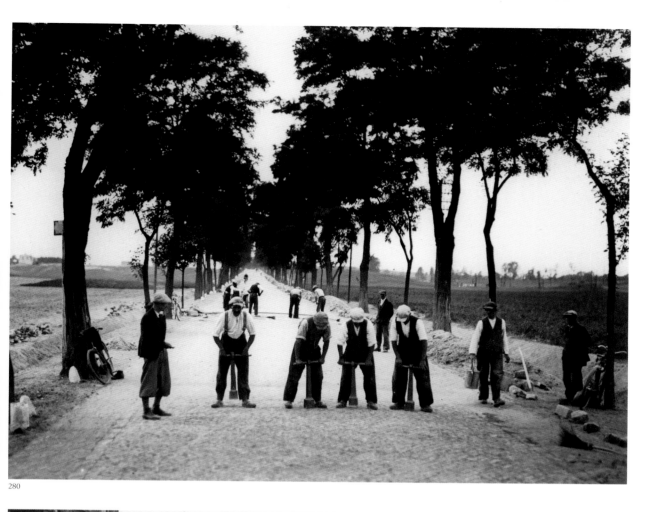

280

282

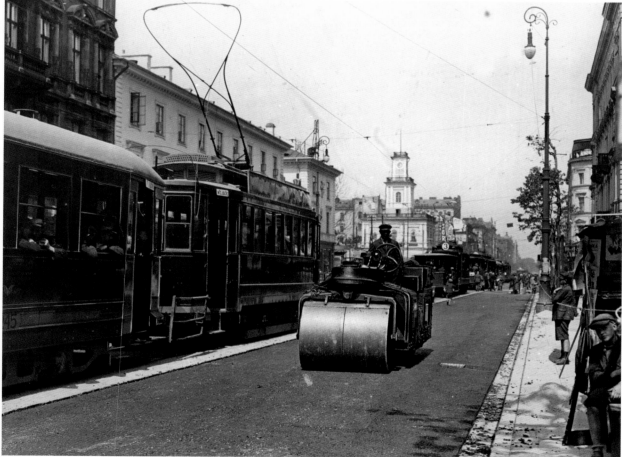

281

280. Road between Poznań and Swarzędz is being renovated (1935). On the old, most certainly earth road, basalt cobbles are being placed.

281. Warsaw modernized gradually. In 1929, on the corner of Marszałkowska Street and Jerozolimskie Avenue, very near the old Main Railway Stations, workers are laying an asbestos carpet on the former cobble stones covering the street.

282. Our major roads looked so much different than today. The newly built road in Polana near Ustroń leading to the peak of Równica (photo from 1934) was defined as a motorway: today, we would call it something else. It climbs up along a gentle curve, the surface is sandy, though some of it may have been cobbled stones, there certainly is no hard shoulder.

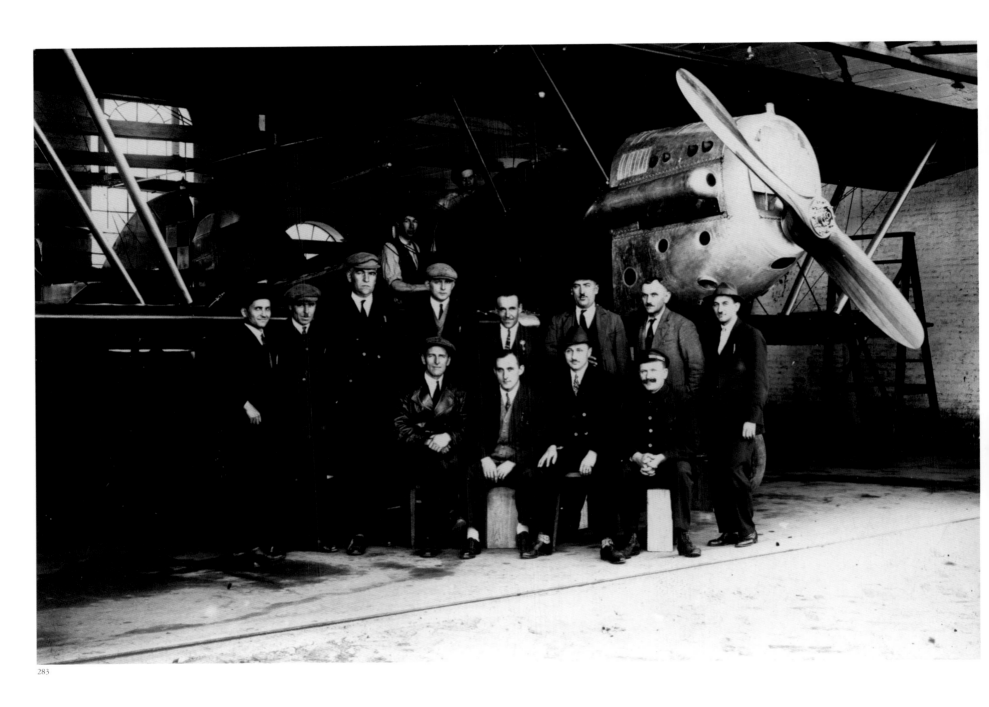

283. The manufacturing of air-planes in Poland started in the 1920s. Potez 25 was made under the French license in the E. Plage and T. Laśkiewicz Mechanic Workshops in Lublin. About 150 of those machines were completed and almost all of them were used in the army. We can see a group picture of the Company's employees and a newly built machine.

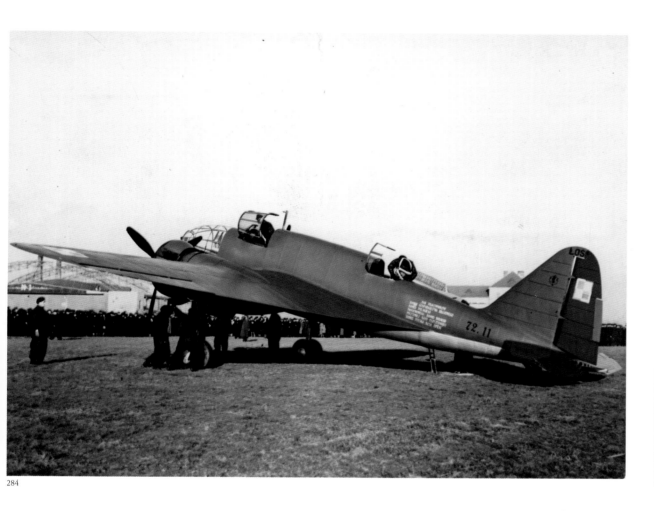

284

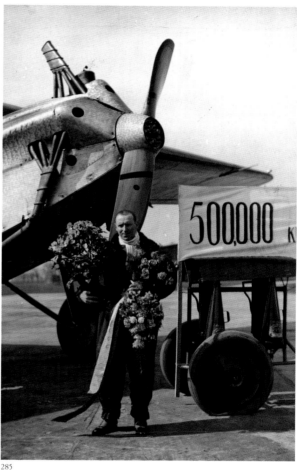

285

283. 'Łoś' Bomber founded by the bankers is being presented to the Polish Army, Warsaw 1938.

285. Pilot Klemens Długaszewski may be the first record-breaker of the LOT Polish Airlines who flew half a million kilometres on passenger planes in 1930. Smiling, with bunches of flowers, he is standing in front of his machine.

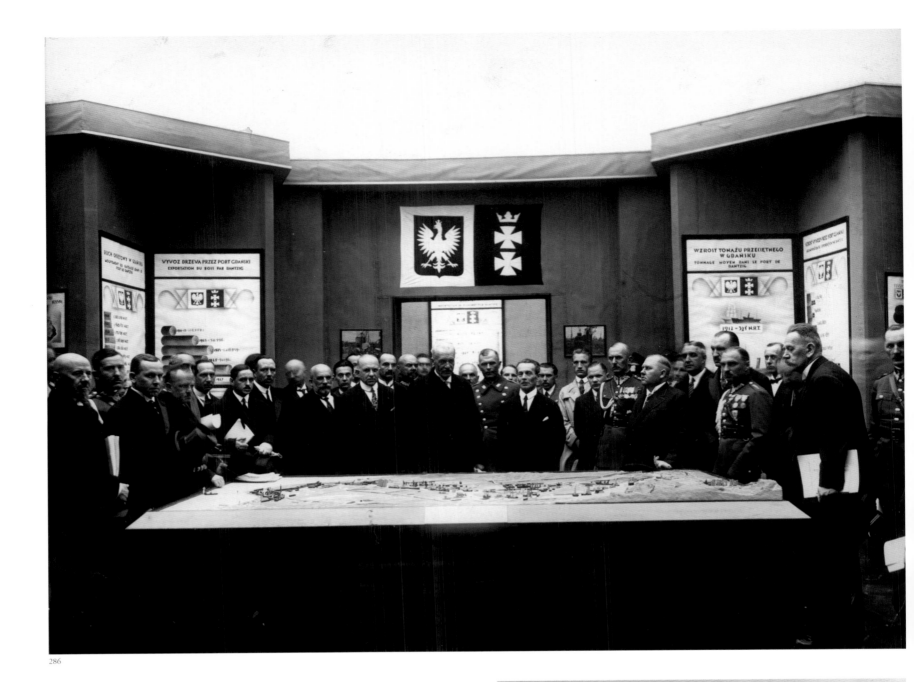

286

287

286. The Poznań Fair, also referred to as a Universal National Exhibition, is the show of Poland's achievements, and particularly of its economic accomplishments. It is not surprising that politicians and dignitaries would show up here: in 1929 the Exhibition was visited by President Ignacy Mościcki. Visitors are watching an exhibition on Gdynia.

287. The port of Gdynia in winter. The construction of Gdynia in between the wars was truly something Polish economy could be proud of.

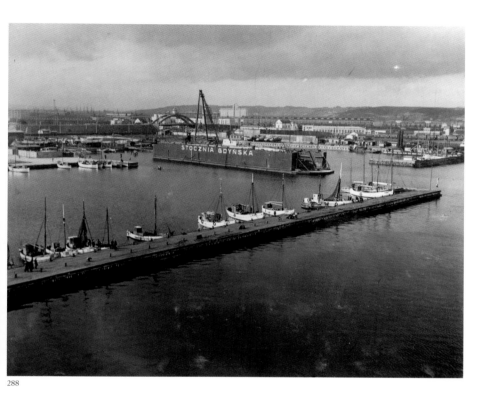

288

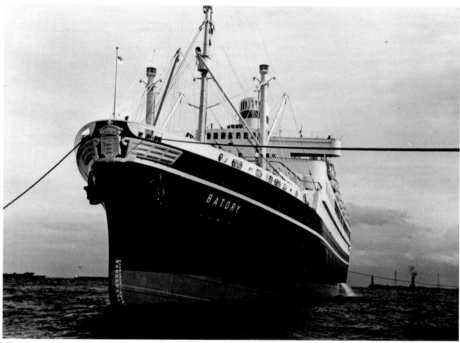

289

288. The fishing harbour and the dry dock of the Gdynia Shipyard.

289. M/S Batory, ocean liner (14,286 BRT carrying capacity) built at Montofalcone Shipyard in Trieste in 1935; she could carry 760 passengers, had seven decks, and a 340-man crew. She was a transatlantic liner cruising between Gdynia and New York. Beautifully furbished, with impressive interiors designed by Polish artists, she was a true pride of our passenger fleet. During World War II she exerted her function of a transport ship with much dignity. It was only in 1967 that she was called off duty.

290

292

291

290. Beer was known already in ancient Egypt. It has survived as
a drink until out times, though naturally its production
technology has changed. The brewery in Okocim founded in
1854 by the Bavarian Goetz family continues to produce this
golden drink until today.

291. The brewery looks like a workshop of a medieval alchemist.
The Brewery in Tychy was founded in 1629. Its former name
had a really proud sound to it: Tychy Brewery of the Archdukes,
since it was established on the estate of the wealthy Pszczyński
family and remained in the family's hands until 1939.

292. It is worth remembering that Lviv was also famed for excellent
vodkas, liqueurs, and rums produced by the Baczewskis' Distillery,
and known not only in Poland, but also abroad.

293

293. There used to operate quite a well known 'Akwawit' Stock Company before the war in Poznań; its business was rectifying aqua-vitae provided by an alcohol distillery and production of chemical products.

294

294. The Poznań Fair was organized for the first time in 1925 and the event has been held with one
interruption only during the war years until today. The characteristic tower over the main entrance
to the exhibition premises, raised in a style modern for those times, has not changed at all since
1929 when the picture was taken.

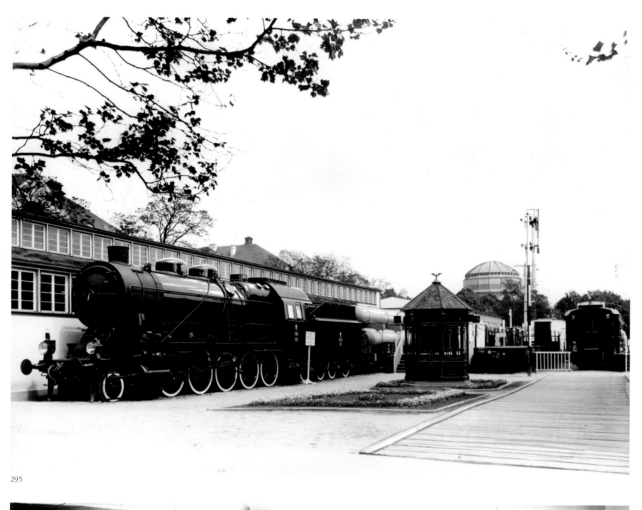

295

297

296

295. A locomotive and the rolling stock are on display by the pavilion of the Ministry of Transportation at the Poznań Fair.

296. In July 1929 an exhibition of flowers and decorative plants was held in Poznań. It is only natural that the photographer focused on the most beautiful exhibits, those awarded with prizes.

297. Problems with building cheap houses available to poorer citizens is not merely the concern typical of cotemporary times. In 1932, the exhibition 'Cheap Housing' was held in Warsaw and President Ignacy Mościcki honoured it with his presence.

298

298. The Department Store of the Jabłkowski Brothers in Bracka Street was very popular. The prices were reasonable and the assortment of goods wide. You could buy almost everything here, also the modern at the time and sought after aluminium dishes. Photo E. Dulewicz

299

300

299. Here we have a young man at the Jabłkowskis', as it was called, wearing his knickerbockers (in vogue at the time) and trying on a new jacket; he is being helped by the assistant to make the right choice. Photo E. Dulewicz

300. The Jabłkowskis' Department Store stood out with its original decor, if compared to other shops. Established in 1914, it was gradually modernized. Its branch opened in Vilnius in 1919.

# Culture
## Science Sports

It is very difficult to find in our history a period equally varied as that by the end of the 19th century and the times from the beginning of the 20th century until 1939. Transformations that occurred over that time were not, naturally, relevant merely for out country. Poland, however, torn among the partitioning powers, was faced after 1918 with the task of creating the whole structure of the state, economy, education. It was not at all easy. Let us briefly recall those changes that occurred in culture, science, and sports, in the intellectual life and every day life.

In the last quarter of the 19th century such writers as Kraszewski, Orzeszkowa, Konopnicka, Prus, Reymont, Żeromski, Wyspiański were active. Later the domineering role in literature would be taken over by personalities like Witkacy, Schulz, or Gombrowicz. Whereas in visual arts the development line is even more astonishing. After the traditional academic painting characteristic of Matejko, Grottger, the Gierymski brothers, there came Art Nouveau brought about by some European tendencies. So we had the art of Wyspiański and Mehoffer, the Kapists in the inter-war period, also

a tendency that was called Polish Art, which sought its roots in the folklore, but at the same time Cubism, Constructivism, and other "isms" that changed so quickly, but had little relevance for the development of art.

What about science? It was not limited to the great inventions of Zygmunt Wróblewski and Karol Olszewski, Maria Curie-Skłodowska, or the works of Stanisław Banach. It also meant establishing of a few universities, and what is more, setting off in motion the whole educational system, from elementary schools to secondary ones, including lycees. It also meant restoring a normal, official teaching about Polish literature and history. Those efforts as hard and tedious as they were cannot be overestimated. We have been benefiting from them up to now. Mention should also be made of People's Universities that were then established, e.g. in Gać near Przeworsk. And like this we almost run out of place to discuss such culturally important factors as theatre which had its great achievements during the Second Republic, or the new media that could reach vaster groups of society, meaning radio and cinema.

Sports held its position apart, but equally important. After all, it was only in the 20th century that the idea of sports competition and education of the young through sports was beginning its triumphant march across the world. It was not only the international skiing association, yachting, horse-riding, football and tennis matches, but also gymnastics and scouting camps that shaped a new way of thinking. Sports from being a slightly elitarian pass-time, became something universal, it fascinated great crowds of people, regardless of their education and profession. It was, as it continues to be, a passion of everyone. With the newly rebuilt state sporting achievements, both small and big, like the golden medals won at the Olympic Games by Janusz Kusociński or Stanisława Walasiewicz, boosted the national pride.

301. A scene from Wyspiański's drama *Bolesław the Bold* staged at the Juliusz Słowacki Theatre in Kraków in 1937.

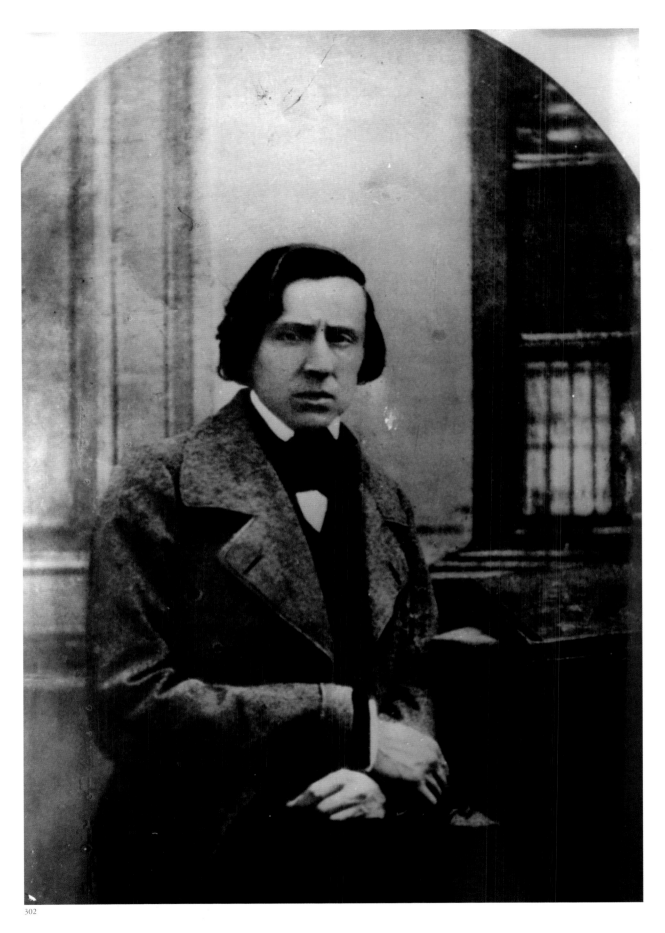

302

303

302. Fryderyk Chopin (1810–1849), a great Polish composer who continues to be famous and popular throughout the world. His compositions: ballads, etudes, waltzes, polonaises, mazurkas, blend together the romantic style with elements of the Polish folklore. Chopin was an excellent pianist. The old daguerreotype from 1849, made just before he died, has immortalized his image for the generations to come.

303. Stanisław Moniuszko (1819–1872), justly called the father of Polish opera, composed numerous works of which the greatest fame was won by *Halka, The Haunted Manor*, and *The Countess*. His musical compositions are of clearly national character. Moniuszko sought for topics in folk culture and the gentry tradition.

304

304. Ignacy Jan Paderewski (1860–1941), a pianist and composer of great genius, was a man who put all his heart to forming independent Poland by being active among the Polish Americans and in the League of Nations. In 1919, he held the position of cabinet's Prime Minister. It was at that time that he paid a visit to France's Prime Minister Raymond Poincare.

305

306

305. At a Warsaw railway station a group of friends and fans is welcoming the composer Karol Szymanowski.

306. Karol Szymanowski (1882–1937) was the greatest Polish composer after Chopin, creator of many grand musical works: symphonies, concerts, etudes, preludes, songs, performed until today in concert halls all throughout the world.

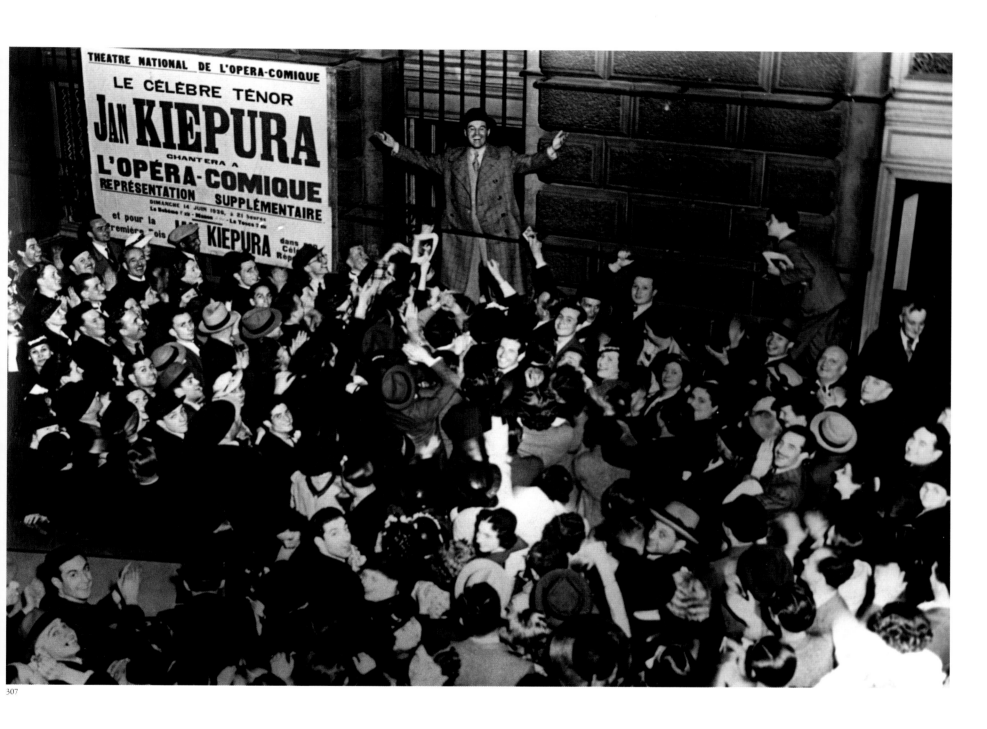

307

307. Jan Kiepura (1902–1966) was a wonderful tenor. After his debut in 1923, he had performances on large opera scenes throughout the world winning breathtaking success. He also acted in several films and his lighter repertory, famous songs, have been unwaveringly popular. In the photo we can see Jan Kiepura singing to an audience gathered in a Paris street.

308

SIENKIEWICZ.

309

308. All the lovers of historical novels are familiar with the works of Józef Ignacy Kraszewski (1812–1887). So many generations of the Poles have been educated on his books. Today, sounding possibly a bit outdated, they once impressed with excellent historical colouring and convincingly sketched characters. Kraszewski was a demon for work: he wrote about 400 novels.

309. *Trilogy, The Teutonic Knights, The Połaniecki Family* are literary works possibly known by almost everyone. It would be hard to imagine Polish literature without them. Historical novels were the main domain of Henryk Sienkiewicz (1846–1916) who was awarded Nobel Prize in Literature in 1905. On that occasion the quality of all Sienkiewicz's oeuvre was actually emphasised. His books, published in great numbers of copies, continue to attract many ardent readers.

310

310. On August 15, 1925 a congress of the peasant party to pay tribute to Władysław Reymont (1867–1925) was held. The organizers intended to thank him for his oeuvre, but mainly for the novel *Peasants* awarded with the Nobel Prize in 1924. The writer is seated on a podium, his wife on his right, and the then voigt of Wierzchosławice Wincenty Witos, who organized the event, on his left.

311

312

311. Eliza Orzeszkowa (1841–1910), a novelist, essayist, wrote many works popular at the time and widely read. She is known, first of all, as the author of the *On the Banks of the Niemen*. Her works feature realism and idealise the lifestyle of the noblemen and the gentry.

312. Stefan Żeromski (1864–1925), an outstanding writer whose oeuvre has had an impact on several generations of the Poles. He authored, among others, *Sisyphean Labours, Homeless People, Ashes, Before the Spring*, as well as numerous short stories and plays. His works tackled on the difficult questions of national identity, independence, and social injustice.

313

314

313. This is a collective portrait of the luminaries of Polish
science and culture. Grouped here are, among others:
Stanisław Kutrzeba, a historian; Wacław Sieroszewski,
a writer; Tadeusz Boy-Żeleński, a writer, translator, essayist;
Adam Krzyżanowski, an economist; Stanisław Maziarski,
a histologist.

314. After 1918 the press market developed rapidly in
independent Poland. In the picture we can see the editorial staff
of the 'Kurier Wileński' daily. Photo M. Maskin

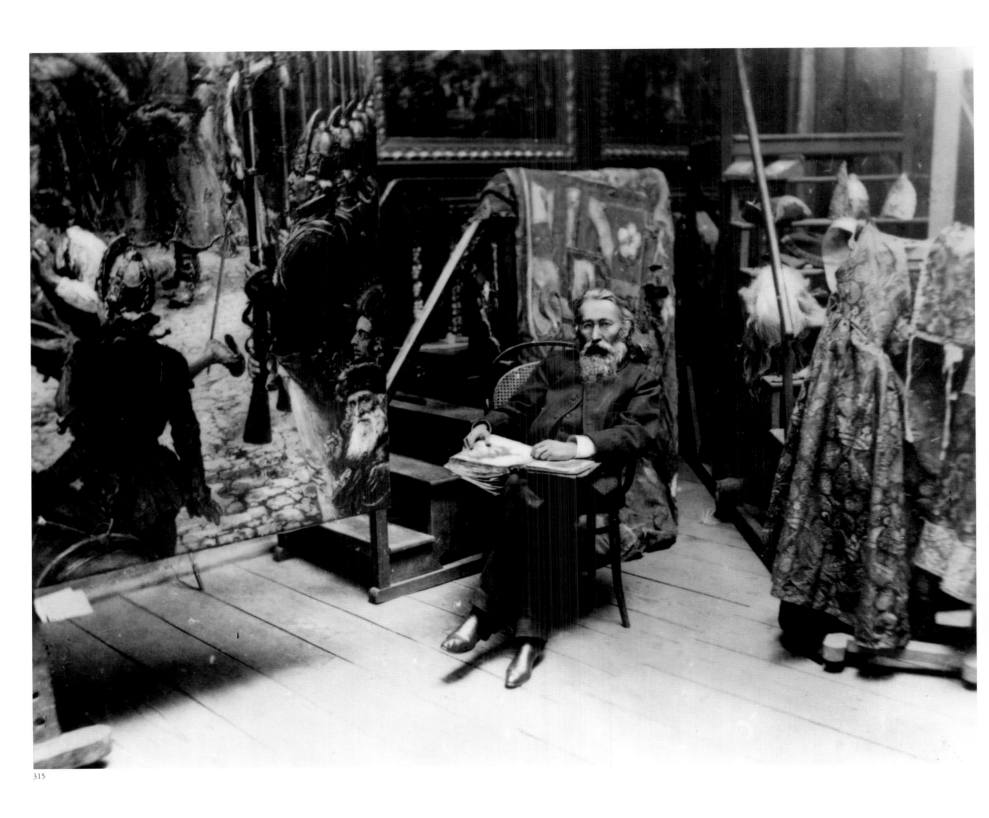

315

315. Jan Matejko (1838–1893), an excellent painter, is known, first of all, for his historical paintings, such as *Skarga's Sermon*, *Rejtan*, *Battle of Grunwald*, *The Prussian Tribute*, to name merely a few, He authored numerous portraits, the polychrome in the Marian Church in Kraków; he also lectured at the Academy of Fine Arts to students like Stanisław Wyspiański, Józef Mehoffer, and Jacek Malczewski.

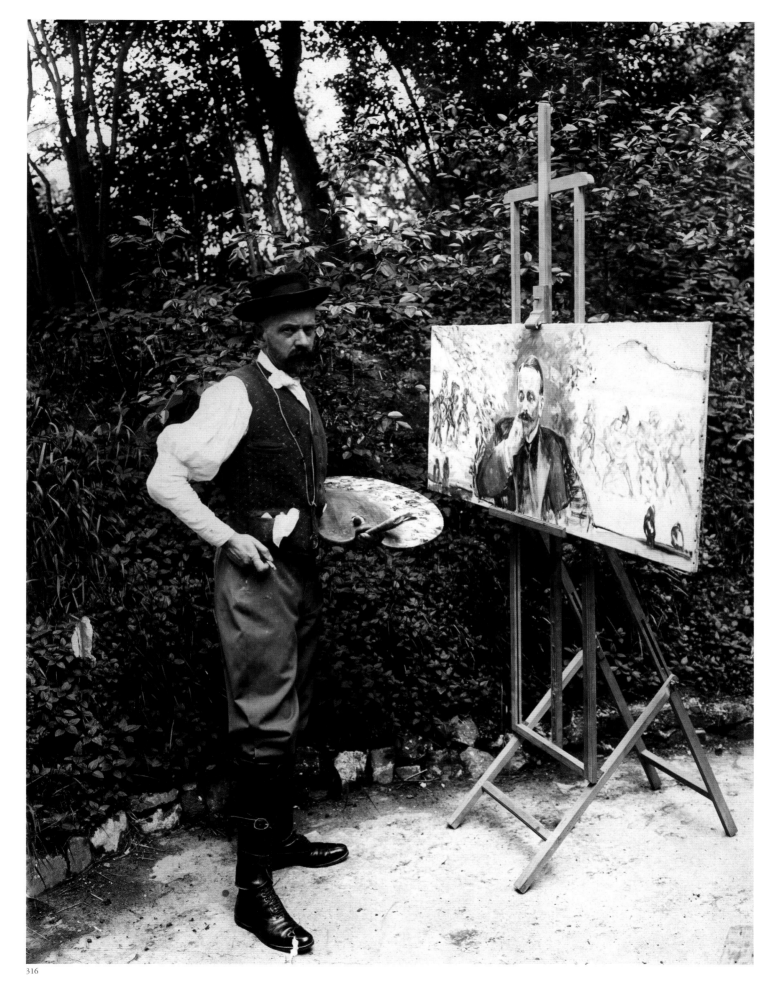

316.

316. Jacek Malczewski (1854–1929) was an outstanding symbolist painter. His works full of weird disquieting figures emanating very special atmosphere, as well as his original portraits and self-portraits, have been admired until today in numerous Polish museums.

317

317. It is April 25, 1936. The President of the City of Warsaw Stefan Starzyński surrounded
by a group of distinguished guests is opening the exhibition 'Warsaw in Painting' at Warsaw's
Zachęta Gallery.

318

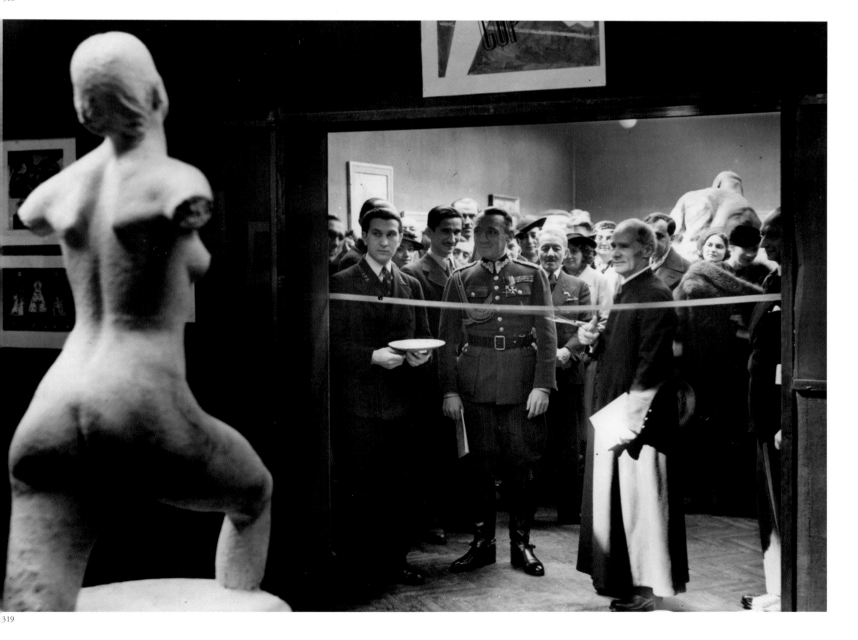

319

318. An exhibition of the group of painters of the Paris Committee, called in Polish the 'Kapists'. The group headed by Józef Pankiewicz was active in Paris starting from 1925. It included such painters as Jan Cybis, Józef Czapski, Tadeusz Piotr Potworowski, Hanna Rudzka-Cybisowa. They were colourists having a lot in common with the then French painting, particularly the works by Cézanne, Matisse, and Bonnard, and their art had a great impact on Polish painting. They returned to Poland in the 1930s and their last common exhibition was held at the Institute of the Propagation of Art in Warsaw in 1934.

319. The Exhibition 'Sports in Art' was held at the Institute of the Propagation of Art, being an institution active in Warsaw from 1930 to 1939; it contributed greatly to the development of the then Polish Fine Arts. The opening was celebrated by deputy minister Bronisław Żongołłowicz.

320

321

320. An excellent actor Aleksander Zelwerowicz (1877–1955) in Aleksander Fredro's comedy *Mr. Jovial* staged at the J. Słowacki Theatre in Kraków.

321. Juliusz Osterwa (1885–1947) was an actor and a director who starting from 1904 worked for theatres in Kraków, Poznań, Vilnius, Warsaw. He created the 'Reduta', a cast co-working with actors' studies, forming as if theatre-laboratory searching for a new method of actors' work. He was a partisan of realist-psychological theatre and stressed supremacy of team work over stardom.

322

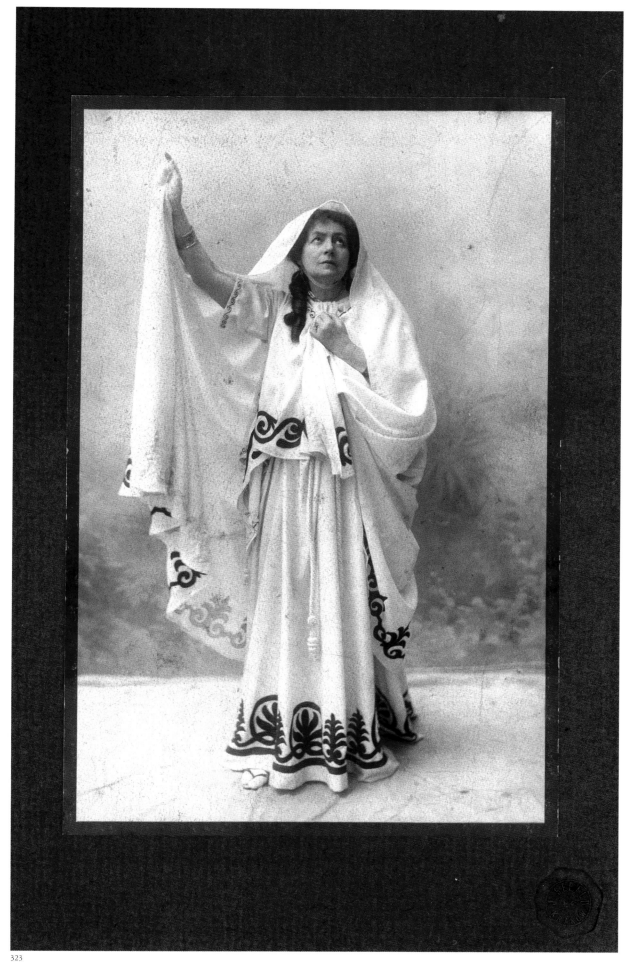

322. Elżbieta Barszczewska (1913–1987) was among the group of the most tallented Polish actors. Her casts, particularly at the Polski Theatre in Warsaw, have become real classics in the history of Polish theatre. She was also a popular film actress, and the characters she cast in films like *The Charlatan* or *The Leperess* were enthusiastically welcomed by the viewers.

323. Helena Modrzejewska, her true name being Jadwiga Helena Misel (1840–1909), was the most famous Polish actress. She made her debut in the provincial theatres of Galicia in 1861. Starting from 1865, she acted in Kraków and Warsaw. In 1876, she left for America where her great artistic career started. She was specially remembered for her cast in Shakespearean plays. She often came over to her homeland to have shows as a visiting actress.

324.

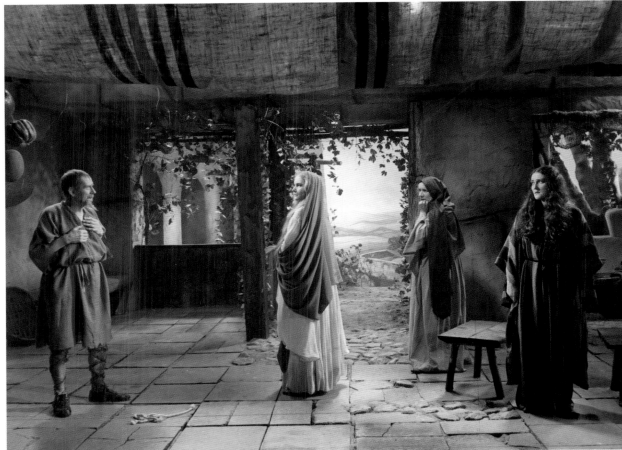

325.

324. At the back-stage of the Polski Theatre in Warsaw there met three great figures of our national stage in 1926: Leon Schiller (1887–1967), Karol Borowski (1886–1968), and Arnold Szyfman (1882–1967), animators of the theatre life in independent Poland, directors, and creators of modern theatre.

325. Ludwik Solski (Ludwik Napoleon Sosnowski, 1855–1954) was a very versatile actor and an actor of great genius. He performed on the Polish stage, firstly in Kraków and Warsaw, starting from 1876 until the end of his long life. His roles, just like that unforgettable one in Wyspiański's *Varsovienne*, have become almost legendary. In this picture we can admire Solski casting Judas in a play by Karol Hubert Rostworowski in 1934.

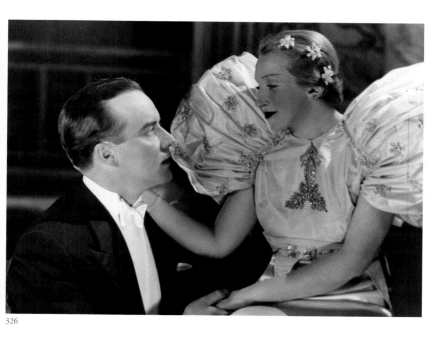

326

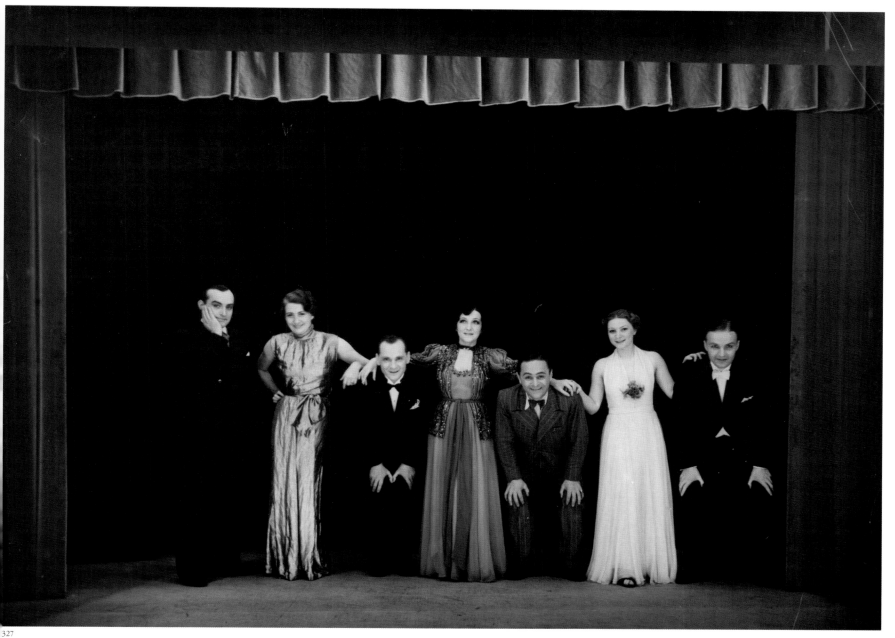

327

326. Hanka Ordonówna (1902–1950), 'Warsaw's nightingale', a singer, actress taking part in many films, comedies, operettas, was really loved by the Varsovians, and her wonderful voice and interpretation of lyrics have been enchanting a vast audience. In 1942, together with the 2nd Polish Corps, she crossed the Soviet border and went to the Middle East as the guardian of Polish orphans and abandoned children. Here we can see her with the actor Igor Sym in a musical comedy *Minister and Dessous* from 1935. Photo S. Brzozowski

327. '*Qui pro quo*, dear old den' is supposed to be the text sung by whole Warsaw, since the Polish capital enjoyed fun and was famed for its entertainment shows, theatres, coffee shops, restaurants. After the performance on the stage of the 'Little Qui pro Quo', the artists are bowing to the public. Among them there is Olga Kamińska, the presenter Wsiewołod Orłow, Mira Zieminńska, Adolf Dymsza, Halina Kamińska, Andrzej Bogucki.

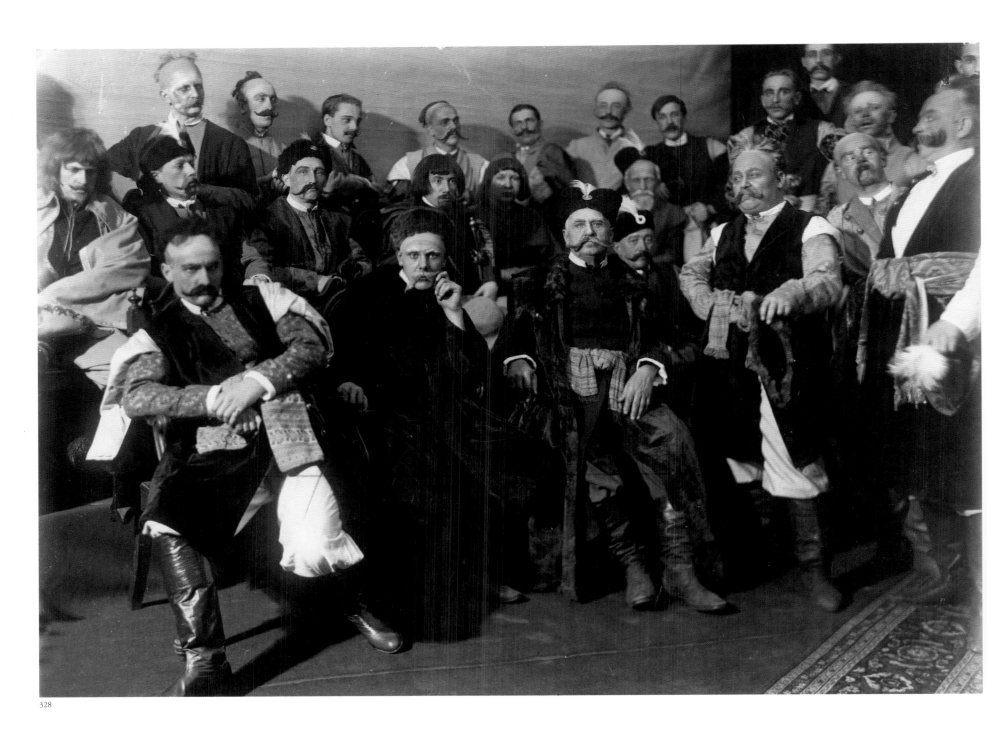

328

328. After the performance of *Hetman Stanisław Żółkiewski* by Kazimierz Brończyk the cast, still in the Old Polish costume, are posing for the photograph.

329. A group of actors from an amateur theatre in Siedlce posed for a memento photograph in 1898. From the poster held by one of the ladies we can assume that the picture was taken after the premiere of *At my Aunt's*. We can clearly see what the fashion for men and women looked like by the end of the 19<sup>th</sup> century.

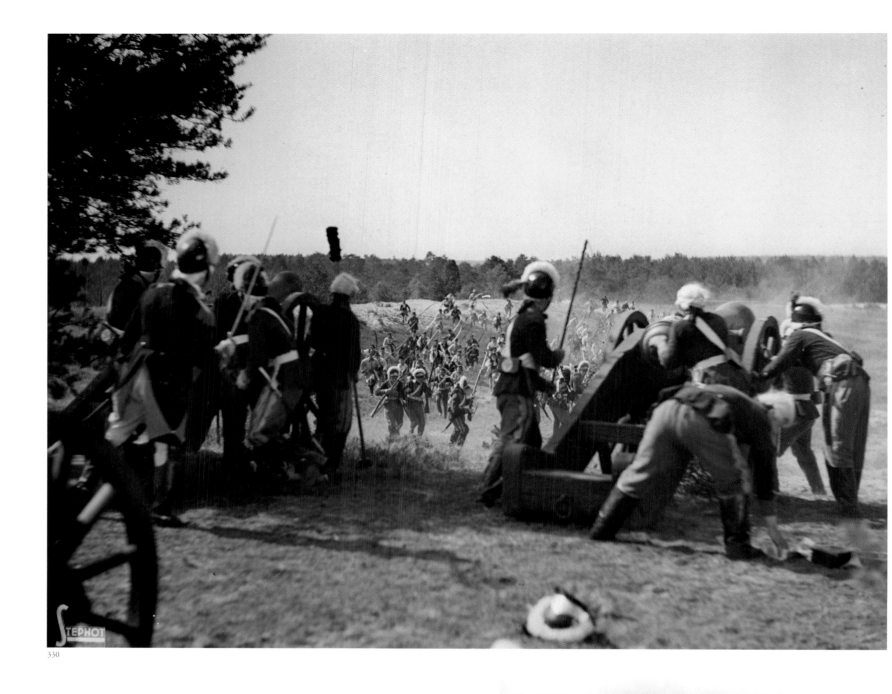

330

331

330. The pre-war Polish film concentrated a lot on our history. The photo presents a scene from *Kościuszko at Racławice*.

331. Eugeniusz Bodo (1899–1943), the darling of all Poland, actor, singer, dancer, was also a director and scenographer. In the photo we can see a scene from the film *Breeze from the Sea* shot in 1931. His numerous casts, e.g. in musical comedies, in Warsaw theatres, were greatly applauded. He died in a Soviet camp in 1943.

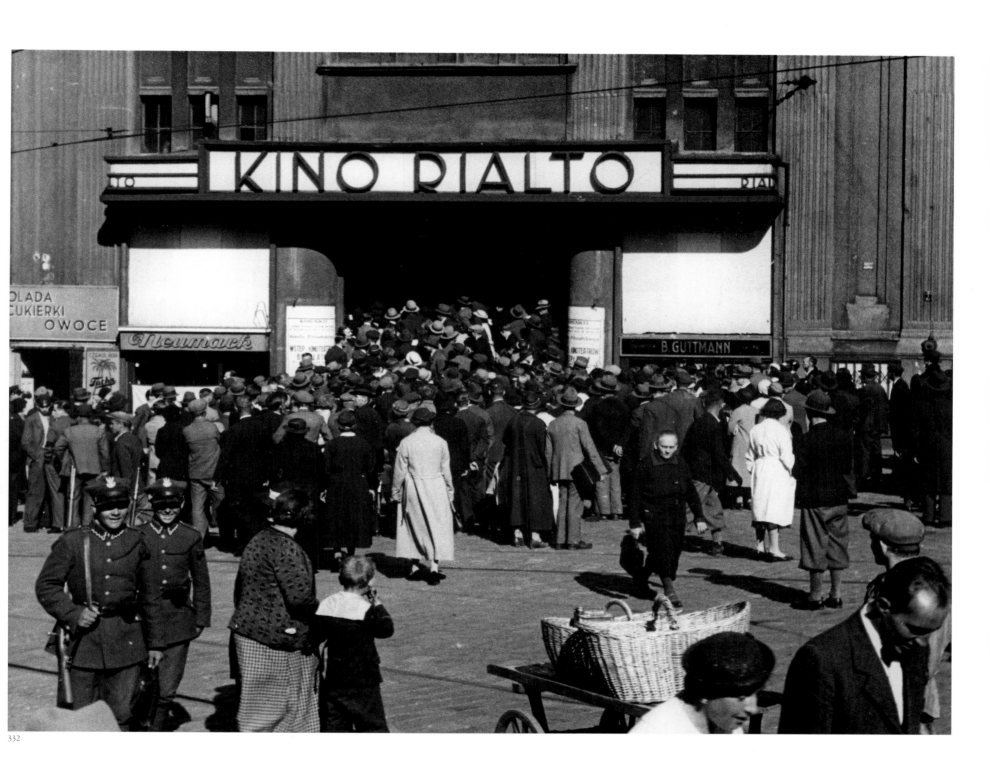

332

332. After World War I the number of cinema halls increased in Poland, since there were also many people who were great fans of good films. Here is the 'Rialto' Cinema in Katowice in a picture from 1935. Photo Cz. Datka

333

334

333. Maria Skłodowska-Curie (1867–1934), a great Polish scientist, working in Paris, co-authored the theory of radioactivity. Maria and her husband Piotr Curie first discovered, and then separated polonium in 1896, and radium in 1898. She won two Noble Prizes: one in physics in 1903, and one in chemistry in 1911. Until her last days she was interested in all that was happening in her homeland and she supported Polish science.

334. Maria Skłodowska-Curie initiated the foundation of Radium Institute in Warsaw. Contributions were collected from 1923, two years later the construction was started, and on May 29, 1932 the Institute was inaugurated. With the money coming from the women's organizations in the United States and Canada, a gram of radium worth half a million of the then zloties was purchased. Maria Curie personally attended the opening of the Institute. Photo J. Binek

335. Stefan Banach (1892–1945), a mathematician, Lviv University professor, member of the Polish Academy of Art and Sciences, was the author of functional analysis and founder of the Lviv Mathematical School.

336. The picture shows the inauguration of People's University in Gać near Przeworsk in 1932. Ignacy Solarz (1891–1940) who contributed greatly to the fostering of culture and education in the Polish country, was the initiator and organizer of such vital institutions.

337

337. In January 1927 a Congress of Polish University Presidents
was held in Kraków. This picture was taken in the Jagiellonian
University Auditorium.

338

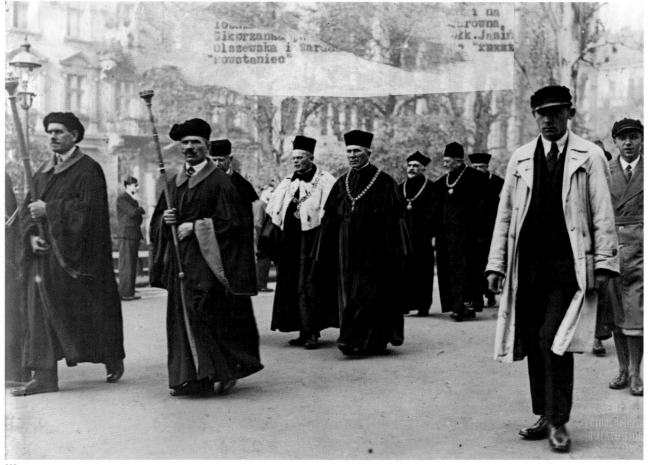

339

338. Inauguration of the academic year 1927/28 at Warsaw
Polytechnics. President of the Republic of Poland Ignacy Mościcki
honoured the ceremony with his presence.

339. This is a very old tradition, cultivated until today.
In October 1931 a ceremonious procession inaugurates the
new academic year at Kraków's Jagiellonian University.

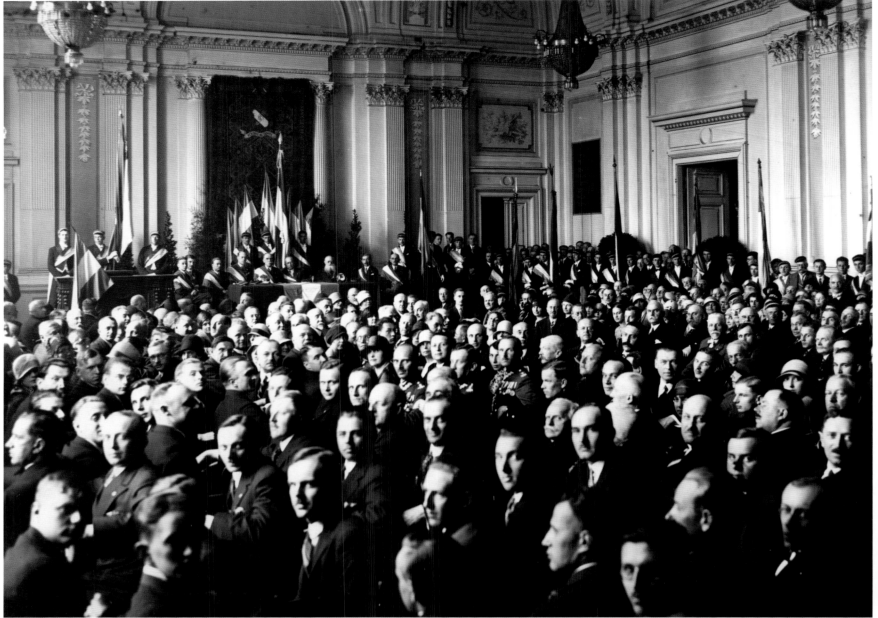

340

341

340. In 1929 the 50th anniversary of the 'Arkonia' students' corporation was celebrated in Warsaw. The organization had been founded in Riga in 1878 and initiated its activity in Warsaw in 1918. The statutory programme of such associations was aimed at fostering honour, loyalty, patriotism, following the principle that acts and work are the most meaningful elements in one's life.

341. Students' corporations appeared in Europe in the 19th century and they were modelled on the organizations set by medieval students at universities. The first such body was organized in Jena in 1818. In 1828, the first Polish organization 'Polonia" was founded in Dorpat (presently Tartu in Estonia). What we see in the picture is a reception that the corporation members would hold, sometimes inviting some distinguished visitors to them. Gen. Władysław Bortnowski participated in such a reception hosted by the 'Aquilonia' corporation in 1938.

342

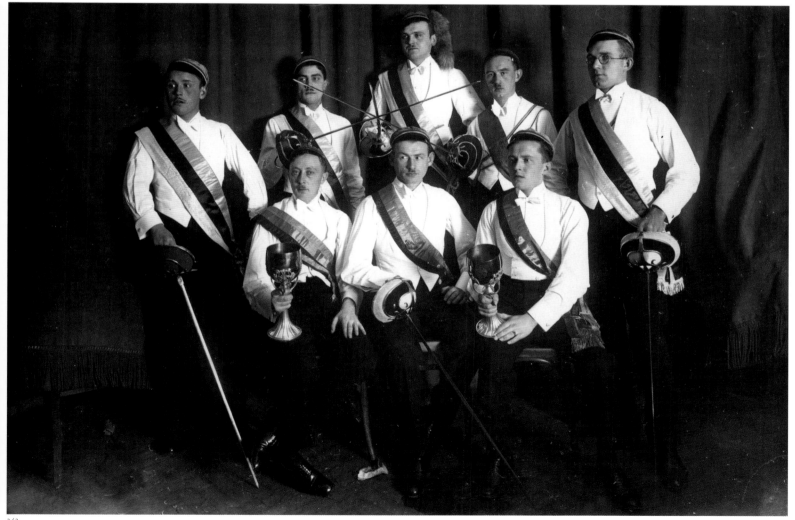

343

342. Female students were also members of the 'Prior' corporation in Warsaw. The photo captured the ceremony of sash handing.

343. The internal hierarchy in students' corporations was very strict. The lowest in rank were the so-called greenhorns, or arm-bearers; then followed the colleagues. There were also the so-called Philistines, meaning adult men who having graduated, remained members of the corporation. Corporation member would wear a traditional costume: a sword, a sash in the colours of the corporation, and a small round cap with embroidered badge on the front. In the picture we can see the presidents of the reception protocol in Lviv in 1929.

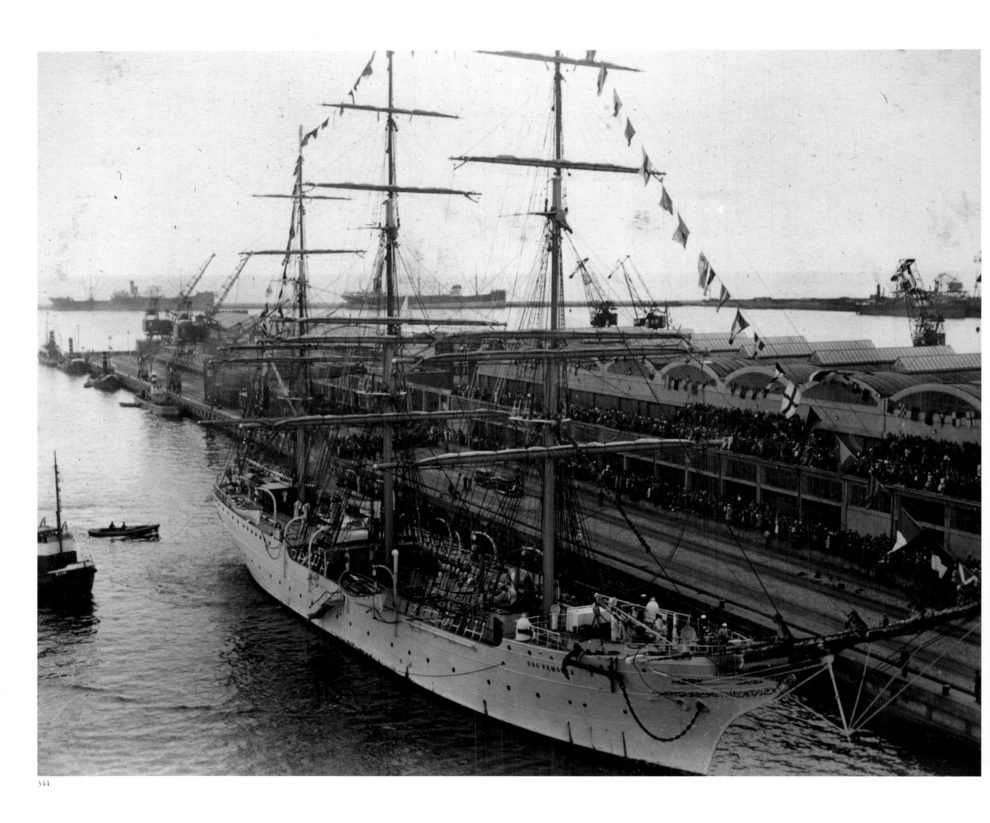

344

344. The 'White Frigate' has become a legend. 'Dar Pomorza' was built in 1909 as a training vessel of the German navy in Hamburg. After World War I she was taken over by the French whom we bought her from in 1929 with the money collected by the inhabitants of Pomerania. From that time on she operated as a training vessel of the Polish navy. Having hoisted the flag on July 13, 1930, on July 26 'Dar Pomorza' set off for the first training trip with the students of State Maritime School. In the 51 years of service, she has sailed around half a million of sea miles.

345

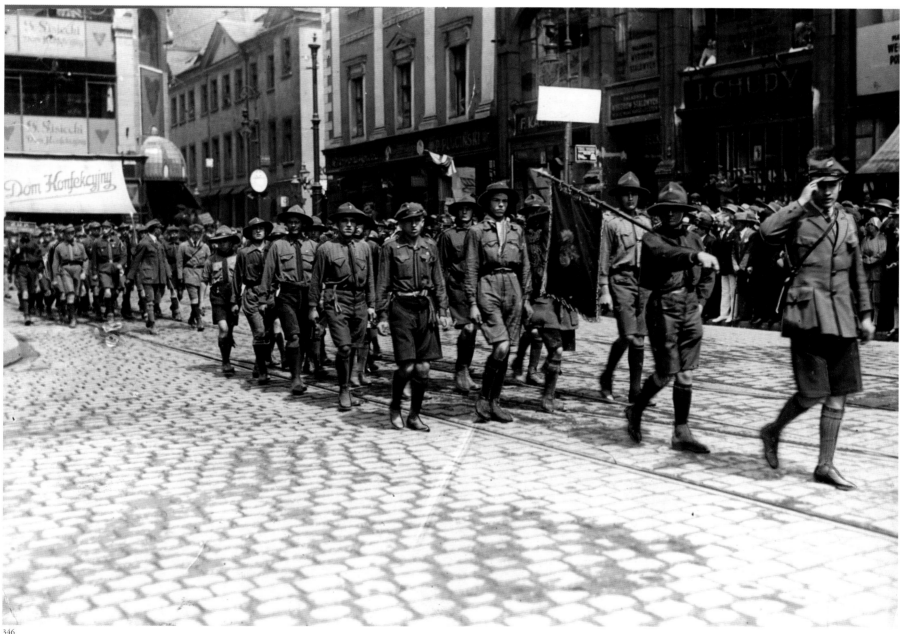

346

345. Polish Scouting and Guiding Association, ZHP was the most numerous youth organization in the pre-war Poland. The scouts would often march across towns, in their green uniforms and characteristic scarfs under the collar. They would spend summer camping. This must have been the most memorable experience to the youngest members, the wolves.

346. ZHP, was formed in 1916. It was a youth organization modelled on the concept of scouting. The scouts fostered patriotism, friendship, and sense of duty among its ranks. Each scout made an oath and kept to his or her promises. This picture was taken during the 2nd National Scouts' Jamboree in Poznań in 1929.

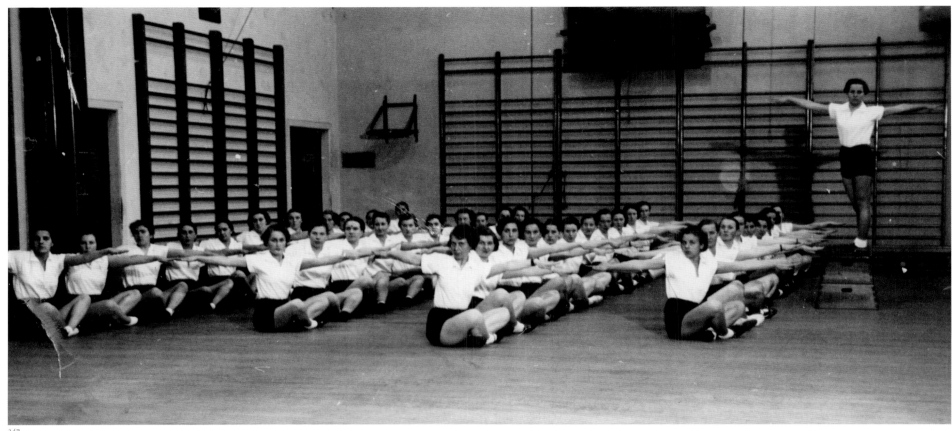

347

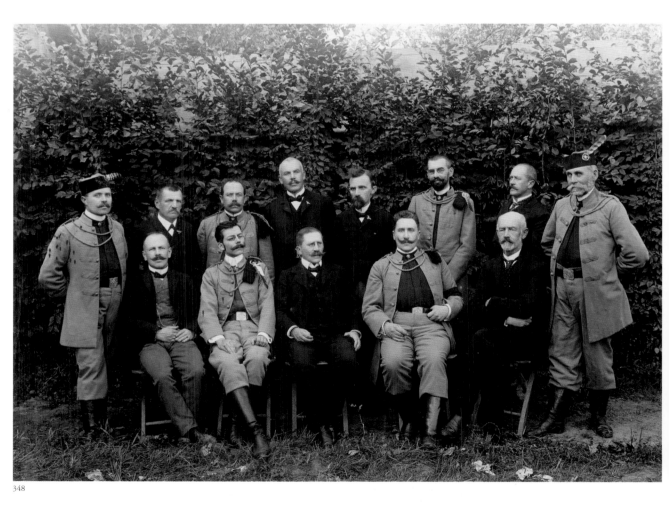

348

347. Secondary-school students are exercising in a gymnasium.

348. 'Sokół' Gymnastic Association was formed in Galicia in 1867 and it aimed at propagating fitness among youth. The organization was also of a clearly paramilitary character: it prepared young people for the struggle for independence. In 1912, paramilitary Field Sokół Squads were formed. Their members would wear quite impressive uniforms, particularly visible during patriotic parades and manifestations. This picture taken in 1900 features the Managing Board of the Association.

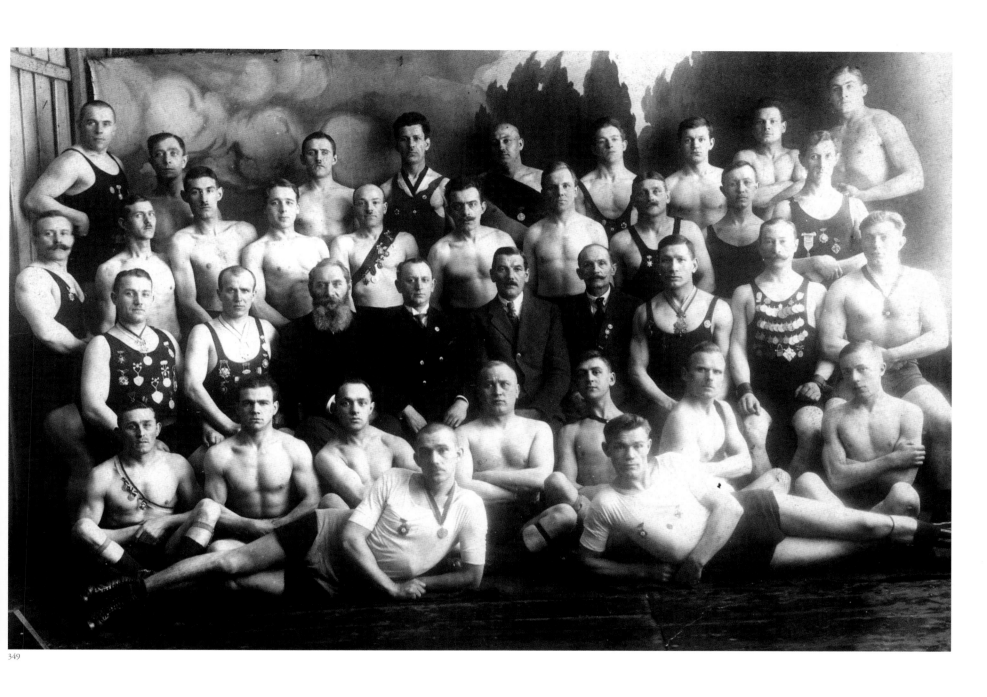

349

349. A group photo of Łódź athletes from 1920.

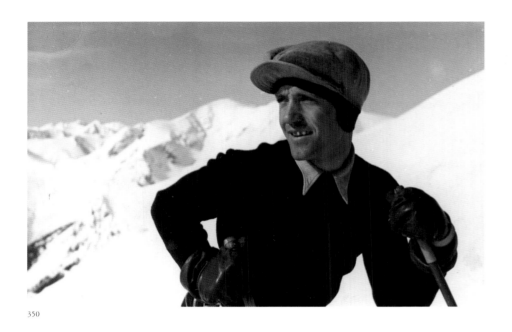

350

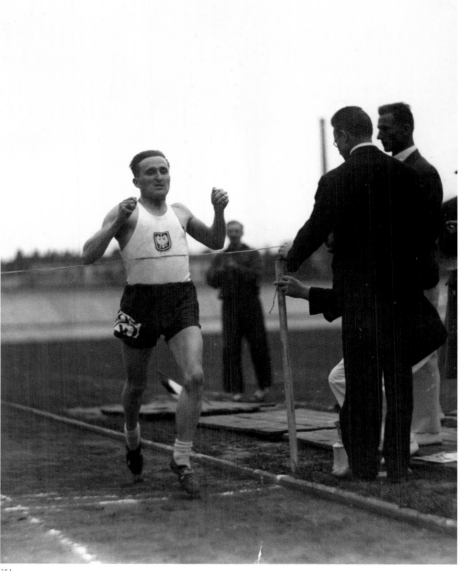

351

350. Bronisław Czech (1908–1944) was one of the world-famous skiers. He practiced cross-country, jumps, and downhill. Champion of Poland on several occasions, he participated three times in the Olympic Games. His other passion was mountain-climbing. He perished in the Auschwitz concentration camp in 1944.

351. Janusz Kusociński (1907–1940) was an unquestionable star of the Polish sports before the war. He won numerous awards, for example, the gold medal at the Los Angeles Olympics in 1932 in a 10,000-metre run; he set the world record in the 3,000-metre run, and was a multiple record holder of Poland. In 1940, he was executed by the Germans in Palmiry near Warsaw.

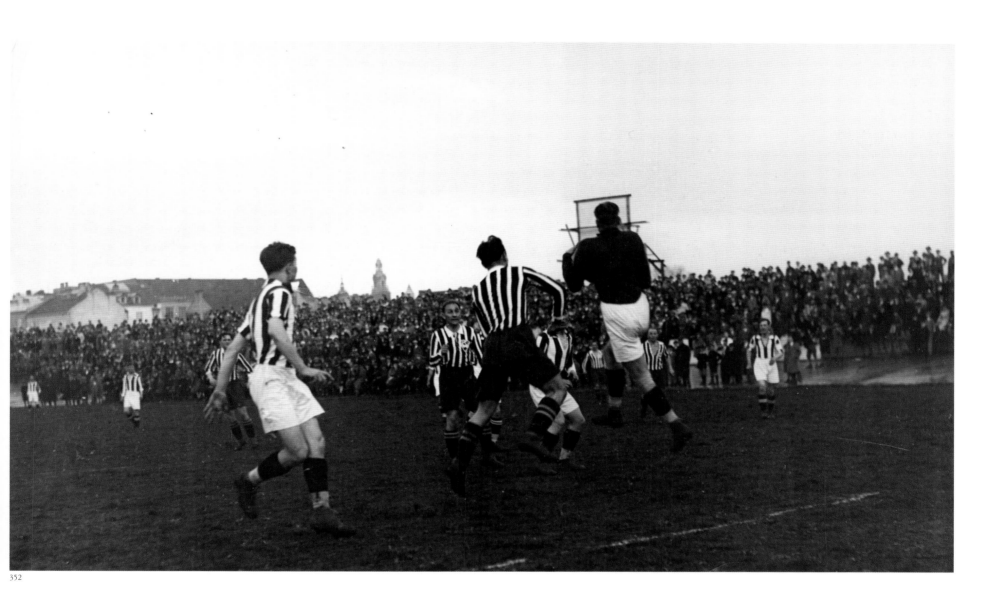

352

352. 'Cracovia' is the history of Polish football: this oldest football club was founded in 1906. Their matches always attracted crowds of fans. In 1921, 'Cracovia' became the first Champion of Poland in the history of Polish football. In the picture we can see the match of the red-and-whites with 'Wacker' from Vienna.

353

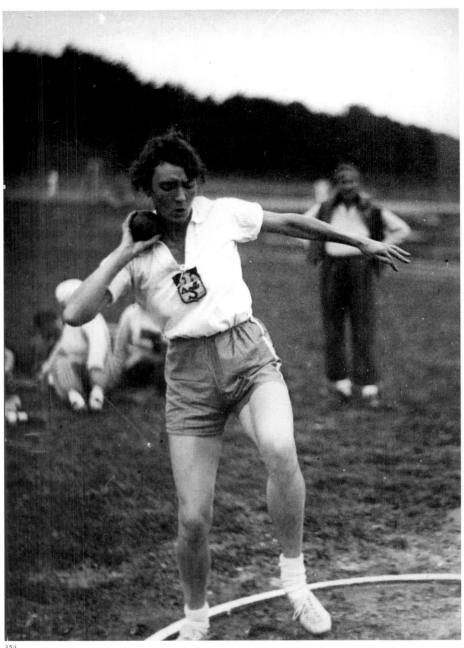

354

353. Halina Konopacka-Matuszewska (1900–1989) was an excellent track-and-field athlete. The first to win the gold for Poland at the 1928 Olympics in Amsterdam in discus throw, in 1940 she moved to America.

354. Halina Konopacka is getting ready for shot-put. Photo L. Jarmuski

355

356

355. Stanisława Walasiewicz-Olson (1911–1980) was a great athlete practising many track-and-fields disciplines. At the 1932 Los Angeles Olympics she won two gold medals in the 100-metre run for women. She was the winner of many sports events. Although she lived in the United States from 1914, she competed for Poland. A known activist among the Polish Americans, she is featured in this photo during a track-and-field match Japan vs. Poland in August 1930.

356. Stanisława Walasiewicz-Olson with the Great Honorary Sports Award, Warsaw 1933.

357

358

357. Human beings dreamt of flying almost from the beginning of their history. The myth of Daedalus and Icarus, Leonardo da Vinci's sketches, are merely stages on the way to the fulfilling of the dream, which was finally achieved by the Montgolfier brothers. In 1783, they succeeded in sending into 'space' a balloon made of paper and canvas and filled with heated air. The gondola carried a sheep, cock, and a duck. Soon, people set off into the air. The first balloon flight in Warsaw was held on May 10, 1789 and the daredevil to do it was the Frenchman J.P. Blanchard.

358. Ballooning competition for juniors in Warsaw 1938.

359

361

360

359. There once used to be a well-known cycling track in Dynasy in Warsaw. In 1927, Zbigniew Gędziorowski won the long-distance classical race. Certainly exhausted, but so proud of his success, he is posing for the photo with a bunch of flowers. Photo Z. Marcinkowski

360. This is a completely forgotten sports discipline. A race of cyclists following motor-bikes was held in Dynasy in Warsaw. The picture was taken around 1911 or 1912. Photo Z. Marcinkowski

361. There used to be rowing competitions held on the Vistula before the war. Slender fours with cox are competing for victory. Photo Z. Marcinkowski

The first archives were founded in Poland by the end of the 12th century. They were established by Church institutions (bishoprics and convents), towns, dukes, and magnates. The so-called Crown Archives (also named Kraków Archives) date back to the mid-14th century and have been partially preserved; by the end of the same century Royal Chancery Register was founded, the latter to soon become the central archives of the Polish-Lithuanian Commonwealth. Gradually, the archives of other central authorities of the Commonwealth were taking on their shape, and so were judicial archives (town and land ones), municipal, Church (lay and monastic clergy), as well as family ones.

In 1794, a part of the archives of the central authorities was taken to St. Petersburg. During the partitions the archives depended strongly on the policy of the partitioning powers: Austria, Prussia, and Russia, who established their own network of archives in the 19th century. During the Duchy of Warsaw, the first modern Polish archives were established in 1808. It was the General National Archives, currently the Central Archives of Historical Records.

In the independent II Republic of Poland there used to be the Central Archives of Historical Records, Treasury Archives, Education Archives, and Military Archives (transformed into the Archives of Modern Records in 1930). State archives were also founded in some provincial towns, church archives were reorganized; moreover, old town and family archives were in operation. Just like today, their task was to collect, protect, elaborate, and facilitate access to the collections.

Some serious devastation of the archives occurred during World War II. The Warsaw archives being under the occupants' control suffered the most, losing 95 percent of their pre-war resources (all the central archives and the Archives of the City of Warsaw were almost completely destroyed), but so were the Poznań and Płock ones.

After World War II the network of archives was reproduced wherever it was possible. The archives from the territories of the former Reich incorporated into Poland were also included and new state archival posts were established. Some very ample records remained outside Poland, meaning Grodno, Vilnius, and Lviv. New archives service was organized. And the Head Office of

State Archives was established to be responsible for a much developed archives network. All state offices, institutions, and plants were scrutinized by the state archival service obliged to systematically transfer the archival material to the state archives.

Currently, the network of state archives headed by the Director of State Archives is made of the following:

— three central archives located in Warsaw: Central Archives of Historical Records (stores records of central authorities and partially local ones as well as family records from before 1918), Archives of Modern Records (keeps records of central authorities, national institutions and associations, as well as the legacy of political activists after 1918), and Archives of Mechanized Documentation (keeping photo-, phonographic and film records)

— thirty state archives collecting archival records produced by local governments and state offices, justice institutions, local governments and their bodies (these including town and commune archives), educational institutions and organizations, religious and social ones, records of families and estates, legacy of private people, regional collections. In the majority of the archives the records kept date from the turn of the 19th century. Some of the archives are in the possession of older records dating from the Middle Ages. The oldest and most valuable records are to be found in the state archives in Gdańsk, Kraków, Lublin, Olsztyn, Poznań, Przemyśl, Szczecin, Warsaw, and Wrocław.

Apart from the above there are numerous central institution archives, the archives of political parties, associations, social organizations, trade unions, higher education institutions, as well as academic and cultural ones. A group apart is formed by Church archives: dioceses, parishes, convents, and there are also some scarce private collections. It is worth mentioning that libraries and museums possess numerous archives, too. The archival records related to Poland and Poles living abroad are collected by libraries, institutes, and museums of Poles abroad, (e.g. in France, United States, Great Britain).

The collections of the archives can be used for any type of scholarly research, as well as for some hobby purposes (e.g. genealogical search), and practical ones (e.g. to confirm ownership titles or the fact of being imprisoned or persecuted).

Currently, the state archives store documents produced by over 75,000 authors. These are made of more than 34 million

archival items (portfolios, books, documents), covering more than 240-kilometre-long shelves. The archives also supervise state and local government institutions storing more than 200 kilometres of documents. The total of the national archival records certainly exceeds 500 kilometres, which means several billion sheets covered with information. They are of totally unique character, since they come from different historical eras and constitute a rich source of information both on the past and today.

Almost all state archives publish information on their records, frequently illustrated with document copies. They also set their on-line services, such as www.archiwa.gov.pl, allowing for the access to the information about their records and in some cases providing digital copies of the most treasured and interesting documents related to a definite topic. The treasures of Polish archives are exposed at www.polska.pl.

Archiwum Dokumentacji Mechanicznej

(Archives of Audio-Visual Records)

p. 6, nos 1, 8, 22, 23, 24, 28, 36, 37, 38, 39, 40, 41, 43, 49, 50, 51, 61, 62, 63, 64, 65, 66, 67, 70, 71, 72, 73, 77, 84, 85, 88, 89, 90, 91, 92, 93, 94, 95, 96, 98, 99, 100, 101, 102, 103, 104, 105, 106, 107, 108, 109, 110, 111, 112, 113, 114, 120, 121, 124, 125, 126, 127, 128, 144, 145, 148, 149, 150, 151, 152, 153, 157, 158, 159, 161, 162, 163, 164, 165, 160, 170, 175, 176, 177, 178, 181, 183, 184, 185, 186, 187, 188, 189, 191, 197, 198, 199, 200, 201, 204, 205, 206, 207, 208, 209, 210, 211, 213, 214, 215, 216, 217, 218, 219, 221, 232, 233, 234, 235, 246, 247, 248, 249, 252, 253, 255, 256, 257, 258, 259, 260, 261, 263, 265, 267, 268, 269, 270, 272, 273, 274, 275, 277, 278, 279, 280, 281, 282, 284, 285, 286, 290, 291, 292, 293, 294, 297, 298, 299, 300, 301, 302, 304, 305, 306, 307, 310, 311, 312, 314, 315, 316, 317, 318, 319, 322, 324, 325, 326, 327, 328, 330, 331, 332, 333, 334, 335, 337, 338, 339, 340, 341, 342, 343, 345, 346, 350, 351, 352, 353, 354, 355, 356, 357, 358

Archiwum m.st. Warszawy

(The State Archive of the Capital City of Warsaw)

nos 2, 3, 4, 5, 6, 7, 16, 17, 18, 19, 20, 21, 30, 31, 53, 54, 68, 76, 78, 79, 81, 82, 83, 97, 135, 136, 142, 160, 173, 174, 192, 193, 212, 244, 347, 359, 360, 361

Archiwum Państwowe w Krakowie

(The State Archive in Kraków)

nos 11, 12, 13, 14, 15, 44, 86, 115, 116, 117, 118, 119, 190, 154, 155, 156, 171, 172, 179, 182, 220, 225, 245, 262, 276, 313, 320, 321, 323

Archiwum Państwowe w Łodzi

(The State Archive in Łódź)

nos 25, 52, 60, 80, 123, 129, 130, 131, 132, 222, 223, 237, 238, 239, 240, 241, 242, 243, 303, 308, 309, 349

Archiwum Państwowe w Poznaniu

(The State Archive in Poznań)

nos 29, 48, 55, 69, 74, 75, 87, 133, 134, 251, 295, 296

Archiwum Państwowe w Przemyślu

(The State Archive in Przemyśl)

nos 56, 122, 146, 147, 166, 167, 168, 195, 224, 226, 336, 348

Archiwum Państwowe w Gdańsku

(The State Archive in Gdańsk)

nos 137, 138, 139, 250, 287, 288, 289, 344

Archiwum Akt Nowych

(Central Archives of Modern Records)

nos 9, 10, 26, 27, 202, 203

Archiwum Państwowe w Kaliszu

(The State Archive in Kalisz)

nos 226, 227, 228, 229, 230, 231

Archiwum Państwowe w Kielcach

(The State Archive in Kielce)

nos 32, 33, 34, 180, 236

Archiwum Państwowe w Piotrkowie Trybunalskim

(The State Archive in Piotrków Trybunalski)

nos 59, 143, 194, 271

Archiwum Państwowe w Katowicach

(The State Archive in Katowice)

nos 45, 46, 254

Archiwum Państwowe w Toruniu

(The State Archive in Toruń)

nos 42, 140, 141

Archiwum Państwowe w Białymstoku

(The State Archive in Białystok)

nos 57, 58

Archiwum Państwowe w Radomiu

(The State Archive in Radom)

nos 35, 264

Archiwum Państwowe w Częstochowie

(The State Archive in Częstochowa)

no. 196

Archiwum Państwowe w Lublinie

(The State Archive in Lublin)

no. 283

Archiwum Państwowe w Opolu

(The State Archive in Opole)

no. 47

Archiwum Państwowe w Siedlcach

(The State Archive in Siedlce)

no. 329

First Edition
Olszanica 2005

ISBN
83-89747-17-0

Wydawnictwo Bosz
38-622 Olszanica 311
Office:
ul. Parkowa 5, 38-600 Lesko
tel. +48 13 469 90 00, 469 90 10
tel./fax +48 13 469 61 88
email: biuro@bosz.com.pl
www.bosz.com.pl